Rejoice!

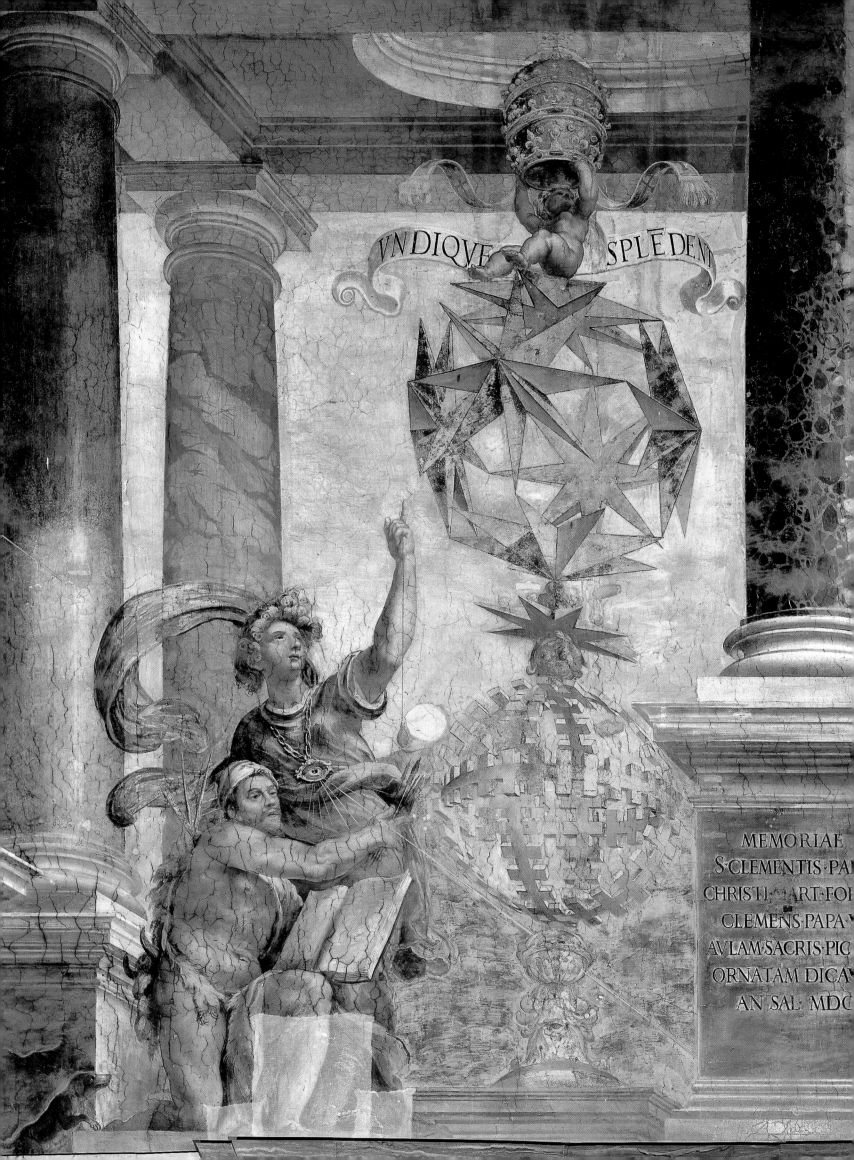

VNDIQVE SPLĒDENT

MEMORIAE
S·CLEMENTIS·PA[...]
CHRISTI·MART·FO[...]
CLEMENS·PAPA[...]
AVLAM·SACRIS·PIC[...]
ORNATAM·DICA[...]
AN·SAL·MDC[...]

Rejoice!

700 Years of Art for the Papal Jubilee

Edited by Maurizio Calvesi
with Lorenzo Canova

RIZZOLI
NEW YORK

PHOTO CREDITS

Page 2:
Cherubino Alberti and Baldassarre Croce
Allegory of Art and Science
Vatican City, Apostolic Palace
Sala Clementina, eastern wall

First published in the United States of America in 1999 by
Rizzoli International Publications, Inc.
300 Park Avenue South, New York, NY 10010

© 1999 RCS Libri S.p.A.
Via Mecenate 91, Milan, Italy

ISBN: 0-8478-2236-2
LC 99-74735

Printed and bound in Italy

American Edition:
Translation: Rhoda Billingsley
Italian Edition:
Editor: Luisa Sacchi
Coordinating Editor: Cristina Sartori
Editing and Picture Research: Roberta Garbarini
Jacket Design: Elena Pozzi
Graphic Design: Sottsass Associati/Mario Milizia, Paola Lambardi
Layout: Break Point/Flavio Guberti

Table of Contents

INTRODUCTION

The Jubilee Year is called in the Latin Vulgate "l'annus iubilaeus." But the etymology of the word "jubilee," so similar to the Latin "iubilare," is really to be found in the Hebrew "yobel" which means "ram," inasmuch as the Hebrew feast of the Jubilee was announced by blowing the ram's horn. The feast occurred every fifty years, and the entire year was sanctified: the land was left fallow, there was neither sowing nor harvesting; freedom was restored to the slaves; and lands or houses restored to those who had alienated them (according to Hebrew custom, that is, in the guise of a kind of rental until the following Jubilee). Lastly, pawns were returned to debtors without their having to pay back the loans they had received. An echo of this practice can be found in a Latin hymn from the beginning of the thirteenth century, "Anni favor iubilaei poenarum laxat debitum." In the Christian concept of the Jubilee, the faithful obtained the remission of their sins by visiting Rome and the sacred basilicas.

Boniface VIII officially launched a great Indulgence which promulgated the first Jubilee (although not referred to as that) in the year 1300. His papal Bull, dated February 22, 1300, established that a jubilee would be staged every hundred years. But, as Clement VIII said when announcing the Jubilee of 1600, the successors of Boniface "propter vitae humanae brevitatem, Iubilaei celebrandi spatium contraxerint"—contracted the space of the jubilee celebrations in consideration of the brevity of human life. On January 27, 1343, Clement VI, with the Bull *Unigenitus*, announced a second Jubilee, or Holy Year, for the middle of the century. The third was declared on April 11, 1389, by Urban VI, to begin on Christmas Day of that year and to be repeated every thirty-three years, a length of time equal to the age of Christ when he was crucified. However, the pope died soon after, and the Jubilee of 1390 was organized by his successor, who took the name Boniface IX. At the end of the century, in the year 1400, Boniface IX announced the fourth Jubilee.

Martin V returned to the thirty-three-year recurrence starting with the Holy Year of 1390, and the fifth Jubilee was celebrated in 1423. But his successor, Nicholas V, returned to the mid-century appointment by declaring the next Holy Year to be 1450, rather than 1456 (perhaps fearing that he would not live that long). Since then, the Holy Years have been repeated every twenty-five years, with the addition of the "extraordinary" Jubilees declared in 1585 and 1590 by Sixtus V (who did not think he would live until the year 1600—and indeed he did not). There were also exceptions in the nineteenth century: both the 1800 and the 1850 Holy Years were skipped, and the Jubilee of 1875 was celebrated semi-clandestinely (after the breach of Porta Pia). This volume presents an anthology of the principal artistic, architec-

tural, and urban projects that were programmed during all the Jubilees, including the works that were planned for the Holy Years, or realized during the year or in close proximity to it, with the exception of the years 1350, 1390, and 1400, which were celebrated with limited artistic production.

The enthusiasm that marked the first Jubilee in 1300—when Giovanni Villani estimated that over 200,000 pilgrims "were in Rome continually during the entire year in addition to the Roman people" (and in those days the pilgrims moved primarily on foot)—has been repeated throughout the centuries. In fact, the number of pilgrims has grown dramatically during our century as the population has increased and as new means of transport have become available. The hopes and desires of the masses have remained unchanged, and no other historical event on this scale has continued to be reproduced in identical fashion from the Middle Ages to the present. The fervid activity of the artists and architects has also remained constant, whether their works were made in preparation for the Jubilee or launched by its momentum.

Many of the most important achievements in the artistic and architectural history of the city of Rome during the past seven centuries have been concentrated around those solemn appointments. Some have been completed far from a Jubilee, others have been planned well before with one in view. All of the efforts of Paul III Farnese, who was elected in 1534, were aimed at creating an "Alma Roma" to show off to Christianity on the occasion of the Holy Year of 1550. That vast project was not simply a matter of a radical and complex urban intervention and the building of great architectural works, but also of pictorial campaigns of the caliber of Michelangelo's *Last Judgment* (which had already been finished in 1541) and the Pauline Chapel. The pope died less than two months before the celebration of his Holy Year.

In other cases, initiatives that had been started just as a Holy Year was to begin continued during the course of the year, and often well beyond it. During 1499, as the mid-millennium Jubilee was approaching, Alexander VI had a group of medieval and ancient buildings hurriedly demolished (among them, the famous *Meta Romuli*, the legendary sepulchral pyramid named after the founder of Rome). The pontiff wished to create a straight road connecting Castel Sant'Angelo and St. Peter's Square to avoid the disastrous bottlenecks that had occurred in the previous Holy Years. It was the first time that the urban fabric of Rome had been gutted, but the pope's rapid decision was immediately expedited. There was only time to trace out the new street, however, and the buildings that would eventually line it were constructed later. As a matter of fact, the pope was forced to mobilize the pilgrims to finish removing the rubble of the *Meta* that was still cluttering the street. Clearly, then, traffic problems, unfinished works, and the obstacles created by archeological ruins (which today are fortunately valued in a different light) are not new issues to the great Jubilee of 2000.

Maurizio Calvesi

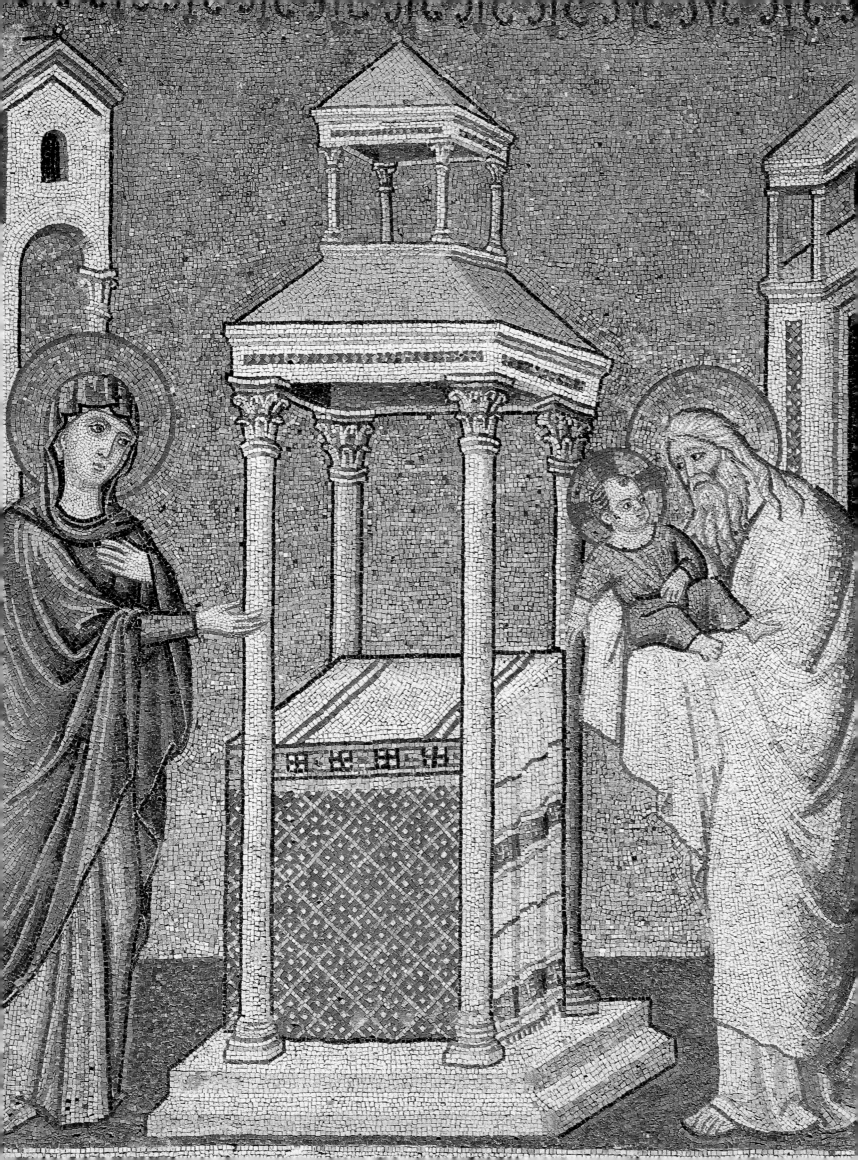

THE JUBILEE OF BONIFACE VIII

THE ROME OF CAVALLINI AND GIOTTO

Alessandro Tomei

The first Jubilee was proclaimed quite suddenly and without any particular preparations by Boniface VIII in his famous Bull *Antiquorum habet* of February 22, 1300. But the city of Rome was prepared for the solemn event and, with its magnificence and sacred character, was able to provoke wonder in the masses of pilgrims who came to visit. During the previous three decades, the major sanctuaries of Western Christianity had been completely renovated, restored, and decorated with impressive fresco cycles, mosaics, sculptures, furnishings, and liturgical objects. It was as if the numerous monumental commissions made by recent popes—in particular Nicholas III (1277-1280) and Nicholas IV (1288-1292)—had been programmed for the Jubilee, to offer the faithful a brilliant image of the *Ecclesia triumphans* (Church Triumphant). If, in the first half of the thirteenth century, the papacy had opposed the imperial power embodied in Frederick II Hohenstaufen

(often rather bitterly), during the second half of the century, the pontiffs were determined to reestablish the spiritual and temporal supremacy of the Vicariate of Christ, even by means of ideological messages contained in the works of art.

The iconographic motifs that were revived at that time were therefore meant to emphasize the direct descent of papal authority from the spiritual legacy of Peter and Paul, the apostles who had spread the Christian word and sanctified the city with their martyrdoms. Nicholas III had commissioned two fresco cycles that depicted the stories of the apostles, one in the portico of the ancient basilica of St. Peter's and the other in the Sancta Sanctorum at the Lateran, the popes' private chapel containing the most precious relics of Christianity. The artists involved in those projects drew their inspiration from the stylistic and iconographic models of the purest classical tradition, reviving the decorative motifs and archi-

Pietro Cavallini
Presentation at the Temple
Rome, Santa Cecilia in Trastevere
detail

tectural frames of the frescoes, and progressively discovering volumetric and three-dimensional values in the representation of the pictorial space.[1] Above all, they opened the way to a revival of the formal values of classical painting which culminated in the great works of Jacopo Torriti, Pietro Cavallini, and Giotto at the end of the thirteenth and the beginning of the fourteenth centuries.

One of the high points of that revival is the great composition representing the *Judgment Day*, located just inside the façade of the basilica of Santa Cecilia in Trastevere, along with fragmentary scenes from the Old and New Testaments. Rediscovered at the beginning of this century by Federico Hermanin, the frescoes at Santa Cecilia marked a radical turning point in the interpretation of late thirteenth century Roman painting.[2] When they were discovered, the extraordinary quality of these paintings, their solid and mature plasticity, the discerning and calibrated chiaroscuro, and the naturalism of the figures put to rest the already antiquated notion that Roman painting was tied to Byzantine stylistic themes. These paintings also undermined the general art-historical opinion that Cavallini was a student of Giotto, a view that can be traced to Vasari (who was anxious that the "renascence" of Florentine painting take the lead over Roman painting).[3] The composition of the *Last Judgment*, which reinterpreted some iconographic elements of the oriental tradition, revolutionized the way the human figure was rendered. The bodies of Cavallini's figures demonstrate a new emphasis on plasticity; their physical immanence is established through a discerning play of chiaroscuro, all based on a subtle variation of color tones that interact with the brilliant highlighting, applied in wide bands.

But the frescoes on the inside of the façade are not the only surviving ones in the church. In addition to the above-mentioned architectural motifs,

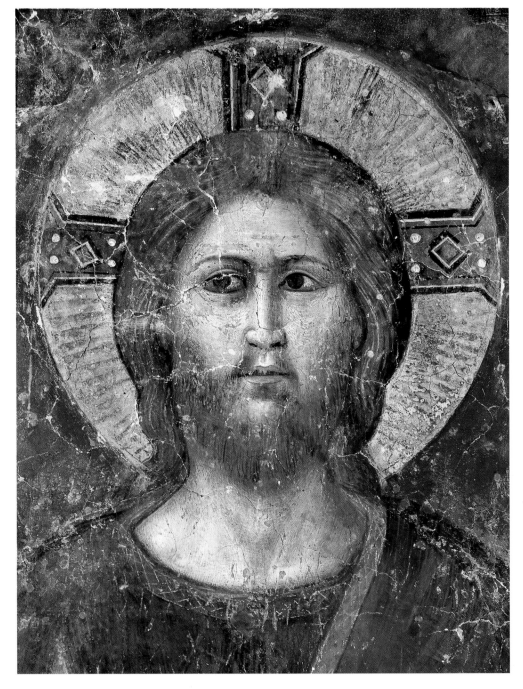

there are fragments on the right wall of three scenes depicting the *Stories of Isaac and Jacob*, while on the left wall there is part of an *Annunciation* and a large figure of *St. Michael Archangel*. It is immediately evident that more than one hand was involved in these works; for that matter, even the lower part of the *Last Judgment* presents rather clear-cut stylistic and technical discrepancies with the upper part. If the hand of a decidedly less skilled artist is evident in the *Annunciation*, the painter who executed the *Stories of Isaac and Jacob* was an artist of real originality and excellence. Like Cavallini, this latter artist constructed his

Pietro Cavallini
Christ
detail from the *Last Judgment*
Rome, Santa Cecilia in Trastevere

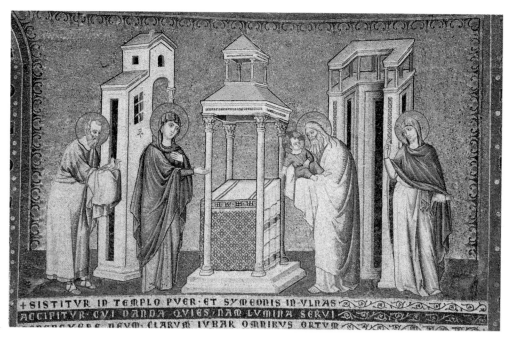

+SISTITVR IN TEMPLO PVER · ET SYMEONIS IN VLNAS
ACCIPITVR · CVI · DANDA · OVIES · NAM LVMINA SERVI

figures with broad fields of color, but he also superimposed on them nervous flickers of light and sudden linear spurts that distance him from the master of the *Last Judgment.* Chronologically, the execution of the cycle probably coincided with construction of the ciborium by Arnolfo di Cambio dated 1293, evidently after a general redecoration of the building.[4]

Cavallini's other great Roman work is the cycle of *Stories of the Virgin* in the apse of Santa Maria in Trastevere, located just below the mosaic representing *Christ and the Virgin Enthroned,* which had been executed during the papacy of Innocent II. The six panels in mosaic depict the *Birth of Mary,* the *Annunciation,* the *Birth of Christ,* the *Adoration of the Wise Men,* the *Presentation at the Temple,* and the *Dormitio Virginis.* There is also a dedicatory panel depicting the donor Bertoldo Stefaneschi, a member of an important Trastevere family and an active patron of the arts, being presented to the Virgin by St. Peter, with St. Paul on the opposite side. The date of execution, once visible on this panel, has now disappeared; Barbet de Jouy read it as 1351, and De Rossi corrected it to 1291, but both proposals are based on extremely weak data.[5] What is certain is that the spatial structure of the scenes, in particular the *Birth*

of Mary and the *Annunciation,* is extremely advanced, with a solidity of the placement of the figures that appears more plastically articulated with respect to Santa Cecilia.[6] The execution of the apse fresco in the church of San Giorgio in Velabro (1296) has also been attributed to Cavallini by most critics. Although the physical state of this work is seriously compromised, it does share similarities both to the frescoes in Santa Cecilia and the mosaics in Santa Maria in Trastevere, and may be considered a work of the bottega.[7]

In the basilica of Santa Maria in Aracoeli on the Capitoline hill, the first headquarters of the Franciscan Order in Rome, Cavallini executed several works. Of particular importance is the fresco for the funeral monument of Cardinal Matteo d'Acquasparta (who died in 1302), which shows the Virgin with Child between St. Peter and St. Francis, who presents the deceased prelate.[8] Here, Cavallini shows a greater interest in the volumetric rendering of the human figure and its positioning in space than in the mosaics of Santa Maria in Trastevere.

The election of Boniface VIII (1294-1303), the figurative production fostered by the papal court, and the Jubilee of 1300 together formed the culminating moment in Roman

Pietro Cavallini
Presentation at the Temple
Rome, Santa Cecilia in Trastevere

11

artistic culture. Indeed, the fervent activity in Rome even attracted the Florentine master Giotto, who had just completed his *Stories of St. Francis* in the upper basilica of St. Francis at Assisi. Boniface VIII was probably responsible for bringing Giotto to Rome, but it is difficult to ascertain which projects he planned for the painter. What we do know is that the first work commissioned by Boniface VIII was probably his own funerary monument, the design and execution of which were entrusted to Arnolfo di Cambio in 1296, when the pope was still alive and newly elected. Jacopo Torriti was also hired to execute a mosaic panel for the wall of the pope's chapel; today, only two fragments of the panel exist (one in the Pushkin Museum in Moscow and another in the Brooklyn Museum of Art in Brooklyn, New York).[9] The complete work originally depicted the Virgin and Child in a clipeus with St. Paul on the left and St. Peter presenting the kneeling pope on the right.

The first Roman work traditionally attributed to Giotto is the fragmentary "Jubilee" fresco, which today is attached to the third pilaster of the right nave of the basilica of St. John in Lateran. It was originally in the Benediction Loggia that Boniface VIII had built on the north side of the *Aula Concilii*. The surviving fragment shows the pontiff flanked by two ecclesiastics in a portico; the priest on the left unrolls a scroll on which is written "*Bonifacius episcopus servus servorum Dei ad perpetuam rei memoriam*" (Bishop Boniface, servant of the servants of God, in perpetual memory of the event); on the extreme right of the scene, between two columns is a bearded figure in profile dressed in a tawny grey tunic. The scene can be completed thanks to a late Cinquecento watercolor (now in the Biblioteca Ambrosiana of Milan) which represents in the lower half, which is lost in the original, a group of the faithful acclaiming the pontiff while ecclesiastics and papal dignitaries stand on the sides of the portico. On the parapet of the architectural structure, the Caetani coat of arms alternates with the insignia of the *umbraculum*, an imperial symbol. The iconography of Giotto's fresco has been interpreted in various ways; besides the traditional reading of it as a celebration of the proclamation of the Jubilee, is the view that it represents Boniface VIII taking possession of the Lateran on January 23, 1295. The fresco was probably executed in 1297 to reaffirm the power of the new pope, which had been questioned by the Colonna family.[10] From a stylistic point of view, the attribution to Giotto tends to be rejected today in favor of an unknown Roman artist of the Cavallini school.

The death of Boniface VIII in 1303 and the transfer of the Holy See to Avignon a few years later, caused a rapid decline in the number of important artistic commissions in Rome. Among the exceptions were those works that Cardinal Jacopo Stefaneschi had commissioned from Giotto. One was the famous mosaic of the Navicella (today, almost completely lost) in the atrium of the ancient St. Peter's. Of the fourteenth-century original, only two clipei enclosing busts of angels survive (in the Vatican Crypt and in Boville Ernica, San Pietro Ispano). Technical aspects of this work suggest that Giotto entrusted the material execution to an unknown mosaicist once he had defined the general lines of the composition (probably with a cartoon or preliminary design). There is a striking similarity in technique between the angels of the Navicella and Cavallini's mosaics at Santa Maria in Trastevere, although the two works are different stylistically. Giotto was then commissioned by Cardinal Stefaneschi to create several works for the basilica of St. Peter's: a large triptych, which involved ample bottega intervention; now-lost frescoes for the apse of St. Peter's, which depicted five stories from the life of

At right:
The Proclamation of the Jubilee by Boniface VIII
Rome, St. John in Lateran

Pages 14-15:
Giotto and helpers
Stefaneschi triptych
Rome, Vatican Pinacoteca

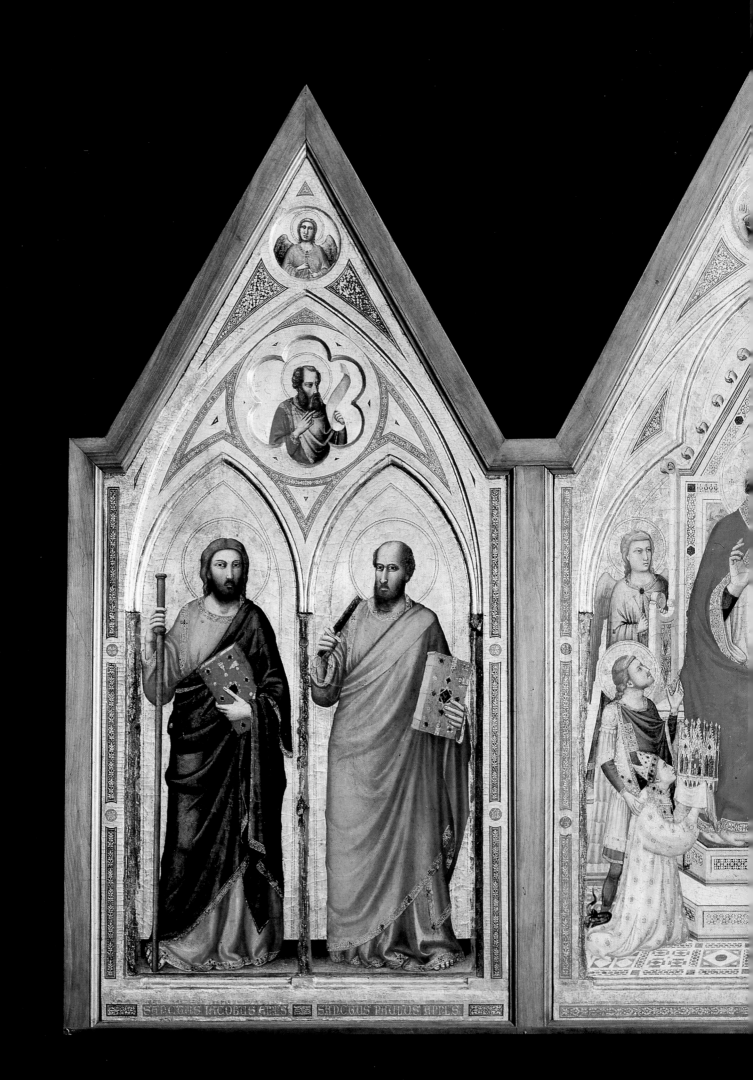

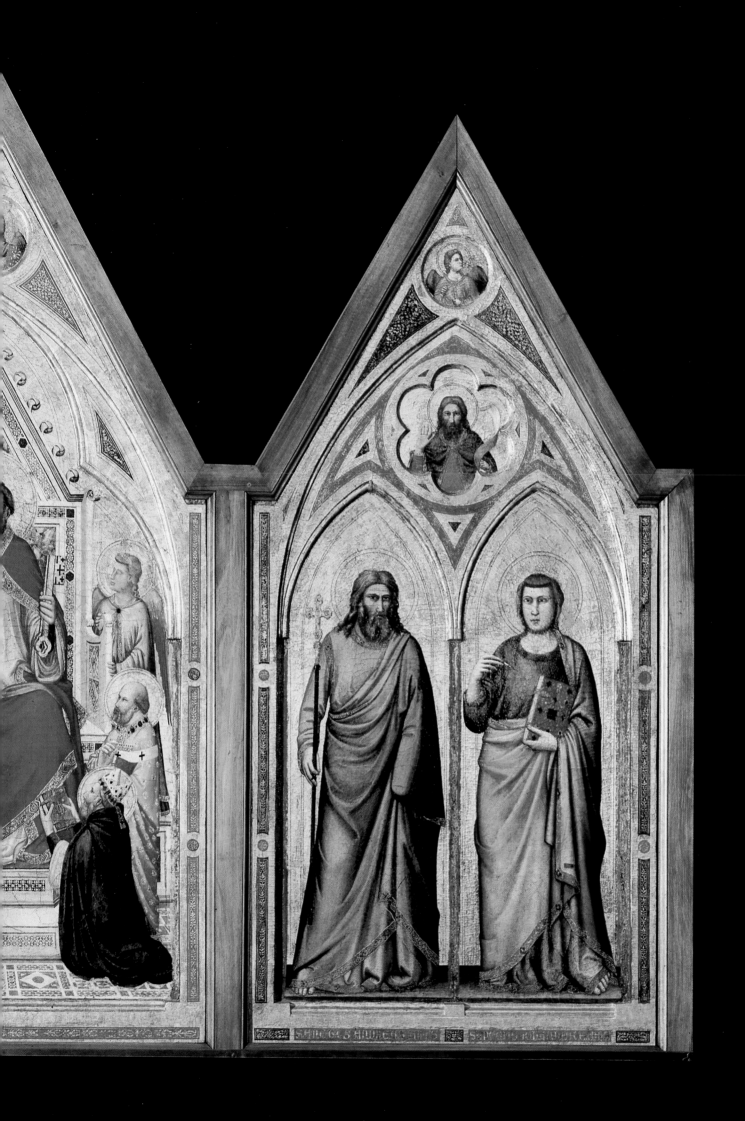

Christ; and the so-called Stefaneschi triptych, now in the Vatican Pinacoteca, painted for the high altar of the basilica, albeit with considerable assistance from his bottega.[11] Giotto's masterpieces represent the zenith of the great era of Roman medieval painting and, at the same time, its conclusion. But in just a few decades Rome's figurative legacy would prove central to the classical revivals of the Renaissance season.

[1] For the decoration of the Sancta Sanctorum, which recent restoration has returned to its original aspect with surprising stylistic and iconographic innovations, see *Sancta Sanctorum* (Milan 1995).
[2] F. Hermanin, "Gli affreschi di Pietro Cavallini a Santa Cecilia in Trastevere," *Le Gallerie Nazionali Italiane*, 5 (1902): 61-115. Fundamental to the study of Cavallini is the monograph by G. Matthiae, *Pietro Cavallini* (Rome 1972). See also the critical history, F. Gandolfo, *Aggiornamento a G. Matthiae: Pittura romana del Medioevo. Secoli XI-XIV* (Rome 1988) 329-35; A. Tomei, "L'arte e le arti suntuarie da Alessandro IV a Bonifacio VIII (1254-1303)," in *Roma nel Duecento. L'arte nella città dei papi da Innocenzo III a Bonifacio VIII* (Turin 1991), pp. 321-403; and "Cavallini, Pietro" in *Enciclopedia dell'arte medievale*, vol. 4 (Rome 1993), pp. 586-94. Also see, for an amplification not always shared of the catalogue of the artist, M. Boskovits "Proposte (e conferme) per Pietro Cavallini," in *Roma Anno 1300*, Atti della IV Settimana di Studi di Storia dell'arte medievale dell'Università di Roma "La Sapienza" (1980), ed. A. M. Romanini (Rome 1983), pp. 297-329.
[3] G. Vasari, "Vita di Pietro Cavallini," in *Le Vite de' più eccellenti pittori scultori e architettori*, ed. R. Bettarini, comment ed. P.Barocchi (Florence 1969). For the age-old dispute on this subject, by now resolved by the uncontestable age difference (about twenty years) between Cavallini and Giotto, see A. Barbero, "Un documento inedito su Pietro Cavallini," in *Paragone*, n.s. 40, no. 16 (1989): 84-87; and Tomei, "La pittura e le arti suntuarie da Alessandro IV a Bonifacio VIII" p. 367ff.
[4] Regarding this point, see, in particular, A. M. Romanini, "Il restauro di Santa Cecilia a Roma e la storia della pittura architettonica in età gotica," in *Tre interventi di restauro*. VI General Assemply I.C.O. M.O.S. International Congress of Studies (Rome 1981), pp. 75-78; S. Romano, "Alcuni fatti e qualche ipotesi su Santa Cecilia in Trastevere," *Arte medievale*, 2d ser., 2 (1988): 105-19; and Tomei, "La pittura e le arti suntuarie da Alessandro IV a Bonifacio VIII," p. 374.
[5] H. Barbet de Jouy, *Les mosaiques chrétiennes de Rome* (Paris 1857), pp. 124-27; G. B. De Rossi, *Mosaici cristiani e saggi dei pavimenti delle chiese di Roma anteriori al sec. XV* (Rome 1872-92), n.p.
[6] For the different datings, see Gandolfo, *Aggiornamento*, p. 329ff. For an unconvincing connection of the cycle to the Jubilee, see V. Tiberia, *I mosaici del XII secolo e quelli di Pietro Cavallini in Santa Maria in Trastevere, restauri e nuove ipotesi* (Todi 1996).
[7] See Matthiae, *Pietro Cavallini*; and Gandolfo, *Aggiornamento*, p. 331ff.
[8] For Cavallini at the Aracoeli, see A. Tomei, "Un contributo per il perduto affresco dell'Aracoeli," *Storia dell'arte*, 44 (1982): 83-86.
[9] Regarding these works, see O. Etinhof, "Mosaici romani nella raccolta di P. Sevastjanov," *Bolletino d'Arte*, ser. 6, vol. 76 (1991): 29-38; A. Tomei, "Un frammento ritrovato dal mosaico del monumento di Bonifacio VIII in San Pietro," *Arte medievale*, ser. 2, no. 2 (1996): 123-31; M. Boskovits, "Jacopo Torriti: un tentativo di bliancio e qualche proposta," in *Scritti per l'Istituto Germanico di Storia dell'Arte di Firenze*, (Florence 1997), pp. 5-16.
[10] For this hypothesis, see S, Maddalo, "Bonifacio VIII e Jacopo Stefaneschi. Ipotesi di lettura dell'affresco della loggia lateranense," *Studi romani*, 31 (1983): 129-50; see also Gandolfo, *Aggiornamento*, pp. 368-69.
[11] Obviously, there is endless material regarding Giotto's activity in Rome. For a synthesis see Gandolfo, *Aggiornamento*, pp. 360ff.; A. Tomei, "Giotto," in *Enciclopedia dell'arte medievale*, vol. 6 (Rome 1995), pp. 649-75; and A. Tomei, "Roma senza papa: artisti, botteghe, committenti tra Napoli e la Francia," in *Roma, Napoli, Avignone: Arte di curia, arte di corte 1300-1377*, ed. Alessandro Tomei (Turin 1996), pp. 11-53.

Giotto and helpers
St. Peter Enthroned and the Donor
Stefaneschi triptych
Rome, Vatican Pinacoteca

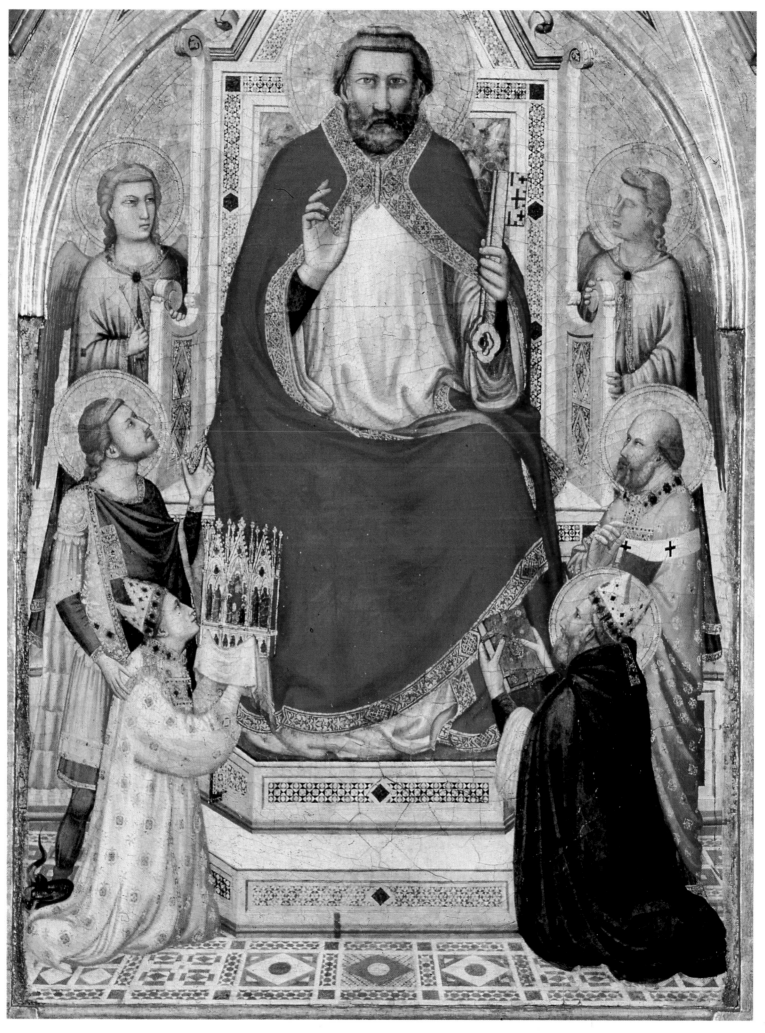

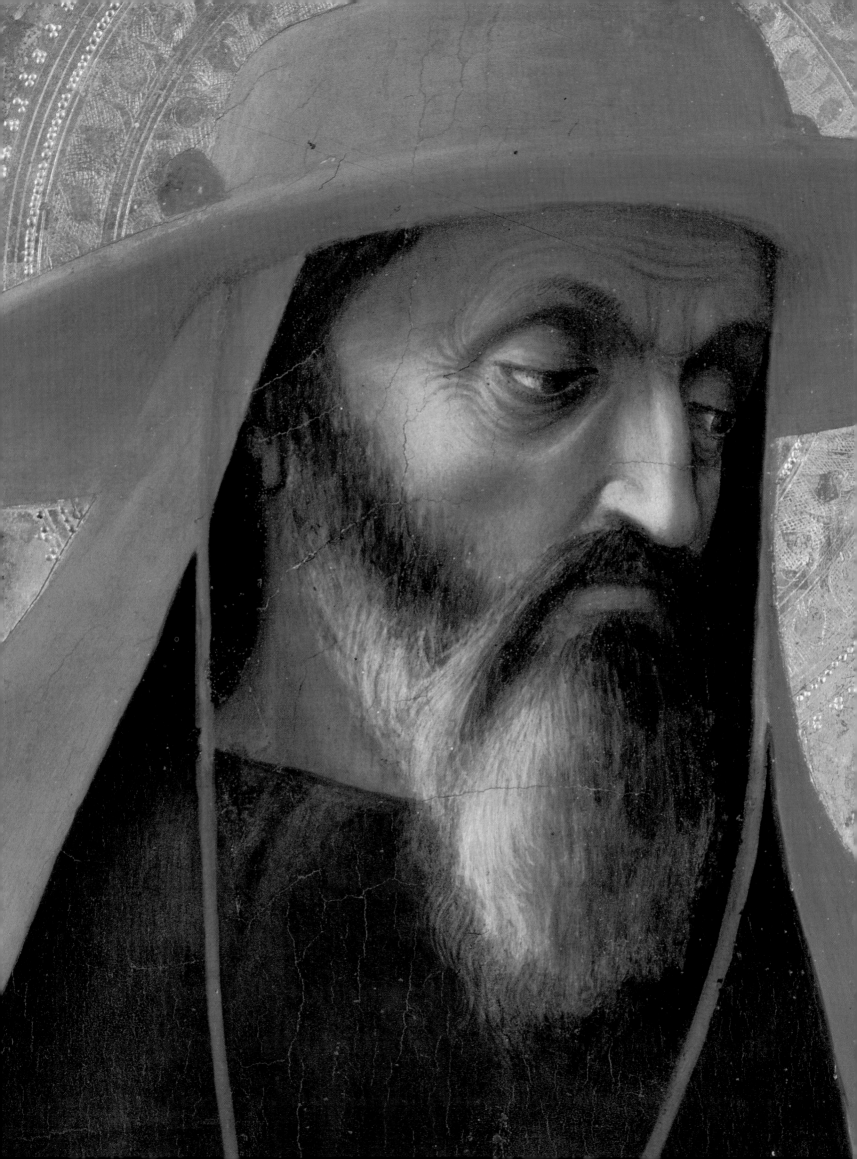

MASOLINO AND MASACCIO: THE JUBILEE OF THE RENAISSANCE

Alessandro Scafi

Masaccio
Saints Jerome and John the Baptist
The Polyptych of the Snow
London, National Gallery
detail

Though recorded in only a few documents, the Jubilee of 1423 was of great historical importance.[1] Christianity had just emerged from the most serious crisis of the late Middle Ages, the Great Schism. By the end of the thirteenth century, the Catholic Church had been rocked by fifty years of internal division during which Christian Europe sometimes had two or even three popes simultaneously. After the death of Gregory XI in 1378, two popes were elected to replace him, Urban VI in Rome and Clement VII in Avignon; their successors continued to oppose one another even when the Council of Pisa, called in 1410 to put an end to the schism, named a third pope. Not until the Council of Constance, which was held from 1414 to 1417 by order of the Emperor Sigismund, was it possible to depose those many rivals and elect a single Vicar of Christ who was recognized by all. This was the Roman Cardinal Oddone Colonna, who, having been elected on St. Mar-

tin's Day, November 11, 1417, took the name Martin V.[2] It was a crucial moment for the church, which we find celebrated and also entrusted to the protection of the Virgin in a painting, executed during the Council of Constance by an anonymous artist (and now in the Musée du Puy in France). The painting depicts Mary protecting Christian Europe under her great cloak; Christianity is represented by the new pope and by those who had contributed to his election, a sign that the Schism had ended. Emperor Sigismund is recognizable among the laity, and among the clerics are outstanding theologians and cardinals of the times.[3]

Thus, the Jubilee called by the new pope in 1423 not only celebrated a new beginning for Christianity after much conflict but also promised a renewal of the arts in Rome after much lethargy. Martin V brought justice, security, and peace back to the city, stimulating economic recovery and vital new social components.[4] The new

pope, praised by contemporaries for his cultural sensibility, also began important campaigns of building reorganization and restoration.[5] On his return to Rome from Constance, Martin V had stopped in Mantua, and then spent two and a half years in Florence, where Brunelleschi was building the Ospedale degli Innocenti. Perhaps stimulated by the artistic renaissance in Florence, Martin had ordered that different sacred buildings in the city of Rome be rebuilt or restored before his arrival.[6] The chronicle of his contemporary Stefano Infessura[7] attests that when Martin V arrived in September 1420, he was greeted triumphantly by the Romans, but the city itself was in a serious state of disrepair with much reconstruction still incomplete.[8]

Two letters from Cencio dei Rustici (perhaps addressed to the future Cardinal Giuliano Cesarini) probably date from this period immediately following Martin V's election and record the widespread hope for the renaissance of the Eternal City. One letter observes that though death is a definitive termination for man, cities can be brought back to life through man's work. The city of Rome, the letter asserts, will soon recover from its long infirmity, thanks to Martin V and to God, who would never abandon Rome, the Holy See. Martin V was celebrated by the leading Roman humanists including Cencio dei Rustici, Antonio Loschi, and Poggio Bracciolini. Their humanism was inspired by the ancient glory of Rome and they regarded Martin V as the third founder of the city, after Romulus and Camillus.[9] Those years marked the beginning of a study of Roman civilization that would characterize humanism for decades, and would determine the ideological and urbanistic vision of Christian Rome.

The preparations for the Jubilee of 1423 coincided with the building projects and artistic works that were undertaken in Rome to celebrate the arrival of the new pope, the triumphant hero of the Great Schism. Already in 1420, a commission of cardinals, including Giordano Orsini and Guglielmo Fillastre, had been given the task of preparing a program of interventions and important restorations to be implemented in the great basilicas.[10] Martin V himself provided for the restoration of the portico roof of St. Peter's and the floor and ceiling in St. John in Lateran, but other works were also carried out in the Vatican Palaces, San Paolo fuori le mura, Santa Maria Maggiore, the Hospice of Santo Stefano degli Ungheresi, the Pantheon, Castel Sant'Angelo, the Senatorial Palace, the basilica of Santi Apostoli, and the adjacent residences of the Colonna family.[11] If the attention Martin V paid to Santi Apostoli and the Capitoline Hill are indicative of his ambition to recreate the grandeur of ancient architecture,[12] then the works of art realized at the time of the Jubilee of 1423 mark the beginning of a fortuitous confrontation between Quattrocento artists and the artistic culture of ancient Rome.

While humanists like Poggio Bracciolini untiringly collected classical texts and epigraphs, the non-Roman painters who were called to the city quickly discovered the fascination of antiquity. In fact, it was during those years that the tradition of traveling to Rome and studying ancient artworks took root.[13] In 1424, Ciriaco d'Ancona went to Rome to visit and draw its monuments; Masolino, Ghiberti, Pisanello, and Jacopo Bellini also journeyed there from Florence. By about 1423, the young Masaccio was in Rome, in search of inspiration, according to Vasari.[14] During the Jubilee, the painter who revolutionized Italian figurative culture was studying antiquity from early Christian and medieval sources.[15]

Masaccio
Saints Jerome and John the Baptist
The Polyptych of the Snow
London, National Gallery

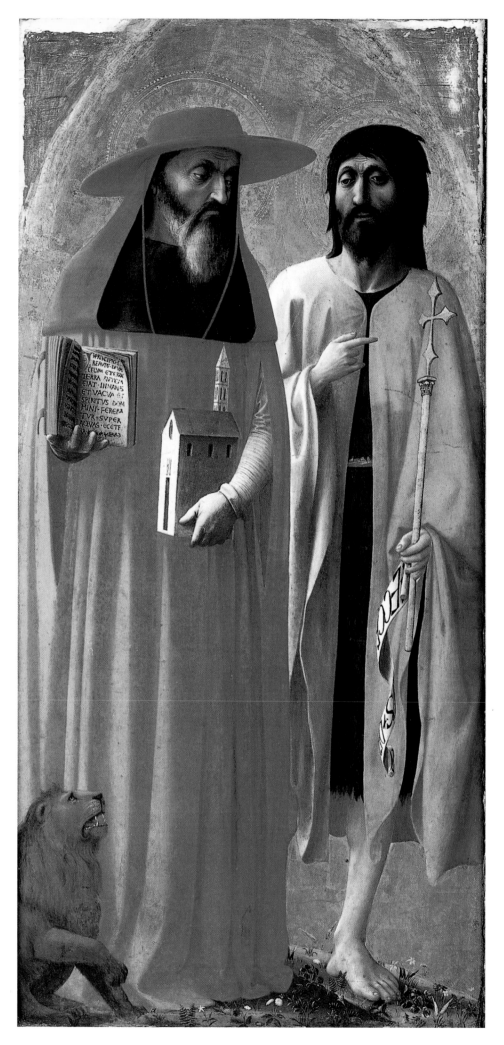

THE POLITTICO DELLA NEVE
(THE POLYPTYCH OF THE SNOW)

Often great leaps forward go hand in hand with devoted returns to origins. The 1423 Jubilee was like that, a moment of rediscovery and renaissance experienced through a renewed contact with Early Christianity and ancient Rome. This new attitude is exemplified by the most important extant work of art from that Holy Year: the *Polyptych of the Snow*. This altarpiece is mentioned by Vasari as being in Santa Maria Maggiore, but it was later removed and dismantled, probably at the end of the Cinquecento during the reconstruction of the basilica.[16] The altarpiece was cut in half and its six panels separated; today they are divided between the National Gallery in London, the Museo Nazionale di Capodimonte in Naples, and the Philadelphia Museum of Art.[17] According to some scholars, the polyptych was originally designed for a chapel to the left of the choir;[18] others argue that it was destined for the main altar.[19] Whatever the case, the work's iconography evokes the legendary origins of the basilica of Santa Maria Maggiore: when a miraculous snowfall covered the Esquiline Hill on August 5, 352, Pope Liberius, who had been forewarned in a dream, witnessed the blessed event and then ordered a basilica built on the site.

One side of the triptych depicted the *Miracle of the Snow* between *Saints Jerome and John the Baptist* and *John the Evangelist and Martin*. The other side represented the *Assumption of the Virgin* flanked by *Saints Peter and Paul* on the left and *Liberius* (or, according to some, Gregory the Great)[20] and *St. Matthias* on the right. Martin V, who commissioned the work from Masolino (Masaccio's possible collaboration) was particularly concerned, as we have seen, about promoting the restoration of church buildings. But, here, the iconography cleverly celebrates

the renovation of the Church of Rome as a symbol for the rehabilitation of the entire community of the faithful. On the left, St. Jerome holds in one hand a model of the church and in the other the Vulgate—his new translation of the Bible which had made him famous—opened to the incipit of Genesis. The passage about creation of the sky and the earth and the presence of the divine spirit on the waters in an empty and formless earth clearly alludes to the election of Martin V after the chaotic void of the Great Schism. John the Baptist, the last of the prophets, the herald of Christ's advent, a saint associated with the beginning of Christianity, and an omnipresent figure in paintings commissioned by Martin V, holds an ancient Corinthian column surmounted by a cross, once again a reference to the renaissance of Christianity, this time under the sign of the Colonna dynasty.

The central panel, representing the *Miracle of the Snow*, or the *Miraculous Foundation of Santa Maria Maggiore*, refers directly to that renaissance and the end of the schism: Pope Liberius, who traces the foundation of the basilica in the snow, has the features of Martin V. Some scholars have also identified Emperor Sigismund, the great inspirer of the Council, in the crowd celebrating the foundation of Santa Maria Maggiore, and on a side panel posing as St. John the Evangelist (standing behind St. Martin of Tours, who has the features of his namesake) Pope Martin V; the columns that decorate the edge of his cope refer to the device of the Colonna family.[21] In the panel with Pope Liberius (or Gregory) and Matthias, on the other side of the work, the pope's features may be those of Martin V, while the papal tiara with its three coronets of gold, lilied and bejeweled, may allude to the tiara that was commissioned for Martin V in 1419 and which was later sculpted on his tomb.[22]

Prevailing over the religious mys-

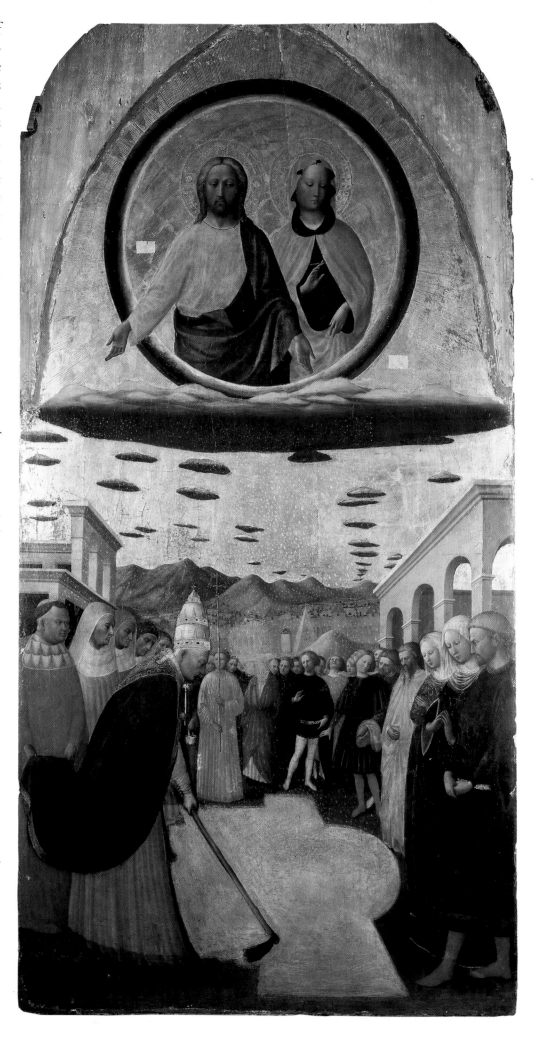

tery and miracle of the polyptych is the contemporary political situation which linked the pope to the emperor and the Christianity of ancient Rome to the new Church of Rome. As we have seen, accompanying the restitution of the Church to Rome was a general restoration of the city's monuments, and it is those landmarks that are emphasized in the panel of the *Miraculous Foundation of Santa Maria Maggiore*. City walls and other edifices in perspective draw the viewer's attention to the miracle occurring before the semicircular crowd, and in the background one can recognize the Pyramid of Cestius, Monte Testaccio, and Porta San Paolo. The foreground figures project small but clearly defined shadows; the pope is painted in profile and his cape falls in regular folds. Before him stands the couple to whom the Virgin had announced the miracle; Mary, next to Christ in Glory, looks down on them and blesses them from above.

The August 5 feast celebrating the foundation of the church of Santa Maria Maggiore was followed on August 15 by the Feast of the Assumption, one of the most popular festivities of the basilica, so it was natural that both scenes were included in the triptych. Mary in Heaven may also represent the final triumph of the Church. She is robed in white and surrounded by ranks of angels: red Seraphim, blue Cherubim, and Thrones, Dominations, Virtues, and Powers, Princedoms, Archangels and Angels. This angelic mandorla seems to lean backward in space, with the superior figures smaller than the inferior ones, an effect compensated for by the increasing brilliance of their robes. This glorious scene culminates in the apparition of Christ, who, at the apex of the composition, receives his mother, the Queen of Heaven.

MASOLINO AND MASACCIO

The *Polyptych of the Snow* decorated the basilica of Santa Maria Maggiore, one of the most important stations along the jubilee route of the pilgrims. In quite another sense, the painting constituted a landmark in the history of Italian art: it marked a shift in the relationship between Masaccio and Masolino whereby the young and talented Masaccio began to assume greater importance than his master. Still, the attribution of the various parts of the polyptych remains controversial. Many consider the entire work to be by Masolino; others assert that the figures of John the Baptist and Jerome, which display a particular energy and solidity, are the work of another artist, perhaps Fra Angelico, Domenico Veneziano, or even Masaccio. Some also see the hand of Masaccio in the execution of the *Assumption*, in the design of the *Miraculous Foundation of Santa Maria Maggiore*, and in the panel with Peter and Paul.[23] However, the prevailing opinion is that the polyptych was a true collaboration between Masolino and Masaccio. Vasari himself attributes the work to Masaccio and many art historians have unhesitatingly recognized his hand in the severity and geometric tension of Saint Jerome and John the Baptist. There is general agreement that the other panels were painted by Masolino and that the altarpiece was executed around 1423.[24]

A careful analysis of the painting reveals the change that occurred in the relationship between Masolino and Masaccio, and the beginning of the younger artist's ascent. There is no doubt that the saints painted by Masaccio, Jerome and John the Baptist, show greater modeling and substance than those by Masolino; not only do they fill the space with more authority, but they were painted to accord with the central panel, as can be seen by their attitudes and the color relationships. Masolino's figures seem to react to the miracle less coherently. Jerome and John the Baptist, in their combination of red and pink, invert the sequence of colors on the left side of the *Foundation*; the

pink of the Baptist's dress is a delicate reference to that of the Pope and a decisive allusion to the robes of Christ and the Virgin, while Jerome's red robe evokes that of the cardinal assisting Pope Liberius. The Baptist's direct connection to the superior divine figures in the *Miraculous Foundation* is reinforced by his upraised right hand which encounters the movement of Christ's right arm as it passes across the edge of the Glory. Meanwhile, as John points to the divine source of that miraculous snowfall, Jerome's eyes look down at the drawing of the foundation of the church.

Evidence of Masaccio's influence on Masolino is provided by the important *pentimenti* on the panels now in Philadelphia, where it is clear that the figures have been changed. The position of St. Paul was originally occupied by St. Peter, who holds the keys in his right hand; Paul was initially in Peter's place, with his sword resting on the ground in front of his left foot. In the other panel, the figure that is now John the Evangelist originally had a miter, while St. Martin's uncovered head had a halo that can still be seen engraved in the golden ground. These changes (which may have been due to requests on the part of the donor) have been interpreted as an attempt by Masolino to balance his figures with those by Masaccio, and to mirror their positions in space. As far as that goes, the group of John the Evangelist and Martin does reflect the one by Masaccio: the figures on the outside are turned inward, their backs are parallel to the sides of the painting, and their headgear closes its extremities. In the first version, the miter and crozier assigned to the inner figures created an interruption, and it is likely that Masolino realized this and modified his design so that it would accord with Masaccio's better solution.

As for the panel with Peter and Paul, Masolino gave it a lighter structure by switching the saints' positions. Had the sword been held by the inside figure, an uncomfortable caesura would have been created rather than the effective parenthesis of closure. That side of the triptych had no composition by Masaccio to compete with Masolino's figures, but by then the older artist had recognized the younger painter's greater structural coherence. Masolino tried to adopt the new style in the panel with Pope Liberius (or Gregory) and Matthias, in which the latter carries an axe, his instrument of martyrdom, in his right hand, and this provides a safe limit to the composition. Masolino's attempt to establish color relationships with the central scene, following Masaccio's example, is evident in the coordination between the green and blue of the angels' robes in the *Assumption* and the gowns of the saints alongside them.[25]

Like the *Polyptych of the Snow*, the fresco cycle executed on the walls of the central nave of the basilica of St. John in Lateran was meant to celebrate both the origins of Christianity and the rebirth of the Church of Rome. The 1423 frescoes were part of a much larger artistic project commissioned by Martin V, one that included the insertion of the Colonna coat of arms in the mosaic floor where the pope's tomb was planned.[26] A bottega directed first by Gentile da Fabriano and later by Pisanello was responsible for the painting. But by an ironic stroke of fate, the fresco cycle, one of the quintessential fruits of the 1423 Jubilee (though executed later), was completely destroyed when the basilica was renovated for the 1650 Jubilee.[27] Records of the fresco cycle survive only in written sources and in some drawings by Pisanello or his assistants. One of these is the *Baptism of Christ*, now in the Louvre, in which the artist's passionate study of antiquity is evident from the complex Hellenistic and Byzantine iconography. This work is proof that the practice of drawing from antiquity had already commenced in the humanistic climate of

Masolino
Assumption of the Virgin
The Polyptych of the Snow
Naples, Museo di Capodimonte

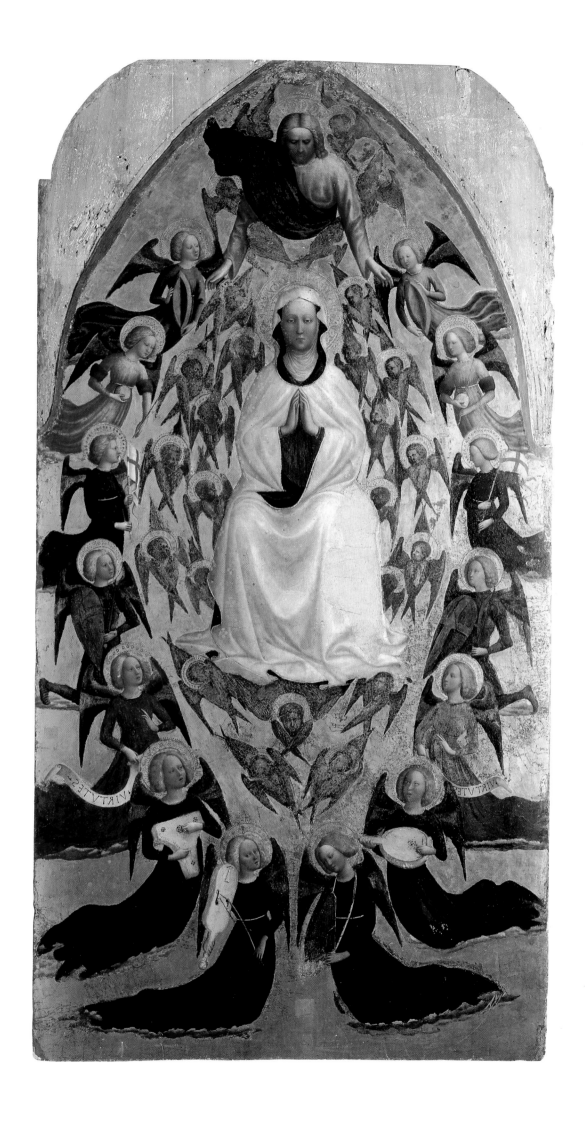

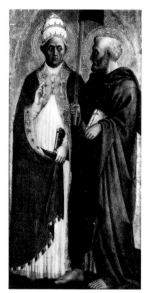

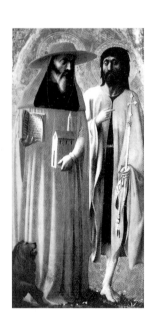
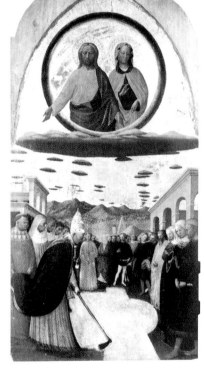
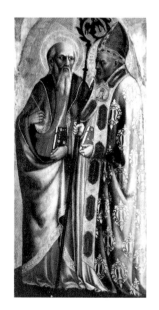

Rome prior to the pontificate of Martin V.[28] Those first strong contacts with antiquity as well as the presence of late Gothic painters of the caliber of Gentile da Fabriano and Pisanello influenced the artistic production of the city.[29] An anonymous biographer of Martin V admired the quality of the Lateran frescoes, which, he said, displayed elegant figures and marvelous art.[30]

The so-called *Vita Martini* contains brief notes about other works the pope

inspired through his pontificate. All were aimed at celebrating the reaffirmation of papal supremacy, the primacy of the Roman Church, and Rome as the pope's natural seat. Through his titular cardinals, for instance, Martin V also directed certain works, such as the chapel of Santa Caterina in the church of San Clemente, attributed to Masolino with Masaccio's collaboration.[31] Although the pope did not specify the exact decoration, it still followed the lines of the pontifical

Masolino and Masaccio
The Polyptych of the Snow

26

artistic policy: next to the coat of arms of Cardinal Branda Castiglioni, who commissioned the frescoes, was the heraldic device of Martin V which was repeated in the columns decorating the scenes of the *Annunciation*, the *Miracle of the Wheel*, the *Miracle of the Bees,* and *St. Catherine's Refusal to Adore a Pagan Idol.* Here, too, the mystery of Christ's redemption interacts with the vicissitudes of the first church and the contemporary one. It has been suggested, for example, that the scene depicting *St. Catherine's Refusal* refers to the Council of Constance. More generally, the scenes of Ambrose and Catherine celebrate the Church of Rome and its teachings, legitimized by Christ's sacrifice and by martyrs like St. Catherine and sustained by the intellect and spirit of men like St. Ambrose. In the background of the *Crucifixion of St. Clement,* as in that of the *Miraculous Foundation of Santa Maria Maggiore* in the *Polyptych of the Snow,* is the city of Rome, the natural seat of the papacy.[32] The Jubilee of 1423 was the dawn of a renascence, an announcement that the Church had recovered its original force and that Rome was reviving to its ancient splendor.

[1] H. Thurston, *The Holy Year of Jubilee: An Account of the History and Ceremonial of the Roman Jubilee* (St. Louis, MO 1900), pp. 63-65.

[2] For the history of the Great Schism, see E. Delaruelle, E. R. Labande, P. Ourliac, "L'église au temps du Grand Schisme et de le crise conciliare (1378-1499)," in *Histoire de l'église*, ed. A. Fiche and V. Martin (Paris 1962), esp. pp. 203-226 (for Martin V).

[3] R. Gounot, "Observations et hypothèses concernant la Vierge protectrice du Musée du Puy," *Gazette des Beaux-Arts* 83 (1974): 75-88. The work was probably commissioned by one of the participants in the Council, the French bishop Hélie de Lestrange.

[4] M. Caravale, "Per una premessa storiografica," and M. G. Blasio, "Radici di un mito storiografico: il ritratto umanistico di Martino V," in *Alle origini della nuova Roma: Martino V (1417-1431)*, Congress Proceedings, Rome, 2-5 March 1992, ed. M. Chiabò et al., (Rome 1992), pp. 1-15, 111-24.

[5] Anonymous, *Vita Martini V*, in Muratori, RIS, 3/2, Mediolani 1734, col. 858.

[6] G. Lombardi, "La città, libro di pietra," and L. Finocchi Ghersi, "Le residenze dei Colonna ai Santi Apostoli," in *Alle origini*, pp. 40-41, *Roma 1300-1875: La città degli Anni Santi*, ed. M. Fagiolo and M. L. Madonna (Milan 1985), p. 81.

[7] *Diario della città di Roma di Stefano Infessura scribasenato*, ed. O. Tomassini (Rome 1890), pp. 23-25.

[8] *Vita Martini V*, col. 864; Bartolomeo Platina, *Liber de vita Christi ac omnium pontificum (aa. 1-1474)*, ed. G. Gaida, in RIS2, 3/1 (1913-32): 312.

[9] Lombardi, "La città, libro di pietra," pp. 35-43.

[10] Ibid, pp. 40-41.

[11] Platina, *Liber de Vita Christi*, p. 312; Fagiolo and Madonna, *Roma 1300-1875*, pp. 81-86.

[12] Finocchi Ghersi, "Le residenze," p. 72.

[13] Fagiolo and Madonna, *Roma 1300-1875*, p. 401.

[14] G. Vasari, *Le vite de' più eccellenti pittori, scultori ed architettori*, ed. G. Milanesi (Florence 1878), vol. 2, p. 293.

[15] S. Maddalo, "Identità di una cultura figurative," in *Alle origini*, p. 51, note 18.

[16] Vasari, *Le vite*, pp. 293-94.

[17] For the altarpiece, its history, and its reconstruction, see, among many studies, K. Clark, "An Early Quattrocento Triptych from Santa Maria Maggiore, Rome," *Burlington Magazine*, 93 (1951): 339-47; M. Davies, *National Gallery Catalogue:The Earlier Italian Schools* (London 1951) pp. 274-276; M. Meiss, "The Altered Program of the Santa Maria Maggiore Altarpiece," in *Studien zur toskanischen Kunst: Festschrift für Ludwig Heinrich Heydenreich zum 23 März 1963*, ed. by W. Lotz and L. L. Möller (München 1964) pp. 169-90; L.

Vayer, "Analecta iconographica masoliniana," *Acta Historiae Artium* 11, no. 3-4 (1965): 219-24; P. Joannides, *Masaccio and Masolino* (London 1993), pp. 72-79, 414-22; P. L. Roberts, *Masolino da Panicale*-Oxford 1993) pp. 86-98, 189-92.

[18] For example, Meiss, "The Altered Program," pp. 169-90, 173.

[19] For example, R. Longhi, "Presenza di Masaccio nel Trittico della Neve," *Paragone*, 25 (1952): 8-15; and M. Boskovits, "Il percorso di Masolino: precisazioni sulla cronologia e sul catalogo," *Arte cristiana*, no. 718 (1987): 57-60.

[20] For example, Vayer, "Analecta iconographica masoliniania," pp. 223-24.

[21] A. Braham, "The Emperor Sigismund and the Santa Maria Maggiore Altarpiece," *Burlington Magazine* 122, no. 923 (1980): 106-112. Other scholars, like Roberts (*Masolino da Panicale*, p. 88 notes 25 and 27) are not, however, in agreement with this identification.

[22] Maddalo, "Identità di cultura figurative," p. 54.

[23] For a recent summary of the different opinions, see Joannides, *Masaccio and Masolino*, pp. 417-18.

[24] Some maintain that the altarpiece was executed in Florence and later transported to Rome. See, for example Joannides, *Masaccio and Masolino*, pp. 420-21. Proof of the vitality of the Roman artistic environment of those years is the safe-conduct issued to Arcangelo di Cola of Camerino by Martin V so that he could work in Rome in 1421. See Fagiolo and Madonna, *Roma 1300-1875*, pp. 334-35 and p. 337, note 6.

[25] It has been possible to reconstruct the history of the changes in the execution of the panels of the *Polyptych of the Snow* thanks to the research of Meiss, "The Altered Program"; and C. Strehlke and M. Tucker, "The Santa Maria Maggiore Altarpiece: New Observations," *Arte cristiana*, no. 719 (1987): 105-24. On the subject, see also Joannides, *Masaccio and Masolino*, pp. 420-21, and Roberts, "Identità di cultura figurative," pp. 96-97.

[26] Regarding Martin V's tomb, see A. Esch, "La lastra tombale di Martino V ed i registri doganali di Roma," in *Alle origini*, pp. 625-41.

[27] For the Lateran cycle, see A. Cavallaro, "I primi studi dell'antico nel cantiere del Laterano," in *Alle origini*, pp. 406-12; and the critical literature recommended by Maddalo, "Identità di cultura figurative," p. 56, note 40.

[28] Maddalo, "Identità di cultura figurative," p. 57; Cavallaro, "I primi studi," p. 407.

[29] Fagiolo and Madonna, *Roma 1300-1875*, pp. 334, 336.

[30] Maddalo, "Identità di cultura figurative," p. 47, note 2.

[31] *Vita Martini V*, col. 864.

[32] Maddalo, "Identità di cultura figurative," pp. 49-53.

THE JUBILEE OF NICHOLAS V

THE CHAPEL OF NICHOLAS V

Anna Cavallaro

Beato Angelico
Pope Sixtus I Ordaining St. Lawrence
Vatican City, Vatican Palaces
Chapel of Nicholas V
detail

As the Jubilee of 1450 approached, Vespasiano da Bisticci noted, "a large sum of money came into the Apostolic See, and the pope began to build in many places."[1] Nicholas V was primarily concerned with decorating his private residence and the great state apartments of the Vatican Palace, so he called to Rome the most renowned painters of the time from Florence and Central Italy. Unfortunately, however, numerous modifications have been carried out in the Nicholas V wing of the Vatican Palace (corresponding to the thirteenth-century buildings facing the Cortile del Pappagallo)[2] and they have eliminated much of the work commissioned by Pope Parentucelli. Indeed, it must be said that today the "absences" outweigh the "presences." The Pope's study, painted by the Beato Angelico between 1449 and 1450, has been lost, and so have the decorations that many artists from Central Italy painted on the walls and ceilings of the great state apartments of the palace.

The only structure that is entirely preserved is the Pope's private chapel, situated in a medieval tower and described in early documents as *parva* and *secreta* (small and secret), perhaps reflecting its use for the daily liturgy of the mass. The chapel was painted by Fra Angelico in 1448,[3] when payments to the painter were registered for the purchase of gold and ultramarine blue for the grounds.[4] The paintings cover the entire ceiling and walls of the small room, recreating the image of an Early Christian chapel. Scenes from the life of St. Lawrence, a Roman martyr who lived in the third century, decorate the upper part of three walls, while in the lunettes above are scenes from the life of St. Stephen, one of the first deacons that St. Peter ordained in Jerusalem. The episodes from the lives of these two saints are depicted in parallel fashion, comparing the most important facts of their development: their consecration as priests, their preaching and distribution of alms, their confession

of faith and their martyrdom. Their exemplary lives demonstrated a continuity between the primitive church of Jerusalem headed by Peter and the primitive church of Rome under the popes' direction, and were meant to promote a recovery of the original values of Christianity.

The Nicholas V chapel made it possible for a wave of modern culture under the aegis of Florentine innovation to enter Rome. It served as a fundamental text for Italian and foreign painters, not only for those just passing through the city but also for the Roman artists themselves, who were able to learn from it the new lessons of Renaissance painting. It was in Rome, in fact, that the premises of Fra Angelico's latest Florentine style matured. Abandoning the bare simplicity of the frescoes of San Marco and the fairylike tones of his Florentine predellas, he had begun to confer on his subjects a new human dimension, influenced in part by the innovations that Masaccio had developed on the walls of the Brancacci Chapel some decades earlier. But Fra Angelico's contact with the city of Rome and its classical and Christian antiquities, and the influence of the cultured humanistic environment of the papal court, where such important figures as Leon Battista Alberti and Lorenzo Valla were present, caused him to turn in his Roman work in the direction of a new Christian "humanism."[5]

The stories of the Nicholas V chapel unfold within the cornice of imposing basilican architecture, designed according to the canons of Florentine perspective and enriched by the liturgical ornaments and architectural details of ancient and medieval Rome. Inside, the figures move solemnly, their volumes clearly defined, looking like ancient heroes clothed in Christian garb. A clear example of this new style is the rabbi in front of whom St. Stephen defends the Christian faith; he is a figure of great charisma in one of the most sublime scenes in the chapel. However, the modernity of these frescoes also lies in the details of the costumes and the daily life depicted in the scenes, especially those representing charity to the poor, and in the artist's ability to characterize equally high-ranking prelates and clerics and women, beggars, and ordinary folk. In the *Alms-giving of St. Lawrence*, especially, the realistic description of the clothes, head coverings, and deformities of the beggars is reminiscent of Masaccio's Brancacci Chapel frescoes and the sorrowful humanity he represented there. But Fra Angelico's tone of classical composure renders the Nicholas V chapel figures more as "types" than real people.

References to the pontiff, his restorations in Rome, and his court are plentiful in the *Capture and Martyrdom of St. Stephen*. The two scenes of the fresco are divided by the city walls of Jerusalem, the curvilinear course of which may refer to the Aurelian Walls that Nicholas V hoped to restore. His secretary and biographer, Giannozzo Manetti, recorded that a reorganization of the Roman walls was one of the five major projects "stuck in the pope's head."[6] In *Pope Sixtus I Ordaining St. Lawrence*, Nicholas V's court comes to life, inaugurating a ceremonial model of papal representation that would last until Melozzo da Forlì. Around the figure of Pope Sixtus I, who has been given the features of Nicholas V, the ecclesiastical hierarchy of the Catholic Church is reconstructed with painstaking liturgical precision, from the acolytes in their white surplices holding thuribles and incense boats and the deacons in their blue dalmatics to the cardinals in their splendid ocher-colored copes standing behind the pope. Of these cardinals, the one who holds a transparent veil in his hands may be a portrait of the Dominican Juan de Torquemada.

Working with Fra Angelico was the painter Benozzo Gozzoli who had already collaborated with him on the frescoes of San Marco in Florence and

At right:
Beato Angelico
Pope Sixtus I Ordaining St. Lawrence
Vatican City, Vatican Palaces
Chapel of Nicholas V

Page 32:
Beato Angelico
St. Lawrence Receiving the Treasures of the Church from Pope Sixtus II
Vatican City, Vatican Palaces
Chapel of Nicholas V

Page 33:
Beato Angelico
Alms-giving of St. Lawrence
Vatican City, Vatican Palaces
Chapel of Nicholas V

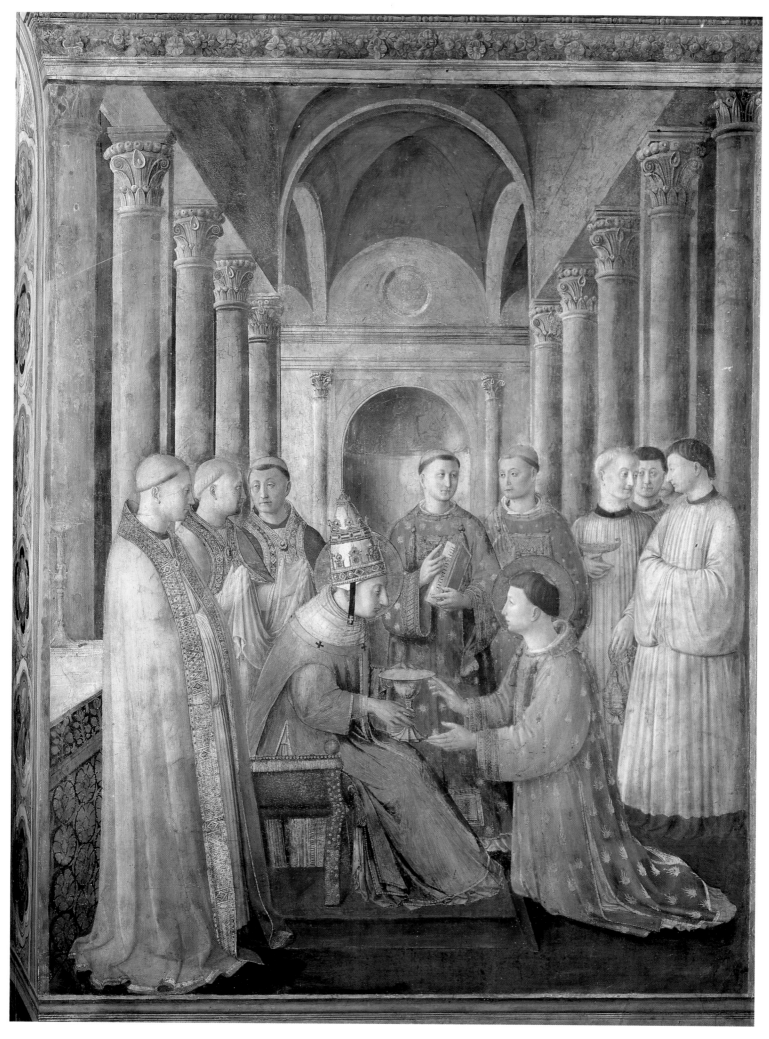

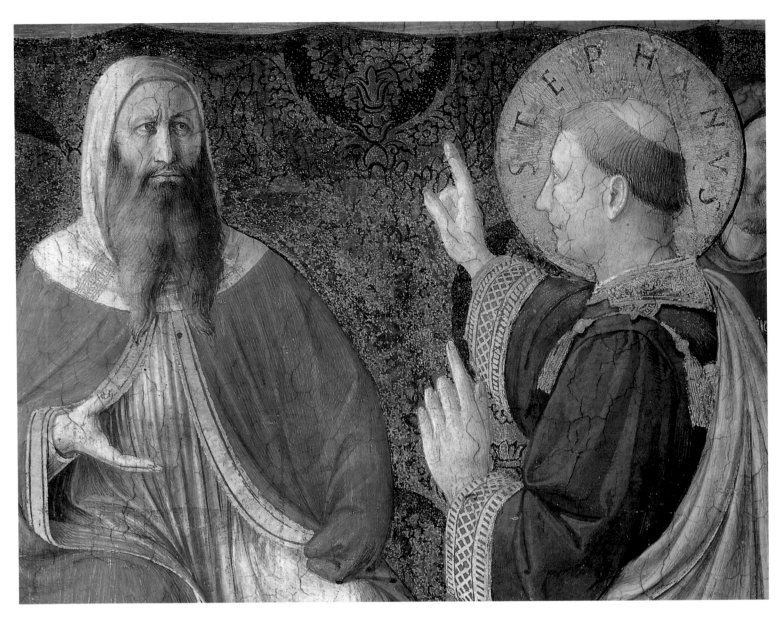

in the Chapel of San Brizio at Orvieto. Here, Angelico was responsible for the plan and execution of the cycle while Benozzo painted the decorations, some of the Evangelists in the vault, and those figures in the stories who appear less expressive and more conventional.[7] The other painters who were decorating the Vatican Palace during the jubilee years came from the Papal State and enjoyed a certain notoriety, like Benedetto Bonfigli, who "wrought many things in Rome in the pope's palaces," and Bartolomeo di Tommaso.[8] Today, most of these other artists are simply names: Simone da Viterbo, Antonio da Orte, Carlo di ser Lazzaro da Narni; some were foreigners, like the German Luca and the Spaniard Salvatore da Valencia.[9] Referred to in the documents as "palace painters" and regularly salaried during the years 1450-51, these artists were employed to paint the decorations of the wooden ceilings and the ornamental friezes on the walls.

A rare survivor of this work is the fragmentary frieze with the *Cardinal Virtues,* which was preserved in the space between the original ceiling and the sixteenth-century one in the Sala Vecchia degli Svizzeri.[10] Painted in vivid colors beside the device of Nicholas V appears *Fortitude,* represented as a warrior wearing a helmet and armor standing in front of a crenellated tower bearing the inscription of her attributes in Gothic characters; *Prudence,* personified as a maiden bearing a burning torch and round shield; and *Justice,* whose hair is disheveled and who holds an open book. These figures of the Virtues (to which *Temperance* should have been

Above:
Beato Angelico
St. Stephen Addressing the Council
Vatican City, Vatican Palaces
Chapel of Nicholas V

At right:
Beato Angelico
St. Stephen Preaching
Vatican City, Vatican Palaces
Chapel of Nicholas V

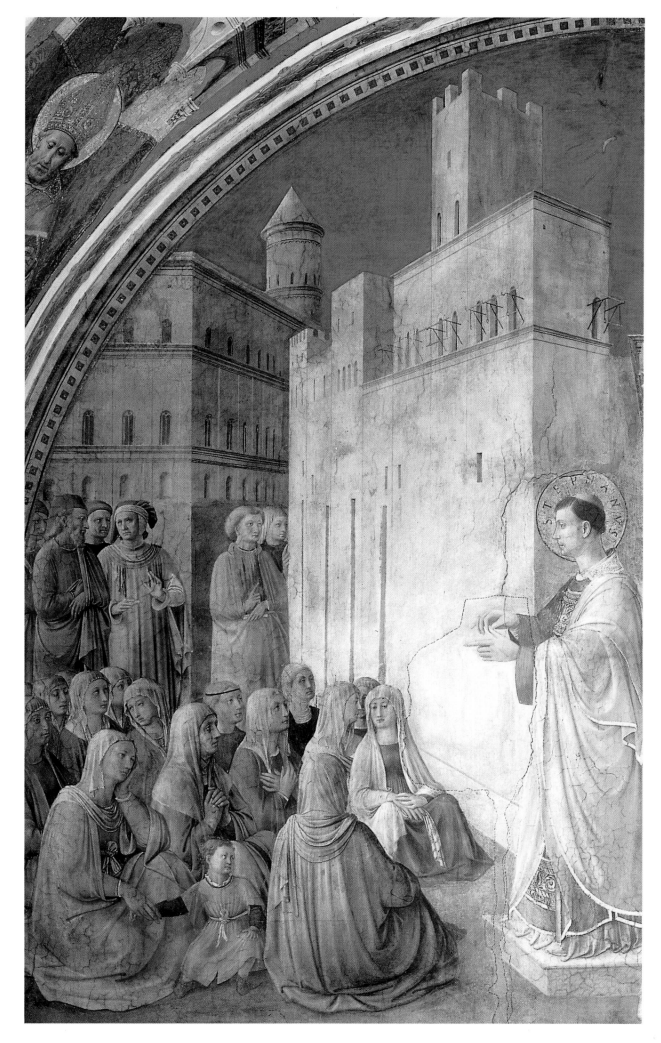

Beato Angelico
Capture and Martyrdom of St. Stephen
Vatican City, Vatican Palaces
Chapel of Nicholas V

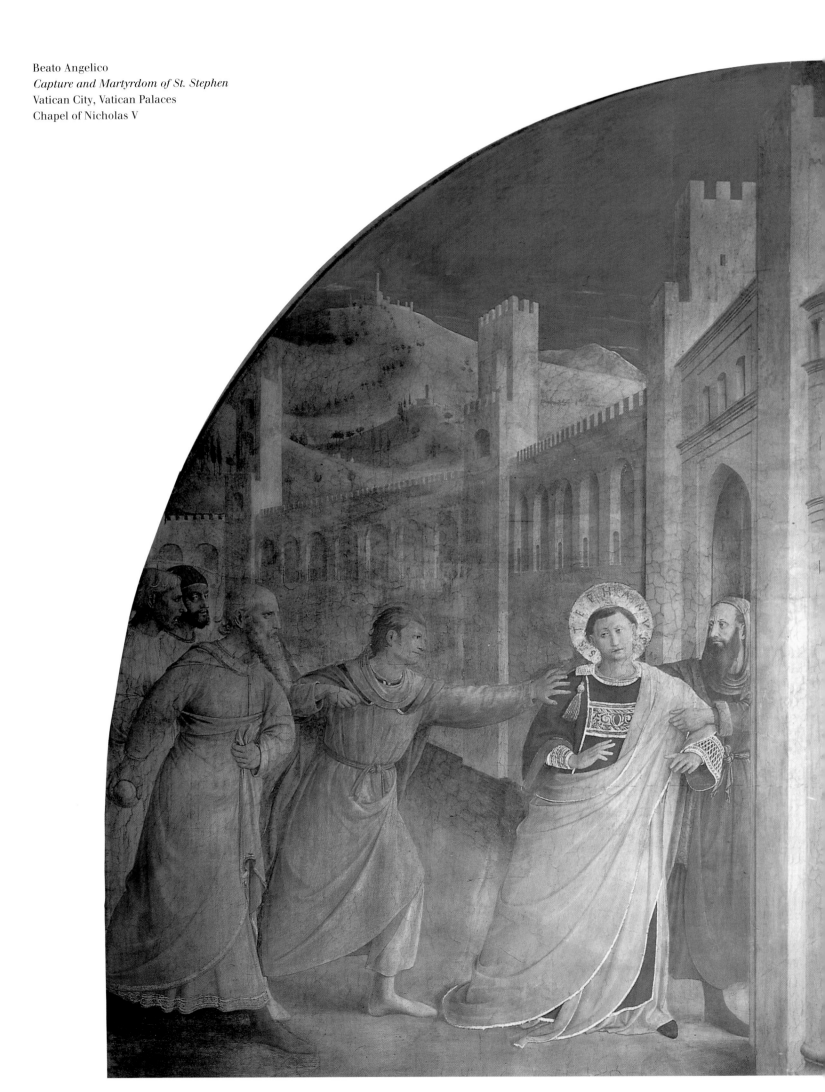

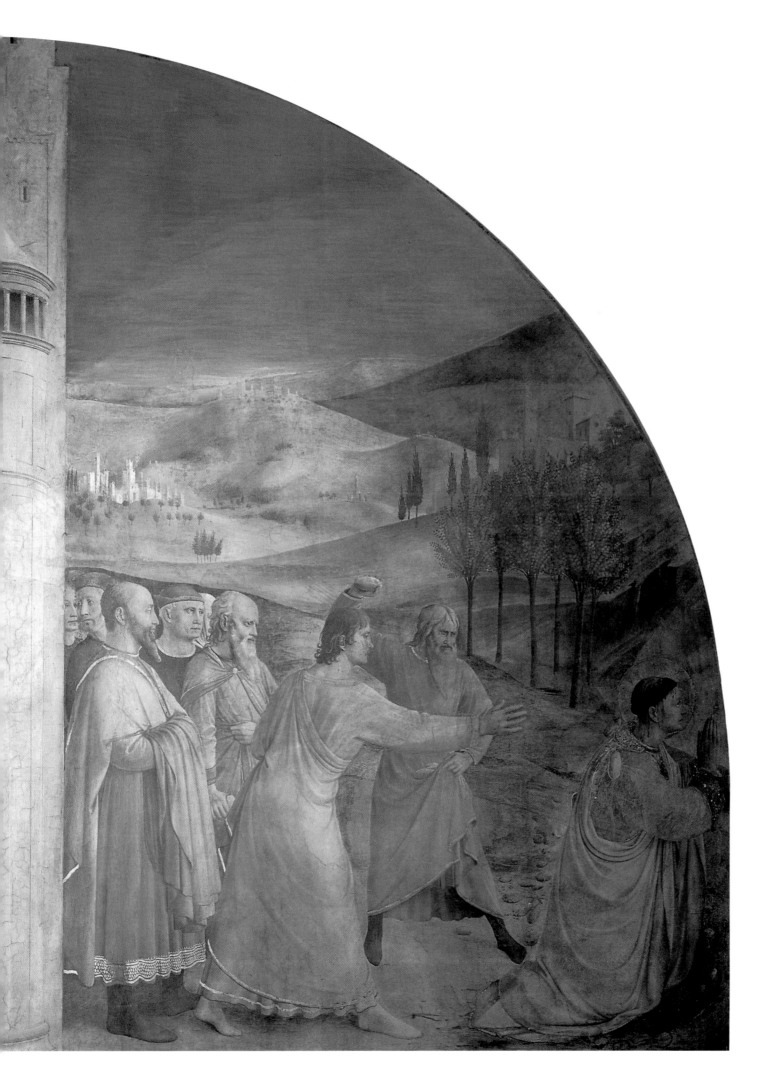

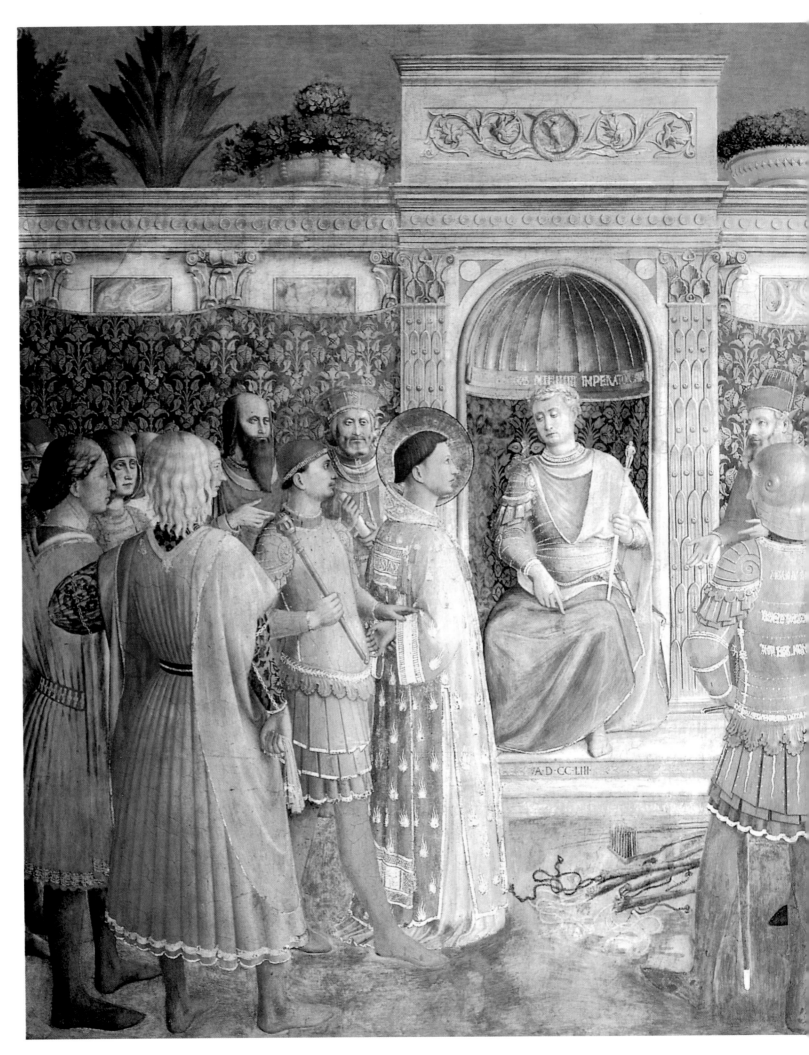

Beato Angelico
St. Lawrence before Decius
Vatican City, Vatican Palaces, Chapel of Nicholas V

Unknown painter from central Italy
Fortitude
detail of the frieze with allegorical figures
Vatican City, Vatican Palaces
Sala Vecchia degli Svizzeri

added to complete the series) refer to the merits of Nicholas V's good government. Their doctrinal and moral function is underlined by the playful putti on the remaining walls of the room, which are often interpreted as symbols of divine love.[11] All in all, both for the style and the choice of young maidens in courtly dress bearing unusual attributes, these paintings follow the medieval tradition, giving the impression that miniatures from the North Italian courts had been transposed into wall painting.

[1] Vespasiano das Bisticci, *Vite degli uomini illustri del secolo XV*, critical ed. with introduction and comment by A. Greco, I, Florence 1970, p. 63.
[2] For the restoration works relative to the Vatican Palace, see C. W. Westfall, *L'invenzione della città: La strategia urbana di Nicolò V e Alberti nella Roma del '400* (Roma 1984; original edition, Pennsylvania State University Press 1974), pp. 233-54. For the Jubiless of 1450, see M. Fagiolo and M. L. Madonna, *Roma 1300-1875. La città degli Anni Santi* (Milan 1985), pp. 88-91.
[3] Fra Angelico had been in Rome since 1446, when he had painted for Pope Eugene IV the Chapel of the Sacrament in the Vatican Palace and the Chapel of St. Peter in the basilica, both lost. See G. Gilbert, "Fra Angelico's Fresco Cycles in Rome; Their Number and Dates," *Zeitschrift für Kunstgeschichte* 38 (1975): pp. 245-65.
[4] For the Nicholas V chapel, see J. Pope Hennessy, *Fra Angelico* (London 1974, pp. 23-27); A. Greco, *La capella di Nicolò V del Beato Angelico* (Rome 1980); L. Castelfranchi Vegas, *L'Angelico e l'umanesimo* (Milan 1989), pp. 109-156; A. M. De Strobel and F. Mancinelli, "Le camere "secrete": anticamera, cubicolo e cappella," in *Raffaello nell'Appartamento di Giulio II e di Leone X*, intro. C. Pietrangeli (Milan 1993), pp. 119-65; J. T. Spike, *Angelico* (Milan 1996), pp. 248-51; D. Cole Ahl, *Benozzo Gozzoli* (New Haven 1997), pp. 24-33.

[5] G. C. Argan, *Fra Angelico et son siècle,* Geneva 1955, p. 103; M. Calvesi, *Le Arti in Vaticano* (1965; new ed., Milan 1980), p. 44.
[6] For Nicholas V's program, see in particular T. Magnuson, *Studies in Roman Quattrocento Architecture* (Stockholm 1958), pp. 351-62.
[7] See A. Padoa Rizzo, *Benozzo Gozzoli pittore fiorentino* (Florence 1972) pp. 29-30, 107-10; and A. Padoa Rizzo, *Benozzo Gozzoli: Catalogo completo* (Florence 1992), p. 34.
[8] G. Vasari, *Le Vite de' più eccellenti pittori scultori e architettori nelle redazioni del 1550 e del 1568*, ed. edited by R. Bettarini and P. Barocchi (Florence 1971), vol. 3, p. 576; for documents, see F. F. Mancini, *Benedetto Bonfigli* (Perugia 1992), pp. 38, 151.
[9] See E. Müntz, *Les arts à la cour des Papes pendant le XVe et le XVIe siècle. I partie: Martin V, Pie II (1417-1464)* (Paris 1878), pp. 94-96, 128-32. For the different pictorial cultures present at the court of Nicholas V, see B. Toscano, "Oscillazioni della committenza religiosa a metà Quattrocento," in *La pittura in Italia. Il Quattrocento*, ed. F. Zeri (Milan 1987), pp. 511-13.
[10] For the frieze in the Sala Vecchia degli Svizzeri, see G. Cornini, A. M. De Strobel and M. Serlupi Crescenzi, "La sala Vecchia degli Svizzeri e la sala dei Chiaroscuri," in *Raffaello nell'Appartamento di Giulio II*, pp. 81-90.
[11] Westfall, *L'invenzione della città*, pp. 282ff.

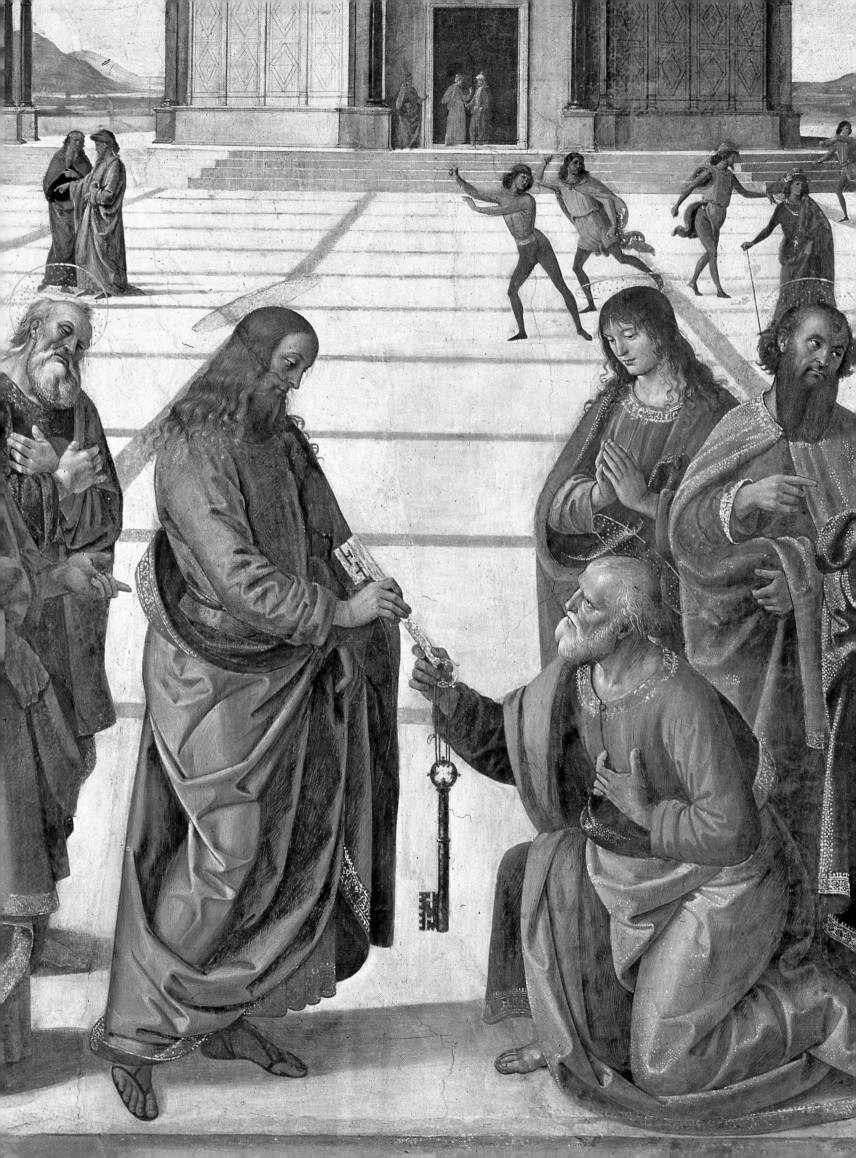

THE CHURCH OF SANTA MARIA DEL POPOLO, PONTE SISTO, THE HOSPITAL OF THE SANTO SPIRITO, AND THE SISTINE CHAPEL

Stefano Valeri

Perugino
The Donation of the Keys
Vatican City, Vatican Palaces
Sistine Chapel
detail

Originally, jubilees had been scheduled to take place every fifty years. But a Papal Bull issued by Paul III in 1470 halved the time period between jubilees and cleared the way for the Jubilee of 1475. In 1472, Paul III's successor, Sixtus IV Della Rovere (1471-1484), confirmed the decision to celebrate a Holy Year every quarter of a century and, as Bartolomeo Platina, rector of the Vatican Library noted, he took advantage of that event and planned an extraordinary and unprecedented urban renewal of Rome.[1] Using the pretext of embellishing the city, Sixtus IV was able to deal with the age-old problem of public order by demolishing the hovels and cleaning up the narrow alleyways in which the bands of the subversive aristocrats were wont to hide.[2] Sixtus IV also busied himself with projects in the other fields of artistic expression, notably architecture, which earned him the nickname "the great builder."

The work that Sixtus IV sponsored at the church of Santa Maria del Popolo was of considerable importance. The pope not only had the church entirely rebuilt (it was finished in 1477) but he also paid particular attention to its safety. The church was particularly prone to damage from enemy attacks since it had been built alongside the Aurelian Walls, and it faced the gate which permitted entry into the city from the Via Flaminia.[3] The solution that Sixtus IV adopted for its defense, documented in texts by the sixteenth-century sculptor Flaminio Vacca and in a drawing by the Netherlandish painter Marten van Heemskerck, consisted of two large quadrangular towers constructed outside the wall beside the gate.[4] Excavations made during the more recent urban renewal of 1877, following the unification of Italy, not only supported Vacca's account but also clarified what the area was like during the late fifteenth century. In particular, workers unearthed some marble slabs which had once covered the bastions and which corresponded to those

described in the Cinquecento in relation to a tomb not far from the gate (on the opposite side of today's Piazza del Popolo, near the site of the present-day church of Santa Maria dei Miracoli). That tomb, called *la meta* in medieval times, had a square plan and pyramidal shape similar to that of Caius Cestius on the Via Ostiense, and its foundations lay twelve meters deep, which would have been the street level in the fifteenth century when it was demolished. The marble slabs on the bastions of the gate were discovered at the same depth, and the inscriptions found on some tablets confirm their pertinence.[5]

Santa Maria del Popolo is a basilica with three naves surrounded by chapels and surmounted by an octagonal cupola supported by a drum. It is, in fact, the first example of that type in Rome. Also unique is its bell tower, a conical, scale-covered spire with four pinnacles at the corners, reminiscent of the late Gothic Lombard type.[6] The church that we see today has been modified by later interventions, the most important of which was that carried out on the façade by Bernini between 1655 and 1659 (the extent of which can been seen by comparing van Heemskerck's sixteenth-century drawing with today's church). The church was given to the Agostinian Order in 1472 by the pope, who wished it to house his family's sepulchral chapel. One sign of the particular favor that Sixtus IV bestowed on the church is the fact that he visited it weekly on Saturday, and solemnized the most important events there.[7]

The church also assumed a remarkable role in promoting the so-called minor arts. The imminent Jubilee provided Sixtus IV with a powerful doctrinal instrument for spreading the cult of the Virgin, and thereby favoring the massive production of popular devotional images. The most important artist employed by the pope in Rome during those years was the painter Antoniazzo Romano,

who, with his bottega, managed to satisfy the urgent requests of a large and heterogeneous clientele. One of the best examples, albeit at a monumental level, is the now-fragmentary chapel of Cardinal Bessarione in the basilica of Ss. Apostoli. Executed by Antoniazzo and his collaborators after 1465, the chapel served as a model for many other fresco cycles in Rome, including that in the Sistine Chapel.[8] Another specialty of Antoniazzo's bottega was the production of copies of Byzantine-type icons of the Virgin, similar to the so-called San Luca Altarpiece on the high altar of Santa Maria del Popolo. Those icons were based in part on the teachings of that great conservator of Byzantine culture, Cardinal Bessarione, who was present in Rome at that time.[9]

Another key project of the *renovatio* was the rebuilding of the so-called Ponte Rotto (Broken Bridge), an evocation of the Roman *pons valentiniani* that had collapsed during a gigantic flood at the end of the eighth century. The new bridge was meant to reduce overcrowding in light of the great tragedy that had occurred during the 1450 Jubilee. A huge throng of people had been pushing their way across the Ponte Sant'Angelo, then the only bridge across the Tiber, when a stampede occurred and more than 150 pilgrims were shoved to their deaths in the river. The ancient Roman bridge, renamed Ponte Sisto, was rebuilt simply but solidly, perhaps by Baccio Pontelli, who incorporated into it part of the preexisting construction and added four arches and an overflow oculus in the central pylon. The bridge not only facilitated the circulation of pilgrims but also linked the quarters of Regola and Parione and Trastevere, thereby stimulating building activity in that poorer neighborhood. According to accounts of the time, the pope laid into the base of the bridge a square stone bearing the words "Built by Pope Sixtus IV in the year of health 1473."[10] The costs for

Marten van Heemskerck
Santa Maria del Popolo
Berlin, Kupferstichkabinett
Staatliche Museen zu Berlin

the construction of the bridge were divided up, and—according to research by Rodolfo Lanciani, the author of a report made in 1877—even prostitutes were forced to contribute through taxation.[11]

Curiously, the construction of the new bridge still did not solve the problem of pilgrimage traffic, given the unusual hydrographic conditions of the area. As a matter of fact, the jubilee of 1475 was extended because of the great flood that occurred in November of that year. Not only did a massive tide of muddy water surge through the city, damaging the already damp Roman houses and sweeping away people and things, but it also brought with it an infestation of pestiferous microbes, making even the few passable streets unsafe for pilgrims. As a consequence, the pope had to discourage visitors from coming to Rome, and order the Holy Year to be continued in Bologna until Easter 1476. Also, the subjects of King

Ferrante of Naples, the first person of rank to inaugurate the Jubilee in January 1475, were allowed to gain indulgences in their own city.[12]

Sixtus IV's preparation for the Holy Year was vast, involving practically all the churches and sanctuaries in Rome. It started with the restoration of the Lateran basilica and the adjacent Vatican Palace, in front of which he placed the equestrian monument of Marcus Aurelius, which had been restored for the occasion. The Pope's activity as the "great builder" also affected the churches of Sant'Ambrogio dei Lombardi, Santi Apostoli, Sant'Agnese on the Via Nomentana, San Cosimato, and Santa Maria Maggiore.

Foremost among the projects for civic buildings was the restoration of the Hospital of Santo Spirito in Sassia, which was greatly needed to tend to the vast number of pilgrims.[13] Raffaele da Volterra observed that because of Sixtus IV's spirit of charity,

which derived from his belonging to the Franciscan order, "Xenodocheum sancti Spiritus pulcherrimis aedificis ampliavit" (He amplified the guest quarters of the beautiful building of the Holy Ghost).[14] Founded in the quarter of the Saxons by Innocent III and already in operation in 1204, the hospital had been intended for the cure of the sick, the poor, and children. During one of his visits, Pope Sixtus IV had noted its run-down state, and, moved to compassion by the great number of abandoned children there, he decided to rebuild the hospital. Bartolomeo Platina described his intervention: "Having summoned the best architects and numerous workers, the work proceeded without delay. Indeed, Sixtus amplified the initial project, and established dowries for the girls who were already adults." The works were largely concluded by the Holy Year, but the entire construction was not finished until 1482.

The façade, modified frequently throughout the years and now the result of a modern reconstruction, was depicted by Botticelli in his Sistine Chapel fresco the *Miracles of Christ*. The original side entrance in sculpted marble remains intact. Inside, two huge rooms were reserved for the sick and connected to each other by a chapel crowned by an octagonal lantern. About 1478, the walls were decorated with fresco cycles by a painter of the Umbrian school; these were partially repainted in the Cinquecento. The scenes represent the foundation of the hospital by Innocent III and episodes from the life of Sixtus IV. All the paintings, moreover, were captioned by Bartolomeo Platina. Those hospital rooms thus served as a Renaissance prototype, the greatest glory of which would be the fresco cycle in the Sistine Chapel painted in 1481-82.[15]

It has been argued that since the architecture of the building shows stylistic features typical of the Lombard area, like Santa Maria del Popolo, it suggests an attribution to Andrea Bregno, rather than to the more commonly hypothesized Baccio Pontelli. Furthermore, the construction of the Sistine Chapel is similar to that of the hospital, especially its aisle, which is divided like the central naves of Franciscan churches (and once again it is important to keep in mind that Sixtus IV was a Franciscan). And in one of the most important frescoes of the Sistine Chapel, Perugino's *Consegna delle Chiavi*,[16] some historians have recognized Bregno's portrait in the figure of the man holding a compass.

The Sistine Chapel frescoes were influenced by the conspiracy of the Pazzi. Organized on April 26, 1478, the conspiracy involved two members of the Pazzi family who plotted to diminish the power of the Medici family. The conspiracy resulted in the death of Giuliano de' Medici and the wounding of Lorenzo the Magnificent. That disastrous event was the epilogue to a growing conflict between the powerful Florentine family and Sixtus IV, one that had begun at least three years before. Indeed, the Pope himself was strongly suspected of complicity in the crime (although it has been emphasized that he did not intend to shed blood but only to instigate a conspiracy against the Medici). As a consequence, the Pope excommunicated Lorenzo, and a series of battles and negotiations ensued (even involving Venice and the King of France) until peace was finally declared on December 3, 1480. On that occasion, the Florentines were absolved in exchange for their promise to respect ecclesiastic liberty and to equip fifteen galleys for the war against their common enemy, the Turks, a matter that was then exerting great pressure on Sixtus IV.

This was the political context that faced the artists employed in painting the Sistine Chapel. Originally known as the Palatine Chapel, and one of three chapels in an early complex, the Sistine Chapel was, for Pope Sixtus IV, the most appropriate permanent place

San Luca Altarpiece
Rome, Santa Maria del Popolo

44

to celebrate the more than fifty yearly services included in the liturgical calendar. During the first six years of Sixtus IV's reign, the chapel was known as the Great Chapel to distinguish it from the *Cappella parva* (small chapel), which had been built for Nicholas III. But in 1477, Sixtus IV decided to demolish The Great Chapel and rebuild it on a larger scale.

The Pope entrusted construction of the new Sistine Chapel to the architect Giovannino de' Dolci, and the work must have been finished by the middle of 1481 since contracts for the first frescoes are dated October 1481.[17] In any case, by the end of 1480, the room had been paved with Cosmatesque mosaics, a sculpted transenna had been installed, and the lower part of the walls had been frescoed with false curtains. Immediately thereafter, in 1481, the Pope decided on an iconographic program: two pictorial cycles based on stories from the Old and New Testaments (Moses and Christ) on the intermediate zone of the walls; a series of pre-Constantinian popes above between the windows; an Assumption of the Virgin on the wall behind the altar (the huge room has no apse); and a firmament on the vaulted ceiling.

It has been justly noted that Sixtus IV's architectural project was based on an earlier plan of Nicholas V, whose own building program was based on winning popular support in the presence of majestic buildings; as a side effect, these buildings—which were continually exposed to the masses—became objects of great devotion.[18] Sixtus IV's project was also probably meant to coincide with the Holy Year, but the financial straits of the first years of his papacy, and later the political crisis between Rome and Florence, caused many delays.

In any case, Sixtus IV's entire program was conceived in relation to the Jubilee, and, in both architectural and pictorial terms, it constituted an ideological confrontation with Solomon's Temple and, therefore, with Judaism. Eugenio Battisti's insights[19] (later picked up and completed by Maurizio Calvesi)[20] first drew attention to this theme by comparing the dimensions of the Sistine Chapel and Solomon's Temple, and proving that they are identical: 40.2 meters (120 feet) long by 13.4 meters (40 feet) wide by 20.7 meters (60 feet) high. Furthermore, Battisti confirmed that even in the pictorial decoration—which had previously been considered an effort by the Pope to distance himself from the symbology of the Temple—Sixtus IV's intention was to confront Solomon.

As Calvesi has pointed out, one of the fresco paintings, *The Donation of the Keys* by Perugino, depicts an octagonal temple in the background flanked by two triumphal arches, a clear ref-

Rome, Hospital of Santo Spirito

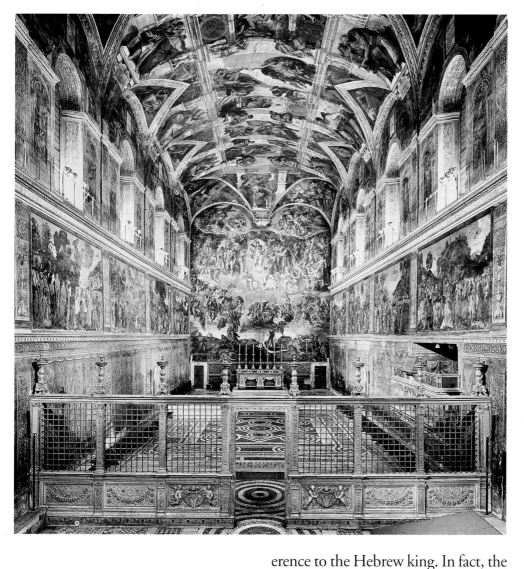

The paintings on the middle zone of the walls, executed between 1481 and 1482, were originally sixteen in number. These were later reduced to fourteen to make space for Michelangelo's *Last Judgment* (1535-41), which also caused the elimination of Perugino's fresco, the *Assumption of the Virgin*, a work associated with the dedication of the chapel and painted on the wall behind the altar. However, the only works that can really be considered authentic Quattrocento paintings are the twelve frescoes on the two long sides of the chapel, since those on the entry wall were damaged, and later repainted in the Cinquecento. The artists employed in this huge undertaking were all from around Florence, while famous local painters like Melozzo da Forlì and Antoniazzo Romano, both often employed by the Curia, were overlooked. This fact alone seems to signal Sixtus IV's desire to make peace with Lorenzo de'Medici after the disturbing conspiracy of the Pazzi.[22]

It has been pointed out that the depiction of these stories shows a greater connection to medieval than to humanistic culture.[23] The scenes unfold from the wall of the altar to the entrance, in parallel fashion, with the stories from the life of Christ on the left and stories from the life of Moses on the right. These were originally meant to be read starting from the wall behind the altar, with the *Assumption of the Virgin*. Right above it, on the right and left respectively, were the *Birth of Jesus* and the *Finding of Moses,* all three painted by Perugino. Then, starting from the left wall were the *Baptism of Christ* (Perugino and Pinturicchio) facing *Moses in Egypt* (Perugino); the *Miracles of Jesus* (Sandro Botticelli) facing the *Burning Bush* (Sandro Botticelli and bottega); the *Calling of Peter and Andrew* (Domenico Ghirlandaio and bottega) facing the *Crossing of the Red Sea* (Domenico Ghirlandaio); the *Sermon on the Mount* (Cosimo Rosselli) facing *Moses on Sinai* (Cosimo Rosselli); the *Donation of the*

erence to the Hebrew king. In fact, the inscriptions on the attics of the two arches say: "You, Sixtus IV, inferior to Solomon in wealth, but superior to him in religion and devotion, consecrated this immense temple." Naturally, by "temple" the inscription did not refer to the one represented in the fresco but rather to the Sistine Chapel itself, which, because of its lack of grandeur, contrasted not only with Solomon's sumptuous building but also with the one that Nicholas V had planned. Still, the final chapter was in complete harmony with the principles of sobriety that regulated the Franciscan Order. And the superiority credited to the Pope in the inscription was developed in the entire pictorial cycle "where an ecumenical reign, universal and spiritual, enlightened by Christ's message" was represented in the New Testament by Christ's superiority over the Moses (like Solomon) of the Old Testament.[21]

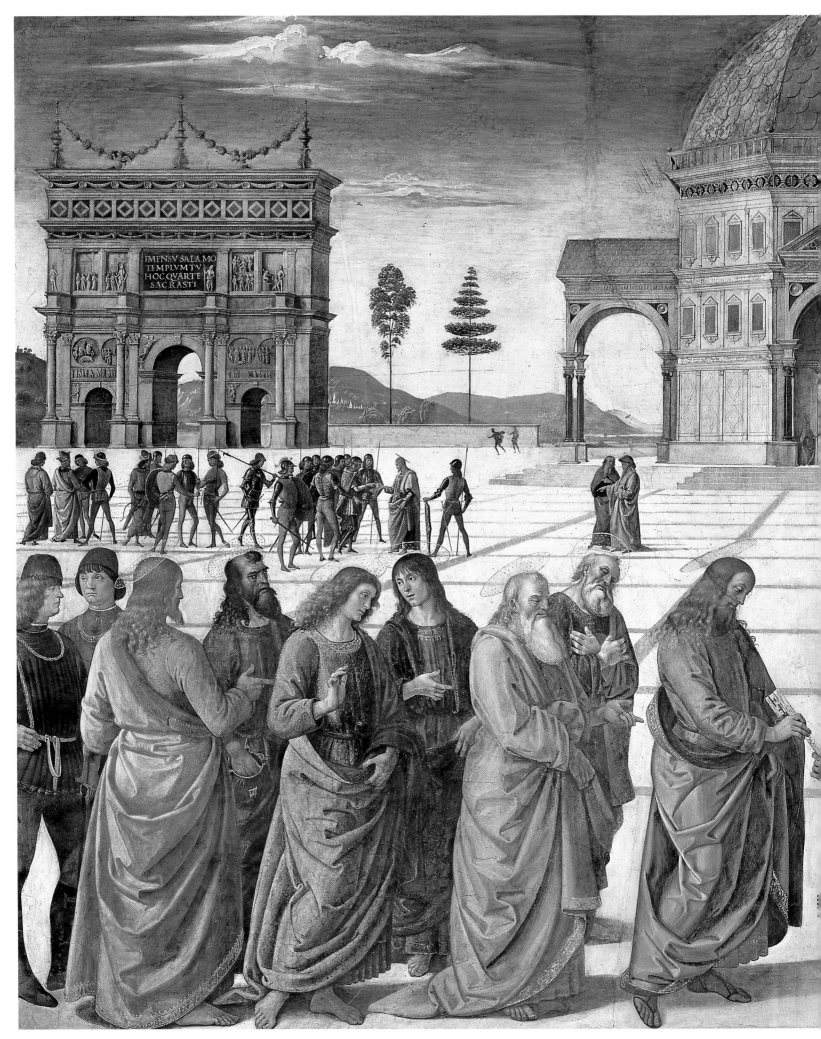

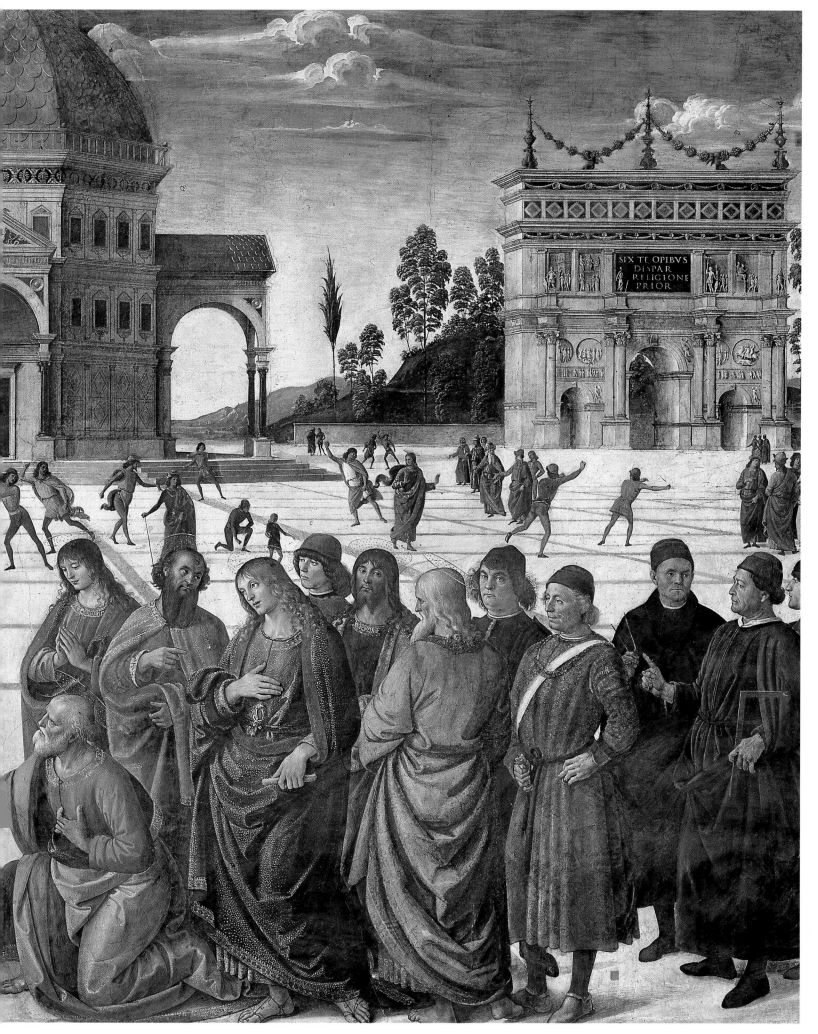

SIX TE OPIBVS
DISPAR
RELIGIONE
PRIOR

49

Keys (Perugino and Luca Signorelli) facing the *Punishment of Korah, Dathan and Abiram* (Botticelli); and the *Last Supper* (Cosimo Rosselli with helpers and Biagio di Antonio) facing *Moses Giving the Rod to Joshua* (Perugino and Luca Signorelli). The cycle concluded with the two paintings of the *Resurrection of Jesus* (Domenico Ghirlandaio, repainted in the Cinquecento by Van den Broeck) and *St. Michael Protecting Moses' Body* (Domenico Ghirlandaio, repainted in the Cinquecento by Matteo da Lecce). This situation remained intact until 1508, when Michelangelo, commissioned by Pope Julius II, the nephew of Sixtus IV, had the starry sky that had been painted on the ceiling by Pier Matteo d'Amelia removed to begin painting his frescoes depicting Genesis.

[1] See F. Benzi, *Sisto IV Renovator Urbis: Architettura a Roma 1471-1484* (Rome 1990).

[2] For general information about the activity of the Roman people during that time, see A. Esch, "Il Giubileo di Sisto IV," in *La storia dei Giubilei*, vol. 2:1450-1575 (Florence 1998), pp. 107-23.

[3] R. Lanciani, *Storia degli scavi di Roma* (Rome 1989), vol 1, pp. 97-98.

[4] C. Hülsen, and H. Eggher, *Die Römischen Skizzenbücher von Marten van Heemskerck im Königlichen Kupferstichkabinett Berlin* (Berlin 1913-16), vol. 1, fol. 7v.

[5] C. L. Visconti, and V. Vespignani, "Delle scoperte avvenute per la demolizione delle torri della porta Flaminia," *Bullettino della Commissione archeologica comunale di Rome* (Jan.-Dec. 1877): 184-240.

[6] For more information about the church, see E. Bentivoglio, and S. Valtieri, *S. Maria del Popolo* (Rome 1976); and R. Cannatà, A. Cavallaro, and C. Strinati, *Umanesimo e primo Rinascimento in S. Maria del Popolo* (Rome 1981).

[7] L. von Pastor, *Storia dei papi* (Rome 1925), vol. 2, p. 643.

[8] F. Benzi, "Arte a Roma sotto il pontificato di Sisto IV," in *La storia dei Giubilei*, p. 216.

[9] A. Cavallaro, "Aspetti e protagonisti della pittura del Quattrocento romano in coincidenza dei giubilei," in *Roma 1300-1875: L'arte degli Anni Santi*, ed. M. Fagiolo and M. L. Madonna (Milan 1984), p. 341.

[10] Pastor, *Storia dei papi*, pp. 484-85.

[11] R. Lanciani, "Monumenti rinvenuti nell'alveo del tevere sotto il ponte sisto," in *Bullettino della Commissione* (1878): 248. In general, see S. Delli, *I ponti di Roma* (Roma 1979).

[12] Pastor, *Storio dei Papi*, p. 492.

[13] P. De Angelis, *L'arciospedale di S. Spirito in Sassia nel passato e nel presente* (Rome 1952).

[14] Lanciani, *Storia degli scavi di Roma*, p. 93.

[15] Pastor, *Storio die Papi*, pp. 649-51.

[16] S. Danesi Squarzina, "Pauperismo francescano e magnificenza antiquaria nel programma architettonico di Sisto IV," in *Sixtus IV e Giulio II mecenati e promotori di cultura*, ed. S. Bottaro, A. Dagnino, G. Rotondi Terminiello (Savona 1989), pp. 189-200.

Botticelli
The Trials of Moses
Vatican City, Vatican Palaces, Sistine Chapel

[17] J. Shearman, "La costruzione della Cappella e la prima decorazione al tempo di Sisto IV," in *La Cappella Sistina i primi restauri la scoperta del colore* (Novara 1986), pp. 22-91.

[18] Ibid.

[19] E. Battisti, "Il significato simbolico della Cappella Sistina," in *Commentari* (1957): 96-104.

[20] M. Calvesi, "Il programma della Cappella Sistina," in *Le arti in Vaticano* (Milan 1980), pp. 55-86.

[21] Ibid., p. 56.

[22] Regarding the presence of Tuscan artists in Rome, see also S. Borsi, F. Quinterio, and C. Vasic Vatovec, *Maestri fiorentini nei cantieri romani del Quattrocento* (Rome 1989).

[23] S. Danesi Squarzina, "La sistina di Sisto IV e l'eredità del pensiero religioso medievale," in *Le Due Rome del Quattrocento Melozzo Antoniazzo e la cultura artistica del '400 romano* ed. S. Rossi and S. Valeri, Proceedings of the Congress, (Rome 1996), (Rome 1997).

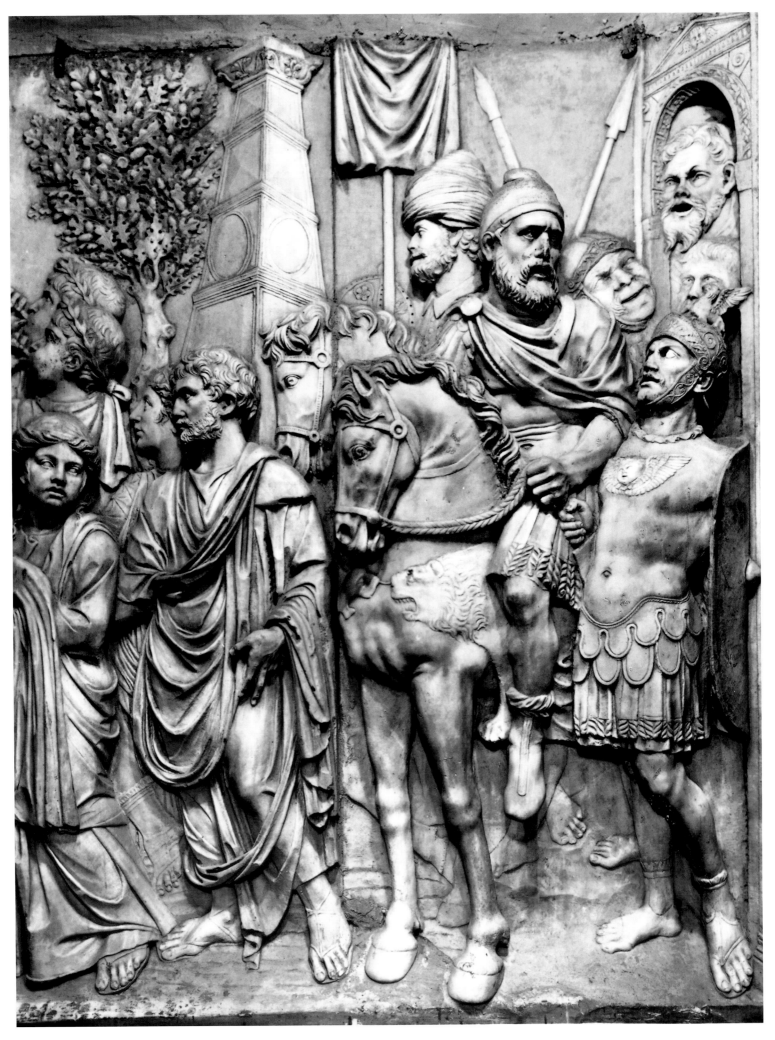

THE CULTURE OF ANTIQUITY AND RELIGIOUS DEVOTION IN THE JUBILEE OF SIXTUS IV

Anna Cavallaro

Just prior to the Jubilee of 1475, Pope Sixtus IV began to promote a particularly important restoration in one of the most prestigious and frequented places of Christianity: the marble ciborium erected by his predecessor Pius II in 1458 on the main altar in the basilica of St. Peter's. The restoration involved the decoration of the four sides of the ciborium containing reliefs representing stories about Saints Peter and Paul. In a guide to the principal attractions of ancient and modern Rome written in the first decade of the Cinquecento, Francesco Albertini noted that the splendor of those extraordinary reliefs was due to the abundant amount of gold used on the panel grounds.[1]

The iconography of the panels follows that of the many ancient works which were still visible during the Quattrocento in the basilica of St. Peter's, such as the thirteenth-century frescoes adorning the four-sided portico and Giotto's Stefaneschi polyptych on the main altar. The *Crucifixion of St. Peter* takes place between the two pyramids—the *Meta Remi* and the *Meta Romuli* (destroyed at the end of the Quattrocento)—then considered the burial places of the two mythical founders of Rome, Romulus and Remus. However, in the Sistine relief, the terebinth, the tree that according to tradition grew next to the *Meta Romuli*, has become an oak tree with acorns, a clear allusion to Pope Sixtus IV Rovere and his efforts to renew the Roman church. What is different from the preceding iconographic tradition is the way the apostles Peter and Paul (who look like Roman senators) are presented in a scene out of antiquity populated by the emperors, centurions, and praetorians of ancient Rome. The principal source for these scenes were the reliefs on Trajan's Column, a monument that was immensely popular as a repertoire of images for artists interested in ancient art. Trajan's Column supplied the authors of the ciborium with models for representing figures in unusual

positions, and a host of arms, costumes, usages, and ceremonials, all of which were suitable for creating an ancient setting and presenting scenes in a precise historical context.[2]

The continuity between pagan Rome and Christian Rome was the guiding principle of Sixtus IV's pontificate. This theme governed many significant initiatives aimed at recognizing and legitimizing antiquity, like the donation of the bronzes of the Lateran to the Roman people, the opening of the Capitoline Museums to the public in 1471, and the inauguration of the Vatican Library with its important collection of ancient codices in 1475. As part of his intensive program for the Jubilee of 1475, Pope Sixtus undertook the restoration of various holy places situated along the pilgrims' route, in particular, devotional shrines at street corners. "Nulla praeterea fuit in urbe aedicula quam Iubilei anno non instauravit" (There was no shrine that was not restored in the year of the Jubilee), wrote Roman chronicler Sigismondo de' Conti in his *Le storie dei tempi suoi dal 1475 al 1510* (The History of His Times from 1475 to 1510).[3] Many churches, chapels, and shrines in Rome today still bear the insignia of Sixtus IV and the inscription "ANNO IUBILEI MCCCCLXXV."

Along with these building renovations, many ancient images of Mary in shrines and chapels were also restored, or new images were painted. One example of Marian devotion during that period is the Madonna of the Consolation, painted in 1470 on a site where, according to local accounts, a miraculous event occurred. In a short time, this work became a popular model for similar images. Both the Roman public and that of Lazio demanded copies from the artist, Antoniazzo Romano, for their private devotions. The Fondi lord, Onorato II Caetani d'Aragona, commissioned a triptych in 1475 for his family chapel in the church of San Pietro in Fondi.[4]

Antoniazzo's bottega produced

numerous Marian images based on his compositions. These were often small in size with frames in the shape of an aedicula, and served as small altars for private devotion at home. The most successful and popular model among the Roman clientele was the *Madonna with Child and Donor* (now in the Houston Museum of Fine Arts) in which the Madonna appears at a window with the donor, a cardinal of the Papal Curia, kneeling on the windowsill. That panel was the source for a whole series produced during the Jubilee years to satisfy the requests of high prelates and the pious middle class. The artist's cartoon was often reproduced with slight variations or in reverse, creating a mirror image of the original.

[1] F. Albertini, *Opusculum de mirabilibus novae et veteris urbis Romae* (Rome 1510), ed. A. Schmarsow (Heilbronn 1886), p. 16. Like the majority of the ornaments in the old St. Peter's, the fifteenth-century ciborium was destroyed at the end of the sixteenth century and the reliefs with the stories of Saints Peter and Paul were dismantled and inserted in the walls of the Grotte Vaticane (Crypt of St. Peter's) where they were almost forgotten for centuries. In 1977, they were removed from the Grotte and are currently preserved at the Archivio Storico della Fabbrica di San Pietro.

[2] For theories relative to the reconstruction of the ciborium and the ancient models used for reference, see *Roma 1300-1875: L'arte degli Anni Santi*, ed. M. Fagiolo, and M. L. Madonna (Milan 1984), pp. 357-68.

[3] Sigismondo de' Conti, *Le storie de' tempi suoi dal 1475 al 1510* (Rome 1883), vol. 1, p. 205.

[4] A. Cavallaro, *Antoniazzo Romano e gli antoniazzeschi: Una generazione di pittori nella Roma del Quattrocent* (Udine 1992).

Antoniazzo Romano
Madonna with Child and Donor
Houston, Museum of Fine Arts

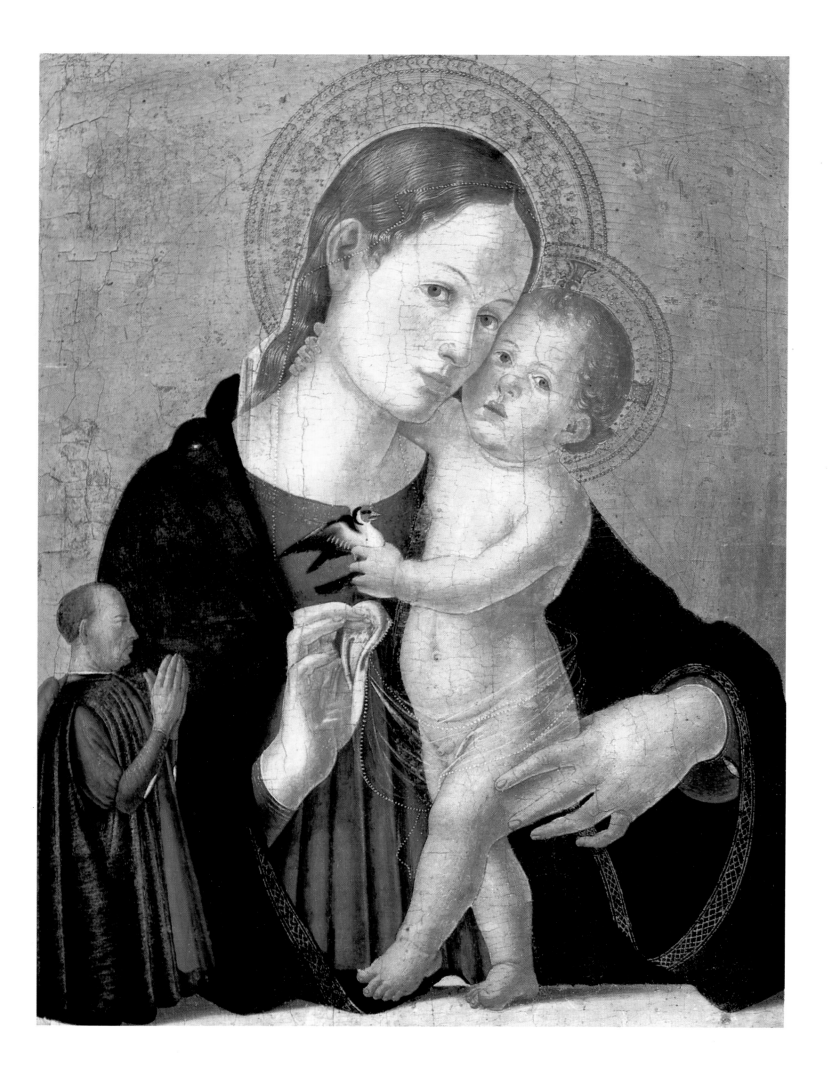

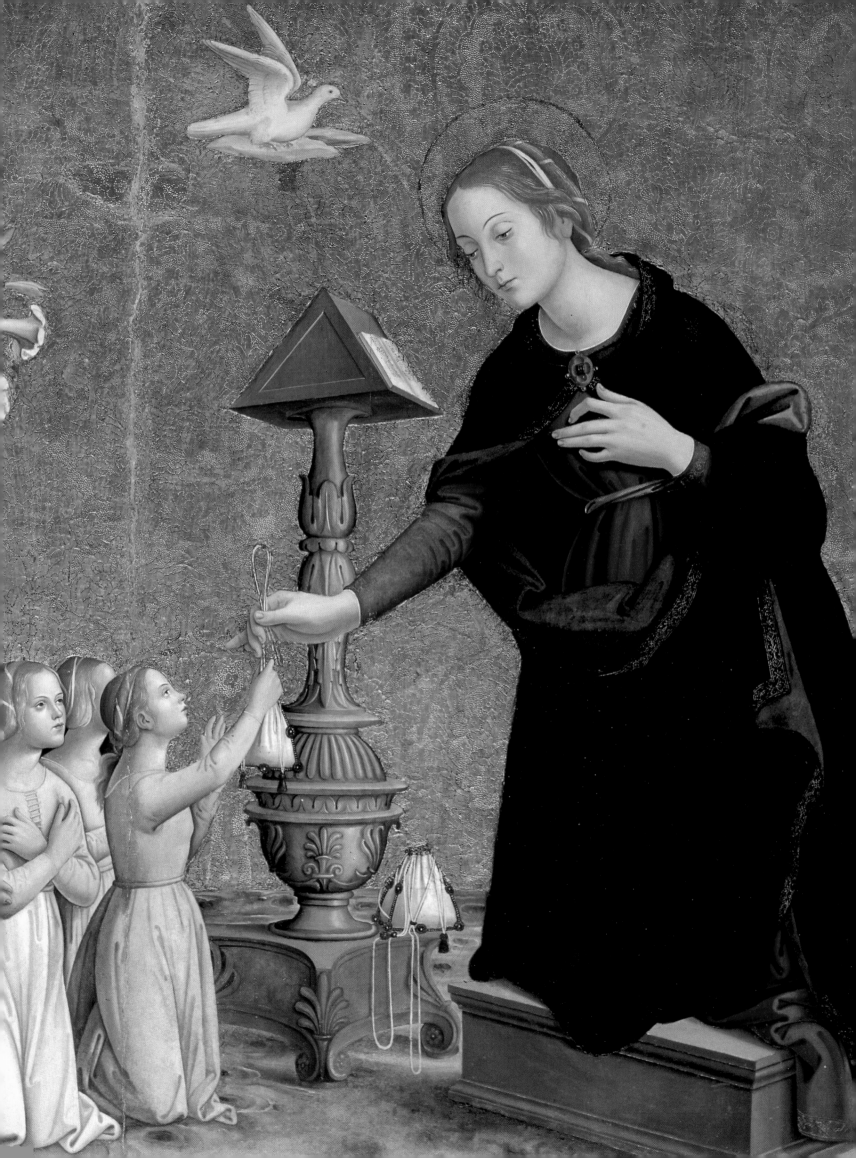

THE VATICAN APARTMENTS, THE WORKS AT CASTEL SANT'ANGELO, AND THE DECORATION OF SANTA CROCE IN GERUSALEMME

Laura Testa

Antoniazzo Romano
Annunciation with Cardinal Torquemada Giving Dowries to the Poor Maidens
Rome, Santa Maria sopra Minerva
detail

Tuesday, 24 December, the Eve of the birth of Our Lord Jesus Christ […], His Holiness came on foot to the door that was to be opened. He received from the hands of master Tommaso Matarasso, the mason and superintendent of the basilica, a mason's hammer, he gave three blows to an opening that had been prepared in advance in the middle of the door and caused the bricks filling it to fall to the floor. Then he stepped back and sat on his chair while the workers proceeded with the demolition of the wall: a task that lasted about half an hour, during which time the singers continued to repeat the antiphonies […]. When the preparation of the door was concluded, His Holiness rose from his chair and approached it. He knelt, bare-headed, at the threshold and started to pray for the duration of half a miserere, holding a lit candle in his left hand; then he stood up, and crossing through the doorway, entered the basilica.[1]

With the solemn opening of the Holy Door of St. Peter's, which had been specially built just a few days before, Pope Alexander VI inaugurated the Jubilee of 1500 with pomp and magnificence in front of some two hundred thousand people. At the same time, three papal delegates were repeating the ceremony in three other Roman basilicas, San Giovanni in Laterano (St. John in Lateran), San Paolo (St. Paul outside the Walls), and Santa Maria Maggiore (St. Mary Major). In that way, a ritual of great symbolic value was repeated according to tradition and institutionalized; a metaphorical reference to Christ's words: "I am the door; anyone who comes in […] through me shall be safe. He shall go in and out and find pasturage."[2]

Before the eyes of the faithful in the Holy Year 1500, the church of St. Peter's was an emblem of the artistic situation of the city: it was a mixture of old and new, suspended in expectation of the events and different solutions. It was still the old basilica from the time of Constantine, with a four-sided portico, five naves, a projecting transept, decorations from the Middle

Ages and the Quattrocento, two round late Antique mausoleums (Santa Petronilla and Santa Maria della Febbre), and, on the east, an Egyptian obelisk. Outside of the Constantine area, the rough structure of the incomplete wall of the choir was visible (less than two meters high); it had been started by Bernardo Rossellino in 1450, but had been abandoned for nearly fifty years since the death of Nicholas V. Masses of travertine and half-built works spread all around the area, making it look like one big ruin. Outside, to the right of the portico, was the Benediction Loggia, begun in the classical style during the pontificate of Pius II and finished with a second order by Alexander VI, the Borgia pope.

According to one commentator, the whole world was in Rome to participate in the celebration of the Jubilee.[3] Thus, the inauguration of the Holy Year—a sumptuous example of the taste for luxury and splendor that pervaded the pontificate of Alexander VI—constituted a sort of religious apotheosis for the pontiff-tyrant, one that helped to conceal the political adversities of the last years of the century. These adversities had begun with his own election in a climate of suspicion and simony, and included the heated opposition of the curia (polarized around Giuliano Della Rovere), the military occupation of Rome by Charles VIII in 1494, and the tragic conclusion in 1498 of Savonarola's rebellion. The tense situation was aggravated, moreover, by the sinister light that was cast on the increasingly complicated family vicissitudes, which were permanently tied up with pontifical politics and which included murders, marriages, and military adventures.[4]

The opening of the Holy Door sanctioned the progressive substitution of Rome, famous for it ancient memories and its numerous relics from Jerusalem, for Jerusalem itself. Already with the institution of the Jubilee in 1300, which established the possibility of gaining indulgences by pilgrimage to the Eternal City, Rome had tended to replace that Jerusalem in the "geography of pardon."[5] The pontiff's intense interest in a reformulation of the ceremonial is attested to by Burckhardt, who describes Alexander VI's urgent search for the holy door near the Chapel of the Veronica at St. Peter's. The investigation proved in vain, so the pontiff ordered the construction, in just six days' time, of a new door, embellished with a richly carved marble frame, through which the pilgrims would immediately encounter the relic of the Veronica, the most venerated in Christendom.[6]

Furthermore, the Holy Door provided an ideal completion to the perspective of the Via Alessandria, the new straight road that the Pope had built from Castel Sant'Angelo to Piazza San Pietro, widening toward the left so as to also include in its panorama both the Portal of the Vatican Palace (the real focal point of the street) and the façade of the basilica of St. Peter's, with the Jubilee door and the Benediction Loggia.[7] Significantly, the street was opened on December 24, 1499, the first day of the Jubilee. Burckhardt described the inaugural procession: "Today, after luncheon, the new street linking the gate of Castel Sant'Angelo directly to the gate of the apostolic palace near St. Peter's was opened. All the cardinals and others also passed along it to go to the basilica of St. Peter's: in fact, the old street had been barred in order to make everyone walk on the new one."[8]

Started in April 1499, and built in only nine months, the Via Alexandrina (later the Via Recta, and now Borgo Nuovo), was "the first demolition in the history of Rome."[9] It disappeared during the fascist period when it, in turn, was demolished to build the Via della Conciliazione. The street constituted a public connection between the Vatican Palace and Castel Sant'Angelo, parallel to the *passetto,* the elevated corridor that was reserved exclusively for the pontiff and his court and which

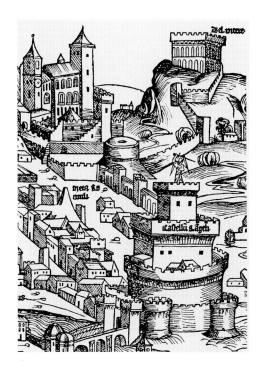

Alexander VI himself had had restored.

Previously, road work in Rome had been more or less limited to straightening or rebuilding streets. But for the new, quarter-mile-long street, houses were demolished in the middle of the zone between Borgo Vecchio and Borgo Sant'Angelo. The project was directed by Raffaele Riario, cardinal of San Giorgio, though private individuals also contributed to the construction of new residential buildings, which eventually formed the monumental, classical wings of the street.[10] The fact that the Via Alexandrina was the first straight road centered on the main entrance of a palace demonstrates that the Pope did not assign any privileged status to the basilica of St. Peter's, instead proposing the palace, the residence of Christ's vicar, as a focal point. This plan established a relationship between the palace and the urban fabric, which would later become the standard for prestigious European architecture.[11]

Although it was initiated as an effort to improve road conditions and avoid the tragic overcrowding that marred the Holy Year of 1450, the Via Alexandrina was not so much a processional route inserted into a coherent town plan as a triumphal street that dominated the Borgo and was used more by church dignitaries than by pilgrims. It was conceived primarily as a connection between the two buildings most representative of pontifical authority; as one official put it, it was "the street that goes directly to the gate of the castle from the palace."[12] This representative function emerged clearly in February 1500, when the road was traversed by a parade of eleven allegorical carts representing the triumph of Julius Caesar which celebrated, before the eyes of the pilgrims of the Holy Year, the victorious return of the Duke of Valentino (Cesare Borgia) from Romagna.[13] Two decades later, when the palaces on both sides of the street had been built, the Via Alexandrina had acquired the classical appearance of a real "street of antiquity," an effect

that was enhanced by the reconstruction of St. Peter's and the Vatican Palaces under Julius II. It is difficult to know, however, if it was the pope's intention to create what has been called "the first classical and neo-imperial street of modern Rome"[14] or if a distorted impression is given of its original form when observing its genesis in retrospect, in light of its later development.[15]

Given the lack of written or visual documentation, a valuation of the primitive aspect of the Via Alexandrina depends in part on the still-controversial question of the so-called *Meta Romuli*. This was a great funerary monument in the shape of a pyramid, traditionally held to be the sepulcher of Romulus or Scipio. It stood out from the medieval fabric of the Borgo and was similar in design to the Pyramid of Cestius. It was once covered with precious marble which, according to the *Mirabilia*, was later used for paving the four-sided portico and building the steps of St. Peter's. Maria Luisa Madonna has advanced the hypothesis that the *Meta* formed the fulcrum of the new street, giving it the look of a real "ancient perspective." Subsequently, however, because of military requirements and the fact that the pope and curia did not approve of the result from an aesthetic viewpoint, the *Meta* was torn down.[16]

According to some documents, including the famous letter from Raphael to Leo X, written about 1519,[17] some remains of the monument were still visible after the pontificate of Alexander VI. On the other hand, many testimonies point clearly to the fact that the demolition of the monument (which had earlier lost its marble facing) had started under the Borgia pope. In a letter to Raffaele Maffei on May 5, 1499, the humanist Michele Ferno drew a plan of the Via Alexandrina, mentioning that it had been built because of the terrible condition of the two existing streets, which were considered unsuitable for the dignity and magnificence of the recently restored castle, and because

the new street would provide reciprocal defenses between the castle and the palace. In the same letter, Ferno described both the *Meta* and the work involved in its dismantling, noting that the pope had begun removing the monument to make room for the straight street, all the while deploring its loss.[18] Alexander VI went so far as to grant a plenary indulgence to those pilgrims who would help tear down

the sepulcher to speed its demolition and to free the street area.[19]

But the monument persisted. In July 1511, a *motu proprio* of Julius II ordered that the removal of the remains of the *Meta*, which "Alexander VI for the decorum of our Apostolic Palace and for the convenience of the Roman Curia had had demolished," confirming that it had been Borgia's responsibility in the first

Pinturicchio
Ceiling of the Sala dei Santi
Vatican City, Borgia apartment

place.[20] And, as late as 1550, a plan of Rome by Leonardo Bufalini shows the foundation of the *Meta* next to the medieval church of Santa Maria in Traspontina (originally a short distance from Castel Sant'Angelo), creating an obstacle in the street, just as Ferno noted in his letter. As for the so-called classical appearance of the street—which was not paved until 1505[21]—it should also be pointed out that of the buildings lining it, only the Palazzo Castellesi had been started before the pontiff's death.

Notwithstanding the fact that Rome, with its multitude of ancient monuments, was the font of classicism, the city that the pilgrims encountered in the Jubilee year of 1500 was one whose architecture was largely an eclectic blend of local styles and Renaissance elements imported from Florence and Urbino.[22] The only new structure built at the end of the century was the Cancelleria, the palace of Cardinal Raffaele Riario, which was probably started in 1489 and in the last stages of construction in 1500. Against the idea of the palaces as fortification, faced in marble and travertine, and articulated according to the classical orders and ornaments, the Cancelleria made only discreet and purified references to the ancient models. It is a synthesis of the classicism of Alberti and the refinement of Bramante, and since it is impossible to dissolve the inextricable knot of its attribution, it may best be considered an "architectural self-portrait" of Riario himself.[23]

Riario, the wealthy great-nephew of Pope Sixtus IV Delle Rovere, directed the road works of the Via Alexandrina in addition to serving as Cardinal of San Giorgio. Riorio was a brilliant humanist, and he showed his passion for antiquity in various ways, from his studies of Vitruvius and Greek theater to the collecting of ancient marbles. However, in architecture, he preferred the archaic and subtle style of Baccio Pontelli to the monumental classicism of Bramante.

As a patron, he did not show good judgment when he refused, after having commissioned it, the Bacchus that Michelangelo had executed in 1497. In giving the statue to Jacopo Gallo, he earned a severe reprobation from Condivi, who commented that Riario "knew and appreciated little about statues."[24]

Although Alexander VI favored humanistic culture, protecting the Academy of Pomponio Leto and establishing the *Studium Urbis*, the architectural projects he promoted prior to the Holy Year suggest that he was more interested in fortifications and military projects than in antiquity or the embellishment of interior spaces. He privileged heterogeneous stylistic expressions that were guided by decorative themes, variety, and formal richness. This is particularly evident in two important architectural projects that Alexander VI promoted: the Vatican apartments and the restructuring of Castel Sant'Angelo.

Alexander VI initiated the construction of the Borgia Tower in the Vatican citadel after the rebuilding of the Porta Sancti Petri (prior to 1492). The latter Porta Sancti Petri is a ninth-century gateway in the Leonine Walls that consists of a large central structure flanked by two high square towers that project inward, surmounted by a celebratory epigraph in classical capital letters. Like it, the new Borgia Tower was military in character and important for the defense of the northwestern corner of the palace as well as its western entrance, which, because of the level terrain, was more exposed to assaults. The almost square tower was integrated into the preexisting building, making it the fourth tower. The two rooms inside the tower, together with three others built by Nicholas V on the *piano nobile* of the palace, make up the Borgia apartments. All these spaces were decorated between 1492 and 1494 by Pinturicchio and his collaborators.[25]

The choice of Pinturicchio corresponded to Alexander VI's unrestrained

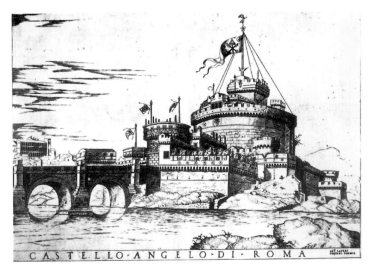

CASTELLO·ANGELO·DI·ROMA

CASTELLO·SANCTO·ANGELO·DI·ROMA

taste for showy colors, gold, carpets, storied coverings, and pomp. And the Umbrian painter did not disappoint; he supplied sparkling decoration, narrative animation, and abundant detail based on the principle of accumulation. Because of these characteristics, Vasari accused Pinturicchio of a "very great heresy," charging that his style was subversive to the classical rules of painting. It is, on the contrary, strongly imbued with an ancient spirit, and swarms with fantastic motifs freely inspired by the grotesques and decorations of Nero's Domus Aurea. It considers antiquity not as a canon but as a myth, a fabulous repertoire of shapes and colors from which to draw. In this case the goal was to exalt his powerful patron, by establishing a syncretism between the Egyptian mythology of Isis and Osiris, figures from classical mythology, and biblical and Christian figures.[26]

In 1495, Alexander VI had Pinturicchio fresco the walls of the papal apartments (now lost) that had been built in Castel Sant'Angelo during the time the mausoleum was being fortified. Those frescoes also contained grotesques and celebrative imagery based on the historical and political events of the times. But the dramatic quality of those political events, as well as the conflicts and clashes the city had to withstand, forced the pontiff to concentrate his efforts not only on fortifying the Vatican Palace but also on making the Borgo and its main defensive bastion, Castel Sant'Angelo, strategically secure.

According to Vasari, the works at the Castel Sant'Angelo were directed by Antonio da Sangallo the Elder, who was "prized" and "esteemed" by the pontiff, and whose efforts earned him great credit from the Pope and his son, the Duke of Valentino."[27]

To reinforce the Castel Sant'Angelo's traditional role as the keystone of the Roman military system and the symbol of the pope's temporal power, Sangallo had the castle isolated, starting in 1494, by the construction of a moat. He strengthened the external quadrangular walls, and incorporated the three circular towers built by Nicholas V into octagonal bastions approximately twenty-five meters in diameter, and added a fourth one ex-novo.

The most radical transformations were carried out on the front of the fortress: a new wall was erected parallel to the entrance wall, creating a double screen of defense. In addition, a massive circular tower (about twenty meters in diameter and some fifteen meters high) was constructed in line with the central axis of the bridge so as to block the way. This rendered it necessary, in anticipation of the crowds for the Jubilee, to demolish and rebuild the wall that Hadrian had constructed down river, since its gate closed the passage toward St. Peter's.[28]

To the right of the circular tower, in a four-sided area enclosed by strong crenellated walls, a hanging garden was created with a porticoed building. There, Pinturicchio and his helpers

On top, from left to right:
Antonio Lafrery (1628), View of the circular tower by Sangallo and View of the Porta Sancti Petri

Above:
Detail of a plan by Faleti (1557) that shows the works inside the walls of the Castle, with the Borgia apartment decorated by Pinturicchio.

Above:
Michelangelo
Pietà
Rome, Basilica of Saint Peter's

Below:
Façade of the Palazzo della Cancelleria

frescoed six scenes relating to the political events that had taken place in January 1496. The subjects of the lost frescoes—which, according to Vasari, depicted "the history of Pope Alexander" and included portraits of "the beautiful Catholic Queen Isabella, the Count of Pitigliano Nicolò Orsino, Giangiacomo Trivulzi with many other relatives and friends of the pope, and in particular Cesare Borgia, his brother and sisters, and many virtuous men of the times"[29]—may be reconstructed more exactly thanks to the transcription that Lorenz Behaim, the pope's private manservant, made of the inscriptions accompanying the scenes.

In general, the compositions commemorated the 1495 treaty that the pontiff made with Charles VIII to end the sack of Rome. The pope granted free passage out of Italy to the French troops, offering his own son Cesare as their guide to the borders of

the Kingdom of Naples. The iconographic program was obviously meant to present the relations between the pope and the French king in the best light possible, giving ample space to the ceremony of reconciliation in the Vatican Palace, Charles VIII in the act of kissing the Pope's foot, the mass celebrated by the Pope in St. Peter's, and the departure of the king for Naples in the company of Cesare Borgia and the Turkish Prince Djem. References to the heavy conditions imposed by the king and the humiliating circumstances undergone by the Pope were omitted from the epigrams.[30] Moreover, the frescoes cast a distorted light on the events surrounding Charles VIII's presence in Rome. It was hardly a festive sojourn, but rather a military occupation of the city. On December 31, 1494, over 20,000 men led by the king, with Cardinal Giuliano Della Rovere at his side, had invaded Rome and had driven the Pope into hiding in the Castel Sant'Angelo. The Pope was forced to reach an agreement to stop the looting and violence.

Only five years later, the pontiff inaugurated the Via Alexandrina, the triumphal link between the Castle and the Vatican Palaces. Celebration and a desire to overcome his own humiliation were certainly among the reasons behind the project, as well as the more practical need for improving the road conditions for the coming Jubilee. However, these aspects do not explain the Pope's intentions in reviving the classical forms of the tragic scene recorded by Vitruvius.[31] Furthermore, there is also a connection between the Via Alexandrina and the first Roman works of Bramante who "left Milan, and came to Rome before the Holy Year of MD where he met some of his friends from Lombardy, he was commissioned to paint, in St. John Lateran above the Holy Door that is opened for the Jubilee, Pope Alexander VI's coat of arms supported by angels and figures."[32] The role of "sub-architect" that Vasari attributed to Bramante and his close relationship to Cardinal Riario have led

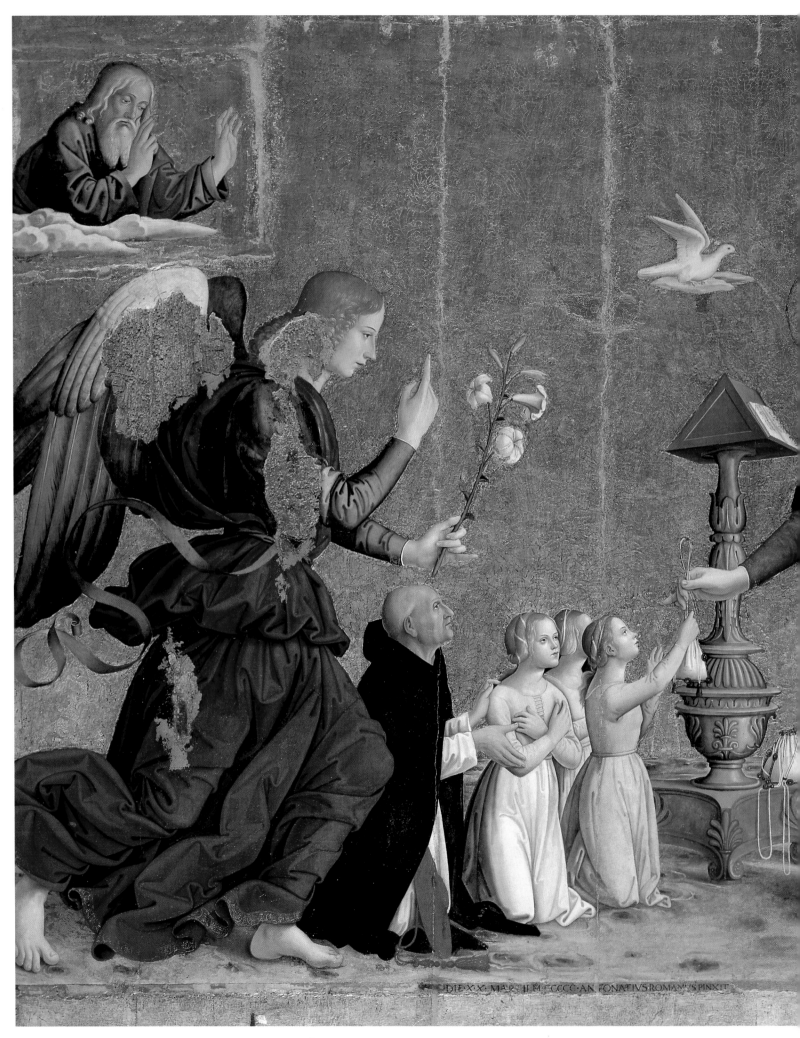

DIE·XX·MAR·II·M·CCCC·AN·FONATIVS ROMAN°·S PINXIT

some to hypothesize that Bramante acted as a consultant in the project for the street. However, it is difficult to believe that the architect from Urbino, who was interested in "measuring all the ancient fabrics of Rome," would have approved of the destruction of the *Meta Romuli*.

Bramante's reputation and prestige, acquired in the service of Ludovico il Moro, was proven, according to Vasari, not only by his nomination as "sub-architect" but also by the fact that he was called on for advice or assistance. Raffaele Riario probably consulted him for the resolution of Palazzo della Cancelleria, and he also advised on the construction of the churches of San Giacomo and Santa Maria dell'Anima. These were, however, interventions that took place during the last years of the fifteenth century and the first years of the sixteenth century, and they did not yet demonstrate his passionate and analytical knowledge of antiquity.[33] What is more, the Urbino architect's participation in these projects, which is not documented, remains controversial, and, when it is accepted, it is chronologically uncertain.

The critical and philological study of Roman monuments that, according to Vasari, Bramante undertook upon his arrival in Rome is evident only in the first Roman work that can be attributed to him with certainty: the cloister of Santa Maria della Pace. According to documents, construction of the cloister began in August 1500, making it a kind of watershed between the two centuries as well as a presage of Roman classicism. Prior to the Jubilee year, there had been an affirmation of an architectural manner that, although not insensible to the revival of classicism, deliberately chose to avoid its relationship to antiquity. Yet, this was an issue that would become central

shortly thereafter, when Julius II ascended to the pontificate.

There was, instead, a tendency among Roman architects to explore a mix of stylistic features and forms from both the medieval tradition and from the new humanistic tradition. Examples of this are to be found in the new churches that were built by the foreign communities which were under Alexander VI's protection: Santa Maria al Campo Santo Teutonico, consecrated in December 1500; San Giacomo degli Spagnoli, amplified between 1496 and 1500 (and, by the Pope's will, endowed that same year with a new façade that faced onto Piazza Navona); and Santa Maria dell'Anima, which was completely rebuilt starting in 1499. They all show an evident syncretism between Gothic-type spatial schemes and fifteenth-century Renaissance formal elements.[34]

The rich ceiling of Santa Maria Maggiore, redecorated in 1499 with the first gold from America, demonstrates the prevailing eclectic taste, mixing a brilliant and heraldic decorativeness with elegant references to ancient forms.[35] From an artistic point of view, Rome in 1500 seemed to be a city without great resources, suspended between the old and the new, between innovation and tradition. Melozzo da Forlì and Antonio del Pollaiolo were dead, Lippi had returned to Florence, Perugino to Perugia, and even Pinturicchio, the Pope's favorite painter, had left the city. There were other important artists present, but they were still lingering in the shadows.[36] In addition to Bramante, who had received the commission to fresco the Pope's coat of arms on the Holy Door of St. John in Lateran (destroyed during Borromini's renovation of the church), Michelangelo had been in Rome since 1496. Young Michelangelo had spent twelve months in the house of Jacopo Gallo executing the statue of the Bacchus "whose form and aspect corresponds in every part with the intention of the ancient writers." It had been refused by Cardinal Riario,

Antoniazzo Romano
Annunciation with Cardinal Torquemada
Giving Dowries to the Poor Maidens
Rome, Santa Maria sopra Minerva

and thus remained to enrich the collection of marbles of the Gallo family in the courtyard.

During the year of the Jubilee, the twenty-year-old Florentine finished the most important oeuvre of his first Roman sojourn, the *Pietà* for the chapel of the French Cardinal Jean de Bilhères Laugraulas, in the rotunda of Santa Petronilla, annexed to St. Peter's. In maintaining the promise of Jacopo Gallo, the guarantor of the contract signed in August 1498 (who had assured the realization of the "most beautiful work in marble in Rome today), Michelangelo created a work that in terms of the beauty of its invention and the perfection of its execution was unprecedented since antiquity. The quality of the *Pietà* earned its author (who, according to his brother's testimony, was then living in poverty) a commission in September 1500 for an altarpiece depicting the *Burial of Christ* (now in the National Gallery in London) for the church of Sant'Agostino, but no papal commissions.[37]

The Roman artistic scene was still dominated by conservative painters like Antoniazzo Romano, who, in 1500, proposed an *Annunciation with Cardinal Torquemada Giving Dowries to the Poor Maidens* for the church of Santa Maria sopra Minerva. This work was described as suspended "between the aulic tone and the fairy-like," for it was constructed by blending medieval elements, such as the gold arabesqued ground and the hierarchic dimensions used to depict the donor and the four young "spinsters," with stylistic features borrowed from Tuscan Quattrocento painting.[38]

Yet, with the reassuring language of his traditional style, Antoniazzo was the chief protagonist of one of the major pictorial cycles realized during the pontificate of Alexander VI for the Jubilee, that in the apse of the church of Santa Croce in Gerusalemme depicting the *Stories from the Legend of the True Cross*.[39] Given the presence there of a relic of Christ's cross—which had been found, according to legend, by St. Helena in Jerusalem—the basilica had been an important pilgrimage site since medieval times. Associated with the holy city since the twelfth century and linked to the spirit of the Crusades, the church of Santa Croce was the theater of an important find at the time of its restoration. The title of the True Cross, lost since the time of Helena, was miraculously revived in February 1492, on the very day that the news of the fall of Granada reached Rome, an event that marked the conclusive victory of the West over Islam and the expulsion of the Moors from Spain. These events had an enormous effect on the Roman public, and, along with itself, influenced the new decoration in the apse.

The donor of the cycle, portrayed in the center of the composition next to St. Helena, has been identified as Cardinal Pedro Mendoza, a powerful Spanish cardinal who was involved in all the major political and religious issues relating to the Spanish realm. Works on the frescoes was probably continued after 1495, the year of Mendoza's death, by his secretary, Bernardino Carvajal, who succeeded him as titular cardinal of the church. The latest date for the completion of the frescoes is probably July 1496, since that is when Alexander VI expressed a particular devotion to the memory of the Holy Land and to the church of the Santa Croce, and issued a Bull granting plenary indulgence to anyone who went to the basilica on the anniversary of the discovery of the relic. Together with the theme of the struggle against the infidels, which was traditionally linked to the history of the True Cross, the apse decoration depicts the theme of pilgrimage, and it is obvious that the imminent Jubilee

played a fundamental role in this iconographic choice.[40]

The apse calotte is divided into two registers: above is Christ Benedictory within a mandorla and below are episodes of the *Invention* and the *Exaltation of the Cross* on either side of the figure of Helena with the cross and the kneeling donor. The sequences are introduced, on the left, by the figure of a young pilgrim—which has recently been identified as a portrait of Marcantonio Aquili, Antoniazzo's son.[41] The scenes are the confession of the Jew Judas, who reveals to Helena the place where Christ's cross is buried; the finding of the three crosses; and the episode of the young man being restored to life on contact with the True Cross. On the right, the protagonist of the Exaltation is Heraclius, the seventh-century Byzantine emperor, who, on defeating the Persian army of King Chosroes II in battle, succeeds in recovering the cross, which had been carried off by the infidels, and restoring it to the city of Jerusalem. The battle episode is synthesized by the duel between the two warriors on a bridge with the two armies watching the conflict. Prominence is given to Heraclius, who, in one scene, rides toward the holy city—a Jerusalem that in reality is an image of Rome—and, in a subsequent scene, enters the city led by an angel and bearing the cross on his shoulders like a humble pilgrim.[42]

With the defeat of the Moors, the discovery of the New World, the expansion of prospects for evangelization for Christianity, and the approaching Jubilee year, the idea of the pacific pilgrim as the evangelizer prevailed over that of the crusader. This shift made the identification between Rome and Jerusalem explicit, especially in places like the basilica of Santa Croce, which had been founded by Helena specifically to preserve the relics of Christ's cross.[43] As a site for meditation and prayer, for the acquisition of indulgences, and for an encounter with relics and legends, the basilica of Santa Croce became a "second Jerusalem" for pilgrims at the end of the fifteenth century. It anticipated by a few years the Jubilee transformation of the whole city into a single great *Sancta Jerusalem*, in which it was possible not only to visit the tomb of the apostle but also to gain indulgences and to witness religious experiences of extraordinary intensity in every church and in every chapel.

[1] G. Burckhardt, *Alla corte di cinque pap:. Diario 1483-1506*, ed. L. Bianchi (Milan 1988), pp. 317-18.

[2] John 10; 1-18: see P. Cannata, "La porta santa: simboli e riti," in *Il Giubileo: storia e pratiche dell'anno santo* (Florence 1995), p. 87; P. Brezzi, *Storia degli anni santi* (Milan 1975), pp. 81-83.

[3] Sigismondo de' Conti, cited in L. von Pastor, *Storia dei papi* (Rome 1908-34), vol. 3, p. 509.

[4] For the historical events of the pontificate of Alexander VI, see ibid.

[5] F. Cardini, "Il viaggio in Terrasanta e il 'perdono,'" in *Roma Sancta: La città delle basiliche*, ed. M. Fagiolo and M. L. Madonna (Rome 1985), p. 14; by the same author, also see, "Gerusalemme la Terrasanta e l'Europa," *Storia e Dossier*, no. 9 (1987).

[6] Burckhardt, *Alla corte di cinque papi*.

[7] M. L. Madonna, "L'architettura e la città intorno al 1500," in *Roma 1300-1875. La città degli Anni Santi* (Milan 1985), p. 130.

[8] Burckhardt, *Alla corte di cinque papi*, p. 319.

[9] I. Insolera, *Roma: Immagini e realtà dal X al XX secolo* (Bari 1988), p. 46.

[10] In the Holy Year, Alexander VI issued a Bull to favor and regulate the construction of the buildings on the side of the street, see *Bullarium romanus*, vol. 5 (Turin 1860), p. 578. For a detailed register of the sources and documents relative to the Via Alexandrina, see H. Guenther, "Die Anlage der Via Alexandrina," *Jahrbuch des Zentralinstituts für Kunstgeschichte*, 1 (1985): 287-93. On construction in general, see M. L. Madonna, "Una operazione urbanistica di Alessandro VI: la Via Alexandrina in Borgo," in M. Calvesi, *Le arti a Roma sotto Alessandro VI: Papers a.a. 1980-81* (Rome 1981), pp. 4-9; E. Howe, "Alessandro VI, Pinturicchio and the fabrication of the Via Alexandrina in the Vatican Borgo," in *An Architectural Progress in the Renaissance and Baroque*, ed. H. A. Millon and S. S. Munshower (University Park, 1992), pp. 64-93.

[11] Insolera, *Roma*, p. 46.

[12] Note written by the Venetian ambassador and transcribed in Guenther, "Die Anlage," p. 289.

[13] The episode is recorded by Burckhardt; see A. Bruschi, "L'architettura a Roma al tempo di Alessandro VI: Antonio da Sangallo il Vecchio, Bramante e l'antico," *Bollettino d'arte*, 70, no. 29 (1985): 68; M. Miglio, "Il ritorno a Roma. Varianti di una costante nella tradizione dell'Antico: le scelte pontificie a Roma," in *Roma centro ideale della cultura dell'antico nei secoli XV-XVI*, ed. S. Danesi Squarzina (Milan 1985), pp. 217-18.

[14] Madonna, "L'architettura e la città intorno al 1500," p. 130.

[15] This doubt was proposed by Howe, "Alessandro VI," p. 64.

[16] Madonna, "Una operazione urbanistica," p. 6; and Madonna, "L'architettura e la città intorno al 1500," pp. 130-31.

[17] "And I can remember with much compassion that, ever since I have been in Rome, not quite twelve years, many beautiful things have been ruined, like the *Meta* that was in Via Alexandrina." See V. Golzio, *Raffaello nei documenti, nelle testimonianze dei contemporanei e nella letteratura del suo secolo* (Vatican City, 1936), p. 83.

[18] B.M. Peebles, "La Meta Romuli e una lettera di Michele Ferno," *Atti Pontificia Accademia Romana di Archeologia* (1936): 21-36; Guenther, "Die Anlage," p. 289.

[19] Fra Mariano da Firenze, *Itinerarium Urbis Romae (1517)*, (Rome 1931), p. 73: "Hanc (metam) Alexander VI anno quingentesimo supra mille, tempore iubilei, amovere iussit, plenarium indulgentiam omnibus peregrinis concedens qui in eius amotione se fatigarent. Qua propter in momento fere diruta et asportata materia, omnes stupuerunt."

[20] Guenther, "Die Anlage," p. 289.

[21] P. De Roo, *Material for a History of Pope Alexander VI, His Relatives and His Time* (Bruges 1924), vol. 4, p. 482.

[22] Bruschi, "L'architettura a Roma," p. 67.

[23] C. L. Frommel, "Raffaele Riario: committente della Cancelleria," in *Arte, committenza ed economia a Roma e nelle corti del Rinascimento* (Turin 1995), p. 207. For a summary of the attribution question that Frommel resolves in favor of Baccio Pontelli, see F. Borsi, *Bramante* (Milan 1989), pp. 233-40, with a bibliography.

[24] M. Hirst and J. Dunkerton, *Michelangelo giovane: Scultore e pittore a Roma 1496-1501* (Modena 1997), p. 31. However, Condivi's judgment is unrelated to his refusal, which he seems not to know about, but rather on the fact that Cardinal Riario never asked Michelangelo for "anything."

[25] For the iconographic program of the frescoes of the Borgia Apartments, see C. Cieri Via, "Mito allegoria e religione nell'Appartamento Borgia in Vaticano," in *Le Arti a Roma da Sisto IV a Giulio II* (Rome 1985).

[26] See M. Calvesi, "Il gaio classicismo Pinturicchio e Francesco Colonna nella Roma di Alessandro VI," in *Roma centro ideale*, pp. 70-101.

[27] G. Vasari, *Le vite dei più eccellenti pittori, scultori e architetti* (Rome 1991), p. 613.

[28] C. D'Onofrio, *Castel S. Angelo e Borgo tra Roma e Papato* (Rome 1978), pp. 258-67.

[29] Vasari, *Le vite*, p. 520.

[30] Howe, "Alessandro VI," pp. 68-69.

[31] Madonna, *cit.*

[32] Vasari, *Le vite*, p. 583.

[33] S. Benedetti-G. Zander, *L'arte in Roma nel secolo XVI*, vol. 1, *L'architecttura* (Bologna 1990), pp. 47-48.

[34] Ibid., p. 32.

[35] Ibid., p. 40.

[36] Regarding the Roman artistic scene around 1500, see S. Rossi, "Tradizione e innovazione nella pittura romana del Quattrocento: i maestri e le loro botteghe," in *Le due Rome del Quattrocento: Melozzo, Antoniazzo e la cultura artistica del '400 romano*, ed. S. Rossi and S. Valeri (Rome 1997), p. 19.

[37] Hirst and Dunkerton, *Michelangelo giovane*.

[38] S. Rossi, "Roma anno 1500: immagini per un Giubileo," in *Homo viator: Nella fede, nella cultura, nella storia,* (Rome 1996), p. 245.

[39] For the Santa Croce cycle, see ibid., pp. 245-56; M. J. Gill, "Antoniazzo Romano and the Recovery of Jerusalem in Late Fifteenth Century Rome," *Storia dell'arte*, 83 (1995): 28-47; F. Cappelletti, "L'affresco del catino absidale di Santa Croce in Gerusalemme a Roma. La fonte iconografica, la committenza e la datazione," *Storia dell'arte* 66 (1989): 119-26.

[40] S. Rossi, "Roma anno 1500," p. 250.

[41] Ibid., p. 253.

[42] Ibid., pp. 250-252.

[43] Ibid., p. 253.

THE SCHOOL OF RAPHAEL
AND ASPECTS
OF ITALIAN MANNERISM
Francesca Cappelletti

Sebastiano del Piombo
Flagellation
Rome, San Pietro in Montorio
Borgherini Chapel
detail

Sebastiano del Piombo was responsible for many of the paintings of Clement VII de' Medici, who succeeded the Flemish Pope Adrian VI in 1523. Most famous among these paintings is the portrait depicting a youthful and beardless Clement VII (now at Capodimonte) executed by Sebastiano about 1526,[1] that is, shortly before the Sack of Rome,[2] the single event that most characterized the pontificate of Clement and which irreversibly influenced his iconography.[3] Even his decision to grow a beard stemmed from a vow made during that event. Thus, the memory of the troubles that began in May 1527 became part of his very expression, even in the later portraits, which present the suffering effigy and later the gelid icon of a pontiff who was destined to rule until 1534.[4]

Before the fire and water of 1527, about the time Sebastiano painted him with the blank gaze of a man inclined toward reflection, was the Jubilee of 1525.[5] That celebration was

not a very propitious one given the circumstances of the Church, which was "clouded [...] by the impious heresy of Martin Luther,"[6] and which had little interest in promoting the arts.[7] The war in Italy, the plague, and Luther's protest were hardly conducive to celebrating the Holy Year, but the future Clement decided to open one December 17, 1524, as a demonstration of his authority and faith. The title of the Bull that proclaimed the Jubilee, *Inter sollicitudines*, was indicative of his concerns. However, the Jubilee did not have the desired success. Pilgrims simply did not come, conditioned either by the adverse propaganda regarding the sale of indulgences, or for fear of undertaking such a journey in the midst of battlefields.[8]

Historians like Von Pastor[9] consider Clement VII the most unfortunate pope,[10] one who ate the bread of suffering in the Castel Sant'Angelo[11] and who was incapable of turning political thought into action. As far as

There was, of course, a strong bond between the Medici Pope in Rome and the artists of Florence. This privileged track facilitated important exchanges even during successive papacies, including periodic sojourns by Michelangelo, Francesco Salviati, Giorgio Vasari, and Jacopo Zucchi. As pope, Clement hardly ever intervened in these artistic endeavors, and, if so, only indirectly. However, others in his court did supervise such matters. Cardinal Lorenzo Pucci, Perino's patron, was entrusted with drawing up the norms regarding the jubilee confession. And Paolo Valdambrini, Clement's secretary, played a crucial role in establishing contacts between the painters: for example, he introduced Giulio Romano, Sebastiano, and Francesco Mazzuoli da Parma to an enraptured Giovanni Antonio Lappoli.[17] Even non-Tuscan artists, like Sebastiano, relied on the traffic between Florence and Rome. When Sebastiano sent a portrait by Anton Francesco Albizzi to Michelangelo in Florence, it aroused the interest of many Florentine artists as well as the master himself.

During the years of Clement VII's pontificate, Sebastiano made a name for himself as a portrait painter. He painted portraits not only of the pope but also of Aretino and Andrea Doria (now in the Palazzo del Principe in Genoa), and drew the attention of Isabella d'Este, who praised his "most perfect hand" as a portraitist.[18] But it was Sebastiano's chapel of San Pietro in Montorio, originally commissioned in 1516 from the Florentine Pierfrancesco Borgherini but not completed until 1524, which aroused the greatest curiousity. In his realization of the *Flagellation,* in that chapel, Sebastiano availed himself of Michelangelesque ideas and studies,[19] but with a severe and simplified composition that was only fully appreciated decades later. The monumental isolation of the figures, together with the placement of the prophets and saints on either side of the chapel entrance, created a sensation and had an immedi-

his cultural interests were concerned, he did not seem to have a plan, beyond the most general inclination for the arts which was known to be part of the family tradition. However, the whole period of his rule was imbued with such richness and variety that André Chastel went so far as to define the painting of that time as the "Clementine style."[12]

Already as a cardinal, Clement had commissioned from Sebastiano the *Resurrection of Lazarus,* which was later often contrasted with Raphael's *Transfiguration.*[13] In the early years of his reign Clement seemed headed toward a policy of promoting the arts. He had Raphael's studio complete the Stanze Vaticane, for instance, in an effort to continue what his predecessor, Leo X, had started.[14] But, as Chastel points out, Clement often encouraged stylistic elaborations of Raphael and Michelangelo that were as personal and eccentric as the artists undertaking them.[15] Clement was open to the refined variations of Mannerism, as the simutaneous presence of Sebastiano del Piombo, Rosso Fiorentino, Perin Del Vaga, and Parmigianino in Rome between 1524 and 1527 suggests. The undeniable diversity of their figurative approachs led Chastel to define the "Clementine style" solely in terms of "ability, charm, and refinement."[16]

Above:
Sebastiano del Piombo
Flagellation
Rome, San Pietro in Montorio
Borgherini Chapel

At left:
Sebastiano del Piombo
Portrait of Clemente VII
Naples, Museo di Capodimonte

ate influence on other artists. Perin Del Vaga shortly after used the same decorative scheme when he placed the elongated figures of Isaiah and Daniel on either side of the huge arch in the Pucci Chapel in the church of Trinità dei Monti.[20] Perino may have received the commission before the plague struck Rome in 1522, at which time the artist took refuge in Florence for about a year and encountered the rich artistic scene in that city.

In relating the story of Perino's sojourn in Florence, Vasari elaborates on the famous comparison between Florentine tradition and Roman innovation. He describes Perino standing in front of Masaccio's frescoes in the Carmine and, in the presence of everyone, executing a drawing of a standing apostle with speed and ability.[21] Here, Vasari makes a clear distinction between the art of his time and that of the Quattrocento in terms of facility of execution and the rapid appropriation of excellent examples.[22] And Perino's later work in Rome seems to confirm the gist of Vasari's anecdote. Besides

copying Sebastiano's work for the Pucci Chapel, Perino produced graceful and at times acute rereadings of Raphael's works in the Stanze, including the architectural framework of the *Visitation*. In the Chapel of the Crucifix in San Marcello, Perino relied heavily on Michelangelesque motifs. In February 1525, Perino began to fresco the vault of the chapel, which housed an important fifteenth-century wooden cross that had miraculously survived the fire of 1519 and was venerated as a relic. Perino's *Creation of Eve* is a direct derivation of Michelangelo's painting in the Sistine Chapel, but it lacks the grace and levity of the original. The scene unfolds inside a gilded Greek fret cornice on a rarefied background; dark gnarled trees stand out against the pastel sky as Eve, her left leg emerging from a rib of the reclining figure of Adam, turns toward the pink-robed figure of God the Father. The Sack of Rome caused an interruption in the work, but Perino returned to it in 1539 after his stay in Genoa.[23]

Perin del Vaga
Creation of Eve
Rome, San Marcello, Chapel of the Crucifix

Rosso Fiorentino
Creation of Eve and Original Sin
Rome, Santa Maria della Pace, Cesi Chapel

Concurrent with these important public commissions, Perino was also active in the flourishing market for engravings. He created an elaborate series of *Amori degli Dei* with Rosso Fiorentino, another of the painters who had arrived in Rome in the spring of 1524.[24] In Rosso's engravings the monumental yet dramatic style of his Roman years was diffused. In his series *Images of the Gods*, for instance, the immobile statues give the effect of being uncomfortably imprisoned in niches rather than simply being placed there.[25] If designing for printers was just one element in Perino's hectic activity, for Rosso it was a lucrative expedient when the commission that had brought him to Rome—the frescoes for the Cesi Chapel in Santa Maria della Pace—proved unsuccessful. "Never in his life did he paint worse," said the usually generous Vasari.[26] There, Rosso had attempted a reinterpretation of Michelangelo's models. His *Creation of Eve*, on the left of the arch, was not based on Perino's scheme but was the result of a

profound meditation on the Sistine Chapel itself. However, instead of repeating individual figures, Rosso merged the motifs into a glorious burst of garbled emulation. Similarly, in Rosso's *Dead Christ*, another work tied to his Roman period, Michelangelo's influence is more apparent in the refined bodies and expressions of his figures than in the tortured structure of the composition.[27]

The brief visits to Rome by Raphael's followers often overlapped as they worked busily on churches and palaces. In those years, Polidoro da Caravaggio (together with Maturino) painted many of the façades with friezes based on historical and ancient themes: these made him popular even after they had deteriorated.[28] Another incomplete decoration and an important work of the Jubilee period is the chapel of Fra Mariano Fetti in San Silvestro al Quirinale.[29] Fetti was a barber and buffoon at the court of Lorenzo the Magnificent whom Pope Leo had honored with the office of the *Piombi* in 1514.[30] The original position

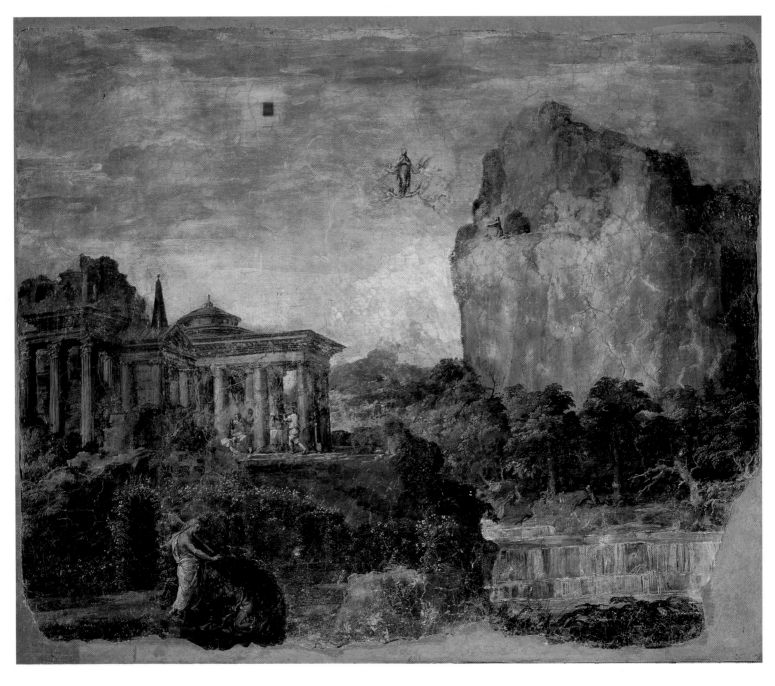

of the chapel has been modified and only a hypothetical reconstruction, based on drawings, can be made of the altarpiece, which is now lost.[31] But the two pictures on the side walls — which were preserved thanks to a seventeenth-century restoration and the fact that they were the object of Annibale Carracci's admiration—are considered crucial to the history of landscape painting.[32] The two landscapes illustrate the *Stories of St. Catherine* and the *Stories of Mary Madeleine* and provide ample views of plateaus, rocks, and valleys dotted with ancient buildings and ruins, where the scenes from the lives of the two saints are depicted. Polidoro created something

completely new by placing the religious stories in an archeologically accurate and vividly naturalistic setting. In addition to paying a debt to Raphael's school and its culture of antiquity, this device reflects Poliforo's more recent and episodic contact with Jan van Scorel. Other Italian and Flemish painters of the Cinquecento turned to Polidoro's model from time to time, but rarely did they equal the force of the fantastic apparition of his buildings and figures.

Amidst the fury of the Sack, in 1527, Maturino died and Polidoro fled to Naples. Sebastiano was shut up with the papal court in Castel Sant'Angelo, and Rosso was imprisoned in the

Polidoro da Caravaggio
Landscape with Stories of Mary Madeleine
Rome, San Silvestro al Quirinale
Chapel of Fra Mariano

Polidoro da Caravaggio
Landscape with Stories of St. Catherine
Rome, San Silvestro al Quirinale
Chapel of Fra Mariano

Della Valle courtyard (from which he would later manage to escape, leaving his property and paintings in the hands of a nun). According to Vasari's account, when the *Landsknechte* (mercenaries) burst in on Parmigianino, who was intent on painting the *Vision of St. Jerome*, they were so dazzled by the scene they had interrupted so brusquely that they left him in peace.[33]

Parmigianino had arrived in Rome in 1524, carrying with him as a gift for the pope and as proof of his exquisite ability his famous *Self-Portrait at the Mirror* (today in Vienna). He immediately joined Valdambrini's Clementine circle, and was flattered with promises of great commissions.[34]

These projects never materialized, but his contact with ancient Roman works and with comtemporary artists who shared his enthusiasm for them encouraged his tendency toward monumentality as well as his natural gift for light and color. This young man, hastily described as a new Raphael, was perhaps the only artist who continued to work undisturbed throughout the devastation around him. Indeed, it was Parmagianino who became heir to a world largely annihilated by the Sack and to Clementine culture itself, that refined rereading of recent tradition. Parmagianino's later meeting with Primaticcio in Bologna only heightened the stately and supple elegance that he

had developed and solidified in the Roman environment. Having screened Raphael, Michelangelo, and Perino in equal fashion, he established the quintessential Cinquecento interpretation of decorative and courtly style, one that would soon be transplanted to France.

[1] M. Hirst, *Sebastiano del Piombo* (Oxford 1981); P. L. de Castris, in *I Farnese. Arte e collezionismo*, ed. L. Fornari Schianchi and N. Spinosa (Milan 1995), pp. 188-89, no. 16; M. Hirst in *Hochrenaissance im Vatikan. Kunst und Kultur im Rom der Papste, I, 1503-1534* (Bonn 1998-99), p. 448, no. 54.

[2] For the event and its repercussions on the artistic situation, see the classic study by A. Chastel, *Il Sacco di Roma* (Turin 1983).

[3] For the pontificate of Clement VII, see the recent contributions in *Hochrenaissance im Vatikan,* especially by A. Nesselrath, "Papstliche Malerei der Hochrenaissance und des fruhen Manierismus von 1506 bis 1534", pp. 240-58, and M. Hirst, "Per lui il mondo has così nobil opera: Michelangelo und Papst Clemens VII," pp. 429-31.

[4] Hirst, *Sebastiano del Piombo,* pp. 89-115.

[5] The paraphrase is taken from a letter from Sebastiano to Michelangelo, quoted by Hirst, *Sebastiano del Piombo,* p. 112.

[6] T. M. Alfani, *Historia degli Anni Santi* (1725), p. 98.

[7] See C. Strinati, "L'arte a Roma nel primo Cinquecento," in *La storia dei giubilei,* vol. 2: 1450-1575, ed. M. Fagiolo e M. L. Madonna (Florence 1998), pp. 238-61 (in particular pp. 257-58).

[8] For the most recent account of Clement's jubilee difficulties, see G. Palumbo, *I giubilei del Cinquecento dalla crisi luterana alla ripresa post tridentina,* in *La storia dei giubilei,* pp. 199-237.

[9] L.F. Von Pastor, *Storia dei papi. Dalla fine del Medioevo,* IV/2 (Rome 1950-1963, 1958): p. 158ff.

[10] See Palumbo, *I giubilei del Cinquecento,* for his judgment of Clement's political action.

[11] From a controversial letter written by Sebastiano del Piombo, regarding which see the critical recapitulation by Hirst, *Sebastiano del Piombo,* p. 112.

[12] Chastel, p. 143; the critical issues raised from a reading of Chastel are indicated in L. Wolk, review of "E. Parma Armani," *Perin Del Vaga,* Art Bulleltin, 71 (1989): 518.

[13] C. Gardner von Teuffel, "Sebastiano del Piombo, Raphael and Narbonne: New Evidence," *Burlington Magazine* (1984): 765-66.

[14] For a recent recapitulation on the conclusion of the Sala di Costantino and on Sebastiano del Piombo's not receiving the commission for the Stanza, see A. Gnamm, "I giovani artisti a Roma dalla morte di Raffaello al Sacco di Roma (1520-1527)," in *1515-1527. Roma e lo stile classico di Raffaello,* ed. K. Oberhuber (Milan 1999), p. 34.

[15] Chastel, *Il Sacco di Roma,* p. 143.

[16] Ibid.

[17] Ibid., p. 142. According to Briganti, this was the fundamental and fascinating crux of Mannerism: *La maniera italiana* (Rome 1961), p. 34.

[18] Hirst, *Sebastiano del Piombo,* p. 91.

[19] Ibid., pp. 49-65; and M. Lucco, *Sebastiano del Piombo* (Milan 1980).

[20] E. Parma Armani, *Perin del Vaga: L'anello mancante* (Genoa 1986), p. 59.

[21] Vasari, *Le Vite,* p. 603ff.; J. Shearman, *Mannerism* (London 1967), pp 62-64; and Chastel, *Il Sacco di Roma,* p. 40.

[22] For a recapitulation of the interpretations of the episode, see Parma Armani, p. 51.

[23] For the circumstances of the decoration, see Ibid., pp. 62-68, and entry 7.

[24] For Rosso's journey to Rome and its implications on the artist's career, see D. Franklin, *Rosso in Italy: The Italian Career of Rosso Fiorentino* (New Haven 1994), p. 121ff.

[25] For Rosso's engraving work in Rome, see ibid., p. 134. and the bibiliography cited.

[26] For the chapel contract, dated April 26, 1524, and for contemporary comments, see ibid., pp. 126-33.

[27] Regading the *Dead Christ,* most likely commissioned by Leonardo Tornabuoni for his private chapel, and the religious implications inherent in the unshaven, majestic beauty of Christ's body, see ibid., pp. 139-40.

[28] For an analysis of these decorations on the basis of written fragments, drawings, and engravings, see Gnamm "I giovani artisti," p. 51, with preceding bibliography.

[29] A. Marabottini, *Polidoro da Caravaggio* (Rome 1969); and L. Ravelli, *Polidoro da Caravaggio* (Bergamo 1978). On his collaboration with Maturino, see N. Dacos, "Ni Polidor ni Peruzzi: Maturino," *Revue de l'Art,* 57 (1982): 9-28.

[30] Fra Mariano had commissioned a *San Bernardo di Chiaravalle* from Baldassare Peruzzi, now lost, at the same time for the chapel; see C. L. Frommel, *Baldassare Peruzzi als Maler und Zeichner* (Vienna 1967-68), pp. 129-30 (he dates it between 1524 and 1527); and Hirst, *Sebastiano del Piombo,* p. 80 (he considers it dependant on the *Sant'Antonio Abate* by Sebastiano).

[31] Marabottini, *Polidor da Caravaggio,*1969, for the project now at the Musée Condé in Chantilly. For the attribution of the figures of the saints on the sides, see Dacos, "Ni Polidor ni Peruzzi", 1982; for the decoration, L. Ravelli, *Polidoro a San Silvestro al Quirinale* (Bergamo 1987); and A. Gnamm, "Polidoro da Caravaggio in S. Silvestro al Quirinale in Rom: Die Ausmalung der Kapelle Fra Mariano del Piombos," *Arte Lombarda,* no. 3-4 (1991): 134-39.

[32] Object of the restorations by Cardinal Sannesio, who acquired the chapel in 1602, and an essential model for Annibale Carracci's landscapes. See Z. Waźbiński, *La cappella di Fra Mariano in San Silvestro al Quirinale e il suo restauratore cardinale Jacopo Sannesio,* in Ravelli 1987.

[33] K. Oberhuber, *Nell'età di Correggio e dei Carracci* (Bologna 1986), pp. 159-76.

[34] A. Ghidiglia Quintavalle, *Parmigianino* (Parma 1929); and C. Gould, *Parmigianino* (New York 1995).

Parmigianino
The Madonna and Child with Saints John the Baptist and Jerome
London, National Gallery

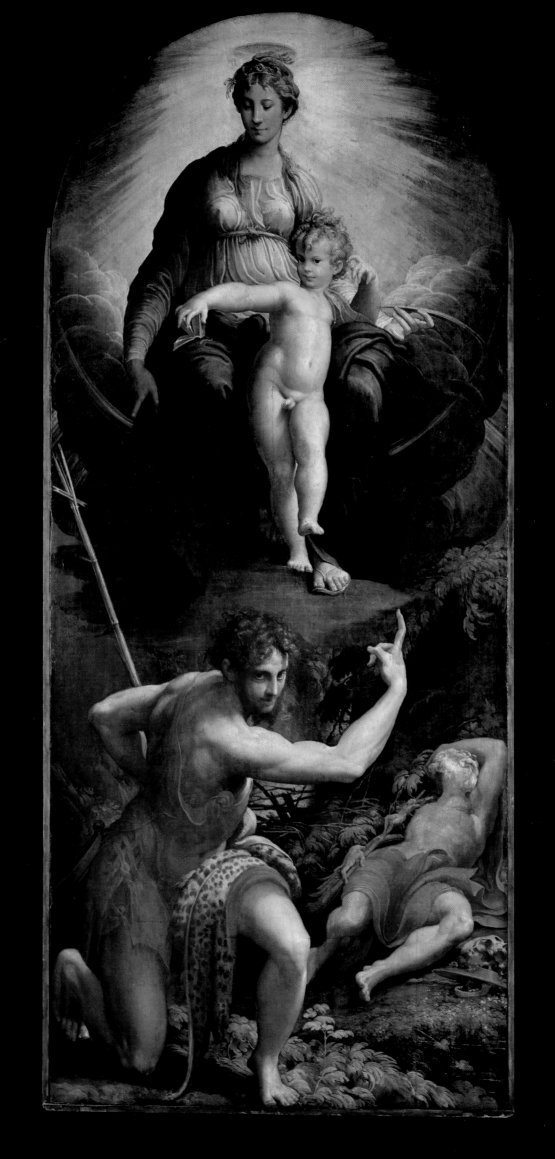

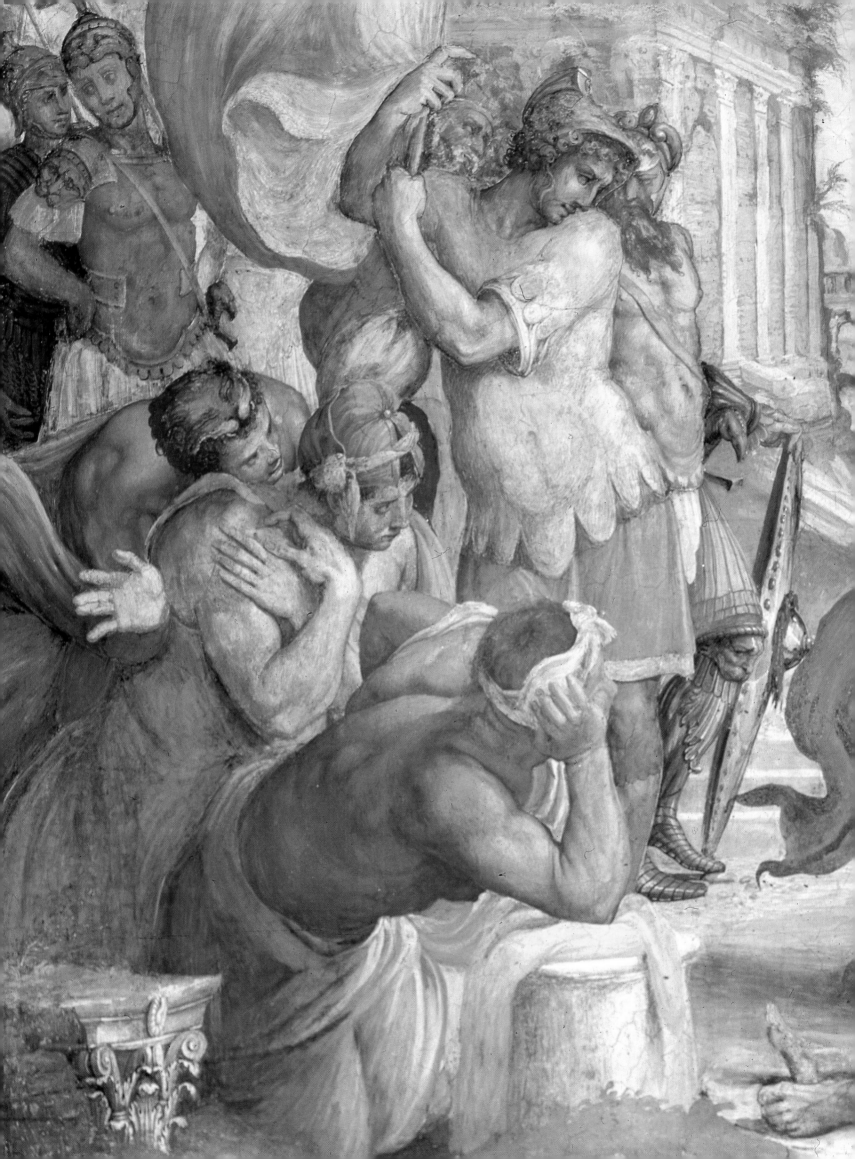

THE JUBILEE OF PAUL III AND JULIUS III

THE LAST SPLENDORS OF THE ROMAN RENAISSANCE
Lorenzo Canova

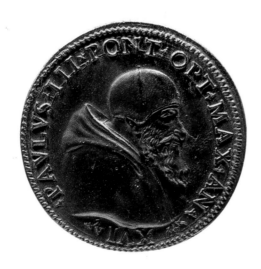

Above:
Alessandro Cesati (?)
Front of the jubilee medal of Paul III of 1550 with a portrait of the Pope

At left:
Francesco Salviati
The Decollation of St. John the Baptist
Rome, Palazzo della Cancelleria, Chapel of the Pallio, detail

On February 24, 1550, two days after his coronation, Pope Julius III Ciocchi Del Monte opened the Holy Door and solemnly inaugurated the celebration of a Jubilee. This event had been prepared by his predecessor, Pope Paul III Farnese, who had died on November 10, 1549, just weeks prior to the beginning of the Holy Year.[1] Paul III had gone so far as to have the opening of the Holy Door of the Jubilee of 1550 represented on his cloak in portraits of him on medals he had commissioned for the occasion. It was to have been the culmination of his pontificate. On becoming pope on October 13, 1534, Paul III had found a Rome wounded by the Sack —a city in which the humiliating conquest by imperial troops in 1527 was still vivid, a country threatened by the raids of Turkish pirates, and a papacy whose role as the leader of Christianity had been attacked and profoundly challenged by the Protestant schism.

The pontificate of Paul III (born 1468), a man of great humanistic culture, who had been educated as a young man by Pomponio Leto at the court of Lorenzo the Magnificent, summed up all the contradictions of the end of the Renaissance. It was an age in which a paganizing culture could mix with Catholic orthodoxy, in which the need for a reformation of the Church (promoted by Paul III at the beginning of his pontificate) overlapped with the establishment of the Roman Inquisition (1542) and the Society of Jesus (1545). For a pope like Paul III, it was more than possible to reconcile his attempts to renew the clergy with his endeavors to endow the Farnese family with a princedom so that they might have the rank of a ruling European family.

Paul III sought, however, to endow the Church of Rome with new dignity by adopting a prudent policy of neutrality among the European powers. He promoted the fight against the Protestants and started a reform within the clergy (as a result of the

Council of Trent which had been opened in 1545), and he set himself up as the mediator between France and Spain. In his desire to confirm his role as the leader of Christianity, the pope headed a new crusade against the Turks which culminated in 1535 with the capture of Tunis by a fleet (which included pontifical troops) commanded by Charles V. The victory at Tunis, however, did not resolve the Turkish problem, for it continued to reappear during the entire pontificate of Paul III, and was only partially eliminated by the battle of Lepanto in 1571.

Paul III's desire to give new dignity to the Church and to the figure of the pope, who was once again to be the arbiter of the spiritual and political destinies of Europe, could not be separated from a need to make the city of Rome and the Holy See important and central once again. This required a radical intervention into the urban fabric of the city. Just a few days after his election, Paul III appointed the humanist Latino Giovenale Manetti as commissioner of antiquity. The text of the brief nominating him constituted a real declaration on the part of the new pope: he denounced the damage already inflicted on the archeological heritage, and he stressed the need to maintain a continuity of the grandeur and primacy of the Rome between the Caesars and the Popes. To reassert the ancient splendor of the spiritual capital of the world, Paul III asserted, it would be necessary to emphasize the glory of ancient Rome by improving and beautifying modern Rome.[2]

The pope's plan was already evident in the renovations (supervised by Manetti) made on the occasion of Charles V's triumphal entry into Rome after the victory at Tunis. A festive apparatus was constructed (in which traces of the ancient city were rediscovered) for the visit of Charles V, supervised by Antonio da Sangallo the Younger and executed by artists like Battista Franco, Raffaello da Montelupo, and Baldassarre Peruzzi. The scenes of the apparatus were placed along a triumphal route that had been especially created by tearing down houses, churches, and ruins (the debris of which was used to fill the area between the arches of Titus and Septimius Severus). This triumphal road started at the Porta San Sebastiano, passed along the Via San Gregorio, through the Forum, and then up the Via di Marforio to Piazza San Marco and the Via Papale. Paul III thus began to trace the guidelines for a new Rome which, during the fifteen years of his pontificate, were directed at some well-defined and strategic places.

After the opening of the Via Leonina (today Via di Ripetta) by Leo X, Paul III started to give a concrete form to the Trident by continuing the axis of today's Via del Babuino, then called Via Paolina Trifaria in honor of the Farnese pope. The Via Paolina was realized to facilitate the connections between the Porta del Popolo, the high area of Rome, and the Quirinal Hill. In this project, even the Via Lata, a preexisting Roman street (today's Via del Corso), was renewed in two different phases so as to connect the city to the Capitoline Hill and the papal residence on the Aracoeli. At their termini, the three streets united in the Via Trinitatis, which was started in 1544 and connected the Pincian Hill to Piazza Nicosia and the Porto di Ripetta. The Via Trinitatis (corresponding to today's Via del Clementino, Via di Fontanella Borghese, and Via dei Condotti) provided the finishing touch to the town plan initiated by Paul III in view of the Holy Year, and became one of the few Jubilee works that his successor, Julius III, managed to complete, thanks to the supervision of the master builder Bartolomeo Baronino. The new street was destined to become a main artery through the new quarter of Campo Marzio, which arose in a zone that had been aban-

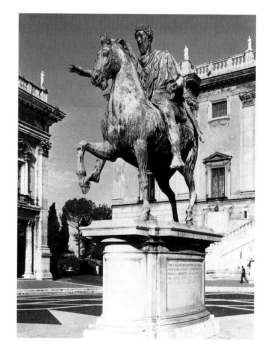

Statue of Marcus Aurelius
Rome, Piazza del Campidoglio

Antonio da Sangallo the Younger
and Michelangelo
Façade of Palazzo Farnese

doned since the fall of the Roman Empire and because of its neglected state was referred to as "Ortacii." Julius III Ciocchi Del Monte continued his reorganization of the Campo Marzio, and his family went so far as to build three palaces there; the most important of those residences was the Palazzo Cardelli-Del Monte (today's Palazzo Firenze), designed by Bartolomeo Ammannati.

Other works that were undertaken by Paul III included the widening of the Via Alexandrina to connect Piazza Navona with the actual Piazza Sant'Apollinare, and the creation of two new arteries extending from Ponte Sant'Angelo—Via di Panico and Via Paola. The intense activity involved in reorganizing the city plan of Rome was commemorated in a marble portrait of Paul III (today in the church of Santa Maria in Aracoeli) that originally stood in the great hall of the Palazzo Senatorio. The inscription on the base of the statue, which was probably written by Latino Giovenale Manetti, praises the pope for having traced out new streets and squares to improve and beautify Rome's street system, which until then had been a maze of narrow alleys and protruding constructions. To make the city more prestigious and to continue the *restauratio* of ancient Rome, Paul III started a series of projects on the Capitoline Hill, which was then inaccessible and badly connected to the rest of the city.[3] In the pope's project, the hill was to become a kind of "Pauline Citadel." The Capitol became the theater of an impressive scenographic reorganization, centered on the equestrian statue of Marcus Aurelius, which was moved in 1538 to the hill from the Lateran by the express will of the pope (and in opposition to the opinion of the Lateran Chapter). On that prophetic spot, Paul III had a villa-tower erected next to the convent of the Aracoeli (destroyed during the construction of the Monument to Vittorio Emanuele), with a corridor linking it to Palazzo Venezia. He also had a new three-arched portico built for the convent of the Aracoeli, and had the Palazzo dei Conservatori restored. All these projects were included in the architectural commission given to Michelangelo. He transformed the irregular space of the hill into a unified whole with three buildings lining the piazza, the equestrian statue in the middle, and the "cordonata," or ramp, connecting it to the city. Unfortunately, what we see today is only a faint suggestion of the original project, which remained unfinished. But with his extraordinary star-shaped design for the piazza, Michelangelo did succeed in transforming the desolation of the Capitoline Hill into the grandiose setting of the *umbilicus mundi*, the center of the world, dominated by the statue of Marcus Aurelius (*kosmokrator*), the philosopher emperor with whom Paul III liked to identify.

The area around the Palazzo Farnese was another focal point in Paul III's imposing reorganization of the city. The pope had a square opened in front of his family palace and had the Via dei Baullari traced out on an axis with the main entrance of the building. The edification of the Palazzo Farnese, built on land that Paul III had purchased in 1495, was originally based on a design by Antonio da Sangallo the Younger dated about 1513. The architect had initially used the model of the traditional Florentine palace based on a large cubic structure with a central courtyard.[4] In its first phase, between 1514 and 1527, the vestibule, the great ashlar portal, and the ground floor windows were built. Sangallo drew his inspiration for the great vestibule from imperial architecture—in particular, Vitruvius—creating a space that is reminiscent of a three-naved basilica in which the center nave (separated from the side aisles by a double row of columns) has a coffered vault and walls with niches separated by semi-columns.

The building was interrupted by

bankruptcy provoked by the Sack of Rome, but continued in 1541 when Paul III, as pope, was able to finance the enormous undertaking. In a new project, Sangallo abandoned the giant order he had originally planned and used quoins for the corners of the building. Sangallo had also planned to use Michelangelo's design for the façade cornice, but he died on September 29, 1546. The commission to finish the palace was then given to Michelangelo, who conferred great importance on his crowning cornice and placed a magnificent shield with the pope's arms in the center of the façade. Michelangelo also changed the shape of the loggia window, substituting Sangallo's blind arch with an architrave supported by *verde antico* marble columns, and he came up with a new design for the courtyard. A great perspective axis (that was to culminate in the ancient marble group of the Farnese Bull transformed into a fountain) was to lead from the main entrance to the garden, from which, as Vasari attests, a bridge was to be built connecting the palace gardens to Trastevere. After Paul III's death in 1549, the works were interrupted; they were again picked up in 1555-56 under Vignola's supervision, and finally concluded in 1589 by Giacomo Della Porta.

Also, coming within the sphere of Paul III's great urban reorganization were the vast fortifications of the city. The ancient city walls were rebuilt and strengthened, primarily to protect Rome from the constant threat of Turkish raids.[5] This work, which captured the interest of the entire city, was also entrusted to Antonio da Sangallo the Younger. At first, he gave preference to the parts of the city that faced the sea. There, two bastions were constructed, the Colonnella on the Aventine hill and the Ardeatino. However, due to constraints of time and money, the fortification work was largely limited to Castel Sant'Angelo and the Borgo where the Porta Santo Spirito and the Belvedere Bastion were con-

structed. The Porta Santo Spirito and the rest of the project remained unfinished because of Sangallo's death, and also because of the adverse opinions of other architects, including Michelangelo. The work was resumed first under the direction of Jacopo Meleghino (a favorite of the pope's), and later under Jacopo Fusti, called "il Castriotto," who remained in charge of the fortification of the Leonine city until the death of the pontiff. Il Castriotto promoted Sangallo's idea of a third wall of fortifications around Castel Sant'Angelo, a work that was finally realized under Pius IV.

One of the most important projects of Paul III's pontificate was the reorganization of Castel Sant'Angelo, which had proven to be an irreplaceable and almost impregnable bulwark during the Sack of Rome, when Clement VII and his court took refuge there for seven months.[6] Castel Sant'Angelo and its bridge also played a significant role in the Jubilee celebrations for they served as a key artery for the flow of pilgrims (and the only means of access from Rome to St. Peter's), as well as the theatrical setting for Roman festivals. In fact, the famous fireworks of the castle concluded and sealed all the felicitous events held in the capital of Christianity. From 1542 to 1544, a vast building program at the castle was engineered by the architect and sculptor Raffaello da Montelupo, who also created the solemn statue of the Archangel Michael which had crowned the castle until 1752 (and is today in the courtyard of the Angel). The projects involved a reorganization of the the upper gallery, and the construction of the entire upper floor, including the papal apartments, the ramp of Paul III, the vestibule of the Sala Paolina, and the loggia of Paul III overlooking the zone of Prati. To create a setting worthy of a pope, Paul III had all the rooms decorated with stuccoes and frescoes. The decorating of the splendid apartments began in 1543 with the frescoes painted by

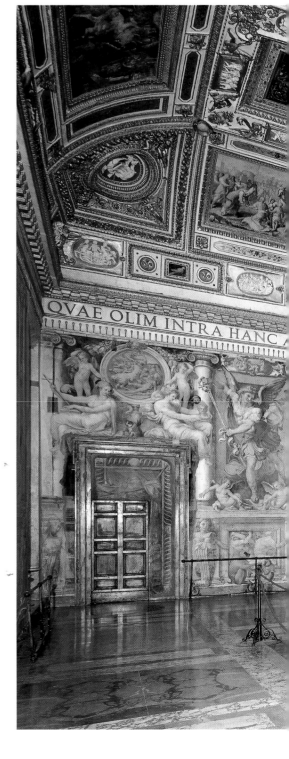

Perin del Vaga and helpers
Sala Paolina
Rome, Castel Sant'Angelo

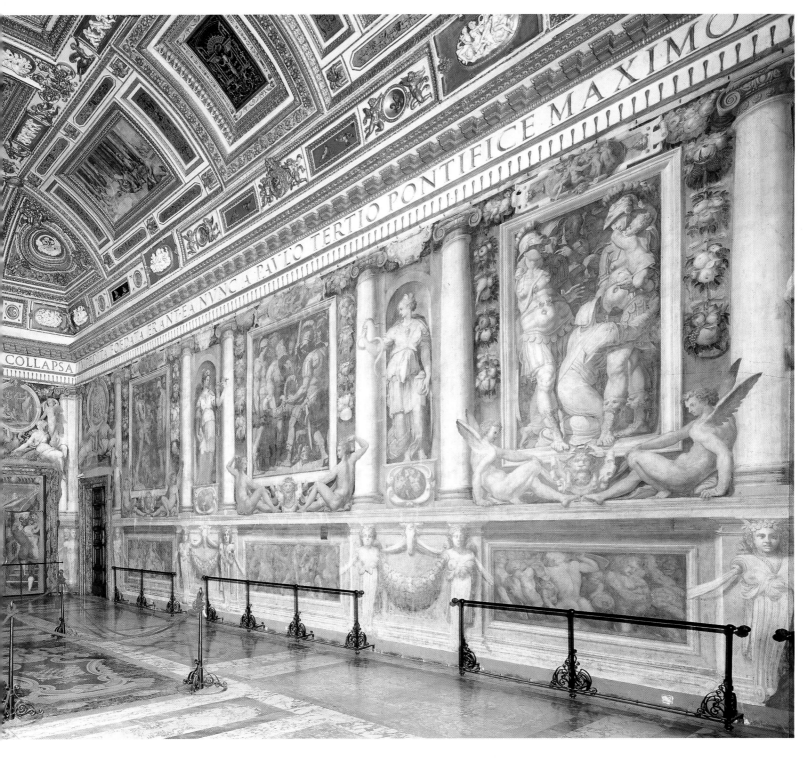

Siciolante da Sermoneta in the loggia of Paul III and continued with Luzio Romano's work in the library, the Sala dell'Adrianeo, the Sala dei Festoni, and the three rooms of Cagliostra, which were terminated in 1545. The last rooms (the Sala of Perseus, the Pompeian corridor, the Sala of Psyche, and the Sala Paolina) were decorated by Perin del Vaga and his helpers (including Siciolante da Sermoneta, Pellegrino Tibaldi, Marco Pino, and Domenico Zaga) between 1545 and 1547, the year Perin del Vaga died.

Domenico Zaga finished the last room, the Sala of Apollo, in 1548.

The complex iconographic program of the rooms was created to celebrate the pope and donor, whose coat of arms and motto appear in all the rooms. The first frescoes by Siciolante and Luzio Romano combined a glorification of ancient Rome with an exaltation of the new Rome and Church during Farnese's peaceful pontificate. The later frescoes, by Perin del Vaga and helpers, represented historical and mythological scenes (the

Stories of Amore and Psyche and *Perseus*).

Without question, the Sala Paolina is the most majestic room in the papal apartments of the castle, due to the spaciousness of its architecture and the beauty and importance of its frescoes and gilded stuccoes. At opposite ends of the room are Emperor Hadrian and the Archangel Michael, symbolizing the union of imperial Rome and papal Rome, classicism and Christianity. They are witnesses to—and integral parts of—the golden age of peace and justice under Paul III, to which the literal golden splendor of the frescoes and stuccoes in the ceiling probably alludes. Overall, the iconographic program of the Sala Paolina, which also represents the heroic achievements of Alexander the Great and St. Paul (alluding to Alexander Farnese, Pope Paul III), was conceived as an indirect encomium of the pope, his work of restoration and improvement in ancient and modern Rome, and his action of pacification and struggle against the Church's enemies.

After the long stasis of the pontificate of Clement VII, Paul III began with a spirit of zeal and commitment the construction of the most important temple of all Christianity, the basilica of St. Peter's. At first, Baldassarre Peruzzi was confirmed as architect of the Fabbrica, while the direction of the works remained in the hands of Antonio da Sangallo the Younger (whom Leo X had engaged for life after the death of Raphael). Sangallo became the chief architect when Peruzzi died in 1537, and devised a completely new plan, a great wooden model of which was built by Antonio Labacco (and is today preserved in the Vatican). Sangallo's model was reproduced on the reverse of a medal that Paul III had minted just before his death in 1549 to celebrate the imminent Jubilee.[7]

Sangallo kept Bramante's Greek cross plan for St. Peter's, but he lengthened the front and added a great portico, the outside orders of which had been inspired by the Colosseum and the Theater of Marcellus. Sangallo's idea had been to unite Bramante's Greek cross with the body of the façade, also on the plan of a Greek cross, surmounted by a benediction loggia. Two bell towers on either side would feature a rich superposition of architectural orders and be surmounted by small, Corinthian-order, peripteral temples, with conical cusps. Capping the entire complex would be a solemn dome, one that echoed the most famous examples of ancient Roman architecture. To separate the new construction from the old one, a dividing wall was erected in the ancient Constantine basilica. A fresco by Vasari in the Sala of the Cento Giorni in the Palazzo of the Cancelleria in Rome, in which Paul III orders the reconstruction of St. Peter's, shows the state of the work in 1546. Sangallo's plan, however, was destined to be discarded.

On November 1, 1546, Sangallo died, and Paul III made Michelangelo responsible for carrying out the project of the basilica. In a *motu proprio* of October 11, 1549, the pope confirmed Michelangelo (who had refused payment for religious reasons) as architect for life for the building of St. Peter's; his project, moreover, was approved and his work executed.[8] According to Michelangelo, Sangallo's project had too many columns on the outside, and the projections, cusps, and ornaments gave the building a "Gothic" appearance rather than a classical and modern one. He also noted that a design of "greater majesty and grandeur" could be adopted with a considerable saving of money and execution time. Michelangelo reverted to Bramante's centralized plan, maintaining the great dome and drawing the external perimeter into one continuous and structurally compact composition. In Michelangelo's conception, the equilibrium and distribution of the architectural forces of the inside were no longer fragmentary but linked to a continuous development that united

Alessandro Cesati (?)
Back of the jubilee medal of Paul III of 1550 with the façade of Saint Peter's designed by Antonio da Sangallo the Younger

Michelangelo
Conversion of Paul
Vatican City, Vatican Palaces, Pauline Chapel

the powerful pilasters to the perimeter mass. Michelangelo gave a simple and solemn parietal unity to the entire external wall sheath, more than 45 meters (135 feet) in height, so that it conformed to the giant architectural Corinthian order surmounted by an attic. At the time of Michelangelo's death, the north and south wings of the transept were almost finished and as well as a good part of the drum; the western side of the apse had also been started, and only the calotte of the

dome and the lantern were executed after the death of the master.

Also linked to Paul III are two important architectural projects inside the Vatican Palaces, both realized by Antonio da Sangallo the Younger: the Sala Regia, the huge atrium of the Sistine Chapel, initiated in 1540 but not completed until 1573, and the Cappella Paolina (the Pauline Chapel). The Sala Regia had been renovated to make it the most prestigious room in the Vatican Palaces, one destined for the recep-

tion of "Christian emperors and kings [who] publicly render obedience to the Roman Pontiff, the pope, the visible leader of the holy Church and Christ's Vicar on earth" (B.A.V., Vat. Lat. 7031, f. 280). Under Paul III, the original wooden ceiling was replaced by a grandiose vault adorned with stuccoes by Perin del Vaga between 1542 and 1547, and, after his death, by Daniele da Volterra, who continued the stucco work and started the pictorial decoration, which he did not finish. The beautiful ceiling stuccoes include a central octagonal lozenge bearing the coat of arms and motto of Paul III, while the wall stuccoes depict angels and classical victories who hold up the coat of arms, lilies, and motto of Paul III. The iconographic program of the room was conceived as a manifestation of the pride and independence of the Church of Rome, a confirmation of the historical and divine justification of papal authority on earth, and an exaltation of the peace between the Christian kings subjugated by the pope, the king of kings, the pacifier and defender of the faith.[9]

After the great commission of the *Judgment Day* (1536-41) so ardently desired by the Farnese pope, Michelangelo received another commission: to decorate the Pauline Chapel, the pope's private chapel. It was Michelangelo's last pictorial work.[10] The new chapel, designed by Antonio da Sangallo the Younger, had been finished by January 25, 1540, just in time for the feast of the Conversion of St. Paul. The decoration of the chapel, which was to serve as the chapel of the Sacrament and the conclave, was commissioned from a reluctant Michelangelo in October 1541, and at the time of Paul III's death in 1549 had not been finished. Michelangelo's two frescoes depict the *Conversion of Paul* (executed between 1542 and 1545) and the *Crucifixion of Peter* (painted between 1546 and 1550). After the death of Paul III the chapel was finished under Gregory XIII with additional frescoes by Lorenzo Sabbatini and Federico Zuccari.

The original iconographic program —based on a glorification of the principles of the apostles, martyrs, and founders of the Roman Church—was ideal for the private chapel of a pope who was used to solemnly celebrating the feast of the Conversion of St. Paul every January 25, his own saint's day. The compositions of Michelangelo's frescoes are oriented so as to make the ideal viewpoint that of the celebrant at the altar. In strict relationship with the long narrow space of the chapel, the figures were painted so as to be observed from different points of view (in particular, oblique ones); the frontal view was, to him, the least important.

In the great drama of the *Conversion of Paul*, the terrestrial half is connected to the celestial by a strong diagonal that begins at the two soldiers in the foreground, passes through the horse, and continues up to the angels and Christ. The curved bodies of the two groups of soldiers, together with the horse, also form a pyramid that is dramatically interrupted by the ray of light coming from the hand of the Savior. In the oblique view one first has on entering the chapel, the light colors and the diagonal movement of the space favor the figure of Paul, creating an immediate relationship between the apostle and the viewer, who becomes the only person who can look directly into the blinded eyes of Saul. It is clear that the only two protagonists of the *Conversion* are Paul and Christ: the Redeemer calls the future apostle with one hand and with the other points to the city of Damascus in the background.

In the fresco of the *Crucifixion of Peter*, the apostle, isolated and solemn among the groups of executioners surrounding him, seems to stare at the pope, his successor, the celebrant at the altar. Peter's martyrdom was a reminder that sacrifice is the duty of every Christian and that only through sacrifice and devotion to Christ can one gain eternal life. The scene of the

Jubilee medal of Julius III of 1550 with a portrait of the Pope and the Holy Door

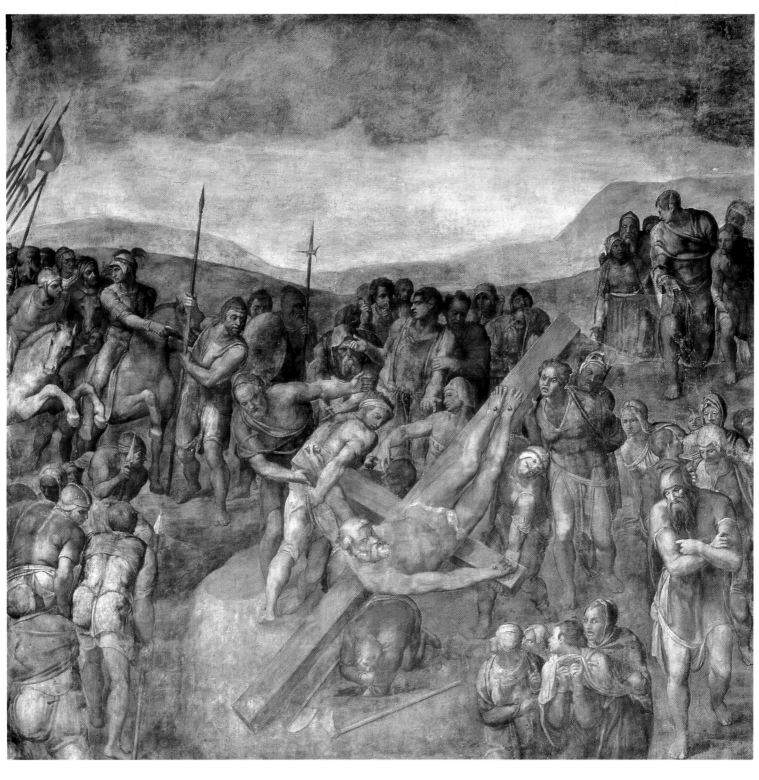

Crucifixion is described with topographic exactness: the climbing figures seem to evoke the ascent to the highest point of the Roman hill of Montorio where, according to an ancient tradition, Peter suffered his martyrdom. Michelangelo places in front of the eyes of the celebrant in the chapel, the real and symbolic fulcrum of the entire spatial, architectural, and pictorial axis, the two supreme moments in the life of a Christian: conversion and martyrdom, the evidence of unshakable faith and *imitatio Christi.* The paintings in the chapel are a concrete representation of an ideal of "heroic" religion (here impersonated by the martyred Peter but which seems inspired by the preaching of St. Paul) in which grace, represented by the conversion of Paul, and faith, represented by the martyrdom of Peter, are elevated to the supreme virtues for all Christians.

The conversion of St. Paul and the martyrdoms of St. John the Baptist

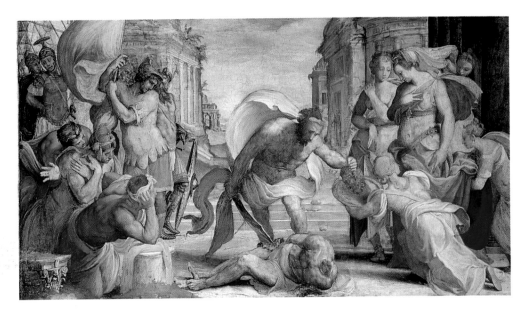

and St. Lawrence are also closely connected in one of the last commissions made by Paul III: the Chapel of the Pallio in the Palazzo della Cancelleria.[11] The frescoes in that chapel, realized by Francesco Salviati and helpers between 1548 and 1550, were commissioned by a nephew of Paul III, Alessandro Farnese, cardinal and vice chancellor. In 1546, Cardinal Alessandro had already had the Sala dei Cento Giorni in the same palace frescoed by Giorgio Vasari and his helpers. Those frescoes constituted a celebration of the pontificate of Pope Paul III, who was exalted in the different scenes as a pacifier, a renovator of the city of Rome and of the Church, and a restorer of a felicitous golden age of peace, justice, and abundance.

The Chapel of the Pallio, a private chapel inside the Cancelleria, had frescoed lunettes and walls while the ceiling was decorated with frescoed panels and stuccoes. The exquisite decoration of the ceiling appears to be an erudite celebration of Alessandro Farnese's "liberality" and love of the arts (he was one of the greatest patrons of the sixteenth century). In the frescoes, the martyrdoms of St. Lawrence and St. John Baptist, the conversion of St. Paul and the celebration of the Eucharist, the attacks against idolatry and the return of Saturn welcomed by Janus (which traditionally symbolized the return of the golden age) are used in a rich icono-graphic program (probably dictated by Annibal Caro), that is suitable for a private chapel in which patristic, biblical, and classical sources were fused. In this scheme, the advent of Christ, represented in the *Adoration of the Shepherds* on the altarpiece (in which appear Cardinal Farnese and Paul III in the guise of St. Joseph) was regarded as the foundation of the Roman Church, which was reformed with a new hegemony thanks to the pontificate of Paui III. Christ's golden age found its confirmation, therefore, in the golden age of Pope Paul III, bearer of an era of peace and prosperity. Sudden death prevented Paul III from opening the jubilee celebrations, but the Rome of 1550 spoke of his grandeur.

It was not by chance that the Farnese pope became a model for all the artistic choices of Julius III, who opened the Holy Door and who, in the years following his election, tried to continue the great decorative and architectural projects of his predecessor in his own family palaces, his chapel in San Pietro in Montorio, and in the construction and decoration of the Villa Giulia. Michelangelo's projects for the Capitol, the Farnese Palace, St. Peter's, the Pauline Chapel; the rebuilding and decoration of Castel Sant'Angelo; the reconstruction and decoration of the Sala Regia; the Cancelleria frescoes; and the reorganization of the streets

Francesco Salviati
The Decollation of St. John the Baptist
Rome, Palazzo della Cancelleria
Chapel of the Pallio

of Rome: all are evidence of Paul III's will to leave in his city a concrete and splendid sign of his own pontificate, one in which Rome and the Church regained their lost grandeur and their ancient splendor.

[1] For a bibliography of Paul III and his Farnese family, and for a historical view of the period, see *I Farnese. Arte e collezionismo*, ed. L. Fornari Schianchi and N. Spinosa (Milan 1995). On Paul III, L. von Pastor, *Storia dei papi* (Rome 1914); C. Capasso, see *Paolo III*, 2 vols. (Messina 1923); A. Frugoni, *Carteggio umanistico di Alessandro Farnese* (Florence 1950); R. Zapperi, *Tiziano, Paolo III e is suoi nipoti: Nepotismo e ritratto di stato* (Turin 1990); and R. Zappen, *La leggenda del papa Paolo III: Arte e censura nella Roma pontificia* (Turin 1998). For a historical picture of the period, H. Jedin, "La riforma della Chiesa. Da Adriano VI a Giulio III (1522-1555)" in *Il Papato. Da S. Pietro a Paolo VI*, ed. C. Hollis (Milan 1964). For Julius III, see L. von Pastor, *Storia degli scavi di Roma, III, Giulio III* (Rome 1990). For an overall view of the interventions of Paul III and Julius III for the Jubilee of 1500, see *Roma 1300-1875. L'arte degli Anni Santi*, ed. M. Fagiolo and M. L. Madonna (Milan 1985), pp. 159-75.

[2] For Paul III's urban interventions (and also Julius III's), see A. Nova, "Bartolomeo Ammannati e Prospero Fontana a Palazzo Firenze: Architettura e emblemi per Giulio III Del Monte," *Ricerche di Storia dell'Arte* 21 (1983): 53-76, esp. pp. 53, 69. For Paul III's road works, see Pastor, *Storia dei papi,* pp. 713-15; G. Simoncini, *Città e società nel Rinascimento*, vol. 2 (Turin 1974), pp. 279-81; L. Spezzaferro (in collaboration with R. J. Tuttle), "Place Farnèse: urbanisme et politique," in *Le Palais Farnèse* (Rome 1981), pp. 83-123. For Charles V's triumphal entry into Rome in 1536: *La festa a Roma dal Rinascimento al 1870*, 2 vols., ed. M. Fagiolo (Turin 1997), esp. M. Fagiolo and M. L. Madonna, "Il revival del trionfo classico. Da Alessandro VI alla sfilata dei Rioni," vol. 1, pp. 34-41; and M. L. Madonna, "L'ingresso di Carlo V a Roma," vol.1, pp. 50-65.

[3] For Paul III's interventions on the Capitoline Hill, see P. Pecchiai, *Il Campidoglio nel Cinquecento* (Rome 1950); G. De Angelis d'Ossat and C. Pietrangeli, *Il Campidoglio di Michelangelo* (Milan 1965); T. Buddensieg, "Zum Statuenprogramm im Kapitolsplan Pauls IIIm," *Zeitschrift für Kunstgeschichte*,32, no. 3-4 (1969): 177-228; C. D'Onofrio, *Renovatio Romae. Storia urbanistica dal Campidoglio all'Eur* (Rome 1973); M. L. Casanova Uccella, *Palazzo Venezia-Paolo II e le fabbriche di San Marco* (Rome 1980), p. 137; H. Thies, *Michelangelo: Das Kapitol* (Munich 1982); F. E. Keller, "Residenze estive e 'ville' per la corte farnesiana nel viterbese nel '500," in *I Farnese dalla Tuscia romana alle corti d'Europa* (Viterbo 1985), pp. 81-82; C. Burroughs, "Michelangelo at the Campidoglio: Artistic Identity, Patronage, and Manufacture," *artibus et historiae,* 28 (1993): 85-111. For Michelangelo as architect, see J. Ackerman, *L'architettura di Michelangelo* (Turin 1968) and G. C. Argan and B. Contardi, *Michelangelo architetto* (Milan 1991).

[4] For the construction of Palazzo Farnese in Rome, see C. L. Frommel, "La construction et la décoration du Palais Farnèse," in *Le Palais Farnèse* (Rome 1981) but quoted above pp. 125-74; M. Hochmann, "Palazzo Farnese a Roma," in *Casa Farnese* (Milano 1994), pp. 73-85.

[5] For the fortifications of Rome under Paul III, see P. Marconi, "Contributo alla storia delle fortificazioni di Roma nel Cinquecento e nel Seicento," *Quaderni dell'Istituto di Storia dell'Architettura* 13 (1966): 109-30; L. Cassanelli, G. Delfini. D. Fonti, *Le Mura di Roma: l'architettura militare nella storia urbana* (Rome 1973), pp. 149-83, 251-59; C. D'Onofrio, *Castel Sant'Angelo e Borgo tra Roma e Papato* (Rome 1978), pp. 276-84.

[6] For the frescoes and Farnese works in Castel Sant'Angelo, see R. Harprath, *Papst Paul III als Alesander der Grosse: Das Freskenprogramm der Sala Paolina in der Engelsburg* (Berlin 1978); C. D'Onofrio, *Castel, Sant'Angelo*, pp. 276-84; *Gli affreschi di Paolo III a Castel Sant'Angelo, progetto ed esecuzione 1543-1548*, 2 vols., ed. F. M. Aliberti (Rome 1981).

[7] For Sangallo's project and the wooden model, see *San Pietro. Antonio da Sangallo, Antonio Labacco. Un progetto e un modello, storia e restauro. Santa Maria del Fiore. Quattro modelli per il tamburo della cupola, restauro*, ed. P. L. Silvan (Milan 1994). For the medal that reproduces the wooden model, see *I Farnese: Arte e collezionismo*, p. 451. The same reverse was vied for another medal coined for the 1550 Jubilee by Julius III, the pope who celebrated the Holy Year of 1550.

[8] For the construction of the Basilica of St. Peter's, the most recent monograph is *La Basilica nel Cinquecento in La Basilica di San Pietro*, ed. C. Pietrangeli (Florence 1989), pp. 138-42; for a documentary history of the Basilica, see E. Francia, *La costruzione del nuovo San Pietro* (Rome 1977); and E. Francia *Storia della costruzione del nuovo San Pietro: Da Michelangelo a Bernini* (Rome 1989). For the history of the works in the early Cinquecento: *San Pietro che non c'è. Da Bramante a Sangallo il Giovane*, ed. C. Tessari (Milan 1996). For an overall view and an updated essential bibliography, see B. Contardi, *San Pietro* (Milan 1998), with an introduction by Cardinal V. Noè and photographs by A. Amendola.

[9] For the Sala Regia, see B. Davidson, "The Decoration of the Sala Regia under Pope Paul III," *Art Bulletin* 58, no.3 (1976): 395-423.

[10] For the construction of the Pauline Chapel, see C. L. Frommel, "Antonio da Sangallos Cappella Paolina: Ein Beitrag zur Baugeschichte des Vatikanischen Palastes," *Zeitschrift für Kunstgeschichte* 27 (1964): 1-42; for Michelangelo's frescoes in the Pauline Chapel, see C. De Tolnay, *Michelangelo*, vol. 5, *The Final Period* (Princeton 1960), pp. 70-79; D. Redig De Campos, *I Palazzi Vaticani* (Bologna 1967), pp. 127-32; P. Fehl, "Michelangelo's Crucifixion of St. Peter: Notes on the Identification of the Hill," *Art Bulletin* 53, no. 3 (1971): 327-43; H. von Einem, *Michelangelo. Bildahauer, Maler, Baumeister* (Berlin 1973), pp. 163-74; L. Steinberg, *Michelangelo's Last Paintings* (New York 1975), p. 51; C. Gilbert, "The Usefulness of Comparisons Between the Parts and the Set: The Case of the Cappella Paolina," in *Actas del XXIII Congreso Internacional de Historia del Arte. Espana entre el Mediteraneo y el Atlantico* (Granada 1978), pp. 519-31; P. L. De Vecchi, *Michelangelo pittore* (Milan 1984), pp. 185-190; W. E. Wallace, "Narrative and Religious Expression in Michelangelo's Pauline Chapel," *artibus et historiae*, 18, no. 10 (1989), pp. 107-22; E. Balas, "Michelangelo's Double Self-portrait in his Vatican Fresco The Conversion of Paul (A Hypothesis)," *Arte Cristiana*, 82 (1994): 3-12.

[11] For the Chapel of the Pallio, see P. Rubin, "The Private Chapel of the Cardinale Alessandro Farnese in the Cancelleria, Rome," *Journal of the Warburg and Courtauld Institutes* 1 (1987): 82-112. For Cardinal Alessandro Farnese, Jr. and his artistic commissions: C. Robertson, *"Il Gran Cardinale" Alessandro Farnese, Patron of the Arts*, (New Haven 1992); L. Neppi, *Palazzo Spada* (Rome 1975); *Palazzo Spada: Le decorazioni restaurate*, ed. R. Cannatà (Milan 1995).

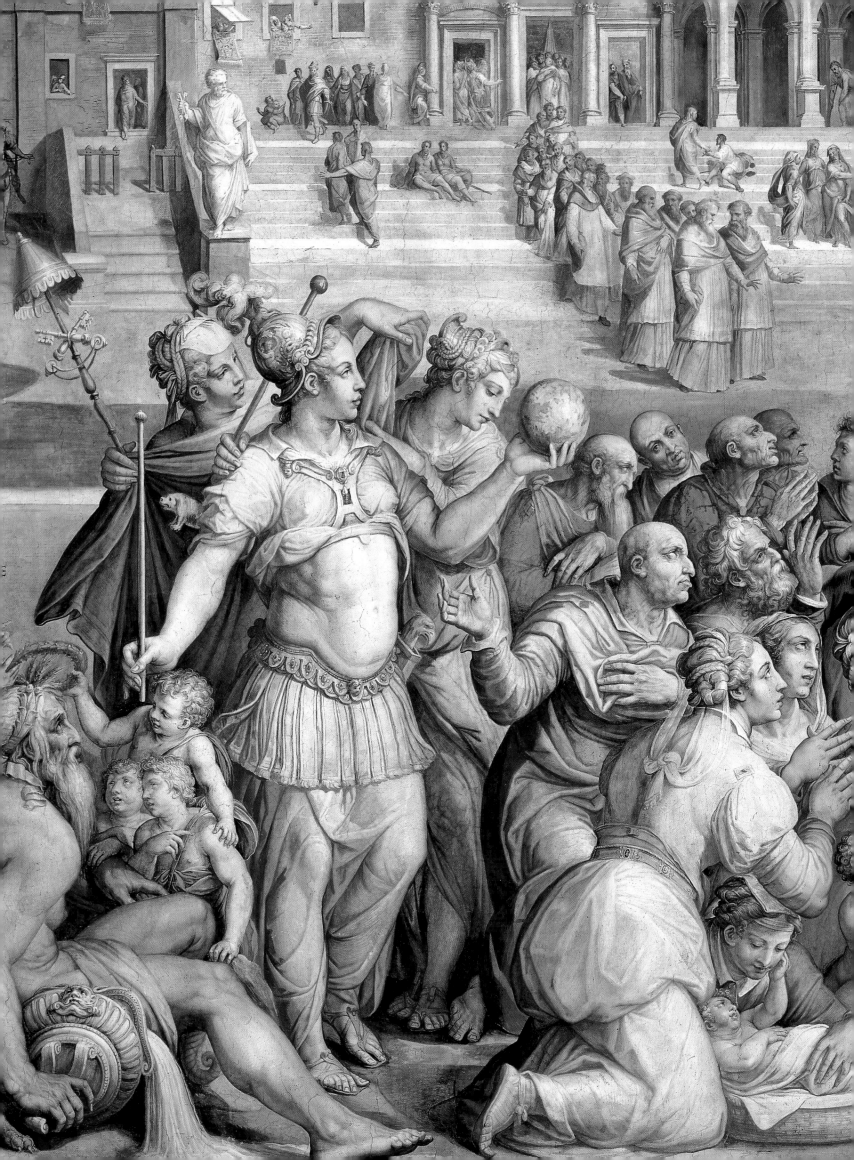

ART AND RELIGIOUS DEVOTION AFTER THE COUNCIL OF TRENT

Lorenzo Canova

Giorgio Vasari
Pope Gregory XI Decides to Bring the Papal See Back from Avignon to Rome
Vatican City, Vatican Palaces, Sala Regia
detail

The Jubilee of 1575, proclaimed and celebrated by Pope Gregory XIII (the Bolognese Ugo Boncompagni, 1572-85), constituted an actual rebirth in the history of the celebration of the Holy Years. It also represented the central moment, almost a turning point, between the religious and political crises that had exploded in the first half of the century and the Counter-Reformation. The Holy Year became the tangible symbol of a new effort to reconquer the terrain lost by the Church after the Council of Trent (1563), which had undertaken the enormous task of reforming the clergy and Catholic doctrine.[1] Following the definitive separation of the Anglican and new Protestant churches from Rome, the papacy had to face the spread of Calvinism in nations like the Netherlands and France where the Huguenots had formed a coalition against the Catholic faction. The battle of Lepanto in October 1571, in which the combined fleets of the Christian nations defeated the Turks, was important as a victory over heresy, and as a new and triumphal crusade of all Christianity against the Ottoman menace.

From the moment of his election on May 13, 1572, Gregory XIII, a pope of juridical formation and wide curial and diplomatic experience (his revision of the Julian calendar which took effect on October 4, 1582, is part of history), started to transform the ecclesiastical and political policy of the papacy. He systematically reorganized the Papal State and the Roman Curia; gave strong support to the action of the religious orders (in particular the Jesuits), as well as the creation of new cultural and educational centers like the German College in Rome; and promoted the fight against heresy, not by trying to repress it but rather by strengthening ecclesiastical organizations and cultural centers. The Jubilee of 1575 was one of the central moments of this new historical age in which Rome and the papacy were to be the center and leader of a renewed

Catholic world. More than 400,000 pilgrims came to Rome to gain indulgences. The majority were from Italian territory, with mass pilgrimages from Milan and Bologna, from across the Alps, and even from recently discovered continents.

The religious confraternities played a preeminent role in the Holy Year of 1575. Associations of the faithful, recognized and approved by the Church (their numbers and material assets had increased with the Counter-Reformation), the confraternities organized the public demonstrations and operations of devotion and *pietà*. They also offered assistance and hospitality to the pilgrims; the confraternity of the Trinità dei Pellegrini (Trinity of Pilgrims), founded by St. Philip Neri, distinguished by welcoming about 145,000 pilgrims in 1575.

The Jubilee was first proclaimed by Gregory XIII on May 20, 1574, Ascension Day, a reminder of the fact that the doors of Paradise would open through the grace of the great indulgence to repented sinners. On Christmas Eve 1574, Gregory XIII solemnly opened the Holy Door at St. Peter's before an enormous crowd. The opening ceremony of the Jubilee and the images connected to it were designed to show the ties between Rome and Jerusalem. The doors, which were opened only during the Holy Year so that the faithful could enter the patriarchal basilicas, were traditionally identified with the Golden Door of Jerusalem and its heavenly equivalent. The concept of the Holy Door as the entrance into Paradise was expressed in a jubilee medal of Gregory XIII of 1575 with the words *Domus Dei et Porta Coeli* (the House of God and the Gate of Heaven). On the medal St. Peter is depicted opening the Gates of Paradise above so that the Celestial Light rains down on his successor, Gregory XIII, who is opening the Holy Door at the same moment. The Jubilee of 1575 was also the first crucial test of Gregory XIII's programs for the urban renewal of Rome with restorations, ex-novo

constructions, and the radical renovation of ecclesiastical buildings and complexes. By opening new streets, repairing bridges along the holy routes that connected one basilica to another, and restoring the early Christian monuments and their accesses, the pope meant to associate the renewed and splendid *sancta Roma* (Holy Rome) with Celestial Jerusalem.[2]

Gregory XIII's building projects were realized by four architects: Giacomo Della Porta, Matteo da Città di Castello, Martino Longhi the Elder, and Ottavio Mascherino. To these names must be added that of Giacomo Vignola, who, however, died shortly after the election of the pope; after his death Della Porta took over the direction of the Fabbrica of St. Peter's. Gregory ordered special interventions on the great Early Christian basilicas: in San Paolo fuori le Mura, the zone of the presbytery was decorated and a precious marble balustrade was installed around the Apostle's tomb; in St. John Lateran, a tabernacle was built for the Sacrament decorated with marbles and stuccoes; the chapel of the Sancta Sanctorum was adorned with hangings; the Baptistery of St. John Lateran (where Constantine had been baptized by Pope Silvester) was restored and decorated; and the portico of Santa Maria Maggiore (built under Eugene III) was restored by Martino Longhi the Elder. At St. Peter's, Gregory XIII did not succeed, as he had hoped, in seeing the completion of Michelangelo's dome by Della Porta (it was finished between 1588-90); work was concentrated on the Cappella Gregoriana (which Della Porta terminated following Michelangelo's and Vignola's projects) in the northern nave of the basilica, which was inaugurated in 1578 and completed in February 1583. The pope paid no attention to costs: the walls were covered with ancient marbles and fine stuccoes, and Girolamo Muziano executed the huge oil paintings and supplied the designs for the mosaics which were made by

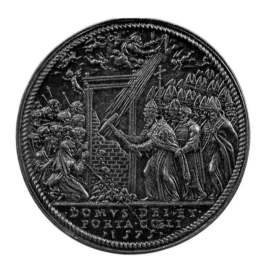

Jubilee medal of Gregory XIII of 1575 with a portrait of the Pope and the opening of the Holy Door

specialists summoned from Venice. For the Jubilee of 1575, (as expressly recorded in an inscription), Gregory XIII had the ancient mosaics in the apse of San Saba replaced by frescoes.[3]

In that period, St. Philip Neri finally obtained recognition for the congregations he had founded: the Oratorians (to whom the pope gave the old church of Santa Maria al Pozzobianco, which would later become Santa Maria in Vallicella) and the confraternity of the Pilgrims (which received as a gift from the pope the see in which it carried out its work: San Benedetto in Piscinula, where the church of the Santissima Trinità dei Pellegrini and its charitable buildings would later be constructed).[4] The Jesuits also managed to have their mother church, the Chiesa del Gesù, built during the pontificate of Gregory XIII, the façade of which was almost finished by 1575. The Gesù was the result of a compromise made with the rich and powerful patron, Cardinal Alessandro Farnese, the major financier of the building, who insisted that the church have a vaulted rather than a flat ceiling, and that the façade be oriented toward the piazza facing the Via Papale.[5] The church, which was designed by Vignola after 1568, suited the needs of the Order remarkably well with a single nave that was to serve as a great prayer hall. Giacomo Della Porta's design for the façade is marked by a distinct verticality and a simplified, clear disposition of the architectural elements.

The "Great Cardinal" Alessandro also commissioned the extraordinary fresco cycle in the Farnese Palace in Caprarola (designed by Vignola), where, in various stages between 1560 and the Jubilee of 1575, artists like Taddeo and Federico Zuccari, Jacopo Bertoja, Raffaellino da Reggio, Antonio Tempesta, and the Flemish Bartholomaeus Spranger developed the stylistic coordinates of the "International Mannerism" that was about to flower in the most important courts of Europe.[6]

One consequence of Gregory XIII's urban program and the jubilee's revival of the procession of the Seven Churches was the construction of the straight wide street from St. John Lateran to Santa Maria Maggiore, and the Via Ferratella, which led from the Lateran to Porta Metronia, and ultimately to the Appian Way. Jacopo del Duca opened the new Porta San Giovanni in the Aurelian Walls, replacing the more modest Porta Asinaria. Gregory XIII also concluded the construction of Borgo Pio, which Pius IV had started; had the Via Gregoriana, which still bears his name, traced out; and opened a new access to the Capitoline Hill on the west between the Rupe Tarpea and Tor de' Specchi. Gregory XIII also repaired the Aqueduct of the Acqua Vergine, which fed some of the fountains designed by Della Porta, such as those in Piazza Sciarra or Colonna and the one in front of the Pantheon (the obelisk there was added in the early Settecento).

The juridical basis for all the urban projects in Rome until the end of the Settecento was to be found in the twenty-two paragraphs of the *Constitutiones de Aedificiis*, promulgated in 1574 in the Pope's Bull *Quae publice utilia* (which abrogated all the regulations regarding building activity that his predecessors had issued). Gregory XIII intervened decisively in the magnificence and elegance of the city by means of that decree, reinforcing state initiative and public control of the buying, selling, and uniting of property; conceding greater power of intervention to the *Camerario* and the *Magistri viarum*; and soliciting private individuals to contribute to the improvement of Rome through a series of concessions that favored costlier and more enterprising investments. He wanted to eliminate the holes and eyesores of the urban fabric—the small houses, the alleyways, the unhealthy neighborhoods—by creating long, straight streets lined with dignified buildings.

Gregory XIII had new buildings

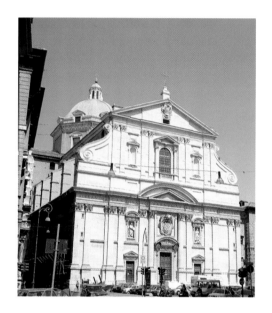

Giacomo Della Porta
Façade of the Church of the Gesù

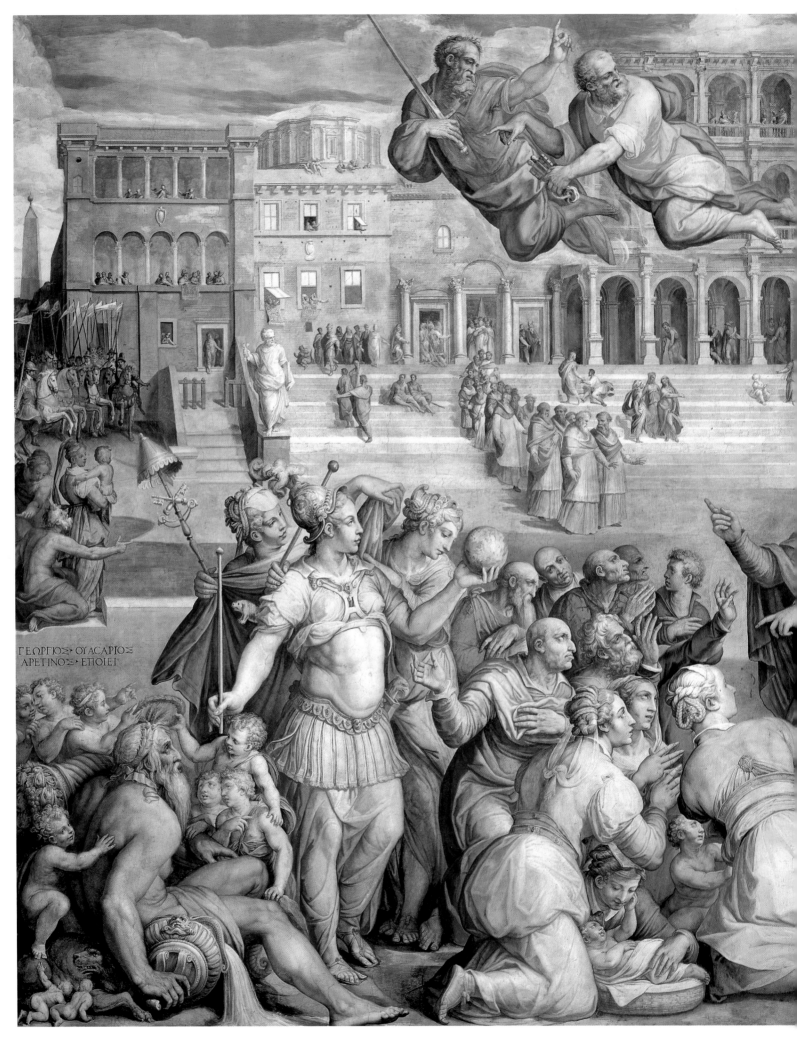

ΓΕΩΡΓΙΟΣ ΟΥΑCΑΡΙΟΣ
ΑΡΕΤΙΝΟΣ ΕΠΟΙΕΙ

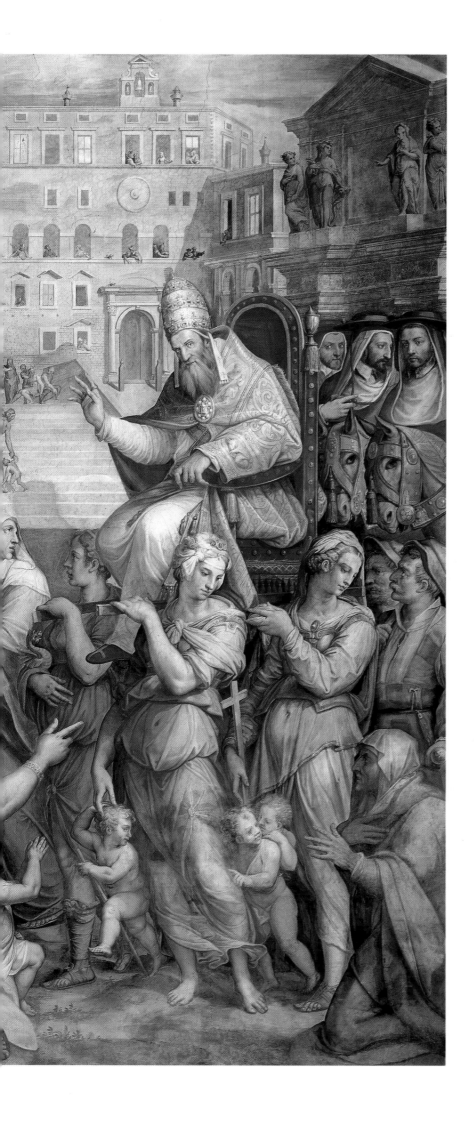

erected in the Apostolic Palace for the Jubilee and concluded the works initiated by his predecessors.[7] One of the most important projects was the completion of the decoration of the Sala Regia, which Pius IV had commissioned from Francesco Salviati, his pupil Giuseppe Porta, and numerous other artists who had been summoned by Pirro Ligorio. As mentioned in a letter from Vasari to Vincenzo Borghini dated February 5, 1573, these other artists included Siciolante da Sermoneta, Livio Agresti, Orazio Samacchini, Giovanni Battista Fiorini, and Taddeo and Federico Zuccari. Also mentioned in the letter were Giovanni Modenese (Giovanni Guerra) and Arrigo Fiammingo, though their names do not appear in the documents (while Giovanni Maria Zoppelli, unmentioned by Vasari, is listed in the documents).

Following the death of Pius IV in 1565, the decoration of the Sala Regia was interrupted briefly; it was resumed by Pius V when he summoned Vasari to Rome to celebrate the victory at Lepanto in two grandiose frescoes. After Pius V died in 1572, the decoration was finished by Vasari and his helpers under Gregory XIII. The Boncompagni Pope had Vasari insert three scenes from St. Bartholomew's Eve in the frescoes, since, thanks to Caterina de' Medici's political acumen, that event was not considered a massacre but rather a providential intervention in defense of the Church which was threatened by a Protestant attack. Vasari also executed a huge fresco titled *Pope Gregory XI Decides to Bring the Papal See Back from Avignon to Rome.* The other major fresco in the room is *The Turkish Fleet Opposing the Holy League's Fleet at Lepanto.* The Sala Regia was solemnly inaugurated on May 21, 1573, on the Feast of Corpus Domini.

Giorgio Vasari
Pope Gregory XI Decides to Bring the Papal See Back from Avignon to Rome
Vatican City, Vatican Palaces, Sala Regia

The decoration of the Pauline Chapel was also terminated under Gregory XIII with Lorenzo Sabbatini's frescoes (commissioned in 1573), which included *The Stoning of St. Stephen, St. Paul's Sight Restored by Ananias,* and *The Fall of Simon Magus.* When Sabbatini died in 1576, Federico Zuccari took over, painting the *Vision of St. Paul* on the vaulted ceiling in 1584.

In additon, the northern wing of the Courtyard of San Damaso, begun by Pirro Ligorio under Pius IV, was completed by Martino Longhi the Elder with a new building. Its façade, composed of three stories of loggias, reflected the architectural and decorative model of the wing by Bramante and Raphael. Behind the Gregorian loggias, Martino Longhi built a new palace (destined to become the residence of the pope and his court) which was decorated by a host of painters, stucco decorators, carpenters, and glassmakers. The decorations of the new loggias, based on those in Raphael's wing on the west, were carried out by Ottavio Mascherino and Mathis and Paul Brill. On the first level (the only one executed for the jubilee year according to an inscription), Giovanni da Udine painted the vaults with false pergolas and foreshortened architecture filled with birds, monkeys, and other animals. The second and third levels of the loggias were painted with grotesques, scenes from the life of Christ, and maps of extra-European countries. Lorenzo Sabbatini was in charge of the frescoing on the first and second levels until his death in 1576. Other painters involved in the project were Marco Marchetti da Faenza, a specialist in grotesques; and Ottavio Mascherino, an architect and an expert in *quadratura* painting. Supervising the geographical representations on the third level was the papal cosmographer, Egnazio Danti, who also oversaw the enormous post-jubilee undertaking, the famous Galleria delle Carte Geografiche, the frescoes of which were executed between 1580 and 1581

under the guidance of Cesare Nebbia and Girolamo Muziano.

The decoration of the Sala Ducale, which included grotesques and stories of Hercules painted by Lorenzo Sabbatini and Raffaellino da Reggio, was also finished in time for the Jubilee. Other projects undertaken at that time included the Chapel of St. Lawrence, frescoed by Lorenzo Sabbatini and helpers; the Sale dei Foconi, with the figures of the Virtues in stucco, grotesques, allegorical figures, heraldic elements, and scenes from the life of St. Gregory the Great (one of the illustrious namesakes who Gregory XIII chose to have depicted with his own features); and the Salette dei Foconi, which Ottaviano Mascherino and his helpers decorated with episodes taken from the *Apocalypse* of St. John. Among the rooms located behind the loggias of the western and northern wings of the Courtyard of San Damaso, were the Sala dei Paramenti; the Sala del Concistoro, with Muziano's great ceiling paintings of the *Pentecost;* and the Galleriola, in which there is a portrait of Gregory XIII depicted as Pope Silvester from the time of Constantine. On the second floor of the western wing, the pope had the Sala Vecchia degli Svizzeri and the Sala dei Palafrenieri redecorated under Egnazio Danti's supervision. As can be seen in an inscription on the marble floor, the so-called Sala Bologna in the northern wing was frescoed in 1575, at the same time that Gregory XIII ordered a map of his beloved city to be depicted on a large scale on the two adjoining walls. The work was directed by Sabbatini and Mascherino who conceived of the bold *quadratura* decoration that opens onto the vault which Giovanni Antonio da Varese later frescoed with the twelve constellations of the zodiac.

Another project that was completed in the jubilee year was the ceiling of the church of Santa Maria in Aracoeli which celebrated the victory at Lepanto. One of the painters who worked on that project was Girolamo

Giovanni Antonio da Varese
Vault of the Sala Bologna with the Twelve Constellations of the Zodiac
Vatican City, Vatican Palaces, Sala Bologna

Siciolante da Sermoneta, who had already executed decorations for the coronation of Gregory XIII on May 15, 1572. Prior to his death in the summer of 1575, Siciolante also painted a *Transfiguration* for the Aracoeli. By fusing Lombard chromaticism with Raphael's graphic solutions, Siciolante created a work of pure compositional simplicity and polished chromatic essentiality in which, as one scholar has observed, a "figurative prayer" was realized with art assuming a metaphoric function in the visual representation of an ethical ideal. The metaphoric function of painting was encouraged, during the Jubilee, by the increased number of commissions made by the confraternities, pious works, and other religious organizations (*giuspatronati*)."[8]

Many of these aspects had been anticipated in the Orvieto Cathedral cycle (destroyed at the end of the nineteenth century, except for the altarpiece) depicting scenes from the life of Christ. The work was directed by Muziano and executed in several phases between 1556 and 1575 by artists such as the Zuccari, Pomarancio, and Cesare Nebbia. The Orvieto cycle was one of the first figurative expressions of the idea that "religious iconography that was eminently liturgical, highly realistic and adherent to the holy texts, and capable of divulging the articles of faith defined at the Council of Trent."[9] In this way, the imagery became a vehicle for spiritual elevation and a real liturgical instrument, "the work of art actually assumed a sacred function" and painting was transformed into a "ceremonial act comparable to exercising the virtues of the Faith."[10] In this climate, art attempted to compete with popular religiosity, and sacred scenes were constructed as easily comprehensible narratives. Such works constitued a pictorial parallel to the "sacred representations" of the Passion of Christ that the Compagnia del Gonfalone enacted until the middle of the Cinquecento.

The great fresco cycle depicting the *Passion of Christ* in the Roman Oratory of the Compagnia del Gonfalone was started at the end of 1568 and almost finished in 1575 (it was completed in 1584). The walls were painted by Jacopo Bertoja, Marco Pino, Livio Agresti, Matteo da Lecce, Cesare Nebbia, and Federico Zuccari. In the different scenes of the *Passion,* such as the decorous *Flagellation* painted by Federico Zuccari in 1573, "the dramatic action in which Christ is the protagonist is shown with the curtain up on the stage of what we may easily define as the designated place" on the sides of which are crowded the "'spectators,' figures in the wings [...] each with his own tacit message to communicate [...] as if wishing to tell the faithful what attitude he should assume in front of the scene of the Passion that has been evoked for him on the wall."[11]

The decoration of the Capranica Chapel, officiated by the Confraternity of the Rosary, in the Dominican church of Santa Maria sopra Minerva, is another example.[12] On the vault are the *Mysteries of the Rosary* painted by Marcello Venusti after 1573 (the night scenes, of Lombard-Venetian influence, are some of the most evocative and interesting examples of pre-Caravaggesque painting in Rome), and on the walls are the *Stories of St. Catherine,* which Giovanni de' Vecchi started after 1575 and finished in 1586. The Confraternity of the Rosary, founded in 1481 and supported by the Dominicans, grew enormously during the Holy Year of 1575 (which may have been the definitive year for the conception of the decoration) and needed a chapel to hold its celebrations. Pope Pius V attributed the victory at Lepanto to the power of the rosary, and its cult was very dear to the Dominicans (since it was believed that it had been founded by St. Dominic) and to Gregory XIII who established its feast day in 1573. The cycles of the Rosary and St. Catherine, commissioned and most probably elaborated by the Dominicans themselves, were based on two separate but

interacting programs: if the subjects of the Rosary are to be interpreted as an announcement of salvation connected to the life of Christ, the wall decoration representing the life of St. Catherine becomes an example for the faithful, a test of her holiness based on her visions.

The Florentine painter Jacopo Zucchi painted his great *Mass of St. Gregory* (1575) for the high altar of the Oratory (now destroyed) of the Trinità dei Pellegrini, the confraternity that was most active during the Holy Year. It was commissioned by Cardinal Ferdinando de' Medici, later Grand Duke of Tuscany, who also ordered Zucchi to fresco part of the *piano nobile* of the Palazzo Firenzo; Zucchi's frescoes of the Sala delle Stagioni and the Sala degli Elementi (also executed in 1575) are the most important cycle of a profane character of the jubilee year.[13] For the Trinità dei Pellegrini altarpiece, with its mixture of Tuscan and Flemish elements, Zucchi created an extraordinary gallery

Federico Zuccari
Flagellation
Rome, Oratory of the Compagnia del Gonfalone

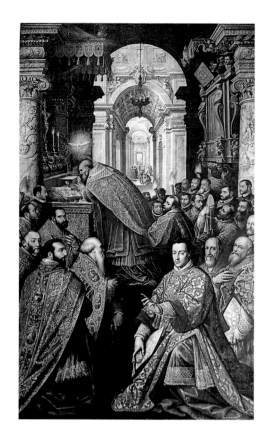

of portraits (where the saint has the face of Gregory XIII and Cardinal Ferdinando de' Medici can be seen in the foreground), the result of an extremely accurate naturalistic attention to details. The dilated, hyperbolic spatiality creates an infinite architectural dimension that also brings to mind Raphael's *School of Athens*. The *Mass of St. Gregory* was an encomium of the renewal and invigoration of the Faith and the Church that Pope Boncompagni had carried out, and a confirmation of the fundamental im-portance of the cult of the Eucharist which the Protestants had challenged. With its mixture of aristocratic and erudite elements and its appeal to popular religiosity, its triumphal celebration of the role of the Church and its ministers, and its allusions to the mission of Charity as implied by the eucharistic sacrifice, the *Mass of St. Gregory* can be considered the ultimate symbol of the 1575 Jubilee, which was meant to consecrate and consolidate the image of *Roma sancta* throughout the world.

Jacopo Zucchi
Mass of St. Gregory
Rome, Oratory of the Trinità dei Pellegrini

[1] For the pontificate of Gregory XIII, see L. Von Pastor, *Storia dei papi* (Rome 1955), for the Jubilee of 1575, pp. 143-55; P. Prodi, "Il giubileo del 1575", in *I giubilei. Viaggio e incontro dei pellegrini*, (Rome 1975), pp. 73-87; G. Palumbo, "I giubilei del Cinquecento tra Riforma e Controriforma," in *La storia dei giubilei*, ed. M. Fagiolo e M. L. Madonna (Florence 1998), vol. 2, pp. 225-30.

[2] For the artistic and urban policy of Gregory XIII, see H. Röttgen, "Zeitgeschichtliche Bilprogramme der Katholischen Restauration unter Gregor XIII 1572-1585," *Münchner Jahrbuch der Bildenden Kunst*, (1975): 89-122; M. L. Madonna, "Il giubileo di Gregorio XIII," in *Roma 1300-1875: La città degli Anni Santi*. (Milan 1985) pp. 178-83; N. Courtright, *Gregory XIII's Tower of the Winds in the Vatican* (Ph.D. diss., New York University 1990) 2 vols. (Ann Arbor 1991) A. Pinelli, "Il bellissimo 'spasseggio' di Gregorio XIII," in L. Gambi, M. Milanesi, and A. Pinelli, eds., *La Galleria delle carte geografiche in Vaticano. Storia e iconografia* (Modena 1994), pp. 18-61, esp. pp. 18-34; M. L. Madonna, "Dalla crisi alla rinascita e rifondazione della città dell'Antico e delle Basiliche. L'Alma Roma e la Roma Sancta," in *La storia dei giubilei*, pp. 192-97.

[3] For San Saba, see P. Testini, *San Saba* (Rome 1961), p. 56.

[4] For St. Philip Neri, see *La Regola e la Fama. San Filippo Neri e l'arte* (Milan 1995); for the confraternity of the Trinity of Pilgrims, see L. Fiorani, "Il carisma dell'ospitalità. La confraternita della Trinità dei Pellegrini nei giubilei cinque-secenteschi,"in *La storia dei giubilei*, pp. 308-25.

[5] For the Gesù, see J. S. Ackerman, "The Gesù in the Light of Contemporary Church Design," in *Baroque Art: The Jesuit Contribution*, ed. by R. Wittkower and I. B. Jaffé (New York 1972) pp. 15-28; E. Levy, *"A Noble Medley and Concert of Materials and Artifice. Jesuit Church Interiors in Rome 1567-1700,"* in *The Saint, Site and Sacred Strategy. Ignatius, Rome and Jesuit Urbanism*, ed. T. M. Lucas (Vatican City 1990), pp. 47-61; T. M. Lucas, "The Saint, Site and Sacred Strategy. Ignatius, Rome and the Jesuit Urban Mission," in ibid. pp. 17-45 (esp. pp. 37-43); C. Robertson, *"Il Gran Cardinale" Alessandro Farnese, Patron of the Arts* (New Haven 1992), pp. 181-96.

[6] For a summary of the Farnese Palace at Caprarola, see I. Faldi, *Il Palazzo Farnese di Caprarola* (Turin 1981); and Robertson, *"Il Gran Cardinale"* pp. 74-130.

[7] For the buildings and decorations in the Vatican under Gregory XIII, see A. M. De Strobel and F. Mancinelli, "La Sala Regia e la Sala Ducale," in *Il Palazzo, Aposstolico Vaticano*. ed. C. Pietrangeli, (Florence 1992), pp. 73-79; G. Cornini, A. M. De Strobel and M. Serlupi Crescenzi, Il Palazzo di Gregorio XIII, in ibid., pp. 151-57; A. M. De Strobel and F. Mancinelli, *"Le Cappelle Pontificie,"* in ibid., pp. 51-59; G. Cornini, A. M. De Strobel, and M. Serlupi Crescenzi, "Il Cinquecento. Gli affreschi," in C. Pietrangeli, *I dipinti del Vaticano*, (Udine 1996), pp. 274ff.; and A. Böck, *Die Sala Regia im Vatikan als Beispiel der Selbstdarstellung des Papsttums in der Zweiten Hälfte des 16.Jahrhunderts* (New York 1997).

[8] C. Strinati, "L'arte a Roma nel Cinquecento e negli anni santi," in *Roma 1300-1875: L'arte degli Anni Santi*, ed. M. Fagiolo and M. L. Madonna (Milan 1984), pp. 374-82; for Siciolante da Sermoneta, see also J. Hunter, *Girolamo Siciolante pittore da Sermoneta (1521-1575)* (Rome 1996), pp. 171-73.

[9] A. Zuccari, "La pittura a Roma attorno ai giubilei del 1550 e del 1575," in *La storia dei giubilei*, pp. 263-80.

[10] Strinati, "L'arte a Roma," p. 380; for the Cinquecento decoration of the Cathedral of Orvieto, see A. Satolli, "Documentazione inedita sugli interventi cinquecenteschi nel Duomo scomparsi con i restauri del 1877," *Bollettino dell'Istituto Storico Artistico Orvietano*, 24 (1978): 129-40.

[11] A. Pinelli, *La Bella Maniera: Artisti del Cinquecento tra regola e licenza* (Turin 1993), p. 142. For the Oratory of the Gonfalone, see A. Vannugli, C. Tiliacos, and C. Mastantonio, "Oratorio del Gonfalone," in *Oltre Raffaello, aspetti della cultura figurativa del Cinquecento romano*, ed. L. Cassanelli and S. Rossi (Rome 1984), pp. 143-71.

[12] For the Capranica Chapel, see C. Strinati, "Espressione figurative e committenza confraternale nella Cappella Capranica alla Minerva (1573)," in *Ricerche per la storia religiosa di Roma, V, Le confraternite romane, esperienza religiosa, società committenza artistica*, ed. L. Fiorani (Rome 1984), pp. 395-428; J. Heideman, "A Fresco Cycle by Giovanni de' Vecchi in the Rosary Chapel of Santa Maria Sopra Minerva in Rome," *Arte Cristiana*, no. 735 (1989), pp. 451-64; and P. Tosini, "Rivedendo Giovanni De Vecchi: nuovi dipinti, documenti e precisazioni," *Storia dell'Arte* 82 (1994) pp. 303-45.

[13] For Jacopo Zucchi at Palazzo Firenze, see L. Scalabroni, G. Mori, and M. G. Tolomeo Speranza, "Palazzo Firenze" in *Oltre Raffaello*, pp. 213-34; for the *Mass of St. Gregory* by Jacopo Zucchi, see the entry edited by C. Strinati in *L'Arte a Roma*, pp. 390-91.

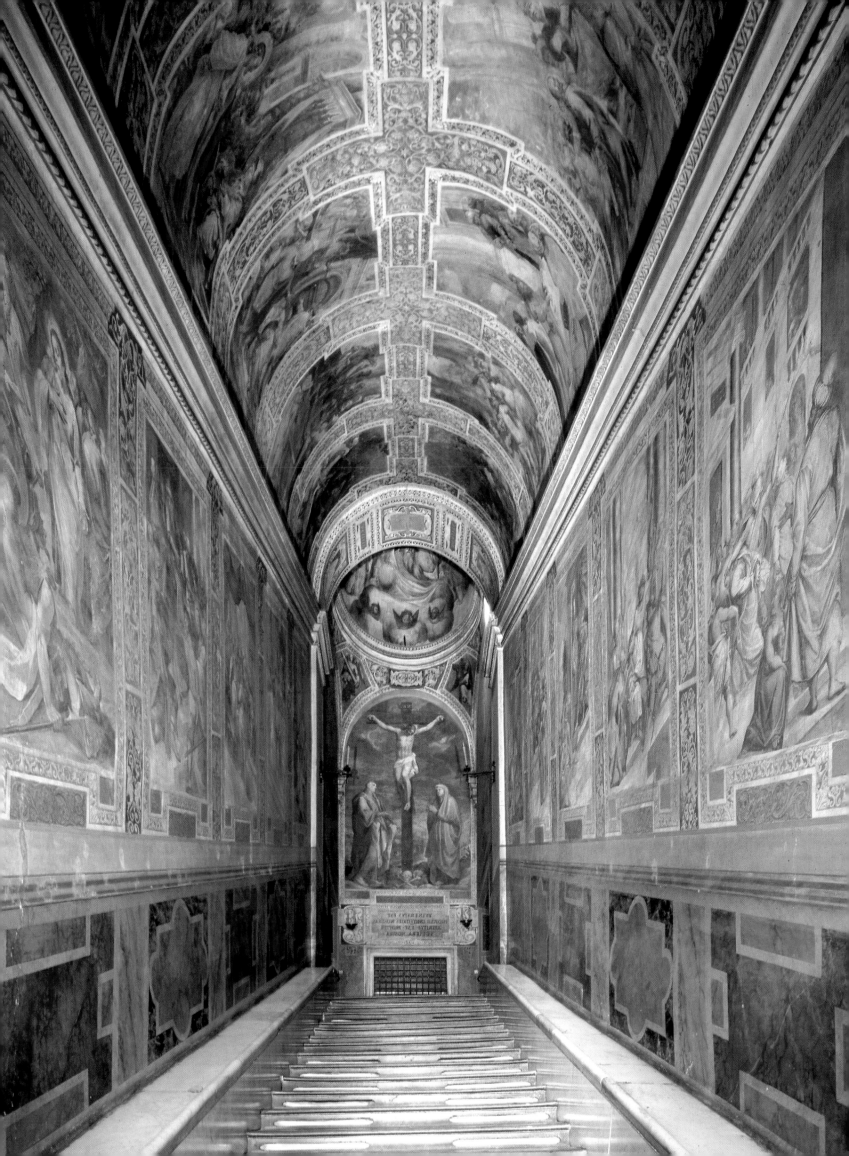

1585 1590

THE JUBILEES OF SIXTUS V

ROME'S URBAN RENEWAL
AND THE GREAT
PICTORIAL CYCLES
OF THE SISTINE AGE
Alessandro Zuccari

Immediately after his election to the pontificate, Sixtus V decided to announce "a great plenary indulgence, in the form of a Jubilee [...] so that all of Christianity might attain for him the wisdom and value to govern such a formidable empire, since he knew and confessed he was unable to sustain such a weight, and at the same time he showed, with this holy custom never practiced by any of his predecessors, that he had already conceived of the idea of undertaking great things."[1] With a declaration of humility, a reminder that he had been a member of the Conventual branch of the Franciscan Order, Felice Peretti proclaimed the first of the two extraordinary jubilees of his pontificate. That initiative, as his biographers have pointed out, already demonstrated that Sixtus V intended to "undertake great things," both in the government of the Church and the city of Rome.

During the five years of his pontificate (1585-90), Sixtus V continued the work of his predecessors but also dedi-

cated himself with unprecedented zeal to building and urban renewal in the papal city. This project earned him the title "creator of the new Rome."[2] From the very beginning of its gradual formulation, Sixtus V's "plan" was both functional and symbolic.[3] He hoped not only to create a modern administrative and political center for the Papal State but also to make Rome into a city-sanctuary organized to satisfy liturgical needs. For one thing, he transformed the major basilicas and the streets connecting them to favor the flow of pilgrims.[4] He also resumed the building of Michelangelo's dome at St. Peter's (which was completed by Giacomo della Porta), and built the new palace which is still inhabited today by the popes. At Santa Maria Maggiore, Sixtus V had the sumptuous Cappella del Presepe, the "Roman Bethlehem," built to house his own mausoleum, and at San Paolo fuori le Mura, he had the transept restored.[5] But his most ambitious project involved a complete reorganization of the Lateran

The Scala Santa
Rome, St. John in Lateran

DVM·RECTAS·AD·TEMPLA·VIAS·SANCTISSIMA·PANDIT
IPSE·SIBI·SIXTVS·PANDIT·AD·ASTRA·VIAM

area: the papal residence was rebuilt, a new façade was added to the side of the basilica with a portico below and the Benediction Loggia above, and the "Scala Santa" was transferred and the Sancta Sanctorum restored.

Obelisks were erected near the four major basilicas both to make them visible from a distance and to exploit their liturgical role in the processional routes. Sixtus V himself, in a Bull of February 1586, had underlined the importance of visiting the "seven churches," relating that ancient devotion to the renovation projects then underway in the city.[6] The pope directed his attention first to the obelisk in the Circus of Caligola, near the Vatican basilica. Continuing a predecessor's project, he announced a competition for its transfer to the center of St. Peter's Square. The arduous engineering project required thirteen

months of work, and cost about 38,000 scudos. The raising of the obelisk took place on September 10, 1586, and employed forty windlasses, one hundred and forty horses, and eight hundred men. The "needle" was inaugurated on September 26 with the consecration of the gilded bronze cross on its summit. The other obelisks were also subjected to the same rite of Christianization, exorcized with water and hyssop, and blessed on their four sides.[7] The crowning of the Egyptian obelisks with the symbol of the cross signified the triumph of the Christian faith over pagan idolatry. Sixtus V acted in a similar fashion when he had the bronze statues of Saints Peter and Paul placed on the columns honoring Trajan and Marcus Aurelius, so that the apostles could tread on "the pomp and pride of the Gentiles."[8]

The second obelisk raised by

The urban plan of Sixtus V
Vatican City, Vatican Library, Salone Sistino

Sixtus V was the one in the piazza behind Santa Maria Maggiore. It is the smallest of the "needles" and comes from Augustus's Mausoleum. The four pieces comprising it had been transferred to the Esquiline Hill in September 1585. However, it was not erected until July 29, 1587; accompanied by the "great joyfulness of trumpets and drums," it was officially inaugurated on August 13.[9]

The installation of the Vatican obelisk had not yet been completed when Felice Peretti ordered that the two obelisks in the Circus Maximus be brought to light. The gigantic one donated by the Emperor Constantine was inaugurated in August 1588, and erected on the side of the Lateran basilica "in perspective with four famous streets": the street leading from the Gate of San Giovanni; the street opened by Sixtus leading to the Colosseum; Via Merulana, the extension of Via Gregoriana leading to Santa Maria Maggiore (Via Merulana); and another street, still in the planning stage, which would lead to San Paolo fuori le Mura, the basilica on the Via Ostiense.[10] As for the smaller obelisk from the Circus Maximus, it was undecided whether to raise it at San Paolo or at Santa Croce in Gerusalemme. However, since the station of San Sebastiano had been transferred to Santa Maria del Popolo "for the universal convenience of the Roman people and all the for-eigners and pilgrims,"[11] Sixtus V chose Piazza del Popolo as its site. The obelisk was consecrated on March 25, 1589, the Feast of the Annunciation, and occupied a felicitous position at the northern entrance of the city of Rome, on axis with the Via Corso, the Via Ripetta, and the Via Babuino.

The network of streets, amplified and "rectified" according to a polycentric plan, was developed principally in the eastern part of the city, and revolved around the Basilica of Santa Maria Maggiore and the huge area of the Villa Montalto.[12] This residence had its main entrances on the Piazza dell'Esquilino and the piazza facing the Baths of Diocletian. The Via Felice was opened as a leading axis in this new system of communication: the straight four-kilometer-long street connected one side of Santa Maria Maggiore to Trinità dei Monti and the other side to Santa Croce in Gerusalemme. Also involved in this operation was the zone of the Quirinal, where the pope started to build the new papal palace and where he had the famous statues of the *Dioscuri* (the Horse Tamers) moved to mark the terminus of the Via Pia (today's Via XX Settembre). The "intersection" of the Via Felice and the Via Pia, enhanced by the Quattro Fontane, again evoked the symbolism of the cross, something the Pope's contemporaries overlook, noting that "the cross raised on Mount Calvary in the east has fallen

FONS FELIX CELEBRI NOTVS SVPER AETHERA VERSV
ROMVLEA PASSIM IVGIS IN VRBE FLVIT

SIXTVS V PONT MAX PICENVS
AQVAM EX AGRO COLVMNAE VIA
PRAENESTE SINISTRO RSVM MVITARVM
COLLECTIONE VENARVM DVCTV SINVOSO
A RECEPTACVLO MIL XX A CAPITE XII
ADDVXIT FELICEMQ DE NOMINE ANTE PONT DIXIT

westward on ancient Rome on a Pia [holy] street of Montecavallo [sobriquet for the Quirinal]."[13]

In addition to his attempt to urbanize the hills of the city, the Pope had a plan to promote the area's economic growth through the development of commercial and agricultural activities. To accomplish this goal, however, it was necessary to resolve the chronic problem of lack of water. Following his election, therefore, Sixtus V decided to restore the Aqueduct Felice. Domenico Fontana completed the work in a short time by employing from two to four thousand workers. To show off the Acqua Felice, the Fountain of Moses was built in Piazza Santa Susanna, halfway down the Via Pia between the Quirinal Palace and the Porta Pia. Both its shape, based on the model of the triumphal arch, and its biblical sculptures corresponded to the pope's self-celebratory intentions.[14] Sixtus V was presenting himself as a new Moses (who made water gush forth from the rocks and nourished the people of Israel with manna), following a parallelism already adopted by some of his predecessors to underline the sacerdotal, legislative, and governing roles of the Roman pontiffs. The fact that similar themes were developed in the great pictorial cycles of the new Sistine buildings was by no means accidental.

The most important of the various building projects of Sixtus V was, as has been said, that involving the Lateran area. His first intervention was the demolition and rebuilding of the ancient Patriarchate, for years the official residence of the popes. Already in June 1585, Felice Peretti had ordered the construction of "a very big

G. Francino
The Aqueduct Felice and
the Fountain of Moses
Vatican City, Vatican Library
Salone Sistino

QVINTVS·RESTITVIT·LATERANA·PALATIA·SIXTVS·
ATQVE·OBELVM·MEDIAS·TRANSTVLIT·ANTE·FORES·

View of the Lateran area with the new
Apostolic Palace, the Benediction Loggia,
the obelisk and, on the left, the Scala Santa
as it appeared in a first project
Vatican City, Vatican Library, Salone Sistino

Apostolic Palace, both as a comfortable residence for the Pontiffs, and also as an adornment of that place, which before had been full of old factories of little value, the majority of which were ruined and without any conveniences."[15] The new building, reminiscent of the monumental organization of the Farnese Palace, had two equal façades and a lower one on the side of the main entrance to St. John in Lateran, which Galilei made equal to the others in the eighteenth century. The difference in height of the façades was a result of the incorporation of the huge, recently restored Pontifical Stairway, which connected the papal apartments directly to the portico of the basilica.[16]

The ancient Aula dei Concili (Council Hall) was replaced by the Salone dei Papi (Salon of the Popes), on the second floor, and decorated with paintings exalting the Church of Rome, with the images of the achievements of the first nineteen popes, who had been proclaimed saints, and the "good works" carried out by Sixtus V.[17] The series of rooms that unwind along the piano nobile is dedicated to a celebration of the virtues and the works of the great biblical figures: Samuel, David, Solomon, Elijah, Daniel, and the Apostles. The Sala degli Imperatori (Hall of the Emperors) and that of Constantine refer to the papacy's relations with civic power. It was at the Lateran that the false Donation of Constantine was confirmed, which legitimatized the pope's temporal power and reaffirmed pontifical primacy over political power. The room leading to the Benediction Loggia takes its name from the Sistine obelisks that are represented there; next to them appear Trajan's and Marcus

109

Aurelius's Columns, which Sixtus V had had restored and decorated with bronze statues of the Apostles Peter and Paul. All the frescoes in the palace were executed between 1588 and 1589 by a group of painters directed by Giovanni Guerra of Modena and Cesare Nebbia of Orvieto; most of the decoration of the Pontifical Staircase was directed by Giovanni Paolo Severi of Pesaro around 1586. The enormous pictorial cycle which covers the porticos, staircases, and minor rooms is sumptuous and brilliant in tone and of great importance because of its complicated iconography.

Felice Peretti's other important project in the Lateran had to do with the restoration of the Sancta Sanctorum, and the transfer and installation of the so-called Scala Santa in front of the ancient papal chapel.[18] The Scala Santa was a medieval ramp that led from the piazza into the Patriarchate, which had always been identified as the staircase that Jesus ascended for his trial in Pilate's Palace in Jerusalem. The first two ramps, on the sides of the Scala Santa, were doubled in size by Domenico Fontana to facilitate the movement of the pilgrims.[19] The frescoes were executed in two stages (1587 and 1589) by a group directed by Guerra and Nebbia, involving painters from different cultures, like Ferraù Fenzoni of Faenza, Giovan Battista Ricci of Novara, and the Flemish Paul Brill.[20] The ceiling of the atrium is decorated with angels bearing the symbols of the Passion. The walls and ceiling of the Scala Santa itself are covered with twenty-eight scenes depicting Christ's Passion, organized to be easily observed by the pilgrims who climb the stairs on their knees.[21] The two side ramps are frescoed with nineteen episodes from the Old Testament which cover the great themes of salvation, among which are the *Creation of Eve,* the *Hebrew Passover,* and *Jonah Saved from the Whale.* The fact that the images are to be read descending the staircase is an indication that this is the way out of the sanctuary, reiterating

the functionality in all of Sixtus V's undertakings.[22] These paintings and those in the other Sistine cycles are generally not of top quality, probably because of the need to finish those vast cycles in a very short time (using a large number of painters of modest talent), and because the pope and his collaborators chose to privilege thematic and functional aspects over formal ones.

The realization of a new library for the Apostolic Palaces was a major undertaking during Sixtus V's pontificate. Gregory XIII had already planned to replace the library that Sixtus IV had established. However, as with other projects of that pope, it took his successor's energetic intervention to bring this about. The new library was built by Domenico Fontana between 1587 and 1588 in the middle of the Belvedere Courtyard, where the tiers of Pius IV's so-called theater were to be found.[23] Sixtus V decided to transform the space that the Renaissance popes had used for tournaments, feasts, and theatrical representations into a new "temple" of culture, thus altering the classical aura of Bramante's courtyard.

The building has three levels: the lowest is the loggia (now closed), above it the floor reserved for services and the librarians' residences, and lastly, the grandiose library. This is comprised of an anteroom, called the Writers' Room, a huge reading hall, and three adjoining rooms. Two adjacent rooms in the Bramante wing make up the "Secret Library," in which confidential volumes were kept. Unlike his predecessors, who had created a residence worthy of the imperial age, Felice Peretti chose to build a new and autonomous structure that would also be visually impressive in the context of the papal palaces. The new Vatican Library had to compete, according to the Pope, with the libraries of the ancient world, and represent their most authoritative legacy. His objectives were effectively illustrated by a series of paintings dedicated to the most famous libraries of

The Scala Santa
Rome, St. John in Lateran

View of the Salone Sistino
Vatican City, Vatican Library

antiquity, those of the Hebrews, Babylon, Athens, Alexandria, the Romans, Jerusalem, Cesarea, the Apostles, and the Popes.[24]

Sixtus V's Library, depicted by Pietro Facchetti, is situated next to the entrance to the hall, in correspondence to the scene in which Moses gives the laws to the Levites so that they may preserve them and transmit them to their descendants. Sixtus V, like Moses,

a "supreme legislator," declares himself to be the caretaker of the true doctrine: one of the objectives of the new Vatican Library was to create a great "arsenal" in which to sharpen the weapons of Catholic controversialism in reply to the Protestant cultural production. The theme of the fight against heresies is widely illustrated in the series of frescoes that represent the great councils, eight Eastern ones and

eight Western ones, which complete the decoration of the Salone Sistino and the three adjoining rooms. The bishops' assizes appearing in these are described with remarkable erudition. They illustrate Christian emperors and condemned heretics, the dogmas that were sanctioned from time to time, and the provisions adopted for the reestablishment of "sound" doctrine and moral rectitude (e.g. the burning of books, the prohibition of tournaments, etc.).

The figurative program of the frescoes (realized between 1588 and 1599) was drawn up attentively by Federico Ranaldi, the librarian, and other learned personages. Giovanni Guerra, responsible for the organiza-tion of the work, assigned each artist parts to execute, and conceived many of the allegories and emblems that enrich the cycle. Cesare Nebbia was in charge of elaborating the preparatory drawings for the single scenes.[25] It is interesting to note that the subjects chosen had to be screened by those who had drawn up the program before being painted. This is evidenced, for example, by the drawing of a portion of the fresco depicting the *Second Council of Lyon*, in which Gregory X was reconciled with the Greeks. In the drawing, preserved in Siena,[26] the Patriarch Germano is at the same level as the pope, while in the painting the Archbishop of Constantinople is at a lower level; obvi-

Cesare Nebbia
First project for *Gregory X is reconciled with the Greeks at the Second Council of Lyon*
Siena, Biblioteca Comunale

Antonio Viviani
*Gregory X is reconciled with the Greeks
at the Second Council of Lyon*
Vatican City, Vatican Library
Salone Sistino

ously prominence was to be given to the pope with respect to the Greeks who had returned to union with the Church of Rome. Furthermore, the papal tiara that the blessed Gregory X wears has given way to a halo to emphasize his sanctity. The new formula was dictated in part by compositional requirements, but there is no doubt that the "hierarchized" position of the protagonists had been suggested by the authors of the figurative program.

Other themes are also contained in the great pictorial cycle decorating Sixtus V's Library. On the pilasters dividing the two naves of the Salone Sistino, the inventors of the alphabets are represented. The selection of the twenty-six subjects, from Adam to Christ, and including historical and mythological figures, is meant to summarize and conciliate ancient and Christian wisdom. But the theme dominating the library fres-

coes is the celebration of the energetic and enterprising pontificate of Sixtus V.[28] The forty-two paintings exalt the pope's many achievements in Rome and his "good government" in the Church and Papal States. The subjects include religious ceremonies and provisions of a social and economic character; they illustrate the repression of the brigands and the reclamation of the Pontine Marshes, the raising of the obelisks and the construction of new buildings, and so on. The frescoes are much like a propaganda film for the pope. Felice Peretti had his monumental marble sepulcher erected in the grandiose Cappella del Presepe (expressly built in Santa Maria Maggiore to display the relics of Christ's birth), but it was also his desire to have a "monument" of images painted in the Vatican Library to celebrate his short but highly efficient pontificate.

[1] C. Tempesti, *Storia della vita e geste di Sisto V* (Rome 1754), vol. 1, p. 133.

[2] L. von Pastor, *Sisto V il creatore della nuova Roma* (Rome 1922).

[3] M. Fagiolo, "La Roma di Sisto V. Le matrici del policentrismo," *Psicon* (July-December 1976): 25-39.

[4] L. Spezzaferro, "La Roma di Sisto V," in *Storia dell'arte italiana, 12* (1983).

[5] F. Toni, "La città e le basiliche nel piano sistino," in *Roma 1300-1875: La città degli Anni Santi. Atlante*, ed. M. Fagiolo and M. L. Madonna (Milan 1985), pp. 198-204.

[6] A. Antinori, "Le basiliche romane meridionali da Sisto V a Paolo V," in *Sisto V. I. Roma e il Lazio*, ed. M. Fagiolo and M. L. Madonna (Rome 1992), pp. 497-518.

[7] C. Mandel, "Simbolismo ermetico negli obelischi e nelle colonne della Roma sistina," in *ibid.*, pp. 659-92.

[8] P. Ugonio, *Historia delle Stationi di Roma* (Rome 1588), p. 70.

[9] C. D'Onofrio, *Gli obelischi di Roma* (Rome 1965), pp. 157-59.

[10] Ibid., pp. 161-66.

[11] M. Mercati, *De gli obelischi di Roma* (Rome 1589), pp. 387-88.

[12] Fagiolo, *La Roma di Sisto V*, pp. 27-32; and Fagiolo, "Roma di Sisto V: i segni dell'autorappresentazione," in Fagiolo and Madonna, *Sisto V.*, pp. Xi-Xvi.

[13] C. Foglietta, *Lettera ad un amico di ragguaglio delle chiese di Roma, et opere fatte da Sisto V Sommo Pontefice con riferimenti morali* [1587], ed. E. Bentivoglio (Rome 1987), p. 15.

[14] T. Marder, "Sisto V e la Fontana del Mosè," in Fagiolo and Madonna, *Sisto V.* pp. 519-43.

[15] D. Fontana, *Della trasportatione dell'Obelisco vaticano et delle fabriche di Nostro Signore Papa Sisto V* (Rome 1590), p. 59.

[16] A. Ippoliti, "Analisi dell'intervento laterano di Domenico Fontana," in Fagiolo and Madonna, *Sisto V,* pp. 441-46.

[17] For the decoration of the palace, see C. Mandel, *Sixtus V and the Lateran Palace* (Rome 1994); and L. Barroero, "Il Palazzo Lateranense: Il ciclo pittorico," in *Il Palazzo Apostolico Lateranense*, ed. C. Pietrangeli (Florence 1991), pp. 217-21.

[18] M. Cempanari, "Le "Scale Sante" dal Patriarchio Lateranense al santuario sistino," in Fagiolo and Madonna, *Sisto V,* pp. 559-82.

[19] C. L. C. Ewart Witcombe, "Sixtus V and the Scala Sancta," *Journal of the Society of Architectural Historians* (1985): 368-79.

[20] A. Zuccari, *I pittori di Sisto V* (Rome 1992), pp. 123-40.

[21] For the imagery of the Scala Santa, see ibid. pp. 106-20; and M. Bevilacqua, "L'organizzazione dei cantieri pittorici sistini: note sul rapporto tra botteghe e committenza," in *Roma di Sisto V: Le arti e la cultura*, ed. M. L. Madonna (Rome 1993), pp. 35-46; and "Programma iconografico della Scala Santa," ed. R. Torchetti, in ibid., pp. 133-35.

[22] A. Zuccari, "Pittura come itinerario nella Roma sistina," in *Sisto V,* pp. 641-57.

[23] G. Morello, "La Biblioteca Vaticana di Sisto V," in ibid., pp. 463-68.

[24] For the themes illustrating the paintings, cf. A. Böck, "Gli affreschi della sala di lettura della Biblioteca Vaticana," in ibid., pp. 693-716, and Zuccari, *I pittor,* pp. 47-63.

[25] Zuccari, I pittori, pp. 75-101, and A. Zuccari, "La Biblioteca Vaticana e i pittori sistini," in Madonna, *Roma di Sisto V,* pp. 59-76.

[26] Biblioteca Comunale di Siena, E. I. 7, c. 47 a recto, pen and brown ink on white paper with trimmed edges, 150x188 mm.

[27] G. Morello and P. L. Silvan, *Vedute di Roma dai dipinti della Biblioteca Apostolica Vaticana* (Milan 1997), pp. 61-62, 72-100, 110.

THE JUBILEE OF CLEMENT VIII

THE WORKS OF CARAVAGGIO IN ROME
Maurizio Calvesi

Caravaggio
Deposition
Vatican City, Vatican Pinacoteca
detail

Shortly after he was elected in 1592, Pope Clement VIII (Ippolito Aldobrandini), started to prepare for the Jubilee of 1600. His ambitious program of building activity continued the grandiose work of renewal that his predecessor, Pope Sixtus V (Felice Peretti), had accomplished before his death in 1590. (Three popes had reigned briefly between them: Urban VII for thirteen days, Gregory XIV for ten months, and Innocent IX for two months). However, Clement VII did not begin massive urban transformations as Sixtus V had, but chose to limit himself to interventions of consolidation, restoration, and reclamation. He also saw to it that the architectural works that Sixtus V had initiated in St. Peter's were completed, a task he entrusted to the direction of Giacomo Della Porta, as well as those in the Capitoline palaces, the Quirinal, the Sapienza, and the new Vatican Palace.

The exceptional flood of 1598, caused by the overflowing of the Tiber, damaged buildings and bridges which needed to be repaired. But streets and squares were also reorganized and paved, especially in relation to the churches that were being restored by their cardinals, including San Nicola in Carcere, Sant'Agnese fuori le mura, Santa Prisca, and San Paolo alle Tre Fontane, San Gregorio al Celio, San Cesareo in Palatio, and Santi Nereo e Achilleo. The restoration of this last church was attended to by a cardinal of particular importance: Cesare Baronio of the Oratorian Order (whose founder, St. Philip Neri, had died in 1595). The Congregation of the Oratory, along with the Theatines, was tremendously influential in the political and religious orientations of the new pontiff and the reformed Church. It was not coincidental that the major churches built in the years just prior to the Jubilee of 1600 belonged to those two Orders: Santa Maria in Vallicella (the "New Church") of the Congregation of the Oratory was consecrated in 1599, and construction of the Theatine church

Sant'Andrea della Valle had been initiated by 1600 but would not be finished until the middle of the Seicento.

The religious ideal of the period focused on a return to the austere spirituality of the original church and a full recovery of its evangelical message. This attitude prompted the exploration and study of the catacombs, for example. Special attention was also paid to the martyrs through their cults and relics. There was a new interest in the historical truth of the Bible, something that animated Baronio in particular in his investigations of the lives of the martyrs. The Oratorians accepted Charles Borromeo's precepts; their interests lay with the poor and needy, and they proposed a popular religiosity, one of direct communication. Their aspirations found a worthy interpreter in the rising star of Italian painting, Michelangelo Merisi da Caravaggio (1571-1610), whose art conjugated in its strong "realism" the search for truth, an emphasis on the image, and human participation with respect to the humble and poor.

For the Chapel of the Pietà in the church of the Oratorians, Caravaggio painted the *Deposition* (now in the Vatican Pinacoteca), the date of which varies according to scholars between 1600 and 1604. This writer tends to believe that the *Deposition* was executed in the Jubilee year itself, and is to be identified with a painting of an unspecified subject (but certainly an altarpiece) commissioned from Merisi on April 5, 1600, and paid for that same year, on November 20. From the contract, it seems that the painter had to adhere to a drawing supplied by the donors, on the basis of which he a study which had been approved. This procedure was customary with the Oratorians, for they were particularly careful about controlling the iconography of paintings destined for their churches, even for those which, like the *Deposition*, were executed for private chapels and had been paid for by private donors. The titular of the chapel of the Pietà, Pietro

Vittrice, died on March 26, 1600, and was buried in the chapel; the contract of the commission was dated just a few days later, which would seem to suggest that Vittrice had expressed a desire in his will to furnish his own tomb with a painting, depicting the entombment of the Redeemer.

The compact plastic block conceived by Caravaggio is centered on the body of Christ, and is sculpted in a light which, much like a giant reflector, emphasizes sculptural volume of the figures. In contrast to the weighty descending movement is the gesture of Mary of Cleophas, who raises her arms in the attitude of the Early Christian suppliants, foreshadowing the glory of the Resurrection. The massive projection of the holy group is exalted by its stretching out toward the beholder some parts that force the space, penetrating it like a wedge: the elbow of Nicodemus who holds Christ's legs and the edge of the stone destined to seal the sepulcher. As in other works by Caravaggio, here, the advancement of a single detail toward the foreground emphasizes its symbolic value: in this case, it is the cornerstone, an attribute of Christ as the foundation of the edifice of the Church. The two plants at the base of the painting, one dried out, the other green, evoke death and rebirth. The Redeemer's limp hand touches the stone with one finger, underscoring its symbolism and also indicating the place where His body will descend. Caravaggio had in mind the opposite gesture, Christ raising His hand toward heaven (as in Muziano's painting of the *Ascension* in the next chapel), thus referring to the death which would be overturned.

An adherence to details dear to the Oratorians and to their concerns for historical veracity can be noted in the form given to the sepulcher, which, unlike the current iconography, is dug into the rock. This is literally as the Gospel describes it, and as Baronio recalled in his writings, "The Fathers of the Vallicella possess a faithful re-

Caravaggio
Deposition
Vatican City, Vatican Pinacoteca

production of the Holy Sepulcher in Jerusalem which, similarly to the picture by Caravaggio, has the entrance to the sepulcher on the left side and in front of it the closing stone turned at an angle."[1] Other details, such as the shape of the sepulcher and the figure with upraised arms, are reminiscent of the deposition scene in Alberto Castellano's *Rosario*, which was so dear to St. Philip Neri, and which, through engravings, influenced the iconography of other altarpieces in Santa Maria in Vallicella. Indeed, the "drawing" that was given to Caravaggio to orient the iconography of his painting may well have been traced from such an illustration.

The Holy Year marked the apex of Caravaggio's commissions, attesting to his sudden success. In July 1599, he received a commission for paintings in the Contarelli Chapel in San Luigi de' Francesi, the decoration of which had remained unfinished after Cavalier d'Arpino had executed the ceiling frescoes. The two lateral paintings by Caravaggio, *The Vocation* and *The Martyrdom of St. Matthew*, were ready a year later, while the payment for the altarpiece with *St. Matthew and the Angel* was settled in September 1602. The painter made a first version of the St. Matthew which was later acquired by Marchese Vincenzo Giustiniani (but destroyed in Berlin during World War II). X-rays have shown that Caravaggio also painted two different compositions of the *Martyrdom* before the final one.

The *Vocation of St. Matthew* is tantamount to a conversion. Matthew, "publican and sinner," as he is called in the Gospels, was in fact redeemed by converting to Christ, who called him to the apostolate. In Caravaggio's *Vocation*, Christ, accompanied by Peter, enters the room together with a band of light that dissipates the darkness. Through repentance, even the reprobate may draw on the light of the Redeemer, the light of salvation. According to verses by Marzio Milesi, a friend of the painter's, the apparition

of Christ "clears and enlightens" the mind of Matthew "which greedy and blind was wrapped in strong bindings in the world." Matthew was a tax collector, and the money on the table is a symbol of terrestrial cupidity. Those who, like Matthew and the two youths in costumes, raise their eyes to Christ and notice His light will be saved; but those who do not respond to His appeal, like the bespectacled old man and the third youth who avidly continues to count the money, are destined to be lost.

According to the Gospel of St. John, Christ is "the true light that illuminates every man," but "darkness does not receive it." In the Bull declaring the Jubilee of 1600 (May 21, 1599), the Pope expressed this very concept: "ad omnes illuminandos sol iustitiae Christus Deus noster [...] utero Virginis expressus est" (Christ, sun of justice, was generated by the Virgin in order to illuminate all men). Light, the symbol of grace, emanated by Christ (who is flanked by Peter, symbol of the Church) descends on all humanity and offers the possibility of salvation to all. But it is up to the individual to choose; obedience to Christ or the contrary path, grace or perdition. This crucial Catholic thesis was in direct contrast to the view of the French Protestants, or Huguenots, who maintained that salvation did not depend on the will of man, but rather on predestination.

To understand the importance of this controversy, one must keep in mind that the Church of San Luigi represented the French nation and that the King of France, Henry IV, had just converted, with significant political consequences, from the Huguenot faith to Catholicism. Henry IV had been solemnly absolved by the Pope with the Bull of 1595, the words of which repeated the theme of light and darkness that Caravaggio had picked up. Like Matthew, Henry IV had come out of the darkness of sin to enter the light of salvation. "While you were dead because of sin," said the

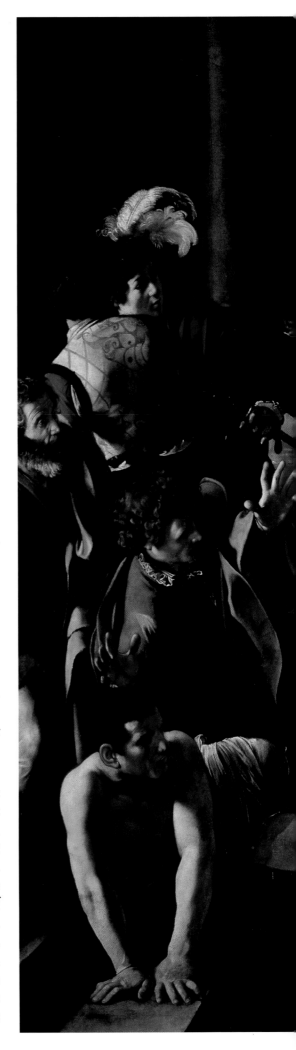

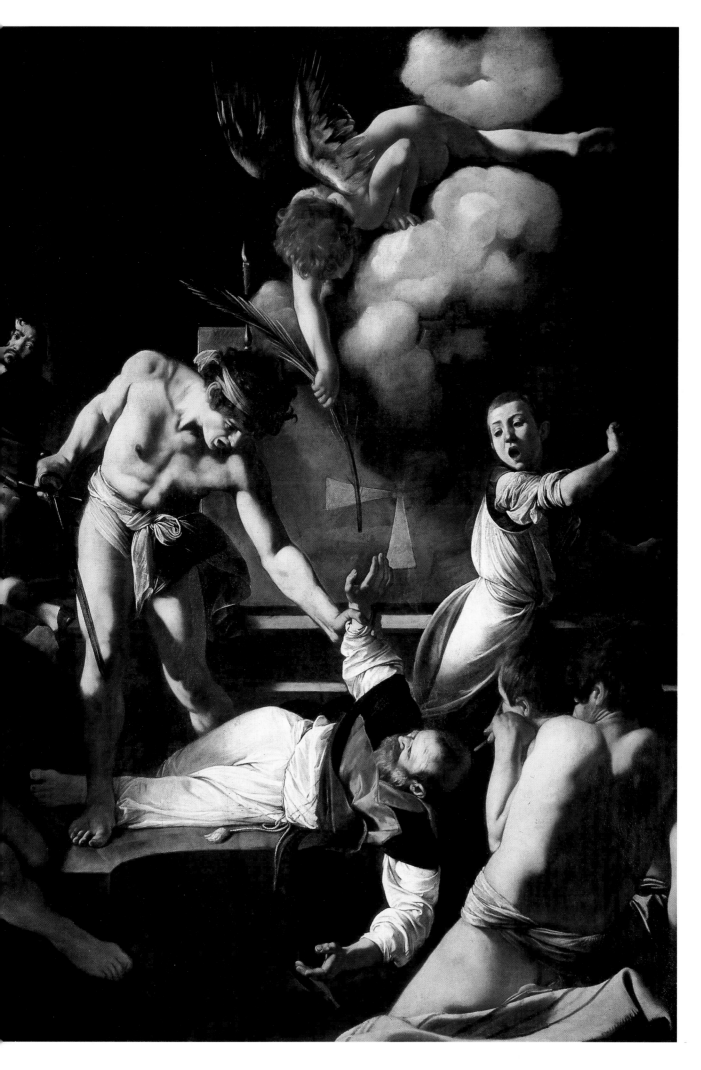

Caravaggio
*Martyrdom
of St. Matthew*
Rome, San Luigi
dei Francesi

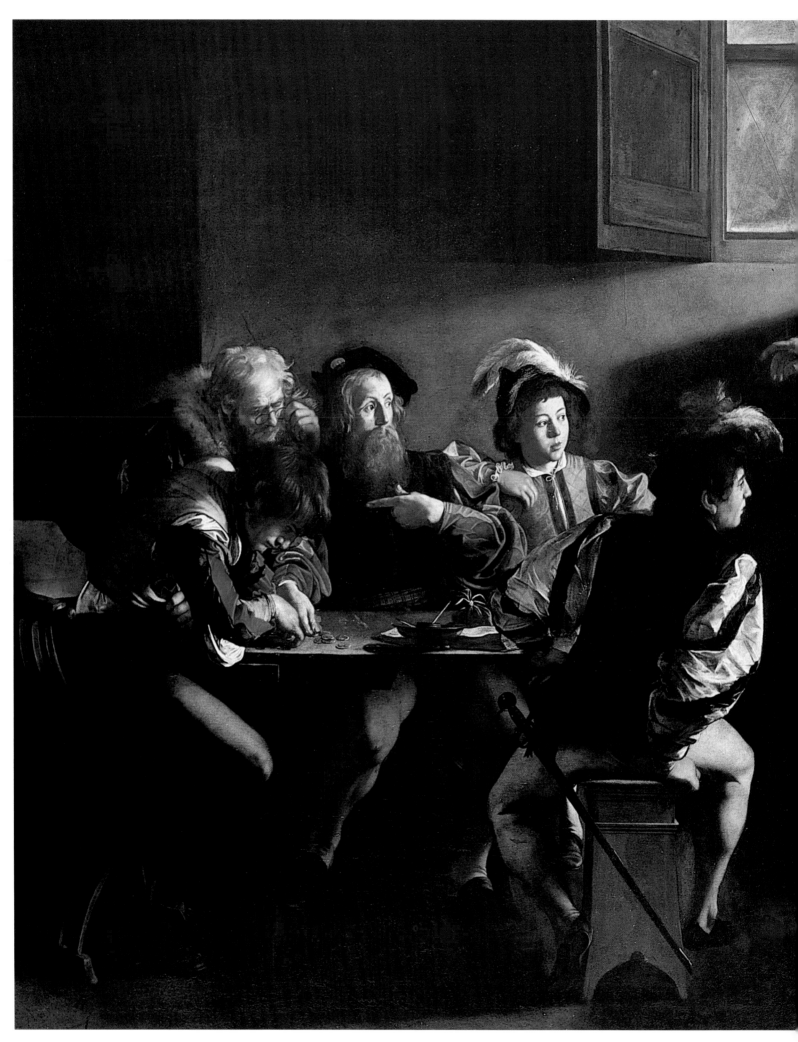

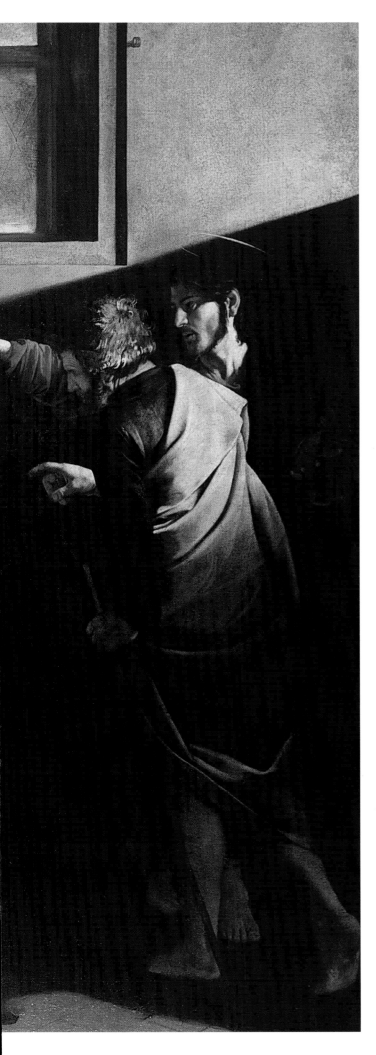

Caravaggio
Vocation of St. Matthew
Rome, San Luigi dei Francesi

Papal Bull, "the Lord vivified you in Christ: We consider the superabundance of divine grace in your conversion and reflect how you, from the densest obscurity of errors and heresies, almost from an abyss of evil, through a powerful act of the Lord's right hand, came into the light of truth." "A powerful act of the Lord's right hand" is evoked by Caravaggio (with a nod to Michelangelo) in the imperious gesture Christ makes with his right hand as he points to Matthew. The latter, still dubious, points to himself as if to ask: really me? The extraordinary orchestration of light and darkness manages to suggest at the same time the abstract force of the symbol and the lived reality of the event.

In the *Martyrdom*, the light designs a wedge that breaks through the darkness, making the executioner, who has thrown Matthew down and wounded him at the foot of the altar, stand out violently in the center of the painting. Blood gushes from the Saint's rib as it did from Christ's, whose passion is repeated here. The symbolic sacrifice of the Mass that Matthew was celebrating is concluded and carried out in this cruel event, which forces a tumult of light to explode. An angel bursts forth bearing the palm of martyrdom which he stretches out to Matthew. The light sculpts distinctly the shouting young boy who flees in horror on the right, while the crowd shudders in awe on the other side. In the background is the sorrowful face of the artist, who witnesses the event with his *pietàs*.

The explosive frenzy of the *Martyrdom* contrasts with the orderly composition of the *Vocation of St. Matthew* and the solemn calmness of the great ray of light entering that room. But the almost Dionysian agitation is not only fright, but also revelation. The executioner himself, whose face expresses marvel, seems possessed by the sacred mystery. The light emanating from the saint strikes him with the blinding intensity of its pardon. Divine grace descends, thun-

121

dering and tumultuous, as in the *Vocation*, on its sinner, who will be saved if he recognizes it.

The reasons why Caravaggio was forced to repaint the altarpiece with *St. Matthew and the Angel* are not clear. The first magnificent version of the painting represented the saint, with the rugged features of an illiterate peasant, writing the Gospel and observing his own words in wonder, his hand guided by the angel. The second version is the one now in the church. The saint has the aspect of a learned man, one who is inspired but not actually guided by the angel, who is no longer at his side, but hovers above. The saint turns toward him, as if surprised by his divine voice, but without excessive wonder; his face is wizened and marked, but not rough.

While he was working at San Luigi de' Francesi, Caravaggio was also executing two paintings for the Cerasi Chapel in Santa Maria del Popolo between 1600 and 1601. The subjects were the *Conversion of St. Paul* and the *Crucifixion of St. Peter*. A first version of the *Conversion of St. Paul* (replaced in the chapel by the current one and today in the Odescalchi collection) depicts the impetuous figure of the Eternal hurling Himself against the future apostle, who has fallen from his horse on the road to Damascus. He is uttering the famous reproach, "Saul, Saul, why do you persecute me?" In the second painting, the figure of the Eternal has disappeared and an extraordinary composure has been substituted for the tumult of the preceding version. The light, emanating from an invisible source, falls from above and slides over Paul's stupendous supine body and dazzled face. Its symbolic valence is more than evident here: it is the light of grace that descends upon the sinner. The church of Santa Maria del Popolo was the seat of the Augustine Order, and for St. Augustine, the great theorist of grace, knowledge was the "pure vision of God," perpetual illumination. Knowledge itself in Augustinian thought is the light of grace,

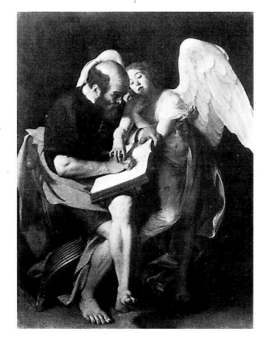

a gift that descends from above.

The upraised hands of the converted persecutor look as if they were forming a circle or an ellipse with the back of the animal, which lowers its head to look at him, pulled down by the groom's hand. Light streams within this magic circuit, transcending the careful, naturalistic rendering of the group into an apex of revelation. In the *Crucifixion of St. Peter*, the light follows a serpentine line along which the cross is solemnly erected: symbolically, it is the erection of the Church itself, which Christ had founded on Peter and which his martyrdom fecundates. Contrasting with the executioners' ugly features and black hair is the serene face of the saint framed by his white hair. Stoically, he participates in his own torture, looking on with proud strength. Here, too, the light that emanates from St. Peter, the symbol of the Church and Christ's "imitator" in martyrdom, is the light of salvation with which the executioners themselves are illuminated, while the "night," or darkness of sin without redemption, intensifies around them.[2]

With the revelation of Caravaggio's paintings, the Jubilee of 1600 could offer to the humble masses of the faithful images of divine grace. Pilgrims could recognize in those paintings their own faces and the same

Above:
Caravaggio
St. Matthew and the Angel
(destroyed during world war II)
formerly Berlin, Kaiser-Friedrich Museum

At right:
Caravaggio
St. Matthew and the Angel
Rome, San Luigi dei Francesi

122

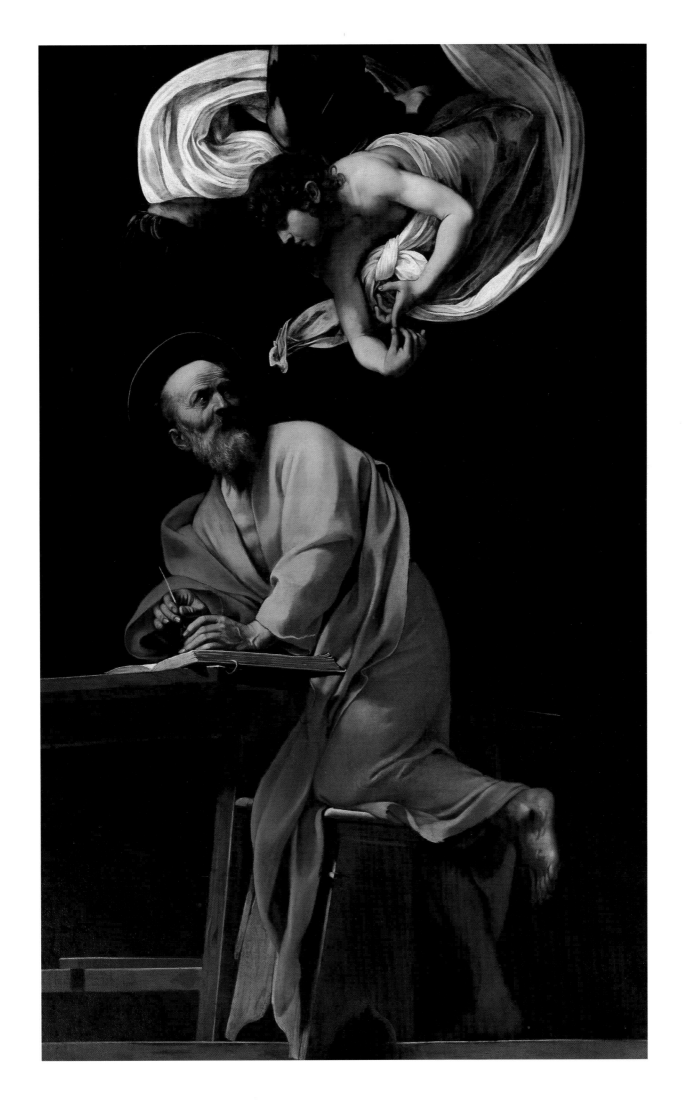

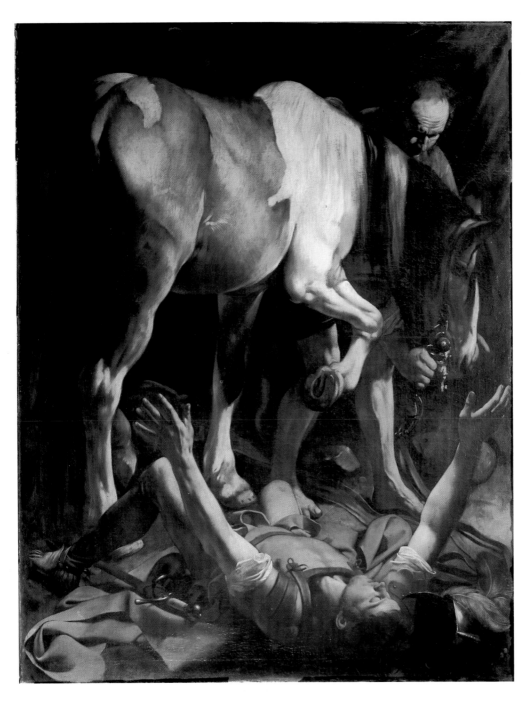

evangelical values of their own poverty as a privileged condition for access to the kingdom of heaven. In the meantime, in the dwellings of the rich and of the Church aristocracy, the artful grandeur of the Mannerist frescoes was giving way, with the work of the Carracci in the Farnese Palace, to a relaxed and cultured reconsideration in a Christian key of the mythology of a celebration of the triumph of Sacred Love over Profane Love. Side by side with the realism and pauperism of St.

Charles Borromeo and St. Philip Neri, as exemplified by the art of Caravaggio, was the serene and overflowing naturalism of the Bolognese masters, who were reproposing the nobility and turgidity of the great cultural syntheses of the Renaissance. Lastly, in the heart of the Vatican, in the Sala Clementina, the pontiff was revealing the erudite repertory of the allegories in a concerted representation of papal power, the Virtues, religion, art and science.

Above:
Caravaggio
Conversion of St. Paul
Rome, Santa Maria del Popolo
Cerasi Chapel

At right:
Caravaggio
Crucifixion of St. Peter
Rome, Santa Maria del Popolo
Cerasi Chapel

[1] A. Zuccari, *Immagini e sermoni dell'oratorio nei dipinti della Chiesa Nuova*, in AA.VV., *La Congregazione dell'oratorio di San Filippo Neri nelle Marche del '600*, Fiesole 1996, p. 177.

[2] For more information on the interpretation here suggested by Caravaggio's painting, see M. Calvesi, *Le realtà del Caravaggio* (Turin 1900).

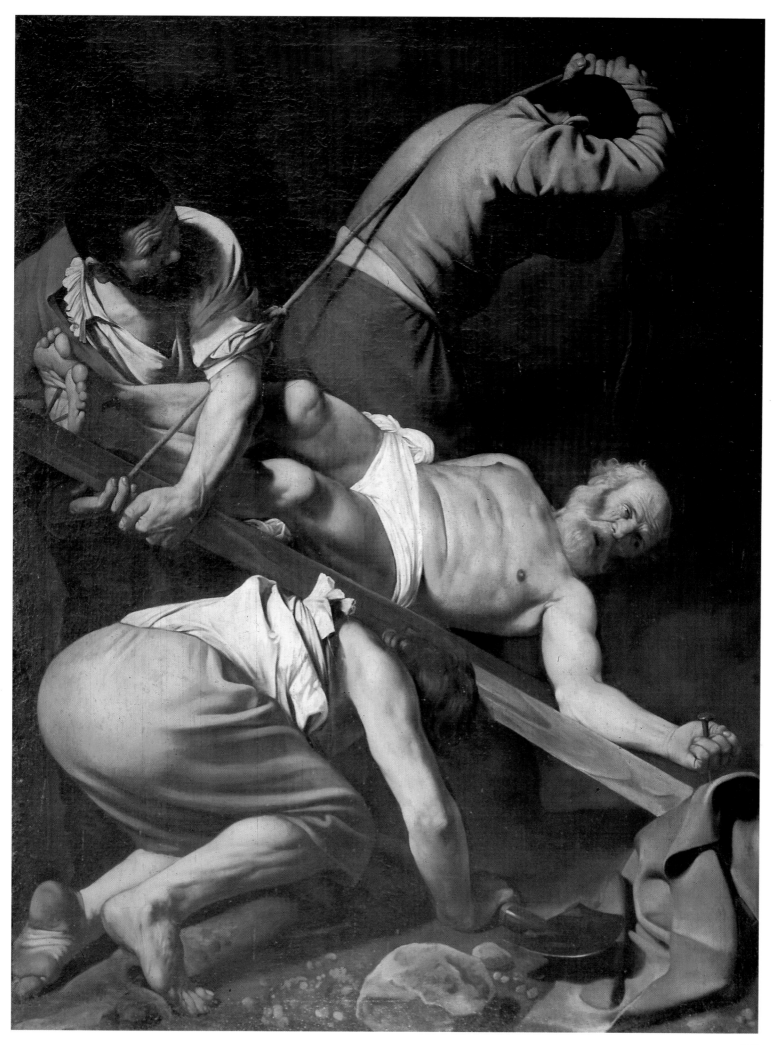

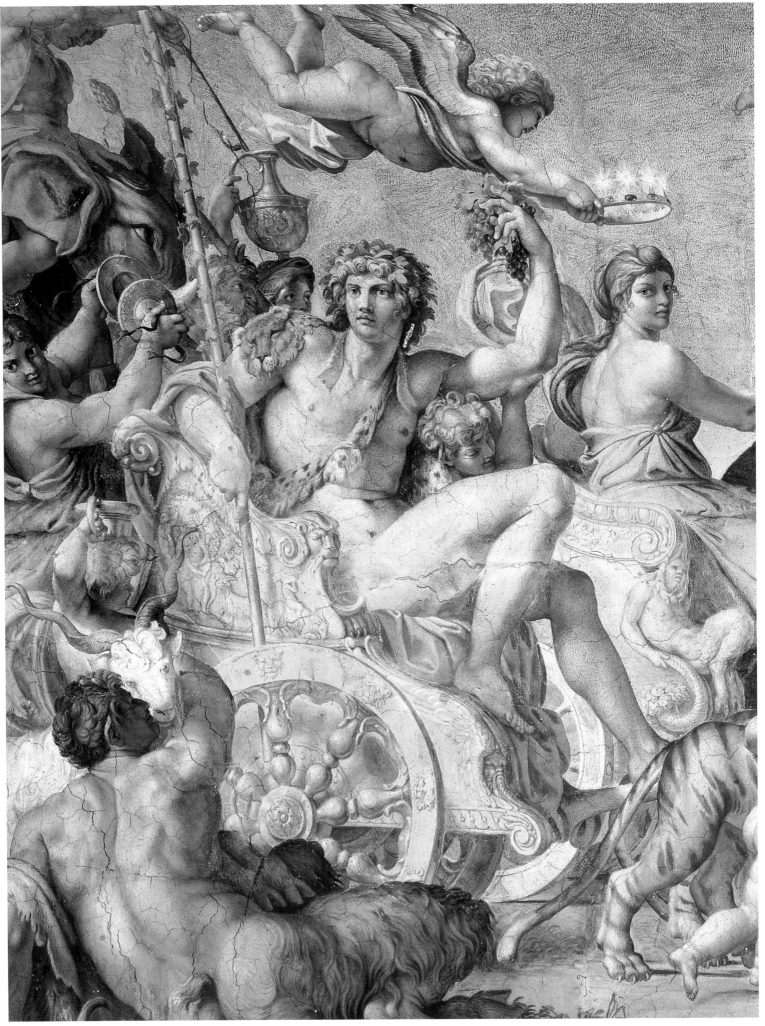

126

THE GALLERY OF THE CARRACCI
Maurizio Calvesi

Immediately after his arrival in Rome, sometime between September and November 1595, Annibale Carracci began to work at the Farnese Palace on a fresco decoration for the so-called Camerino, the private study of Cardinal Odoardo. When he finished this first commission, the painter dedicated himself to the preparation, in the same palace, of the famous cycle of the Galleria, a long room that was a little over twenty meters (sixty feet) in length, six-and-one-half meters (twenty feet) in width, and almost ten meters (thirty feet) high at its highest point, located on the second floor of the wing facing the Tiber River.

The traditional dating of 1597-1600 for the decoration of the ceiling has recently been reconsidered. The current belief is that the ceiling paintings seem to have been executed between 1598 and the beginning of 1601, with the wall paintings terminated a couple of years later (1603-04).

In the center panel of the ceiling is *The Triumph of Bacchus and Ariadne*, flanked by the stories of *Pan and Diana* and *Mercury and Paris*, and followed by *Ganymede Carried off by the Eagle* and *Apollo and Hyacinth*. In the lower band, on the two short sides, are the stories of *Polyphemus and Galatea* and *Polyphemus and Acis*, while there on each of the long sides are three scenes: *Jupiter and Juno*, *Aurora and Cephalus* (painted by Agostino Carracci, Annibale's brother), *Diana and Endymion*, *Venus and Anchises*, *Peleus and Thetis* (by Agostino), and *Hercules and Iole* (or *Omphale*). Alternating with the paintings on this band are twelve medallions with mythological subjects, and at the four corners of the ceiling are pairs of fighting cupids. The compartments have the appearance of *quadri riportati*, or framed easel pictures, and together with the medallions they are supported by a *quadratura* framework decorated with simulated reliefs of masks, puttos, sphinxes, shells, bucranes, garlands of flowers and fruit, among which stand out vigorous telamons in simulated stucco.

Caracci's orchestration of the modeled fleshy figures, refined colors, and airy backgrounds of the sky creates a bewildering effect of unsurpassable mastery and vivacity. Although it is in sharp contrast with the serious model of Michelangelo's Sistine ceiling, Caracci's work echoes the architectural and structural value conferred to Michelangelo's imagery, but with a richness of effects that are "most joyful to the eye" (Bellori) as well as an interweaving and overlapping of spaces that prefigure the Baroque. The sensuality of Carracci's brush has made a good number of critics doubt Bellori's (1672) explanation of the frescoes, as simply "different emblems the war and peace between celestial and vulgar love as established by Plato."[2] That would mean that the whole concept and allegory of the work hinges on the struggle between the cupids painted at the four corners of the vault. According to Charles Dempsey, the frescoes are rather a paganizing and lascivious celebration of profane love, conceived perhaps to honor in epithalamic fashion the marriage of the year 1600 between Ranuccio Farnese, Duke of Parma and Piacenza, and Margherita Aldobrandini, grand-niece of the Pope.[3]

In reality, this is not an indirect reference to the wedding but a precise and pointed one. This can be deduced from the still-obscure *Canzone nelle nozze del Serenissimo Ranuccio Farnese* (Song for the Nuptials of the Most Serene Ranuccio Farnese), published by Nicolò Mutij in Rome the year of the Jubilee, and written by the unexpectedly erudite pen of the architect Onorio Longhi, Michelangelo da Caravaggio's great friend. The composition contains a wealth of mythological references. These are particularly helpful in understanding the principal scene of the ceiling, the *Triumph of Bacchus and Ariadne*, a work that Longhi undoubtedly had seen before composing his song, since it was certainly one of the first to be executed, being the highest in the vault.

Alluding to the fact that Ranuccio

had been united with an Aldobrandini, whose coat of arms bear stars, Longhi spoke these words to him,

Questa corona, che di gemme e d'oro
splendeati accesa quasi in ciel
regal diadema a tuoi capelli intornoa hor
di stelle risplende (alto thesoro).
Il Gran Giove terreno
così cangiolla, e fe' il tuo crin piu adorno.
Tal già vide Arianna, e ancor fiammeggia
del crudo Theseo
la sua corona a la celeste Reggia,
e così vide le sue chiome belle
risplender Berenice in ciel di stelle.

(This crown, which of gems and gold
serenoglitters brightly on you in the
 serene sky
royal diadem around your hair
now shines of stars (great treasure).
The great terrestrial Jupiter
so changes it to adorn your hair
 all the more.
Ariadne saw such a one, and still blazes
a scornoher crown in the celestial realm
to spite cruel Theseus,
and in the same way did Berenice see
her lovely locks shine in the sky.)

In other words, Ranuccio's regal diadem has been enriched by the Aldobrandini stars, according to the Pope's will ("the great terrestrial Jupiter," i.e., Clement VIII Aldobrandini); and this starred crown is like that of Ariadne, whose golden diadem (which Bacchus gave to her when he married her and took her to Olympus) was later transformed into a celestial constellation, equal to Berenice's locks.

In Annibale's monumental fresco (which instead of "*Triumph*" should be titled the *Wedding Procession of Bacchus and Ariadne*, says Bellori), we see a winged cupid crowning Ariadne's head with a star-studded diadem ("Ariadne is crowned with stars," comments Bellori, stars which were later "placed in the sky"). Clearly, as in Longhi's song, Ariadne is the allegorical figure of Margherita Aldobrandini, just as Bacchus is of Ranuccio

Farnese. In the song, the warrior Ranuccio—Cardinal Odoardo's brother and the son of the condottiere Alessandro, who had died while fighting in Flanders—is compared to Hercules and Achilles:

O figlio d'Alessandro il grande il forte
RANUCCIO Invitto a guisa di Fenice
a trionfar dei popoli rinato [...]
Come all'hor quando vendicar ti vide
ancor fanciullo il glorioso padre
quel sangue, che per Dio da lui fu sparso

(Oh son of Alessandro the great and
 the strong
Ranuccio unconquered in Phoenician guise
reborn to triumph over the populations
As when still a boy you saw
your glorious father vindicate
that blood, shed by him for God)

Quando sembrasti qual tra mostri
 Alcide [...]
E che da tua spada escono tuoni,
onde par, che si spezze,
non sol l'orgoglio a l'Ilide, e a i Gerioni
ma da Gange, dal Nilo, ed l'Eufrate
condichin le provincie incatenate.

(When you seemed Alcide among monsters
And thunder echoes from your sword,
whence it seems that it shatters
not only the pride of Elis and Geryon
but from the Ganges, Nile, and Euphrates
the provinces are led in chains.)

Therefore, Ranuccio could also be compared to Bacchus, whose victory in the Indies is alluded to by the elephant in his retinue in the Carracci fresco. And we can see among the stories painted on the walls *Hercules and the Hydra* and *Hercules and Prometheus*, episodes that are clearly connected to the ceiling and still allude to Ranuccio's virtues as a warrior.

The wedding procession of Bacchus and Ariadne does not take its cue

Annibale Carracci
The Triumph of Bacchus and Ariadne
Rome, Farnesi Palace
Gallery of the Carracci

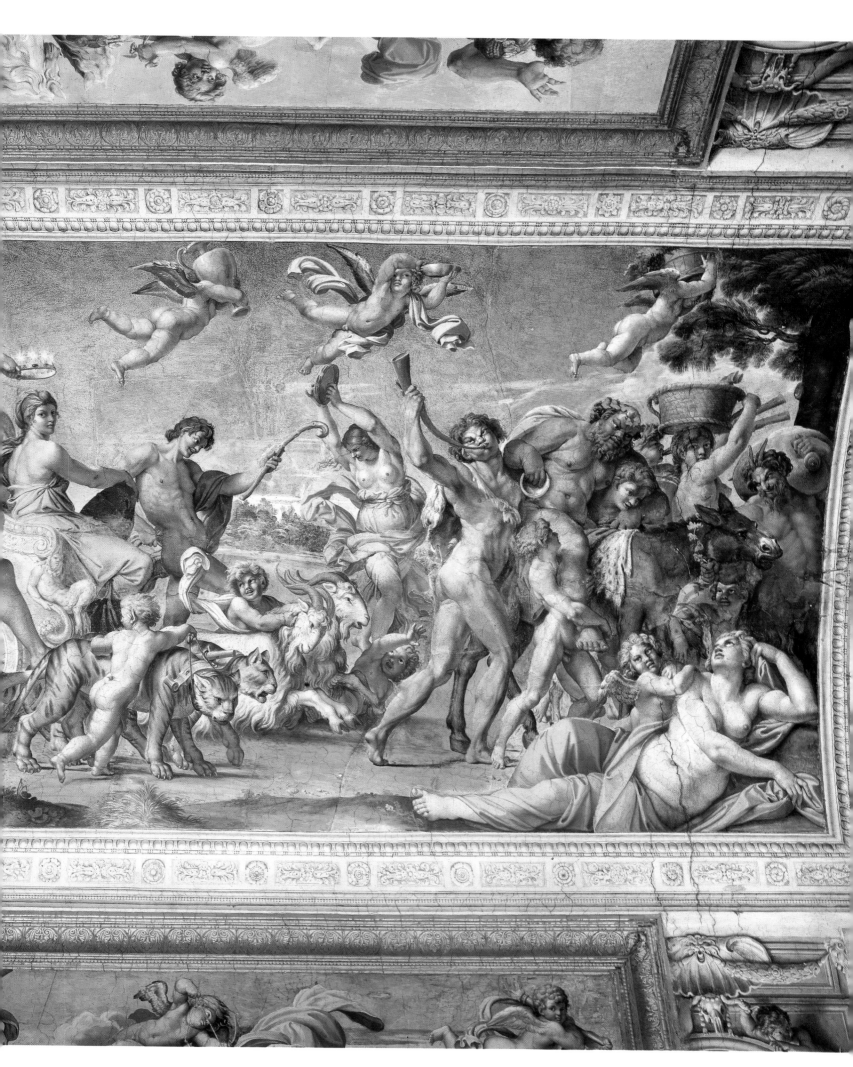

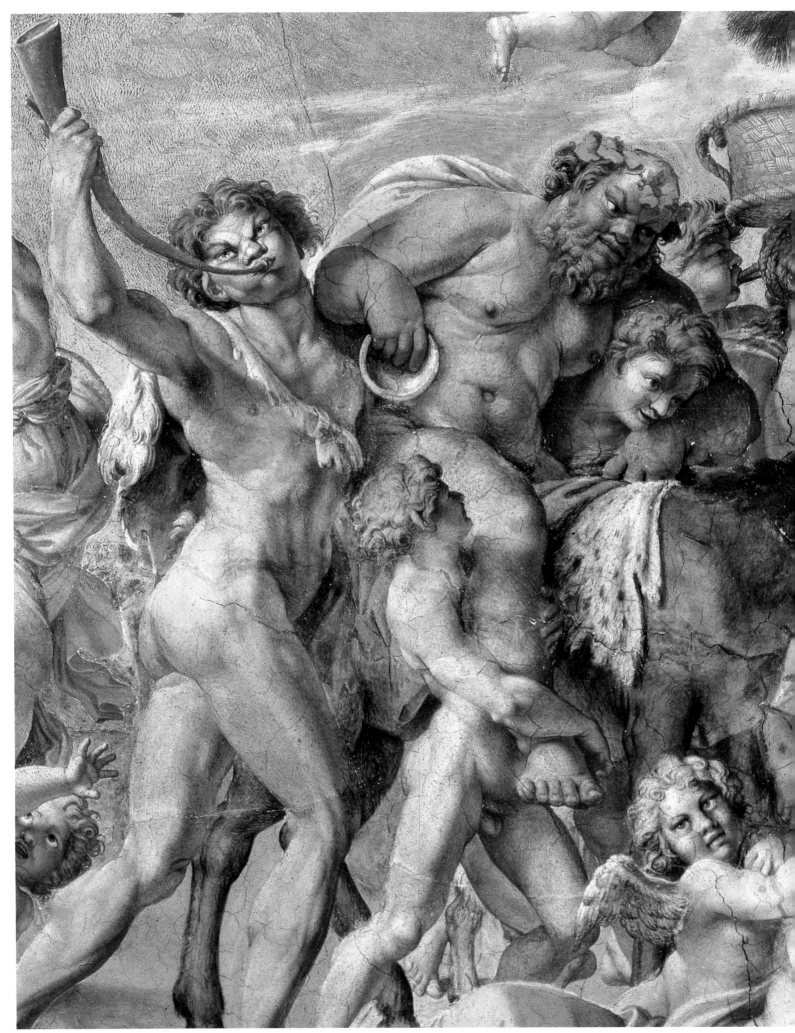

Annibale Carracci
The Triumph of Bacchus and Ariadne
Rome, Farnesi Palace
Gallery of the Carracci
detail

from Ranuccio's actual marriage to Margherita, but portrays it in allegorical form. It is ironic to think that the painter intended to show the triumph of lascivious love in a fresco designed to honor the wedding between a "glorious" condottiere and the pope's grand-niece. The love of Ranuccio/Bacchus for Margherita/Ariadne is sanctified by marriage and celebrated in the year of the Jubilee; its aim was to unite the Church of Rome with one of the most prestigious Italian families. It is love that ascends to "celestial spheres," and it triumphs rightfully over those kinds of vulgar love alluded to in some of the stories on the lowest band of the ceiling, a sort of sampling of the various types of love that should be analyzed. Finally, the adjacent scene of Ganymede being carried off by the eagle symbolized in the Cinquecento a sublimation of the divine.

On the walls below the ceiling, decorated by Annibale and a considerable number of collaborators (including Domenichino), are the figures of the Virtues, painted in a somewhat more subdued tone, and additional scenes of allegorical significance. Since he could not deny the latter, Dempsey thought that a change may have been made in the program. Giuliano Briganti expanded on this theory, saying, "It is highly probable that the classical spirit of fully Cinquecento character that fills the vault, and the lascivious subjects illustrating the loves of the gods had been generated by a strong desire on the part of Cardinal Odoardo [...] to assert his own independence from the Pope's moralistic rigorism. Perhaps

even from a desire to offend the bigotry of Clement VIII [...] The tedious negotiations for the marriage of Margherita and Ranuccio were concluded with their nuptials, and although the relations between the two families never really became amicable, the cardinal's independently laical spirit was assuaged. When other interests and objectives supervened, even his spirit reversed to rigorism, so that the erotic-satiric decoration no longer corresponded to Odoardo's sentiments, and Carracci was forced to change the second part of the work."[4]

In reality, as we have seen, the fresco that Briganti considers "lascivious" already celebrated the wedding between Ranuccio and Marghertia, which marked the reconciliation between the two families. Indeed, it must have been unveiled on or shortly after the day of their wedding. Thus, no satirical or transgressive intent lay behind Annibale's project. It was, rather, a joyful and festive scene in which lasciviousness and eroticism played no part. Eros—not to be confused with eroticism—is certainly present, but it is created from the sensuality of the painter's brush, as with Rubens, whose painting is sensual even in sacred representations. This type of sensuality was, for the Renaissance, equated with a felicitous impulse toward life and with the double-edged version of love (both conceptual and carnal, chaste and lusty) that lay behind even "virtuous" programs. Annibale, as Bellori correctly suggested, wished to consider all the various incarnations of love so that the culminating fresco would commemorate the triumph of the love sanctified by the wedding between Farnese and Aldobrandini, an event that united secular and religious power in the Rome of the Year of Grace 1600.

[1] For updated information regarding the dates legible in the Farnese Gallery and the documents that have been found, see G. Briganti, "Risultati di un'esplorazione ravvicinata della volta Farnese," in AA.VV., *Les Carrache et les décors profanes* (Rome 1988), pp. 66-70.
[2] G. P. Bellori, *Le vite de' pittori scultori e architetti moderni* (1672), ed. E. Borea (Turin 1976), p. 60.
[3] C. Dempsey, "'Et nos cedamus Amori: Observations on the Farnese Gallery," *Art Bulletin* 50, no. 4 (1968): 363-74.
[4] Briganti, *op. cit.*, pp. 71-72.

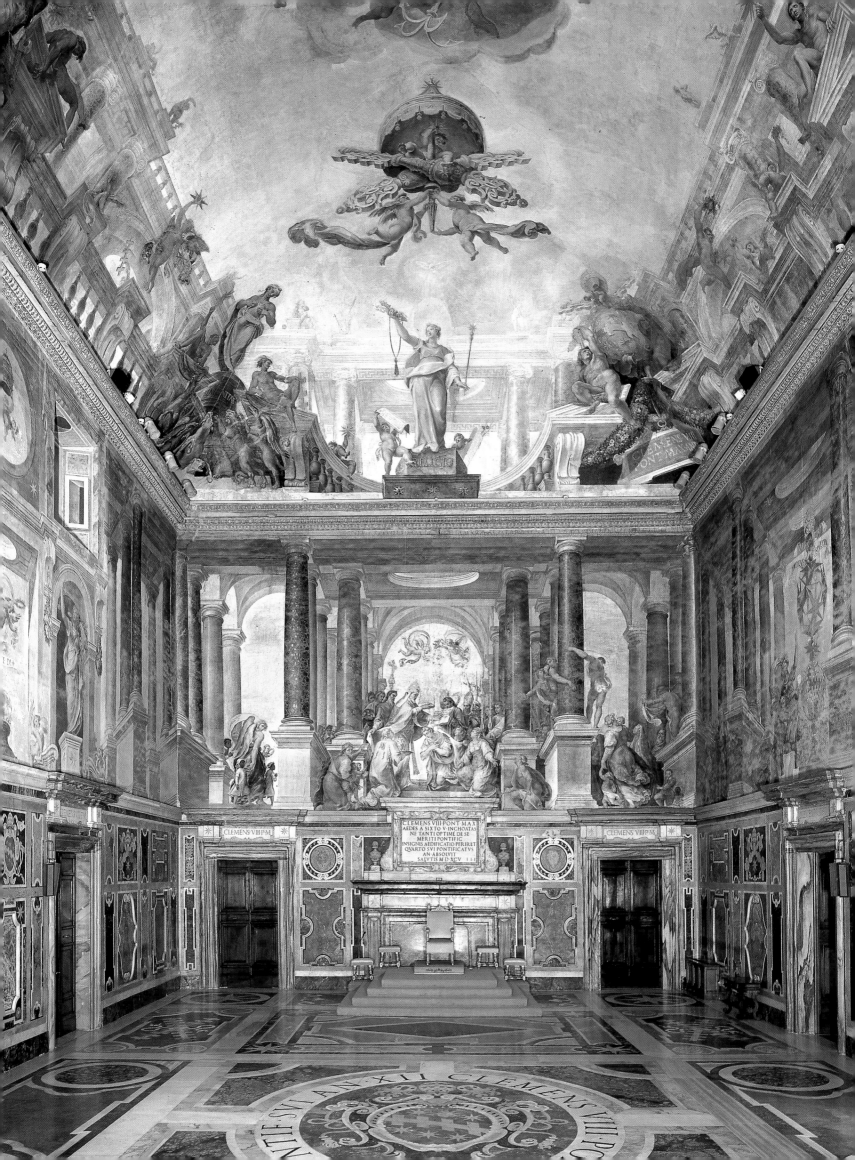

THE SALA CLEMENTINA

Stefania Macioce

The papal apartments occupy the third floor of today's Apostolic Vatican Palace, built for Pope Sixtus V by his trusted architect, Domenico Fontana. At the level of the Second Loggia is the Pope's apartment, the vestibule of which is the Sala Clementina, where delegations and representatives from foreign countries are received today, as they were in the past.[1] Clement VIII transformed Fontana's original project by uniting two zones and eliminating the attic, creating an immense room with a vaulted ceiling two stories high. When the renovation work was finished in 1595, Clement VIII decided to commission the entire pictorial decoration from the brothers Giovanni and Cherubino Alberti of Borgo San Sepolcro. On February 5, 1596, the two painters signed a contract for the ceiling that required the work to be completed by the beginning of 1600, in time for the Jubilee.

Some early sources attribute the execution of the ceiling to Giovanni, and the walls to his brother Cherubino, together with Baldassarino Croce of Bologna (this is clear in the note that Bellori added to Baglione's *Vite* in a manuscript preserved at the Accademia dei Lincei in Rome).[2] However, more precise information is available in a seventeenth-century manuscript, which states, "Those from the cornice and above, figures and perspectives, are by Giovanni Alberti from Borgo. Those from the cornice under the perspectives on the outside, which are by the said Giovanni, are by Baldassarre from Bologna and Giovanni's brother, the sea is by Paul Brill."[3] It is probable that Baldassarre Croce came to work on the frescoes later, following Giovanni Alberti's death in 1601.[4] A study of the drawings relative to the decoration has made it possible to single out their principal stylistic characteristics.[5] Giovanni Alberti's work shows a strong interest in the art of Michelangelo, combined with a use of sharp contours and old-fashioned

compositions that seem pompous and solemn. On the other hand, Cherubino adheres more to the style of Raphael or Polidoro, and his work is marked by quick flickering brushstrokes that exalt the idea of movement; his figures have tapered, slender proportions, though the more sinuous stylistic features, so typical of Parmigianino, are probably attributable to the presence of a third, lesser-known brother, Alessandro Alberti.

The unifying element in the entire decoration of the Sala Clementina is the illusionistic architecture painted at the base of the ceiling; this extends the real architecture into pictorial space with great effectiveness. The proto-Baroque vault opens onto an immense space in which the painted architecture comingles totally with the real space. This was a new solution in the Roman circle of those years, one that anticipated the later private commissions by Guido Reni in the Rospigliosi-Pallavicini Palace and, Guercino in the Casino Ludovisi. The paintings by the Alberti brothers went beyond the "pozzo" (well) effect found, for example, in Tibaldi's previous decorations in Bologna, or the *quadro riportato* (transferred easel picture) that Annibale Carracci used during those years in the Farnese Palace. Even the beautiful Olgiati Chapel in Santa Prassede that the Cavalier d'Arpino painted (along with Giovanni Alberti, who executed the false perspective) about 1595, was more traditional.

In the Sala Clementina, instead, a different cultural component entered the picture: theatrical scenery. In June 1587, Giovanni Alberti had gone to Sabbioneta, near Mantua, where his brother Alessandro had been since November 18, 1586. There, the two artists collaborated on works for Vespasiano Gonzaga's Palazzo del Giardino, notably the frescoes in the Galleria degli Antichi. But the sojourn was even more decisive for the fact that Giovanni was able to perfect his knowledge of perspective through

At left:
Sala Clementina
Vatican City, Apostolic Palace

Pages 134-135:
Giovanni Alberti
Triumph of St. Clement
Vatican City, Apostolic Palace
Sala Clementina

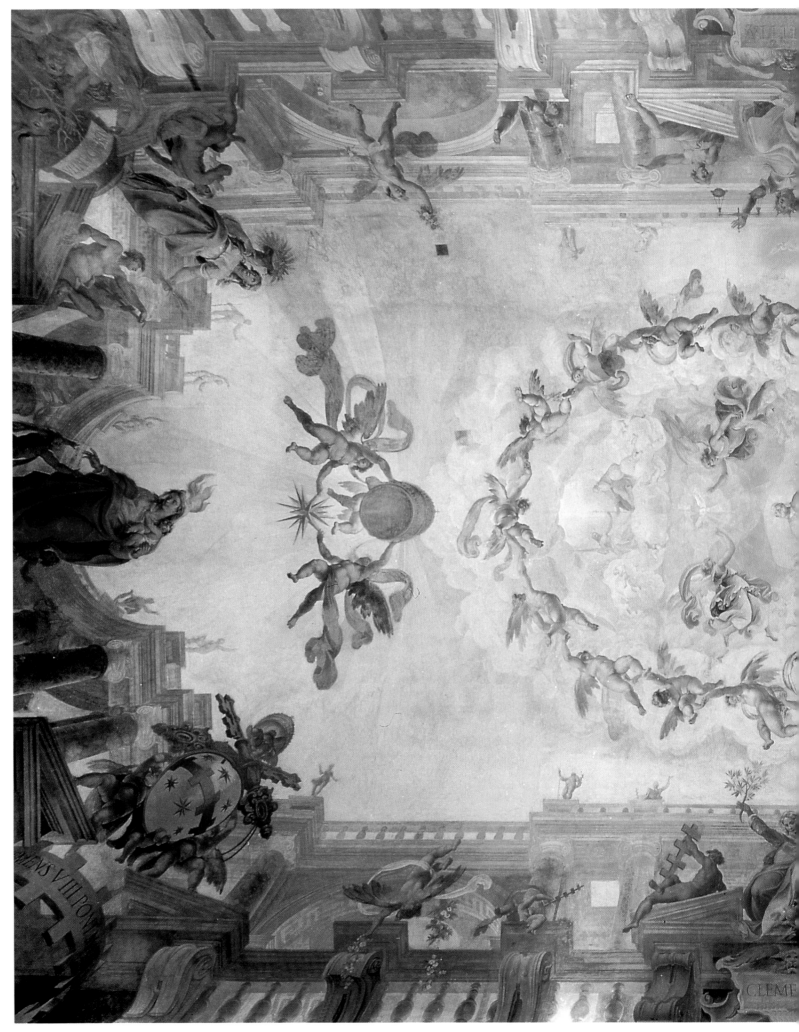

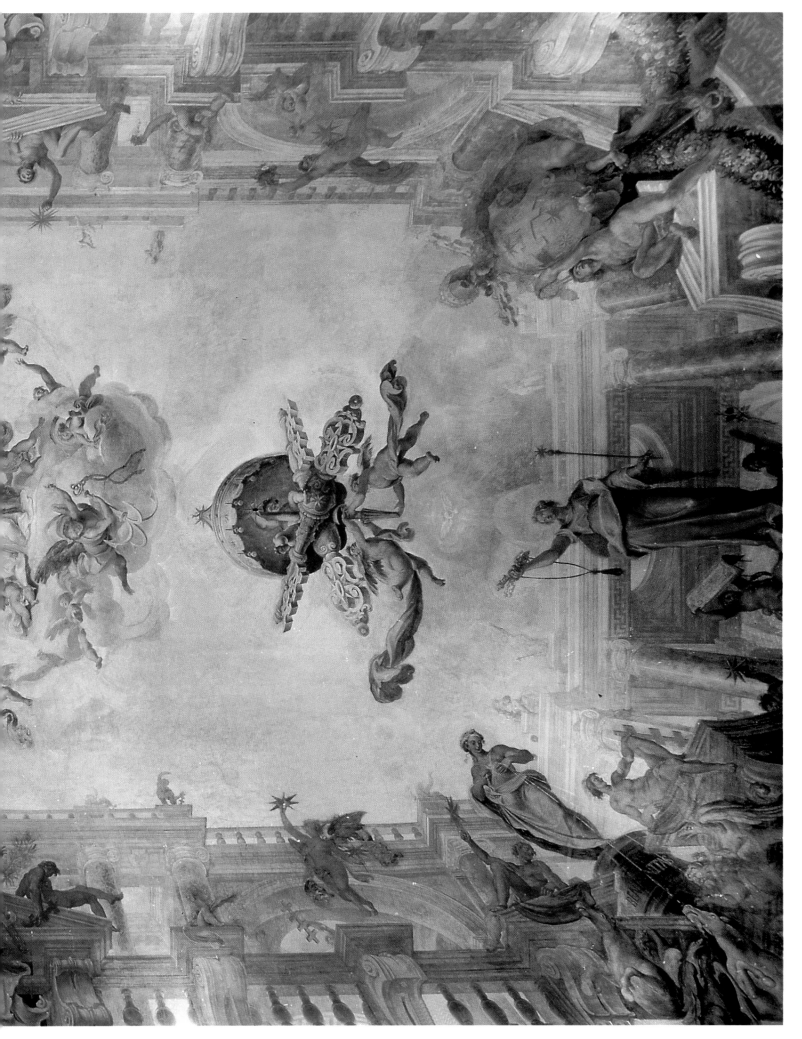

contact with the noted theatrical set designers Giandomenico and Vincenzo Scamozzi. With Andrea Palladio, Vincenzo Scamozzi had designed the famous Teatro Olimpico in Vicenza (1580-85), and he later wrote a theoretical treatise titled *Dell'Idea dell'architettura universale* (begun in 1591, published in Venice in 1615). A common Palladian style is evident in the painted architecture of the Albertis' Sala Clementina and Scamozzi's later Teatro Olimpico, which he designed for Gonzaga's new city of Sabbioneta around 1590. Scamozzi had often been to Rome, and he returned to the city in 1598, the year the Albertis were working for Clement VIII.[6]

The decoration of the Sala Clementina exalts the figure of Clement I, the third pope after Peter and a martyr, as pointed out by the following dedicatory epigraph painted on the plinth of one of the columns alongside the great *Allegory of Art and Science:* "MEMORIAE/S. CLEMENTIS PAPAE/ CHRISTI. MART. FORTISSIME/ CLEMENS PAPAE VIII/AULAM.SACRIS. PICTURIS./ORNATAM. DICAVIT/AN. SAL. MDCII." (*Pope Clement VIII dedicated the hall, decorated with sacred pictures, to the memory of Christ's Pope Clement, the great martyr, in the Holy Year of 1602.*)

The focal point of the complex decorative program is naturally the center of the ceiling with the *Triumph of St. Clement* positioned between the insignia of pontifical power which are supported by puttos. The thematic parallelism between the historic and contemporary pontiffs, based on the equivalence of their names, accentuates the theme of the historical continuity of the Roman Church with the original Christian culture. The second epigraph, placed under the fresco of the *Baptism of St. Clement* is dedicated to Clement VIII's predecessor, Sixtus V, whose program the new pontiff was continuing.

The suggestive illusionistic architecture that circumscribes the ceiling is populated with the allegorical figures of the Virtues, who correspond exactly to the descriptions codified by Cesare Ripa in *Iconologia* (which had been published just a few years before in 1593). These figures represent *Religio* (Religion), *Benignitas* (Benignity), *Charitas* (Charity), *Abundantia* (Abundance), *Clementia* (Clemency) and *Iustitia* (Justice), and celebrate, each by her own iconographic attributes, the virtues necessary for the good government of the Church. The Holy Year itself is celebrated in a dedicatory inscription under the Aldobrandini coat of arms in the corner of the ceiling: "CLEMENS VIII PONT. MAX AN. IUBILEI MDC." (*Clement VIII Pontifex Maximus in the Jubilee Year of 1600.*)

On the north wall of the room, the fresco of the *Baptism of St. Clement* faces the scene of his *Martyrdom.* In the first, the baptism of the saint by St. Peter also alludes to his successive nomination as pope, as attested to by the angels above, one of which holds a crown, while the other one scatters rose petals, symbolizing martyrdom. Bishops and deacons, bearing candles, are present at the ceremony, while in the right foreground some men are tying a column. According to an episode recounted in the sources, these men are Sisinnio's servants, who were blinded by a miraculous event when they came to arrest Clement, and, instead of seizing and tying the saint, they tied a column. This episode is also represented in the lower church of San Clemente in Rome and is evidence of the diffusion of the legend through the *Martirologio romano,* the first post-Council revision of which had appeared in 1583. This text was later revised and republished by Cesare Baronio, the Oratorian cardinal confessor of Pope Aldobrandini, in 1586. On the left side of the fresco, the personages in Oriental attire probably allude to the Jesuits whom the pope had sent to the Turkish court in 1598 to settle the age-old problem of the infidels.[7]

On the opposite wall is *The Martyrdom of St. Clement,* frescoed by Paul

Giovanni and Cherubino Alberti
Theological Virtues
Vatican City, Apostolic Palace
Sala Clementina

Brill of Antwerp. The events are set in a vast landscape, reflecting a new compositional scheme that the Florentine Agostino Ciampelli had developed around the same time in the Sacrestia dei Canonici (Sacristy of the Canons) in San Giovanni in Laterano. St. Clement is shown here suffering his martyrdom according to tradition: tied by his neck to an anchor, he is being thrown into the sea. But this key episode is largely overshadowed by the prominence given to the large ship in the fresco. The ancient motif of the *navicella* (ship), symbolizing the Church of Rome, was very popular from the beginning of the sixteenth century. Contemporary evidence of this ico-

nography is Philippus Thomassinus's very elaborate engraving *Navis Misticae Contemplationis* (1602), the basic theme of which is the *Ecclesia Triumphans* in opposition to the *Eresia Eversa*. In the Sala Clementina, on the occasion of the Jubilee, this theme most certainly referred to the triumph of the papacy of Rome over the Protestant heresy in the climate of renewed post-Tridentine spirituality. In the background of the painting is a tiny depiction of the miracle which brings the martyr's sepulcher out of the sea every year. The vast panoramic setting of this fresco is unusual both in relation to the contemporaneous preference for autonomous pictures and

VIAS · TVAS · DOMINE

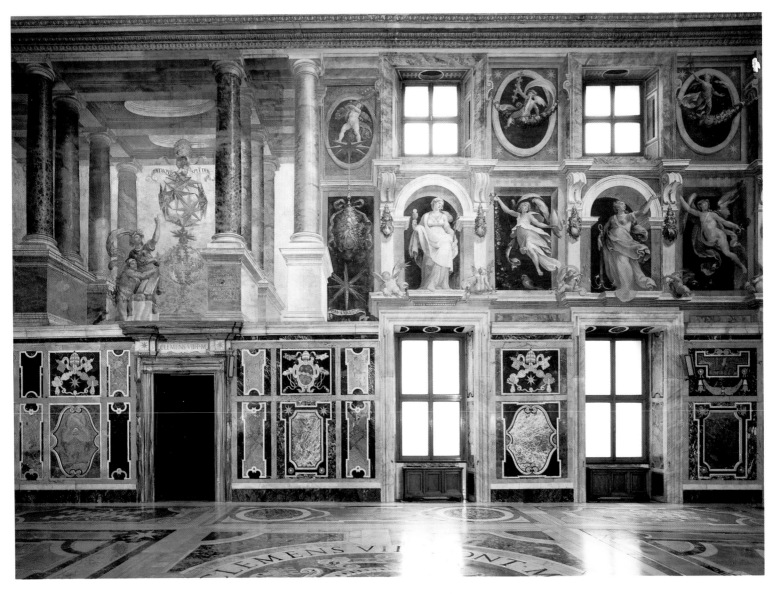

for the fact that it celebrates the historical event in lyrical harmony with the grandeur of nature.

On the long walls of the room, inserted into a solemn sixteenth-century architectural setting, are the *Cardinal Virtues* and the *Theological Virtues*, facing each other and corresponding literally to Ripa's descriptions. In those very years, the influence of the virtues in Christian life had been the subject of the Jesuit Bernardo Rossignoli's treatise *De Disciplina christianae perfectionis pro triplici hominum statu, incipientiuò et perfectorum ex Sacris Scripturis et Patribus libri quinque* (1600), and his later work *De actionibus virtutis* (1603). In the first text, the Jesuit shows how the three actions of the virtues (the "purgative," "illuminative," and "unitive") form an ascending path leading to divine contemplation. Similarly,

the action of the Theological Virtues is demonstrated in Johannes David's *Veridicus Christianus* (1601), which is also enhanced by detailed images. In the theory of the Theological Virtues, Charity, already represented on the ceiling, was substituted by the Heroic Virtue, which, as Ripa wrote, triumphed in man "when reason has subjected the sensitive affections."[8] The powerful action that the virtues exerted in Christian life was later clearly illustrated in an engraving by Cherubino Alberti in which one of the angels (which alternate with the Theological Virtues in the room) is accompanied by the explanatory words "NON SINE VIRTUTE." Without the contribution of the virtues, a Christian cannot reach sanctity, emblematically represented in the frescoes as the Heroic Virtue who indicates the scene of martyrdom.

Giovanni and Cherubino Alberti
Theological Virtues and
Allegory of Art and Science
Vatican City, Apostolic Palace
Sala Clementina

On the same wall, the entire decoration is concluded by the great and complex *Allegory of Art and Science.* Here, next to the female figure who represents Perspective, is a kneeling male figure who can be identified as Labor. Both personifications flank a large, golden instrument composed of two superimposed spheres connected by a sloping star, formed respectively by toothed bars and stars, the heraldic elements of the Aldobrandini family. The instrument refers to armillary spheres, so often represented in Cinquecento treatises on perspective. It is surmounted by a putto who holds the papal tiara from which extends a scroll bearing the words "UNDIQUE SPLENDENT." The whole allegory was certainly meant to exalt the submission of artistic activity (represented by Labor, with brushes in his hand) to the laws of Perspective. This latter figure, which also corresponds to Ripa's description, carries in her right hand instruments that are useful for correct pictorial representation: a compass, a ruler, a square, and a plumb line. The necklace she wears has a pendent in the shape of an eye from which rays extend to illuminate the writing on the column plinth, where the "sacred" paintings decorating the room are mentioned. All of this refers to a recondite message concealed within the decorative program itself. Indeed, in its entirety, it refers to the Pope's programmatic declaration on the occasion of the Holy Year.

The great allegory with its unmistakable references to artistic investigation and scientific research—in particular, to astronomy as suggested by the presence of the armillary spheres—celebrates the right and proper submission of all intellectual speculation to divine will, whose luminous rays shine everywhere. The allegory may therefore be interpreted as Pope Clement's project for the Holy Year. As a matter of fact, the recurring motto on the scrolls that adorn the room is "VIAS TUAS DOMINE" (Demonstra Mihi) from Psalm 24:4, which was often adopted by rulers, as may be seen in many sixteenth-century devices.[9]

The magnificence of the whole decoration confirms the centrality of the Church of Rome in the person of the Pope. He rules over his faithful Catholics and shows them, by means of "sacred" pictures, the teachings that a Christian must abide by according to the canons that the Jesuit Richeome established regarding "pittura parlante" (spoken painting).[10] Only a few years before, in 1598, St. Robert Bellarmino, the doctrinal pilaster of the Counter-Reformation Church, had succinctly expressed those teachings, illustrated in the Sala Clementina, when he said, "Virtue is a quality that is received in the soul, which sees to it that man is good. And like science sees to it that man is a good philosopher, and like art that he is a good craftsman, in the same way, virtue sees to it that he is good."[11]

1 G. Cornini, A. M. De Strobel, and M. Serlupi Crescenzi, "L'Appartamento Papale di Rappresentanza," in *Il Palazzo Apostolico Vaticano,* ed. C. Pietrangeli (Florence 1992), pp. 169-86.
2 G. Baglione, *Le vite de' pittori, scultori et architetti* (Rome 1642), p. 70.
3 ASV, *Ottoboniano Latino* 2975, ff. 57v, p. 58.
4 M. C. Abromson, *Painting in Rome during the Papacy* of *Clement VIII (1592-1605)* (New York 1981), p.37ff, and App. 1, pp.8, 18, and 42ff.
5 K. Hermann-Fiore, *Disegni degli Alberti* (Rome 1983).
6 S. Macioce, *Undique Splendent: Aspetti della pittura*

sacra nella Roma di Clemente VIII Aldobrandini (1592-1605) (Rome 1990), p. 175f.
7 The documents relative to the Jesuit mission are cited in P. Ilario Rinieri, "Clemente VIII e Sinau Bassà Cicala," in *Civiltà Cattolica* (Rome 1898): 37-38.
8 C. Ripa, *Iconologia* (1593) ed. P. Buscaroli (Turin 1986), p. 237.
9 J. Typotius, *Symbola Divina et Umana Pontidficum Regum* (Prague 1601).
10 L. Richeome, *Tableaux sacrez* (Paris 1601), p. 4ff.
11 R. Bellarmino, *Dichiarazione della vita cristiana* (1598), chap. 38, p. 148.

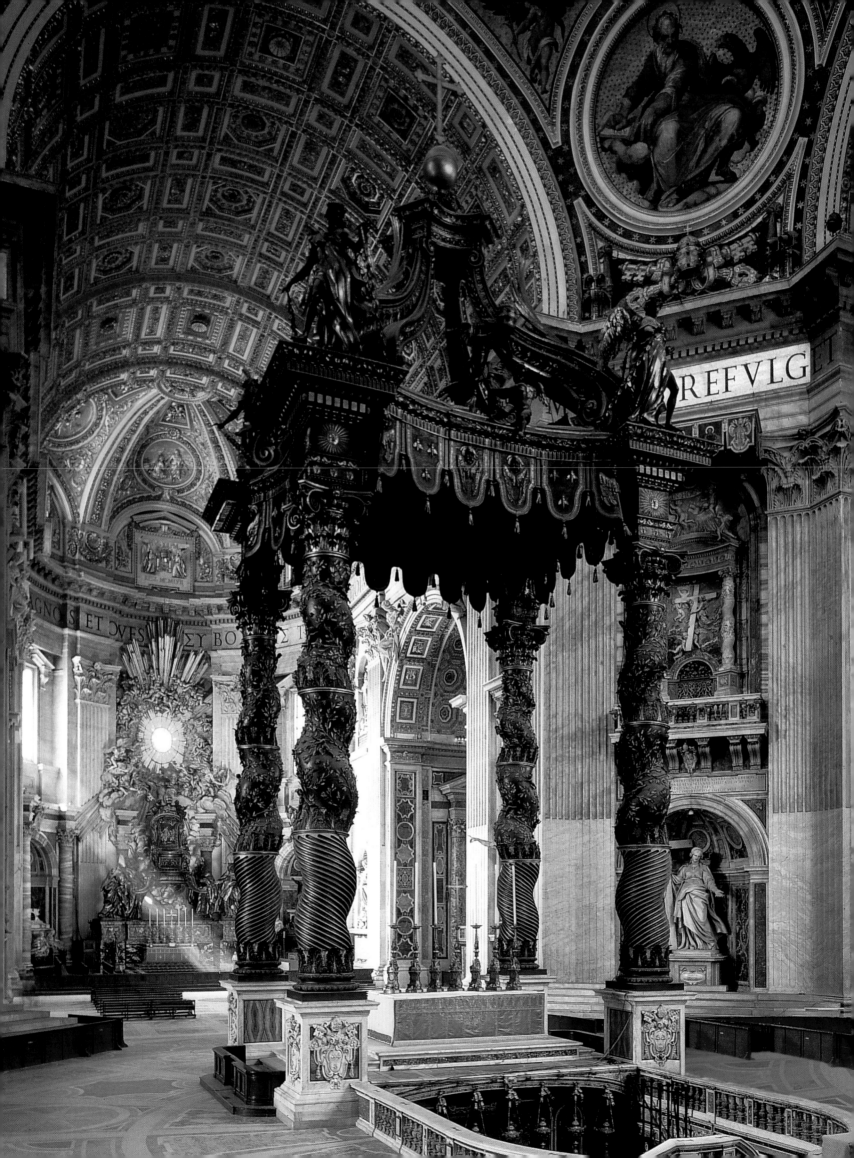

BERNINI
AND THE BAROQUE
Silvia Danesi Squarzina

Gian Lorenzo Bernini
Baldacchino of St. Peter
Rome, Basilica of St. Peter's

Urban VIII Barberini (1623-44), the pope who freed Tommaso Campanella from prison, the aristocrat who delighted in writing, the culturally informed intellectual, knew how to turn the Jubilee he had proclaimed in 1625 into a moment of reflection about the history of the city of Rome.[1] He had earlier raised his voice against Paul V, when he argued in defense of Michelangelo's central plan for the basilica of St. Peter's, which the Borghese Pope (1605-21) had decided to alter by having Maderno lengthen it and add a new façade.[2]

One of Urban VIII's first steps—in 1624, a year after his election and a year before the Jubilee—was to commission Gian Lorenzo Bernini (1598-1680) to design the baldacchino of St. Peter's.[3] That difficult project was started immediately but was not completed until 1633, too late for the Jubilee. It was a colossal undertaking, which began with the installation of the four columns in 1627. Collaborating with the architect were Pietro

and Luigi Bernini, Andrea Bolgi, François Duquesnoy, Nicolò Cordier, Giacomo Antonio Fancelli, Stefano Speranza, Giovan Battista Soria, and Francesco Borromini. According to Giovanni Battista Passeri,[4] the enchanting hovering putti in low relief on the branches of laurel that wind around the columns are by Giuliano Finelli.[5] The bees on the bronze surfaces allude to the Barberini coat of arms (the gadflies, originally on the family coat of arms, having given way to industrious bees).[6]

The felicitous choice of Bernini, the splendor of the work, and its profound symbolic value, have yet to be explained sufficiently by scholars. The gilded bronze columns of the great baldacchino, which occupy pride of place in the basilica, have a great formal quality and value, and allude to the role of the pontiff and the history of the Church. The twisted shape of the columns—the inferior part deeply grooved, the superior decorated with a delicate interlacing of leaves—is drawn

from the so-called columns from the Temple of Solomon, which had been preserved in the old St. Peter's. One of them—according to tradition, the one that Christ leaned against—is now in the Treasury of St. Peter's, while the others can be seen where Bernini placed them, up above in the four pylons supporting the dome, in the four loggias of the relics. These very columns, decorated with vine twigs, once formed a *pergola* that was placed above the *Confessio* of St. Peter Martyr in the Constantine building, and was to have constituted the support of the new baldacchino in an early project by Tiberio Alfarano.[7] Bernini did not want to be limited by the dimensions of the sacred marble columns and preferred to reproduce them in bronze, in a much bigger size, in emulation of the enormous arches on which Michelangelo's dome rests. It is unknown, however, whether this enlarged recreation of the ancient columns was his choice or whether he felt obliged to satisfy the wishes of the Pope, who most certainly knew about Tiberio Alfarani's project.

To better understand the debate regarding the baldacchino of St. Peter's, which is documented by engravings that show the different phases of the project, it is necessary to make a very brief excursus on Solomonic symbology. King Solomon, whose personality has been transmitted by the Bible, was able to administer justice with supernatural equity by penetrating into the soul of man. Having been a king, a priest, and a great builder, he became a model for those popes who aspired to unite temporal power with spiritual power and to prove their authority by building great public works. In 1475, Sixtus IV Rovere (1471-84) had begun construction of the Sistine Chapel using the proportions of the Temple of Solomon as his guide. Indeed, in the central fresco of the Sistine Chapel, which represents Christ giving the keys to St. Peter, Sixtus IV appears as King Solomon.[8] Sixtus IV was the pontiff who reaffirmed his own authority with respect to the Council and opened the

way both to nepotism (his nephew Giuliano della Rovere became the great warrior pope Julius II, and Michelangelo's patron) and to the splendors of the Renaissance. Urban VIII, in turn, felt the necessity, after the tedious problems of the Protestant Reformation and the Counter-Reformation, to reaffirm his role as the head of state in addition to being its high priest; this is evident in his military policy and his choice of political alliances.

That Tiberio Alfarano may have been the ideologue of a new comparison between the Pope and King Solomon is suggested by the fact that the Pauline chapel, designed by Maderno and Alfarano for the Quirinal Palace (under the preceding pontiff), was of exactly the same size as the Sistine Chapel, which in turn was based on Solomon's Temple. Similarily, the baldacchino of St. Peter's, which is placed in the center of the basilica—which is to say, the center of Christianity—was significant because of its connection to David's son. In the Quirinal Palace, to which Urban VIII dedicated much attention, a fresco dated 1625 and attributed to a collaborator of Agostino Tassi, shows off with appalling magnificence the new pontifical armory.[9]

Although Urban VIII did not hesitate to strip the Pantheon of its bronzes, he did show greater respect for Early Christian buildings and the memories of the first martyrs. For those he chose an intelligent line of restoration in which his nephew, Cardinal Francesco Barberini, played an important part. Cardinal Francesco was heir to a tradition of studies of Christian archeology that included such personalities as Onofrio Panvinio, Cardinal Cesare Baronio, and Antonio Bosio, the author of *Roma sotterranea.*[10] The young prelate made intelligent use of his power as the pope's nephew; he was very close to the cultural circle of the first Accademia dei Lincei and was surrounded by such intellectuals as Cassiano dal Pozzo, founder of the Museo Cartaceo, and

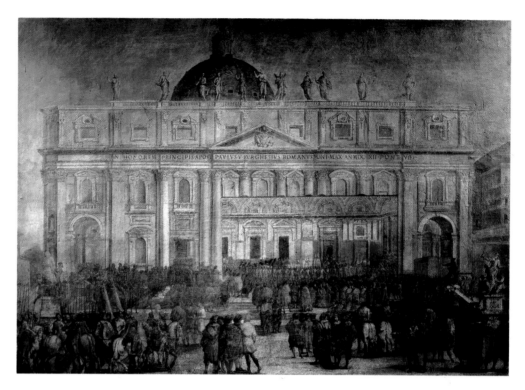

Agostino Tassi
*Opening of the Holy Door
for the Jubilee of 1625*
Rome, Quirinal Palace
Corridoio of Urban VIII

Nicolas Claude Fabri di Periesc. For these scholars, every monument from the past, be it major or minor, was a potential source of knowledge.

Francesco directed the restoration of the Lateran Triclinium, erected by Pope Leo III (795-816), for the Jubilee of 1625, a project that involved conservative restoration and a documentary analysis.[11] His anxiety for faithfulness, not only of a religious but also of a philological-cognitive nature, can be inferred from the letter that he addressed to Cardinal Federico Borromeo, requesting documentation regarding the ancient mosaic of the Triclinium. Unfortunately, Federico was unable to satisfy the cardinal's request; and it is not known how the missing parts of the decoration were reconstructed. But the absolute rigor with which the restoration was completed is exemplified by the publication in 1625 of *De Lateranensibus parietinis,* with a text by Nicolò Alemanni and engravings by Matthaeus Greuter.[12] The surviving scenes and relative lacunae are documented in the tables; the only thing that remained of the ancient edifice was the central niche with the mosaic of the apse (Christ Benedictory with the twelve apostles below) and that of the right pendentive (St. Peter enthroned giving the pallium and Emperor Constantine's banner to Leo III). Implicit in the restoration was a political objective that was consonant with the jubilee event: the exaltation of the figure of the pope.

These were not years of economic prosperity, and, in the Bull that Urban VIII issued on May 16, 1624, announcing the Jubilee, there is also a hint that the specter of the plague might be an impediment for pilgrims.[13] But the proclamation of the Holy Year stimulated building activity and a greater circulation of money, which relaunched the city's economy. Many cardinals followed the pope's lead in sponsoring public works. Cardinal Alessandro Peretti Montalto, nephew of Sixtus V (1585-90), had lost no power after the death of his uncle, and he used his wealth and authority to sustain the building of the church of Sant'Andrea della Valle. Maderno was the architect of the middle phase of that immense undertaking, but credit is also due to the painter Domenico Zampieri, known as Domenichino, for his contribution to the conception of space by his use of the majestic stucco decorations that frame and give rhythm to the frescoes depicting the stories of St. Andrew in the apse, and the four colossal evangelists

in the pendentives of the dome.[14] A recent restoration of these frescoes has made it possible to examine the pictorial surface and to take note of Domenichino's surprising technique: the shadows are created with tiny dots, not unlike the *pointillisme* used by the Divisionists in the nineteenth century. Rather than dirtying the light colors by mixing them with earth to obtain shadows, Domenichino superimposed dark points on the luminous surfaces. On close examination, the dots appear quite large and are not mixed with the surrounding color, although from a distance they blend together into the design. This technique supplies evidence of Domenichino's mastery of the laws of perspective and mathematics, as taught by Fra Matteo Zaccolini, the Theatine from Cesena whom Bellori mentions.[15] A painter and the author of a treatise on color and perspective, Zaccolini may have had contacts with the Theatine Fathers for whom the church of Sant'Andrea was destined from the beginning.

Perspective illusionism shaped another splendid element of the great church: the inside of the dome, where, just after the jubilee, a radiant host of saints and angels was painted by the Parmese artist Giovanni Lanfranco, a student of Caracci and heir to the luminosity of Correggio, his famous predecessor and fellow citizen.[16] According to Bellori, an authoritative witness: at the death of Cardinal Montalto in 1623, his nephew, the Abbot Francesco Peretti, pressured by the Theatine Fathers who were anxious that the work be finished, decided to take the commission to paint the dome from Domenichino and give it to Lanfranco, who had trained in the same school and was known in Rome as having contributed to the extraordinary Gallery of the Caracci in the Farnese Palace.[17] On the other hand, Passeri, an equally reliable source, reports that the division of work occurred without any rivalry well before the death of Cardinal Montalto.[18] Did Bellori embroi-

der his story when he wrote, "While he [Domenichino] was showing his drawings, Lanfranco could be seen above on the scaffolding painting the dome"? And since, it would appear not, in the 1664 inventory of the property of Francesco Raspantino, Domenichino's student and heir, are listed: "Watercolor drawings of the dome of S.Andrea della Valle of Domenichino which were not used no. 10." This would seem to confirm Bellori's claim that Domenichino had "made drawings of the dome with three different designs," and, when Lanfranco was given the job, Domenichino was very sorry "he had tired himself out to finish the Evangelists in a little less than a year."[19] What is clear from these contentions is the haste of the Fathers to complete the task for the Holy Year, as well as a confrontation of two artists who were both highly skilled, but in different ways.

Domenichino's grace and equilibrium are surpassed by the pictorial splendor and dramatic movement of the skies in the *Glory of Paradise* that Giovanni Lanfranco painted in the dome; Bellori compared it to "full music, when all the sounds together form harmony."[20] In the same church, Lanfranco was also entrusted with

Domenichino
St. John the Evangelist
Rome, Sant'Andrea della Valle

Giovanni Lanfranco
Glory of Paradise
Rome, Sant'Andrea della Valle

painting the right transept altarpiece, which was dedicated to the patron saint of the Theatine Fathers, Sant'Andrea Avellino, beatified in 1624. The saint stands before the altar on which he places the chalice. Legible to only the most attentive viewer are the words emanating from his lips: "*Introibo ad altare dei.*" It is thus the precise moment of the Mass. The richness of his silver brocade cope covered with golden flowers contrasts with the ascetic thinness of his hands and hollow cheeks. A young priest in a white tunic supports the saintly priest in ecstasy, his eyes lost in a miraculous vision, while the space above is rent by the flight of angels and cherubim bathed in a solar light. The work signals Lanfranco's return to his Parma origins and to the style of Correggio, as shown in the gentle rendering of the celestial beings and the splendor of divine light.

Lanfranco emerged as the star of

this Jubilee. The new trends in taste converged on him and he received other important commissions. One of these was for the Chapel of the Santissimo Sacramento in the basilica of San Paolo fuori le Mura, a painting that today is unfortunately divided among various collections, among them the Getty Museum in Malibu.[21] Cardinal Scipione Borghese, perhaps advised by Ferrante Carlo, a refined connoisseur and admirer of Lanfranco,[22] commissioned the Parma painter to fresco the loggia on the second floor of the Casino Pinciano, today the Borghese Gallery.[23] In that space, which was originally open air, Lanfranco painted *The Assembly of the Divinities at Olympus,* an ethereal theme and thoroughly appropriate subject.

Scipione Borghese's patronage included another high-ranking artist: Gian lorenzo Bernini, the foremost interpreter of the encounter between Baroque religiosity and the splendor of pagan mythology. Bernini's marble sculptural group *Apollo and Daphne,* executed between August 1622 and November 1625, embodies a page out of Ovid's *Metamorphosis.* In those years he also produced the *Rape of Persephone* and *David,* a masterpiece in which the sculptor portrayed himself, giving David an age that was less adolescent than usual. According to legend, Cardinal Maffeo Barberini, who was soon to become pope, held the mirror in front of the artist as he shaped his own face.[24]

Bernini's statue of Santa Bibiana in the church of the same name is linked to the Jubilee inasmuch as Bernini received a payment for the acquisition of the necessary marble on August 10, 1624.[25] But the renovation of this tiny Early Christian church (fourth or fifth century) also marked Bernini's debut as an architect.[26] And when the body of Santa Bibiana was discovered under the main altar (along with that of her sister, Santa Demetra, and their mother, Santa Dafrosa), it was a clamorous event. Urban VIII saw to it that his

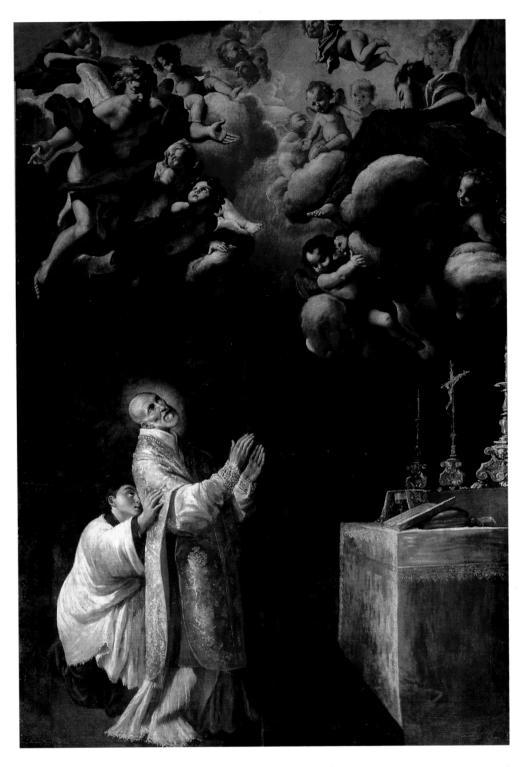

own name and the jubilee year 1625 were engraved on the three entrance doors. Pietro da Cortona and Agostino Ciampelli were commissioned to decorate the walls of the central nave with stories of the saint.[27] They also produced paintings for the chapels to the right (Cortona) and left (Ciampelli) of the main altar. Ciampelli was also responsible for the *Angel Musicians* just inside the main façade.

In another Early Christian church, Santi Quattro Coronati, Giovanni da San Giovanni frescoed the apse with *Stories of the Martyrs of Pannonia* and *Stories of the Four Crowned Saints,* and the calotte of the apse with a triumphal *Glory of All the Saints*. Underneath the latter work he placed his signature and the date 1623, the year Urban VII ascended to the pontificate. The work was supervised by the donor, Cardinal Giovanni Garzia Mellini.[28]

In conclusion, one might argue that the main protagonists involved in the decorations executed for the Jubilee of 1625 (that is, Bernini, Lanfranco, and Pietro da Cortona), were

Giovanni Lanfranco
Sant'Andrea Avellino
Rome, Sant'Andrea della Valle

Above, left:
Gian Lorenzo Bernini
Santa Bibiana
Rome, Chiesa di Santa Bibiana

Above, right:
Gian Lorenzo Bernini
Apollo and Daphne
Rome, Borghese Gallery

exponents of the High Baroque, while classical artists (such as Domenichino) continued to obtain important commissions but seemed to be losing ground. Nicholas Poussin had just arrived in Rome but had not yet succeeded in making himself known, while Simon Vouet, the interpreter of the French tendency toward a harmoniously expressive language still controlled by ancient canons, had made a name for himself with his *Temptation of St. Francis* in San Lorenzo in

Lucina, a work that revealed the latent sensuality of Counter-Reformation mysticism. Meanwhile, favored by the Bolognese pope Gregory XV Ludovisi (1621-23), the young Guercino had appeared on the Roman scene. He was commissioned to paint an altarpiece for the chapel of St. Michael and St. Peter, which he finished in the spring of 1623.[29] The huge canvas depicting the *Burial of Saint Petronilla* (today in the Pinacoteca Capitolina) attests to both the continuity and the renewal of

150

the Emilian school of painting. Today, we look with great interest at the pictorial masterpieces left to us by the Barberini pope and the cardinals surrounding him. Together with the architectural and town planning projects they undertook, these works demonstrate the taste and style of those men as well as the foundations of our own culture.

[1] T. M. Alfani, *Istoria degli Anni Santi dal dì del loro solenne cominciamento per insino a quello del Regnante Sommo pontefice Benedetto XIII* (Naples 1725) G. Moroni, *Dizionario di erudizione storico-ecclesiastica* (Venice 1857), vol. 86; L. Fiorani, "Le visite apostoliche del Cinque-Seicento," in *Ricerche per la storia religiosa di Roma* (1980): p. 53ff.; M. Fagiolo, and M. L. Madonna, *L'arte degli Anni Santi* (Milan 1984); M. Fagiolo, and M. L. Madonna ed. *Roma 1300-1875: La città degli Anni Santi. Atlante* (Milan 1985); M. A. Visceglia, "Giubilei tra pace e guerre (1625-1650)" in *Roma Moderna e Contemporanea* 5, no. 2/3 (1997): 431-74, S. Cabibbo, *Civilité e anni santi: La santa opera di albergar li pellegrini nelle cronache dei giubilei (1575-1650)*, pp. 405-30.

[2] P. Portoghesi, *Roma barocca* (Rome, Bari 1973) vol. 1, pp. 148-49.

[3] H. Brauer, and R. Wittkower, *Die Zeichnungen des Gianlorenzo Bernini*, 2 vols. (Berlin 1931); M. and M. Fagiolo, *Bernini* (Rome 1967); I. Lavin, *Bernini and the Unity of the Visual Art* (New York 1980); F. Borsi, *Bernini architetto* (Milan 1980).

[4] G. B. Passeri, *Vite de' pittori scultori et architetti che anno lavorato a Roma, morti dal 1641 fino al 1673* (Rome 1772), ed. J. Hess (Leipzig 1934), p. 248.

[5] D. Dombrowski, "Addenda to the Work of Giuliano Finelli," *Burlington Magazine* 140, no. 1149 (1998): 824-28.

[6] For news about the Barberini family and their palaces, see L. Mochi Onori, *Palazzo Barberini. Origine e sistemazione del museo* (Rome 1998).

[7] T. Alfarani, *De Basilicae Vaticanae antiquissima et nova structura*, ed. M. Cerrati (Rome 1914).

[8] E. Battisti, "Il significato simbolico della Cappella Sistina," *Commentari* 8 (April-June 1957); M. Calvesi, *Le arti in Vaticano* (Milan 1981); S. Danesi Squarzina, "La Sistina di Sisto IV e l'eredità del pensiero religioso medievale," in *Ricerche sul '400 a Roma: Pittura e Architettura*, lectures for the History of Modern Art I, vol. I, a.a. 1990/91, Istituto di Storia dell'Arte, Facoltà di Lettere, University of Rome; S. Danesi Squarzina, "La Sistina di Sisto IV e l'eredità del pensiero religioso medievale," in *Le Due Rome del Quattrocento*, Congress Proceedings, ed. S. Rossi, and S. Valeri (Rome 1997).

[9] G. Briganti, *Il Palazzo del Quirinale* (Rome 1962); G. Briganti, M. Del Piazzo, and V. Garesio, *Il Palazzo del Quirinale* (Rome 1973); T. Pugliatti, *Agostino Tassi tra conformismo e libertà* (Rome 1977); L. Laureati, and L. Trezzani, *Il patrimonio artistico del Quirinale: Pittura antica, La decorazione murale* (Roma 1993).

[10] A. Bosio, *Roma sotterranea (1632)* ed. G. Severano (Rome 1998).

[11] I. Herklotz, "Francesco Barberini, Nicolò Alemanni and the Lateran Triclinium of Leo III: an episode in restoration and Seicento medieval studies," in *Memoirs of the American Academy in Rome* 40 (1995): pp. 175-96; A. M. Jezzi, *Lo studio e la conservazione di antichità cristiane nella Roma del Seicento: Il mecenatismo del Cardinal Francesco Barberini (1597-1669)*, graduation thesis, University of Rome, La Sapienza, 1999.

[12] N. Alemanni, *De Lateranensibus parietinis*, engravings by M. Greuter (Rome 1625); B. Agosti, "Il cardinal Federico Borromeo le antichità cristiane e i Primitivi," in *Annali della Scuola Normale Superiore di Pisa* 2 (1992): 481-93.

[13] *Bullarium romanum* (Rome 1638), vol. 4, *Indictio Iubilaei*, May 16, 1624: the ecclesiastics are invited to announce the Jubilee, to pacify fights and anger, and to give a good example; the new emperor is asked to be zealous and favor the pilgrims.

[14] R. E. Spear, *Domenichino*, 2 vols., (New Haven 1982); *Domenichino 1581-1641*, ed. R. Spear, and A. Tantillo (Milan 1996).

[15] G. Bellori, *Le vite de' pittori, scultori e architetti moderni* (Rome 1672) ed. E. Borea (Turin 1976), p. 361, and no. 6. Zaccolini's manuscript is at the Biblioteca Laurenziana of Florence, Ms. Laur. Ash. 1212, 1-4: see C. Pedretti, "The Zaccolini manuscripts," *Bibliothèque d'Humanisme et Renaissance* (1973): 39-53; see also E. Cropper, "Poussin and Leonardo: Evidence from the Zaccolini MSS," *Art Bulletin* 62 (1980): 570-83. The restoration of Domenichino's frescoes was directed by M. G. Bernardini; those by Lanfranco by A. Costamagna; both were executed by the laboratory of the Soprintendenza ai B.B.A.S.

[16] E. Schleier, *Disegni di Giovanni Lanfranco* (Florence 1983); E. Schleier, "Disegni inediti del Lanfranco," in *Antichità Viva* 22 (1983): 40-49.

[17] Bellori, *Le vite*, p. 341, 382. For the payments to Lanfranco, see H. Hibbard, "The date of Lanfranco's Fresco in the Villa Borghese and other Chronological Problems," in *Miscellanea Bibliotecae Hertzianae* (1961), p. 364.

[18] Passeri, *Vite*, p. 382.

[19] Spear, *Domenichino*, p. 242; Bellori, *Le vite*, p. 341.

[20] Bellori, *Le vite*, p. 384.

[21] E. Schleier, "Lanfrancos Malereien der Sakraments—Kapelle in S. Paolo fuori le mura in Rom: das Wiedergefundene Bild des "Wachtelfalls," in *Arte Antica e Moderna* 29 (1965): 62-81; 30 (1965): 188-64; 31 (1965): 343-64; E. Schleier, "Lanfrancos 'Elias und der Engel' und der Bilderzyklus der Sakramentskapelle von San Paolo fuori le Mura in Rom," *Bulletin van het Rijksmuseum* 18 (1970): 3-33; L. Ficacci, "Lanfranco e la nascita del 'Barocco,'" in *Bernini scultore: La nascita del Barocco in casa Borghese*, ed. A. Coliva, and S. Schütze (Rome 1998): 332-88.

[22] The description that Bellori gives of the dome frescoed by Lanfranco is taken from Ferrante Carlo: N. Turner, "Ferrante Carlo's 'Descrittione della Cupola di S. Andrea della Valle depinta dal Cavalier Gio. Lanfranchi': A Source for Bellori's Descriptive Method," *Storia dell'Arte* no. 12 (1971).

[23] Ficacci, "Lanfranco," with bibliography.

[24] M. Winner, "Ratto di Proserpina," in *Bernini scultore*, pp. 180-230. see, in the same catalogue, R. Preimesberger, "David," pp. 209-19; A. Coliva, "Apollo e Dafne," pp. 252-75; M. Minozzi, p. 441.

[25] O. Pollak, *Die Kunsttättigkeit unter Urban VII*, 2 vols. (Vienna 1928), vol. 1, pp. 22-30.

[26] F. Borsi, *Bernini architetto* (Rome 1980); A. Blunt, *Guide to Baroque Rome* (London 1982).

[27] G. Briganti, *Pietro da Cortona o della pittura barocca* (Florence 1982), p. 168, for the stories of S. Bibiana by P. da Cortona and A. Ciampelli; for the payments to Cortona (1624-26), see Pollak, *Die Kunsttäggittkeit*, vol. 1, p. 561.

[28] A. Banti, *Giovanni da San Giovanni: Pittore della contraddizione* (Florence 1977).

[29] Pollak. *Die Kunsttaggittikeit*, vol. 2, p. 564.

Guercino
Burial of Saint Petronilla
Rome, Pinacoteca Capitolina
(formerly in the Basilica of St. Peter's, Chapel of St. Michael)

INNOCENT X, BORROMINI, AND VIRGILIO SPADA

Caterina Volpi

In January 1655, while the body of Pope Innocent X (Giovanni Battista Pamphili) lay putrifying in the cellar, Olimpia Maidalchini and her son Camillo Pamphili argued about who should be burdened with the honor of carrying the coffin, and, worse, with the expensive funeral that was necessary for the high-ranking deceased.[1] The domination of the city of Rome by the pope and his family was characterized by financial difficulties, in particular the oppressive costs of maintaining a prestige that was acquired by election and necessitated by secular and spiritual events. Not even the coincidence of the grandiose Jubilee of 1650 had succeeded in rendering their extravagence more acceptable to the impoverished Roman population. And the men of culture that his predecessor, Pope Urban VIII Barberini, had protected had been pushed aside by Innocent X, a pontiff who had little interest in the arts, science, and literature.[2]

It may have been an oversight or simply the practical problems imposed by economic straits and unexpected events, but the contretemps over Innocent X's burial came as the last of a series of divisive incidents that marred the personal lives of the pope's family. Yet, the pontiff had been provident enough that in 1644, when still a cardinal, he began planning his final resting place. He chose to build a funerary chapel on the east side of Santa Maria in Vallicella, the church of the Oratory of St. Philip Neri, to whom the future pope was particularly devoted. Francesco Borromini designed a circular chapel for the tomb; a veritable ancient mausoleum, the grandiose rotonda was referred to as a Patheon in a memorial of the Oratorian Father Virgilio Spada. Among the practical doubts of the noble Oratorian, however, was why the Pamphili family needed a mausoleum, given that Giovanni Battista's only heir, don Camillo, was about to be named a cardinal, thus eliminating any idea of descendants.[3]

Giovanni Battista Pamphili (1574-

View of the Casino del Belrespiro

153

1655) never did have his Pantheon, and the events that occurred between 1644 and the year of his death would completely change his artistic, architectural, and dynastic plans. Don Camillo was indeed elected cardinal on December 12, 1644, but the Pope was forced to make a compromise a few years later, when his nephew appeared ready to give the family the descendant that Spada had wondered about. As for the mausoleum, it was postponed indefinitely. Instead of thinking too much about his own death, in 1644, Giovanni Battista was most likely participating in the funeral of the Marchese Ludovico Facchinetti, which took place in April. The funeral was organized by Cristoforo Segni and realized by Alessandro Algardi and Giovan Francesco Grimaldi at San Giovanni e Petronio, the church of the Bolognese community in Rome, which was decorated for the occasion with a new façade made of four skeletons, two pyramids, the personifications of two rivers, and, in the center, the figure of Fame in flight to the sound of a trumpet.[4]

Between 1644 and 1650, Rome celebrated the election of the new pope and prepared for the Jubilee. The city was enhanced with new forms, ephemeral and eternal, to welcome the pilgrims and to greet the illustrious rulers and ambassadors who would flock to the city for the Holy Year. Architects, painters, and sculptors were mobilized to restore the slightly faded image of the center of Christendom. With its symbols and spectacle, the ephemeral was perhaps the most significant form of self-representation of the "new" Rome and the new pope. Two statues in stucco, *Peace-loving Rome* and *Triumphant Rome,* greeted the newly elected Innocent X at the foot of the Capitoline Hill on November 23, 1644, during his ceremony of "possession." On the following day, massive floats depicting *Noah's Ark* (at Piazza Navona) and *Triumphant Rome* (in front of Palazzo Borghese)

continued the festivities surrounding the papal cavalcade.[5]

The opening of what was described as an "Innocent golden age" was also commemorated by various artists through their personal contributions, which may have been suggested by the pope or may perhaps have been an effort by the artists to ingratiate themselves with the new patron. In 1644, Pietro Testa (1612-1650) made an engraving of an *Allegory in honor of Innocent X* in which Peace, Justice, and Purity are indicated as the virtues of the newly-elected pope. According to the ingenuous hopes of the artist, Pope Innocent X was destined to chase away vice, poverty, and avarice, and to install a prolific reign of the arts and wisdom.[6]

The apparatuses, the work sites, and the celebrations of that initial pontifical possession were indicative of the years to come. Innocent X would look on them as a model for the jubilee celebrations, while he, who was more qualified and inclined to choose counselors and artists than aesthetic theories and works of art, would willingly delegate the planning of the new projects for the Holy Year to people like Virgilio Spada, Cristoforo Segni, Francesco Borromini, Pietro Testa, Alessandro Algardi, and Giovan Francesco Grimaldi.[7]

Giovan Francesco Grimaldi
The façade of San Giovanni e Petronio decorated for the funeral of Ludovico Facchinetti
Bologne, Biblioteca Comunale dell'Archiginnasio

154

Shortly after his election, Innocent X nominated the Oratorian Father Virgilio Spada (1596-1662) as his private almoner and supervisor of the pontifical fabrics.[8] It was a nomination that would be instrumental in the development of the Pamphili buildings, and the ascent of the architect Francesco Borromini (1599-1667), Spada's friend and protégé. As Connors has pointed out, the building of the Vallicella was as crucial for Spada as it was for Borromini.[9] It cemented the friendship and collaboration between the two, refining Spada's abilities as architectural consultant while certifying Borromini's skills as a designer. Borromini emerged from the building of the Oratory (1636-52) with a perfectly mature architectural language, one that he would use with variations in the later Pamphili buildings. He also profited from the suggestions offered by the animated scientific and cultural community that had flourished in the Oratorian circle since the beginning of the century, and which was now protected and encouraged by Spada's activity.[10]

Father Virgilio Spada's background, like that of his brother, Cardinal Bernardino, was characterized by an extraordinary interest in the sciences and mathematics. In 1622, he became a member of the congregation, and probably came into contact with the researchers, archeologists, and scientists who were active in Pope Urban VIII Barberini's Rome. Now, some twenty years after Galilei's censure and the new cultural policy of the Church started by Urban VIII, certain interests might have aroused perplexity and suspicions, but neither of the Spada brothers was about to give up his passion for astronomy. In 1644, Bernardino had the painter Giovan Battista Magni paint a meridian in the gallery of his new palace, since he wished to compete with the princely Roman residences frescoed with the chariots of Apollo and Aurora.[11] And the following year, Virgilio commissioned his own favorite painter, Nic-

colò Tornioli (1598-1651), who had painted the frescoes for the Oratorians in 1643, to paint *The Astronomers,* which was almost a figural thesis about Copernico's heliocentric theory and Galileo's discoveries.

Evidently, the election of a new pope in 1644 revived hopes for a recovery of scientific activity, which was once promoted in Rome by the Academy of the Lincei, but which had been relegated to Florence thanks to the auspices of Grand Duke Leopoldo de' Medici (1617-75). The Pamphili pope was not about to concern himself with Roman scientific culture and its future, but at times this could be an advantage for research. When the Grand Duke of Tuscany asked to intercede with the pope in 1650 to revoke the anathema against Galileo Galilei's *Dialogue on the Two Principal Systems of the World* (1632), Spada optimistically replied that he deemed the task "a facile success" given that "His Holiness's genius is alien to mathematical things, which he does not consider at all." Spada's hopes proved to be too optimistic, however. The Pope accepted Leopoldo's gifts of Guercino's painting of the *Sleeping Endymion* and Galileo's telescope, but ignored the issue of the revocation.[12]

Spada's wry comment about the pope's limited mathematical gifts probably referred to an episode that had occurred six years earlier, during the building of the Villa Pamphili outside of Porta San Pancrazio (1645-48). Innocent X always showed remarkable faith in the practical and organizational qualities of the Oratorian Father, who supervised the building works. But he regarded Spada's archeological and astronomical passions as incomprehensible and fantastic eccentricities. Thus, in 1644, when Spada sent Pamphili and his nephew a project for the Casino del Belrespiro, together with two designs by Borromini, Pamphili was thoroughly confused by the explanation, which illustrated Spada's "curious, studious and most modest thought for a building [that] should

be a study of practical mathematics." The erudite Oratorian's had proposed as the model Nero's *Domus Aurea*, arguing that the construction should follow the underlying mathematical and astrological principles therein. A zoological garden next to the building had also been planned "in the shape of Noah's Ark" crowned with a statue of the pope placed so that the sun "with its ray on September 15 may kiss the foot of the statue at the hour he was made Pope."[13] As a matter of fact, the idea of the Casino as a cosmos was more suitable for a private residence. It reflected the taste for collecting and

in the Falconieri Palace on Via Giulia (1650-56), where the symbols based on astronomical motifs on the white ceilings of the rooms succeed in combining the "curious and studious thought" with elegance and formal purity.[16] But in the case of the Villa Pamphili, the project did not reflect an idea of magnificence appropriate for a papal residence, as Bene has justly noted.[17] It may also have been perceived as too much irrelevant solar symbolism, so Innocent X quickly set it aside, and his nephew, after consulting Bernini, gave the commission to Girolamo Rainaldi and Alessandro

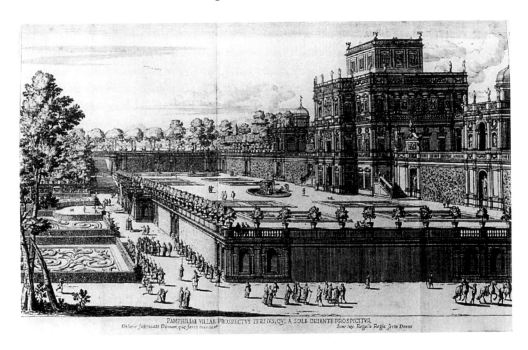

PAMPHILIAE VILLAE PROSPECTVS TERTIVS,QVI A SOLE ORIENTE PROSPICITVR

curiosity cabinets (using one's private study to house ancient objects and natural and scientific rarities) that Spada later pursued at the Vallicelliana Library, while the Jesuit Father Athanasius Kircher (1602-80) did the same at the Collegio Romano.[14]

Francesco Borromini was influenced by the research conducted in such scholars, and, on at least two occasions, collaborated in creating iconographies that drew inspiration from science, mathematics, and astronomy. One was the famous perspective in the Gallery of Cardinal Bernardino Spada, conceived by the mathematician Fra Giovanni da Bitonto (1652-53),[15] the other was the design for the stucco decorations

Algardi. They created a building of classical and noble elegance, a villa on the Renaissance plan in which the ancient did not constitute a symbolic and mathematical model but merely provided an ornamental covering. Even the stuccoes echoed the papal casino par excellence, that of Pius IV at the Vatican.

Spada was also employed by the pope to supervise the building of the palace at Piazza Navona and, above all, for the renovation of St. John Lateran, where, once again, he collaborated with Borromini. The latter project was perhaps the most emblematic and challenging of all the works undertaken for the Jubilee celebrations of 1650. By using alchemy and

Dominique Barrière
Casino del Belrespiro

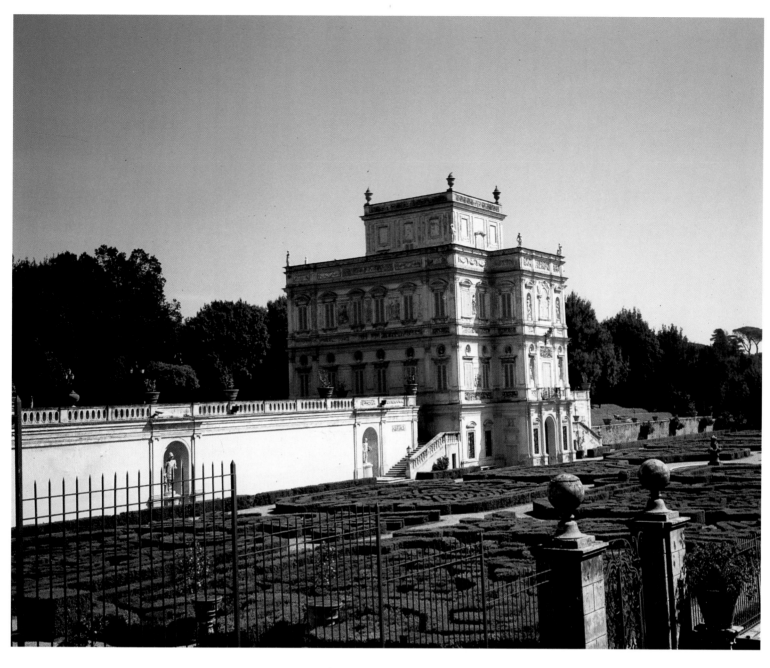

Above:
View of the Casino del Belrespiro

Pages 158-159:
Francesco Borromini
Interior of St. John in Lateran

great architectural expertise, Borromini managed to overcome the limitations that the pope had imposed, respecting the preexisting medieval construction and leaving the Cinquecento ceiling intact. Innocent X's desire to keep the primitive Constantine structure of five naves and wooden ceiling was determined in part by the fact that St. John Lateran was the *ecclesia mater*.[18] But this decision was also governed by considerations of a financial and practical nature, since less time and money was involved in a project of consolidation, restoration, and embellishment. From 1646 to 1650, the basilica was endowed with a new look by Borromini, who proved that he could give it

a new monumentality and decoration without betraying the pope's wishes or the scientific and archeological culture of his advisor, Virgilio Spada.[19]

While Spada and Borromini hurriedly prepared for the jubilee festivities, Camillo Pamphili returned to Rome after a brief absence following his marriage to Olimpia Aldobrandini in 1648. At home, he gave proof of an interest in art that was in striking contrast with that of his uncle. The prince was a connoisseur of architecture, with a marked preference for sculpture—in particular, that of his favorite, Alessandro Algardi—but he did not disdain painting. He was more enterprising than his uncle, with original tastes that tended

157

toward the genre of landscape and toward artists who were, in a certain sense, "marginal" to the Roman mainstream. Many of these artists he met through Niccolò Simonelli, his wardrobe keeper.[20] Camillo's variable tastes and the experimental nature of the formal researches that were going on in painting in Rome during the 1640s and 1650s are well illustrated in two decorative projects. These were commissioned from painters whom the prince and his wardrobe keeper had been supporting, but who were not used to public religious commissions or fresco painting.

"The noble breadth of Piazza Navona has been completed by the tearing down of the building that was before the Palazzo of the Signori Torres," reported Cassiano dal Pozzo in March 1647 to the future successor of Innocent X, Fabio Chigi, "and every day the magnificence and splendor of the public and private buildings continue to advance in this city."[21] Pressed by the coming Jubilee, the new General of the Carmelite Order, Father Giovanni Antonio Filippini, started to restore the church of San Martino ai Monti in 1648; although the inscription states "restored and

adorned" by 1650, it was actually concluded five years later.[22] The choice of decorating it with hermitic episodes from the lives of Elijah and Elisha made it possible to commission Gaspard Dughet to paint a series of landscapes. The prominence given to landscape painting in a sacred building was most likely based on practical considerations, such as cost and speed of execution. However, on the whole, the church, with altarpieces painted by Fabrizio Chiari, Jean Miel, Giovan Angelo Canini, and Pietro Testa, was, as Strinati has pointed out,[23] adorned like a sumptuous princely residence—rather like Prince Pamphili's new palace at the Collegio Romano.[24]

When the prince was given the Palace of Valmontone in 1651, he immediately summoned the best landscape artists in Rome. The same Gaspard Dughet, together with Agostino Tassi, Guglielmo Cortese, and Pier Francesco Mola frescoed the salon with allegories of the continents and elements, giving life to a new type of painting that was elegant and light.[25] However, in 1651, after squabbling with Mola about money, the prince, whose parsimony was famous, sud-

Gaspard Dughet
Landscape
Rome, Church of San Martino ai Monti

160

denly discharged the painter and replaced him with the Calabrian Mattia Preti, who was enjoying his first real public success.[26] Preti's participation in the Pamphili project (favored perhaps by Camillo's wife, Olimpia Aldobrandini, Princess of Rossano, as Cappelletti has theorized)[27] was an important event in the Roman world of art. The brilliant success of his frescoes in the apse of the church of Sant'Andrea merited a strong reaction, albeit negative, from Cassiano dal Pozzo in a letter to Fabio Chigi, the future Alexander VII, on June 3, 1651. In that letter he also listed the most important Jubilee projects. These included the tribune painted by Mattia Preti in Sant'Andrea della Valle (1650-51), the dome of the Chiesa Nuova painted by Pietro da Cortona (1647-50), and the Fountain of the Four Rivers in Piazza Navona by Gianlorenzo Bernini (1648-51).

The Cavalier dal Pozzo, an intimate of the Barberini and Chigi families, was more sympathetic to those artists who had already made names for themselves during the previous pontificate. He observed with a touch of nostalgia the difference between the Roman style of the 1620s, repre-sented at the moment of its greatest splendor by the "contest" between Domenichino and Lanfranco in the dome and apse of the Barberini church, and Preti's huge pictures, which, while respecting the preexisting works, had distorted the scale and the emotional impact of the stories painted by the two artists. According to Cassiano, Pietro da Cortona at the Vallicella, unlike Preti at Sant'Andrea, "does not conflict, there is only his painting, which he has perfected by changing it many times and ornamenting it, placing beautiful stuccoes in the middle together with an abundance of gold."[28] But Cassiano's enthusiasm was absolute when he went on to describe Bernini's fountain, promising Cardinal Chigi an engraving and some literary compositions of "the most noble fountain that the Pope has had the sculptor Bernini make in order to adorn the obelisk in Piazza Navona and beautify the latter. It is truly the most noble and extraordinary fountain that has ever been seen in Italy."[29]

Bernini was doubly victorious with the Fountain of the Four Rivers: he triumphed over his competitors, whom the pope had previously favored, and

he conquered the engineering and hydraulic problems which involved new conduits for the Acqua Vergine. As a reward, he won praise and financial recognition from the pope who had kept him on the sidelines for so long.[30] In 1623, Bernini had already received a lifetime commission making him responsible for the conduits of the fountains of Piazza Navona. But Innocent X had also asked Borromini to solve the problem of the conduits, the obelisk, and the fountains. In a guidebook written by Fioravante Martinelli, Borromini noted that he himself had "conducted the water and came up with the idea of leading it to the spire and decorating it with a pedestal in the shape of a shell in which four low reliefs were sculpted with the four most famous rivers of the world and with other ornaments from Padre Virgilio Spada, which was later given to the Cavalier Bernini on the insistence of the Signora Donna Olimpia Pamphili, and it was adjusted with his design to the form now seen."[31] This information, corroborated by a drawing of a fountain by Borromini[32] preserved in the Spada papers, is of great interest because it attributes the iconographic invention of the four rivers to the well-known collaboration between Spada and Borromini.

Bernini later modified their invention by adding other symbols and using his own artistic ingenuity to transform the simple monument into a grandiose work of art. The final version is rich in scholarly references to the ancient based on the contemporary studies of the Jesuit Father Athanasius Kircher (1602-80), and is a clear allusion to modern Rome as the center of the world under Pope Innocent X.[33] Thus, the influence on Bernini of Kircher (who, in 1650, was publishing his *Obeliscus Pamphilius*

Nicolas Poussin
Moses Saved from the Waters
Oxford, Ashmolean Museum

163

about the symbolism in the fountain at Piazza Navona) must be added to the original motif of the four rivers, elaborated by Borromini and Spada, who got the idea from *Roma sotterranea*, an important treatise that was republished in 1650.[34]

In 1632, an Oratorian Father, Giovanni Severano da San Severino, had completed and published *Roma sotterranea* by Antonio Bosio, a key text and one that still merits investigation.[35] Bosio dealt with "the precious treasures, like things in sacred cemeteries:

Nicolas Poussin
Moses Saved from the Waters
Paris, Musée du Louvre

reported by Bosio is "the image of Our Lord above a mountain, from which flow four rivers," and the explanation reads, "Innocent the Third then applies the fountain of Paradise to the Holy Scriptures which like them divides into four rivers, as the Scriptures have four senses."[37]

In the center of the race circus of Christian Rome, the Egyptian obelisk became the symbol of divine and earthly power conferred by Our Lord on His Vicar on earth, Pope Innocent X. The pope's power extends over the four continents of the world in the same way that the fountain of Paradise divides into four rivers in the eternal city. The obelisk was an obvious reference to the ancient Egyptian civilization, which, through Moses, was established as a foundation and premise for the triumph of Christianity throughout the world. But it was also a new landmark in the city together with the obelisks that Sixtus V had had erected (1585-90) to properly celebrate the religious festivities at various high points along the pilgrims' route through the holy city. This incredible visualization of the spiritual and earthly power of the pope, as God's Vicar and the head of Christianity, and of the triumph of the Christian religion in the world, the heir to the Egyptian civilization, was an unsurpassable milestone, reaffirming not only Bernini's success but also that of the principal Egyptologist of the times, the Jesuit Father Athanasius Kircher.

From Munster, where he received news from his friend Cassiano dal Pozzo and where he met the learned Kircher's brother, Fabio Chigi (1599-1667) set out for Rome a few years after the Jubilee. According to documents, he had a long visit in 1654, accompanied by Cardinal Azzolini, at the Pamphili Palace in Piazza Navona.[38] Following the publication of his *Obeliscus Pamphilius* and his more recent *Oedipus Aegyptiacus* (Rome 1652-54), Kircher had become so famous as an Egyptologist that he was the protagonist of what

real ideas and images that represent realistically the nascent church: theaters, and race circuses, where the Christian gladiator saints prepared and exercised in order to win prizes and earthly crowns."[36] Among the various images of the primitive church

can only be described as a mania for Egypt.[39] Kircher had arrived in Rome in 1633 with a recommendation from Nicholas de Peiresc (1580- 1637), an antiquarian in Aix-en-Provence, which enabled him to join the Barberini circle and earn the favor of Cassiano dal Pozzo.[40]

Kircher's first contacts with Nicolas Poussin, the painter favored by Pozzo, probably date back to those years. It is probably also not coincidental that Poussin's paintings with "Egyptian" themes are concentrated in the decade that Kircher was at the height of his activity, and in close proximity to the realization of the fountain at Piazza Navona, that is between 1647 and 1657. In 1654, Poussin sent his painter friend Jacques Stella a painting titled *Moses Saved from the Waters* (today in Oxford).[41] As Rubinstein has attentively pointed out, the principal source that explains the physical embrace between the figure of the Nile and the sphinx in the right foreground, and the presence of the Nile meter, the bow and arrows, and the

panpipes hanging on the branch behind the strange couple is undoubtedly *Oedipus Aegyptiacus*, with its illustrations and syncretistic explanations of the Egyptian myth.[42] In the painting of Moses, Poussin confronted the theme of the Nile floods and fertility, which, as has been noted, is also present in Bernini's fountain. He also alludes to the passage from Egyptian civilization to Christianity through the figure of Moses, who prepared and announced the advent of the new kingdom. Charles Dempsey has already underscored a singular fact in Poussin's works, the historical incongruity of the Roman monuments in the background of the Oxford painting.[43] But the cumbersome presence of Castel Sant'Angelo, which Moses's sister Miriam indicates with a gesture that refers to Arpocrate's silence about the sacred mysteries, also alludes to the Pharaoh's palace, in this case the tangible symbol of the destiny and task to which Moses has been called.

In the same year that the Fountain of the Four Rivers was inaugurated,

Raffaello, G.L. Bernini and others
Egyptian cenotaphs
Rome, Santa Maria del Popolo
Chigi Chapel

Poussin finished another painting with Moses as its subject. In this work, destined for Bernardin Reynon, Poussin repeated the Nile-Sphinx couple in an obvious relationship with the flooding river, but this time placing it above a rocky arch flanked by palm trees, which seems to echo the mountain sculpted by Bernini in Piazza Navona.[44] A further allusion to the Pamphilis is the sacred door on the left in the background, which was taken, as Dempsey has pointed out, from the frescoes of the colombarium discovered during the building of the villa outside of Porta San Pancrazio.[45] The collaboration, or parallelism, of Poussin's and Kircher's research continued until 1655, and was concentrated on the Palestrina mosaic of the Nile. The German antiquarian wrote a complex description and interpretation of the mosaic in the *Oedipus Aegyptiacus*, and it was one source of inspiration for the French painter's beautiful work *The Rest on the Flight into Egypt*, executed between 1655 and 1657 for Mme de Montmort.[46]

Fabio Chigi must have followed his learned friend Kircher's research with great interest, as the pyramids were not only of historical interest to him, but also of personal and family interest. Raphael had decorated his famous ancestor's chapel in Santa Maria del Popolo with two Egyptian cenotaphs, and on the occasion of the Jubilee of 1650, the cardinal asked that they be restored by Bernini. On becoming pope, Chigi renewed Innocent X's project, commissioning Bernini to create a proper installation for the *Obeliscus Alexandrinus* in Piazza della Minerva, and asking Kircher to resume his written project regarding the new symbol of the pope's power and wisdom.[47]

The Jubilee of 1650 left Roman citizens with empty pockets, the pontiff with undiminished popularity, and the city of Rome transformed into a theater for festivities. Obelisks and pyramids had been decorated with figures of totally Baroque rhetoric which were designed as a reminder of the divine origins of papal primacy and the Holy See and of the universality of the Church whose immutable laws derived from the very foundations of civilization. If the greatest artists of the century had not been able to provide a concrete image for the triumph of that ideology, the Church would never have been able to acquire so much strength.

Nicolas Poussin
Moses Saved from the Waters
Londra, The Trustees of the National Gallery at Cardiff, The National Museum of Wales

I would like to thank Alberto Campitelli, Stefania Macioce, and Alessandro Zuccari for their help and advice.

[1] F. Haskell, *Mecenati e pittori. Studio sui rapporti tra arte e società italiana nell'età barocca* (Florence 1980), pp. 234-41.

[2] During the works at Piazza Navona, there was a flourishing of pasquinades and protests from the people: "We want other things besides spires and fountains, we want bread; bread, bread, bread." See ibid., p. 240.

[3] For the project of the mausoleum and its history, see J. Connors, *Borromini e l'Oratorio romano: Stile e società* (Turin 1989), pp. 292-94.

[4] For the funeral apparatus of Ludovico Facchinetti, see M. Fagiolo, *La festa barocca* (Rome 1997), pp. 321-26; and C. Johnston in *Algardi: L'altra faccia del barocco*, ed. J. Montagu (Rome 1999), pp. 234-39.

[5] Fagiolo, *La festa barocca*, pp. 329-68.

[6] E. Cropper, ed. *Pietro Testa (1612-1650) Prints and Drawings* (Philadelphia 1988), cat. nos. 85-86.

[7] For Innocent X's lack of interest in art, see F. Haskell, *Mecenati e pittori;* and F. Cappelletti, "Tra gl'ozi delle scarse occasioni. I Pamphili e gli artisti durante il pontificato di Innocenzo X," in *Algardi. L'altra faccia del barocco* (Rome 1999), pp. 41-48.

[8] Regarding Virgilio Spada, see F. Ehrle, "Dalle carte e dai disegni di Virgilio Spada (+ 1662) (Codd. Vaticani lat. 11257 and 11258)," *Atti della Pontificia Accademia Romana di Archeologia. Memorie,* vol. 2 (1928), pp. 1-98; L. Neppi, *Palazzo Spada* (Rome 1975); R. Cannatà and M. L.Vincini, *La Galleria di Palazzo Spada: Genesi e storia di una Collezione* (Rome 1992); and, above all, Connors, *Borromini e L'Oratorio romano* (esp. pp. 144-51 and 192-96).

[9] Conners, *Borromini*, pp. 144-51.

[10] For the scientific and archeological interests of the Oratorian circle around Borromini and, above all, with regard to some of the architect's works, see A. Zuccari, "Borromini tra religiosità borromaica e cultura scientifica," in A. Zuccari, and S. Macioce, *Innocenzo X Pamphili. Arte e potere a Roma nell'Età Barocca* (Rome 1990), pp. 35-74; and S. Macioce, "La 'chiocciola' di S. Ivo alla Sapienza," in ibid., pp. 75-96.

[11] Regarding Bernardino Spada's patronage (1594-1661) and his collection of paintings and scientific instruments, among which were two globes made by the famous cartographer W, Janzoon Bleau, and a telescope decorated by Paolo Maruscelli, see Neppi, *Palazzo Spada;* and Cannatà and Vincini, *La Galleria di Palazzo Spada.*

[12] Virgilio Spada's letter to Leopoldo de Medici is quoted in Neppi, *Palazzo Spada.* For Leopoldo de Medici's patronage of the sciences, see in particular P. Galluzzi, "L'Accademia del Cimento: 'Gusti' del Principe, filosofia e ideologia dell'esperimento," *Quaderni storici* 48 (1972): 788-844. For the painting *The Astronomers* (Gallery Spada Rome) see M. L. Vincini in *La ragione e il metodo: Immagini della scienza nell'arte italiana dal XVI at XIX secolo*, ed. M. Bona Castellotti, E. Gamba, F. Mazzocca (Milan 1999), p. 148, with a preceding bibliography (where the origin of Tornioli's composition can be noted in the frontispiece of *Dialogo dei Massimi Sistemi*, engraved by Stefano della Bella). For Guercino's *Endymion*, see G. Capitelli, "Una testimonianza documentaria per il primo nucleo della raccolta della raccolta del principe Camillo Pamphili," in *I capolavori della collezione Doria Pamphilj da Tiziano a Velasquez* (Milan 1996), pp. 62-63; P. Tosini, *Immagine degli Dei. Mitologia e collezionismo tra '500 e '600*, cat., (Milan 1996), pp. 162-65; C. Volpi in *Scienza e miracoli nell'arte del '600. Alle Origini della medicina moderna*, ed. S. Rossi, (Milan 1998), pp. 76-77; and M. Carminati in *La ragione e il metodo. Immagini della scienza nell'arte italiana dal XVI al XIX secolo*, ed. M. Bona Castel-

lazzi, E. Gamba, F. Mazzocca (Milan1999), p. 118.

[13] For the Casino of the Belrespiro, see O. Raggio, "Alessandro Algradi e gli stucchi di Villa Pamphili," *Paragone* no. 251 (1971): 3-38; C. Benocci, *Villa Doria Pamphili* (Rome 1989); C. Benocci, "Camillo Pamphilij e la grande villa barocca: le componenti culturali," in *Le Virtù e i piaceri in Villa. Per il nuovo museo comunale della Villa Doria Pamphili*, ed. C. Benocci (Milan 1998), pp. 36-51; M. Benes, "Algardi a Villa Pamphili," in *Algardi. L'altra faccia del barocco*, (Rome 1999), pp. 49-60.

[14] For the museums of curiosities of Athanasius Kircher and Virgilio Spada, see *Enciclopedismo in Roma Barocca. Athanasius Kircher e il Museo del Collegio Romano*, Conference Proceedings (Venice 1986); Cannatà and Vincini, *La Galleria di Palazzo Spada;* Neppi, *Palazzo Spada;* Connors, *Borromini* (especially pp. 192-96); G. Incisa della Rocchetta Chigi Marchese "Il Museo di curiosità del Card. Flavio Chigi Seniore," *Archivio della Società Romana di Storia Patria, ser. 3,* vol. 20 (1967): 141-92.

[15] Neppi, *op. cit.;* M. Heimburgher Ravalli, *Architettura, scultura e arti minori nel Barocco Italiano. Richerche nell'Archivio Spada,* (Florence 1977), R. Cannatà, ed., *Palazzo Spada: le decorazioni restaurate* (Milan 1995).

[16] For the Falconieri Palace, E. G. Howard, *The Falconieri Palace in Rome. The role of Borromini in its reconstruction (1646-1649)* (New York 1981); E. Battisti, "Il simbolismo del Borromini," in *Studi sul Borromini* (Rome 1967), vol. 1, pp. 231-84; M. Tafuri, "Il palazzo e il palazzetto Falconieri" in L. Salerno, L. Spezzaferro, and M. Tafuri, *Via Giulia: una utopia urbanistica del '500* (Rome 1975), pp. 445-59. The interior decorations repeat the emblems depicting a radiant sun at the intersection of three crowns, and a shining eye above a scepter placed on a globe surrounded by a crown crossed by a serpent forming two spheres around a central axis surmounted by a sun.

[17] In Algardi. *L'altra faccia del barocco* (Rome 1999), pp. 316-18.

[18] For St. John Lateran, see A. Roca De Amicis, *L'opera di Borromini in San Giovanni in Laterano: gli anni della fabbrica (1646-1650)* (Rome 1995). For the symbolism underlying Borromini's restoration choices see M. Fagiolo, "Borromini in Laterano. Il Nuovo empio per il Concilio Universale," *L'Arte* 4 (1971), pp. 5-44; and Zuccari, "Borromini tra religiosità borromaica."

[19] Zuccari, "Borromini tra religiositá borromaica."

[20] For Camillo Pamphili's role as a patron, see Capitelli, "Una testimonianza documentaria," pp. 57-69; and Cappelletti, "Tra gl'ozi delle scarse occasioni."

[21] Cassiano dal Pozzo to Fabio Chigi, March 1, 1647; Rome, Corsini Library, Pozzo Archives XXI (18), ff. 123 r. and v. For the friendship between Cassiano dal Pozzo and Fabio Chigi, see F. Solinas, "Cassiano dal Pozzo (1588-1657): il ritratto di Jan Van der Hoecke e l'Orazione di Carlo Dati," *Bollettino d'Arte* 92 (1995): 141-64. For the construction of the "Isola dei Pamphili," see *Piazza Navona. Isola dei Pamphili* (Rome 1970).

[22] For S. Martino ai Monti, see A. Sutherland Harris, *Burlington Magazine* 56 (1964): 63-69, 117-20; M. N. Boisclair, *Gaspard Dughet 1615-1675* (Arthena 1985); C. Strinati, "Pietro da Cortona e Mattia Preti intorno al 1650," in Zuccari and Macioce, *Innocenzo X Pamphilij. Arte.*

[23] Strinati, "Pietro da Cortona."

[24] Cappelletti, "Una testimonianza documentaria."

[25] On Valmontone, see L. Montalto, "Gli affreschi del palazzo Pamphilij in Valmontone," *Commentari* 6 (1955): 267-302; on Mola and the Pamphili, see A. Mignosi Tantillo, "Un ciclo inedito di Pier Francesco Mola: gli affreschi del palazzo Pamphili a Nettuno," *Paragone* no. 471 (1989): 72-98; and *Pier Frnacesco Mola 1612-1666* (Milan 1989).

[26] Strinati, "Pietro da Cortona."

[27] Cappelletti, "Una testimonianza documentaria," pp. 46-47. M. Utili, "Lo stile plasticoluminoso, eclettico, di Mattia Preti," in *Mattia Preti tra Roma, Napoli e Malta*, ed. M. Utili (Napoli 1999), pp. 34-40.

[28] Cassiano dal Pozzo to Fabio Chigi, June 3, 1652, Rome, Corsini Library, Pozzo Archives XXI (18), ff. 143v.-144v.

[29] In C. Lumbroso, *Notizie sulla vita di Cassiano dal Pozzo* (Turin 1874), pp. 66-67.

[30] For the Fountain of the Rivers, see *Piazza Navona. Isola dei Pamphili*, pp. 80-90; R. Preimesberger, "Obeliscus Pamphilius," *Münchner Jahrbuch der Bildenden Kunst* 25 (1974): 77-162; C. D'Onofrio, *Acque e Fontane di Roma* (Rome 1977), pp. 450-502; M. Calvesi, "L'elefante con obelisco tra Colonna e Barberini," in Zuccari, and Macioce, *Innocenzo X Pamphili: Arte,* pp. 17-25; P. Portoghesi, "Borromini e Innocenzo X: architettura e politica pontificia," in *ibid.*, pp. 27-34; Fagiolo *La festa barocca*, pp. 149-63.

[31] Borromini's note is published in D'Onofrio, *Acque e Fontane* and Fagiolo *La Festa barocca*, p. 151.

[32] Borromini's drawing preserved in the Vatican Library, was published in Preimesberger, "Obeliscs Pamphilius." There are also fountain projects relative to Piazza Navona by Alessandro Algardi (in *Algardi. L'altra faccia del barocco*, cat. nos. 89-90, pp. 280-83) and P. Testa in Cropper, *Pietro Testa,* cat. no. 88, p. 189.

[33] For the iconography of the Fountain of the Rivers, see note 30.

[34] Kircher's importance with regard to iconography is underscored in Fagiolo *La festa barocca*, pp. 149-63; and M. Fagiolo *Jean Lemaire—pittore "antiquario"* (Rome 1996), pp. 106-16.

[35] For the influence of Bosio's work on Borromini, see Zuccari, "Borromini tra religiosità borromaica."

[36] A. Bosio, *Roma sotterranea. Compiuta, disposta e accresciuta dal P. Giovanni Severani da S. Severino* (Rome 1650), Introduction.

[37] Ibid., pp. 611-12.

[38] Chigi's visit is mentioned in a letter from Giovanni Sarti to Donna Olimpia and reported in R. Preimesberger, "Pontifex Romanus per Aeneam praesignatus. Die Galleria Pamphilij und ihre Fresken," *Romisches Jahrbuch fur Kunstgeschichte* 17 (1976): 221-87 (p. 247*)*.

[39] For a survey about the vogue for Egyptology in the Roman Baroque, see G. Cipriani, *Gli obelischi egizi: Politica e cultura nella Roma barocca* (Florence 1993).

[40] For the relationship between Kircher and Peiresc, see P. Findlen, "Claude Fabri de Peiresc and Other French Correspondents of Athanasius Kircher (1602-1680)" *Austrian Journal of French Studies* 9 (1972): 250-73; and J. Fletcher, "Athanasius Kircher and his correspondence," in J. Fletcher, ed. *Athansius Kircher und seine Beziehungen zum gelehren Europa seiner zeit* (Wiesbaden 1988), pp. 139-95.

[41] For an updated bibliography of the painting preserved at the Ashmolean Museum in Oxford, see *Nicolas Poussin, 1594-1665*, ed. P. Rosenberg (Paris 1996), pp. 415-33.

[42] R. Rubinstein, "Poussin et la sculpture antique," in *Nicolas Poussin (1594-1665)*, Actes du colloque (Paris 1996), pp. 415-33.

[43] C. Dempsey, "Poussin and Egypt," *Art Bulletin* 45 (1963): 109-19.

[44] London, National Gallery, and Cardiff, National Museum of Wales; see Rosenberg, *Nicolas Poussin, 1594-1665*, cat. no. 211.

[45] Dempsey, "Poussin and Egypt."

[46] For the painting, preserved in the Hermitage Museum in St. Petersburg, see Rosenberg, *Nicolas Poussin, 1594-1665*, cat. no. 223.

[47] In his *Obeliscus Alexandrinus,* published in 1666 concurrently with the monument conceived by Bernini and executed by Ercole Ferrata in Piazza della Minerva, Athansius Kircher interpreted the Egyptian monument as the form of divine power conferred on the pope directly by God and irradiating in four-sided fashion so as to reach the four continents; for a similar reading, the Jesuit obviously had to keep in mind Bernini's work of ten years before. That same year, Alexander VII saw to the restoration of the Pyramid of Caius Cestius, and Ottavio Falconieri, the erudite antiquarian and relative of Orazio Falconieri, and councilor of the pope, compiled a *Discorso di Ottavio Falconieri intorno alla piramide di C. Cestiuis et alle pitture che sono in essa* (Rome 1666). For the obelisk in the Piazza della Minerva in relation to Kircher's studies and counsel, see Fletcher, "Athanasius Kircher and his correspondence;" and Calvesi, "L'elephante."

THE DECORATION OF THE CHURCH OF THE GESÙ AND THE TWO TWIN CHURCHES OF PIAZZA DEL POPOLO

Marco Gallo

Baciccia (Giovanni Battista Gaulli)
Jesuit Saints' Vision of Paradise
Rome, Church of the Gesù

The progressive dismantling of the great building sites and the inexorable slowdown in undertaking new urban architectural and decorative projects marked the pontificate of Clement X (1670-76). If his pontificate may be considered the high point of the Baroque, it also marked the beginning of a period of austerity that led to a sort of artistic paralysis in Rome toward the end of the century. Cardinal Emilio Altieri was elected pope on April 29, 1670, when he was almost eighty years old, and when the political power of the papacy had been weakened considerably. The French king Louis XIV was playing a more dominant role on the European scene, and there was a momentary stasis in international relations following the "pace clementina," which the preceding pope, Clement IX, had stipulated with the Jansenists. In a certain way, the Jubilee was a celebration of that religious truce, although that policy would be criticized in coming years. Furthermore, at the time of the Jubilee, the papacy disapproved of

the current policy in France, then involved in a war with Holland (1672-78), and the Pope was being pressured to form a united western front in support of Poland and King John Sobieski against the eternal danger of Ottoman expansion.

In the preparations for a Holy Year characterized by austerity, the Pope was particularly concerned with two problems: the improvement of the road system linking Rome to the outside world and the restoration—in terms of a reaffirmation of Christianity (the Church) Triumphant—of civic areas that had significance in antiquity. On the one hand, great attention was paid to the maintenance of the consular roads and city streets, implemented through repairs and improvements as prescribed by special papal edicts. On the other hand, Bernini and his group—in the wake of their achievements at the beginning of the decade, such as the completion of the statues on the ancient Ponte Sant'Angelo—concluded the organi-

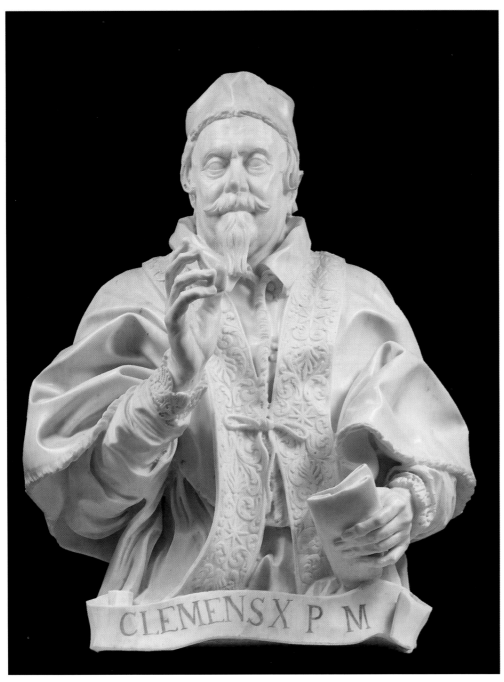

zation of St. Peter's Square with the installation of the second fountain and the last statues on the colonnade.

The Pope restored not only the Pantheon but also the Colosseum, which, after Cardinal Altieri's permission to hold bullfights in the arena was revoked in 1671, was given a new Christian designation. A cross was erected on the Colosseum and frescoes based on the iconography of the martyrs were added; Bernini was even charged with studying schemes (like the construction of a small temple in the center) for transforming it into a Temple of the Martyrs. Unfortunately, he missed out on finishing a major project of that period: although

Altieri had a monument erected in Santa Maria Maggiore to his predecessor Clement IX, he gave up the idea of building the grand new tribune in the basilica, which he had previously commissioned from Bernini. But, by far, the most important jubilee project was the Tabernacle of the Chapel of the Sacrament in St. Peter's, executed by Bernini and shown to the public at the opening of the Holy Year.

The elderly and sickly pope was frequently absent from the jubilee liturgical ceremonies. Also, the number of pilgrims was reduced by the ongoing French-Dutch war, making that Holy Year in a certain sense more low keyed than previous ones. In any

Gian Lorenzo Bernini
Half-Length Portrait of Clement X
Rome, Altieri Palace

case, the presence in Rome of Queen Christina of Sweden, who had been living in the city for twenty years ever since her conversion to Catholicism, stimulated the representatives of the European nations to celebrate the traditional feasts with particular solemnity. Six months after the closure of the Holy Year, the pontiff died, and the many portrait busts then being sculpted by the elderly Bernini appropriately remained unfinished.[1]

The most significant pictorial project of the Jubilee involved the decoration of the cupola, nave, and cross vaults of the Church of the Gesù. In view of the Jubilee and also the first centenary of the foundation of this church (due to occur in 1674), the Father General of the Jesuits, Giovanni Paolo Oliva, had been planning since 1671 to complete the building with a series of frescoes, which would culminate in a great work in the apse. These paintings he commissioned from Jacques Courtois, called the Borgognone, who was a member of the Society of Jesus. The frescoing of the presbytery and nave had been interrupted in 1589 by the death of the founder of the church, Cardinal Ales-

sandro Farnese. Although Farnese had long supported the decoration of the apse, none of his heirs completed the project. Further delays were caused by the Duke of Parma, Ranuccio II Farnese, who disputed the authorization of the works and the payment of the funds requested by the Jesuits, and by the death of Borgognone in November 1676.

Nonetheless, Oliva had signed a contract on August 21, 1672, with the Genoese painter Giovanni Battista Gaulli, called Baciccia (1639-1709), for the frescoing of the parts of the church that were not subject to Farnese patronage. According to the terms of the contract, in exchange for the conspicuous sum of 14,000 scudos, Gaulli had to fresco the dome (including the lantern and the pendentives) by Christmas 1674, and the nave and cross vaults by the end of 1682. Gian Lorenzo Bernini himself had recommended Gaulli, to the detriment of other important artists who aspired to the commission (including Carlo Maratta, Ciro Ferri, and Giacinto Brandi). Bernini had also supplied drawings for some of the subjects of the frescoes and helped to solve the numer-

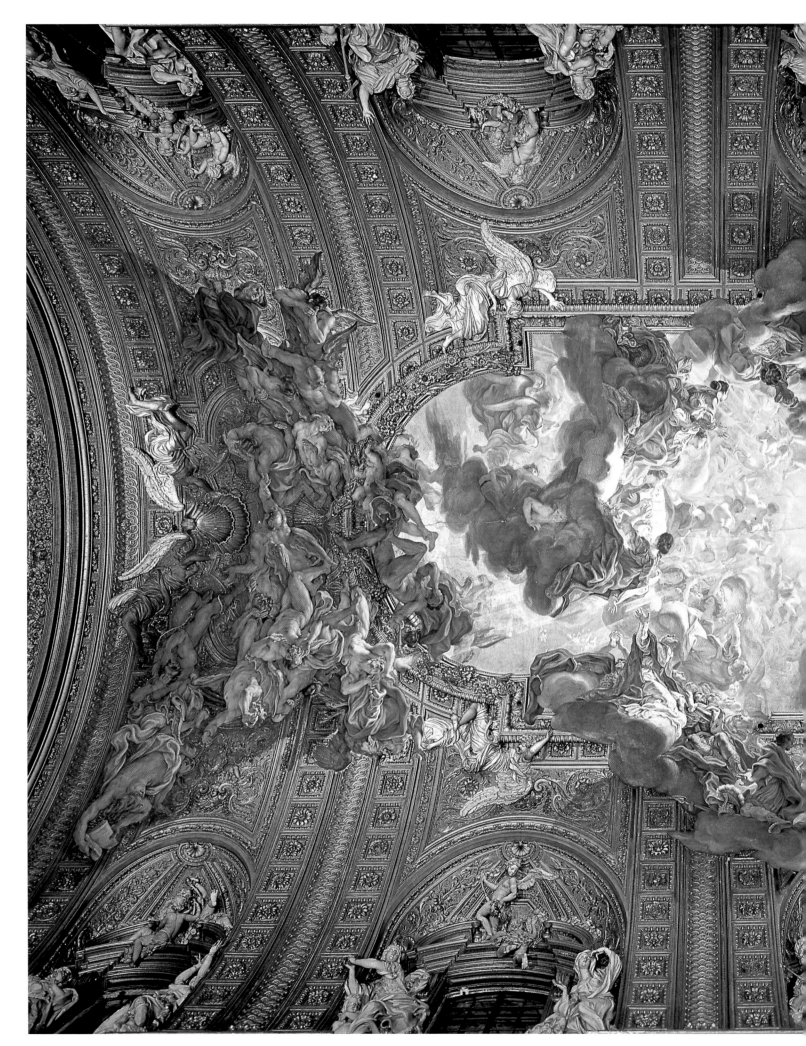

ous compositional difficulties involved in painting such a vast area.

The only fresco that Baciccia managed to complete in time for the Jubilee (fortunately assisted by the stucco decorators Ercole Antonio Raggi and Leonardo Reti) was the *Jesuit Saints' Vision of Paradise* in the dome. This was unveiled on April 14, 1675, while the artist was working on the four pendentives, which depict the *Four Evangelists,* the *Four Doctors of the Church,* the *Prophets of Israel,* and the *Military Leaders of Israel* (1675-76; the dome and pendentives have recently been restored). In the ensuing years, until 1685, Baciccia worked in the nave, first completing the grandiose *Triumph (or Glory) of the Holy Name of Jesus* (1676-79) on the ceiling; then the *Adoration of the Mystical Lamb* (1680-83) on the semidome of the apse; then the *Angelic Concert* (about 1683) on the ceiling above the high altar; and finally the *Glory of St. Ignatius* (1685) on ceiling of the left transept.

Although painted later, all these frescoes (with the exception of the apse, which Borgognone was meant to paint) had already been planned by 1672 and were part of an organic iconographic program, presumably conceived by Oliva himself. A theological expert and preacher, Oliva intended "to visualize the mediation between Heaven and Earth that Christ and his successors had carried out" (Fagiolo), while underscoring the apostolic zeal of the Jesuit missions (as evidenced by the presence and role of the three Jesuit saints in the dome). Further confirmation of the unity of the cycle is the fact that the saints and personages are not omnipresent, each appearing on the scene only once. Particularly innovative, although it follows in the tradition of the "celestial glories" first used

Baciccia (Giovanni Battista Gaulli)
Triumph of the Name of Jesus
Rome, Church of the Gesù

175

in the domes of Parma by Correggio, and later by Lanfranco and Pietro da Cortona in the Barberini Palace in Rome, is the invention of the *Triumph of the Name of Jesus* (the famous model of which is in the Galleria Spada in Rome). The use of a frontal viewpoint rather than the more usual upward looking one, and the construction of an architecture exclusively by light mark the climax of the Roman Baroque.

In this complicated allegory, members of the Farnese family are depicted with Cardinal Alessandro in the act of offering the model of the church. With them are the Wise Men, the personification of the Church, and behind them the damned fall into hell. It is a new kind of Last Judgment in which redeemed Humanity is attracted into the luminous vortex emanating from the monogram IHS, the symbol of the name of Jesus and the device of the Society of Jesus. The monogram also stands for St. Paul's verse "Ut in nomine Jesu omne genu flectatur cœlestium, terrestrium et infernorum" (Phil 2:10) (*At the name of Jesus every knee should bow – in heaven, on earth, and in the depths*), which is painted on the scroll held by the angels. Therefore, the conflict between good and evil takes place on earth and in history in the Name of Jesus, or rather, in the name of the Society of Jesus. In the Jesuit context, the Apocalypse (the true subject of the apse fresco)—now shown without any eschatological contrasts, since they have been resolved by the actions of the Society—is transformed into an absolute celebration of the Divinity. The dome painting alludes to the present Church Triumphant, summarized by the Jesuit triad of St. Francesco Saverio, St. Ignatius, and St. Francesco Borgia (who had just been canonized in 1671), who are introduced into Paradise by St. Peter and St. Paul.[2]

As with the decorations for the Gesù, the most significant architectural event that occurred during the jubilee period—the completion of Santa Maria di Montesanto in Piazza del Popolo and concurrently the initiation of the building of Santa Maria dei Miracoli—had nothing to do with the policies of Clement X. The idea of building twin churches on the corners of the streets that lead from the piazza was conceived in 1661 by Pope Alexander VII and Monsignor (later Cardinal) Girolamo Gastaldi. The need to renew the Piazza del Popolo had often been considered in the past, since the city gate (then called Porta Flaminia) had always been one of the principal entrances to Rome. In 1589, under Sixtus V, an obelisk that had been in the Circus Maximus was set up in the piazza to mark the scenic intersection of the three streets that radiate from the piazza: Via del Babuino (then Via Paolina), Via del Corso (Via Lata) and Via Leonina (which during the papacy of Clement XI was renamed Via Ripetta). This site had originally been marked by two pyramidal sepulchers or *mete*. The one at the corner of Via del Babuino and Via del Corso had been disman-

Carlo Rainaldi
First project for the Church of Santa Maria dei Miracoli in Piazza del Popolo
Vatican Apostolic Library

Medal representing the foundation
of Santa Maria dei Miracoli and Santa Maria
di Montesanto

tled in the second quarter of the six-
teenth century; the other, on Via del
Corso and Via Leonina, was popularly
referred to as the *trullo* and was stand-
ing until the pontificate of Alexander
VII, when it was decided to build the
twin churches.

The project was commissioned
from the architect Carlo Rainaldi,
the son of Girolamo Rainaldi, who
had been one of Sixtus V's favorite
architects. To compensate for the dif-
ference in size of the two available
sites, Rainaldi first chose a Greek-
cross plan (as can be seen in the pro-
ject approved and signed by Alexander
VII in 1661), but this was later
changed to a circular plan; the domes
of both churches were the same
dimensions. Rainaldi was in charge
of the building of Santa Maria di
Montesanto on the corner of Via del
Babuino and Via del Corso from
1662, the year its foundation stone
was laid, until 1667, when the work
was interrupted due to the death of

Alexander VII. Carlo Fontana took
over in 1673 and, with the allocation
of funds by Gastaldi, finished the
church in 1675. Working under the
supervision of Gian Lorenzo Bernini,
Fontana made considerable changes
to the project: namely, on the pro-
naos and façade (replacing the high
attic of Rainaldi's project with a less
intrusive balustrade, which allowed
the dome to be seen), in the interior
(which was not finished or opened to
the public until the end of 1679),
and on the dome (oval on the inside,
dodecagonal on the outside), the
drum, and the lantern.

On becoming a cardinal in 1675,
Gastaldi undertook the construction
of Santa Maria dei Miracoli on the
corner of Via del Corso and Via di
Ripetta, which was directed by Rai-
naldi until 1677, and faithfully com-
pleted by Fontana two years later.
This church differs from the preced-
ing one in size and in the shape of
its dome, which is circular on the

inside and octagonal on the outside. The monumental urban character of the two churches, their isolation, their location at the entrance to the city, the arrangement of the converging axes (accompanying the sense of depth of the street perspectives), all served to transform them into the "propyleae of Rome." Based on a radical reinterpretation of the model of the Panthe as celebrative classicism, as well as certain of Bernini's remarkable works (such as the church of the Assunta at Ariccia and Sant'Andrea al Quirinale), the twin churches provided confirmation of the oval ground plan as the most perfect and scenic liturgical machine of Christianity.[3]

Piazza del Popolo with the Flaminio obelisk and the two twin churches: on the left, Santa Maria di Montesanto and, on the right, Santa Maria dei Miracoli

[1] For Clement X's pontificate, and the liturgy of the Jubilee of 1675, the rapid notations of L. von Pastor are fundamental, *Storia dei Papi* (Rome 1961), vol. I, pp. 628-84 (for the Jubilee, see, in particular, pp. 656-658). See also M. Petrocchi, *Roma nel Seicento*, (Bologna 1970); P. Brezzi, *Storia degli Anni Santi. Da Bonifacio VIII al Giubileo del 2000* (Milan 1997), pp. 134-38; and, above all, A. P. Latini, "L'architettura e la città intorno al 1675," in *Roma 1300-1875. La città degli Anni Santi. Atlante*, ed. M. Fagiolo and M. L. Madonna (Milan 1985), pp. 268-70. In general, see L. Osbat, "Clemente X," in *Dizionario Biografico degli Italiani* (Rome 1982) vol. 26, pp. 293-302. For the liturgical ceremonies, a detailed first-hand source not used by Pastor or Obsat is the long diary by Ruggero Caetano, *Le Memorie de l'Anno Santo M. DC. LXXV celebrato da Papa Clemente X* (Rome 1691). For Bernini's busts of Clement X, see E. Villa, "Uno sconosciuto episodio della ritrattistica del Seicento: Clemente X, Bernini e Gaulli; e altre novità sulle committenze Rospigliosi, Altieri e Odescalchi," in *L'ultimo Bernini 1665-1680: Nuovi argomenti, documenti e immagini*, ed. V. Martinelli (Rome 1996), pp. 137-59. For the projects of the tribune of S. Maria Maggiore, the installation of the second fountain in St. Peter's Square, the completion of Ponte S. Angelo, and the Tabernacle of the Holy Sacrament in St. Peter's, see, at least, F. Borsi, *Bernini architetto* (Milan 1980), n. 64, p. 340; n. 65, p. 340; n. 66, pp. 340-41; n. 73, pp 345-46.
[2] For the decoration of the Church of the Gesù, see P. Pecchiai, *Il Gesù di Roma* (Rome 1952), pp. 106-37; R. Enggass, *The Painting of Baciccio: Giovanni Battista Gaulli 1639-1709* (University Park 1964), pp. 31-74, 135-40; J. Tonkovich, "Two Studies for the Gesù and a 'quarant'hore' design by Bernini," *Burlington Magazine* 140 (1998): 34-37. For the church, also see A. Dionisi, *Il Gesù di Roma: Breve storia e illustrazione della prima chiesa eretta dalla Compagnia di Gesù* (Rome 1982); and C. Pericoli Ridolfini, *Chiesa del Gesù* (Rome 1997). For Baciccia, see R. Enggass, "Gaulli, Giovanni Battista" in *Dictionary of Art*, ed. J. Turner (New York 1966) vol. 12, pp. 197-203 (the bibliography is updated to 1984). For an interpretation of the iconography of the fresco, see M. Fagiolo, "Strutture del trionfo gesuitico: Baciccio e Pozzo," *Storia dell'Arte* no. 38/40 (1980): 353-60; also C. Strinati, "L'arte a Roma nel Seicento e gli anni santi," in *Roma 1300-1875;. L'arte degli Anni Santi*, ed. M. Fagiolo and M. L. Madonna (Milan 1984), pp. 398-406, 405. For the model of *the Triumph of the Name of Jesus* (Rome, Galleria Spada), see the entry of R. Cannatà, in *Genova nell'età barocca*, ed. E. Gavazza and G. Rotondi Terminiello (Bologna 1992), no. 95, pp. 189-91. The dome and pendentive frescoes have been recently restored (see M. P. D'Orazio, "Restauri in corso agli affreschi del Gaulli 1672-1685," in *La chiesa del SS. Nome di Gesù. Gli ultimi restauri*, ed. L. Gaudenzi [Viterbo 1996], pp. 93-109; at the moment of the writing of this book, the *Triumph of the Name of Jesus* on the ceiling of the nave is still in restoration.
[3] For the history of the two churches, see M. L. Casanova, *Santa Maria di Montesanto e Santa Maria dei Miracoli* (Rome 1958); and R. Luciani, *Santa Maria dei Miracoli e Santa Maria di Montesanto* (Rome 1990). See also P. Portoghesi, *Roma barocca* (Bari 1992), p. 282; Maurizio and Marcello Fagiolo dell'Arco, *Bernini: Una introduzione al gran teatro del barocco* (Rome 1967), pp. 110, 130-31, 167, and entry 234; R. Wittkower, *Art and Architecture in Italy 1600-1750* (Harmondsworth 1980), pp. 282-86; and Borsi, *Bernini architetto*, no. 74, p. 346.

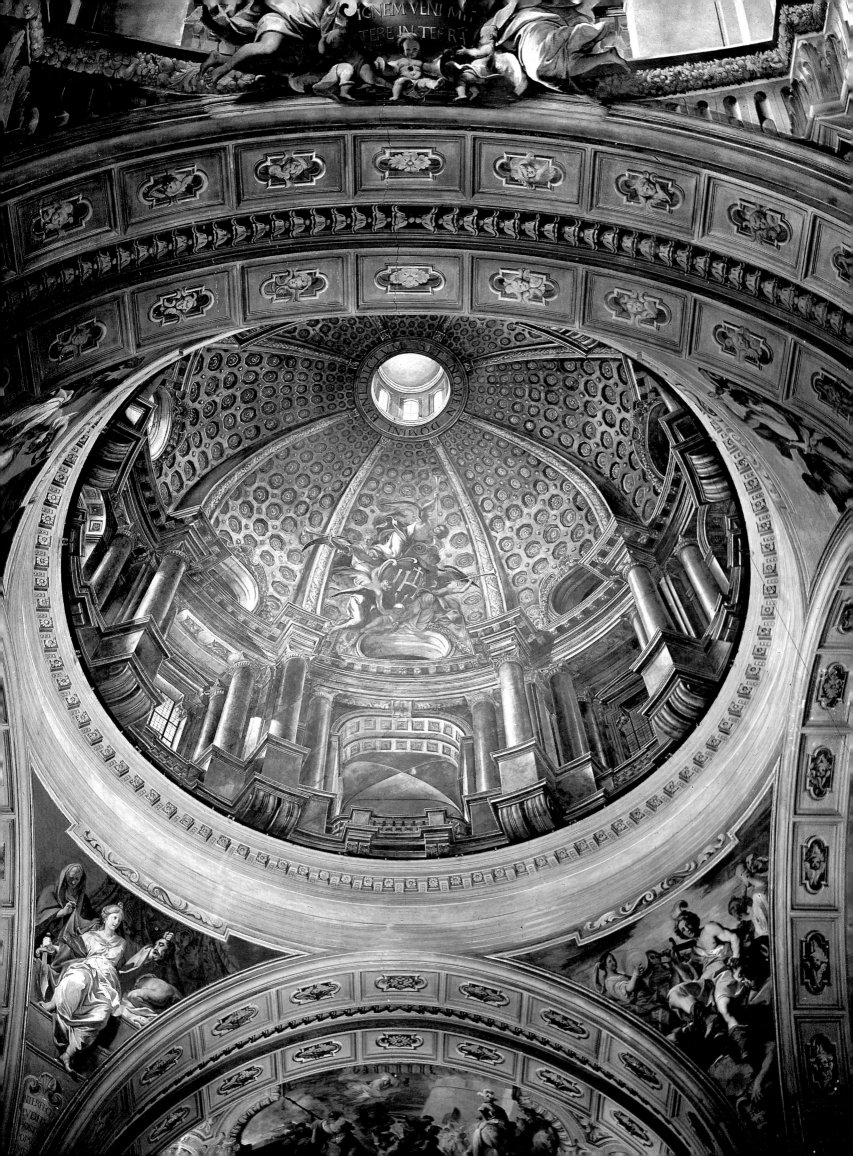

THE WORKS
OF FRATEL POZZO
IN SANT'IGNAZIO
Antonio Vannugli

The jubilee year of 1700 was characterized by two extraordinary events: the death of the pope who had organized it (Antonio Pignatelli, who had reigned since 1691 as Innocent XII) in September, and the conclave that elected his successor Clement XI (G. F. Albani) in October. Innocent XII was already too seriously ill to participate in the opening of the Holy Door, and he was replaced by Emanuele di Buglione, but during his nine-year reign he had concentrated completely on preparing the city of Rome for that appointment. The new edition of the guidebook *Il Mercurio errante* by Pietro Rossini, published during the jubilee year, listed "the additional buildings that Innocent XII had had built inside and outside of Rome," for a total cost of 17,600 scudos. These were "Montecitorio today the Roman Curia," the "Dogana di Terra" [Land Customs], the "Buildings of San Michele and the Dogana di Mare [Sea Customs] at Ripa Grande," the "hospice of St. John Lateran," the "port

of Anzio, the aqueduct and village of Civitavecchia," as well as the "baptismal font, and sepulchers of the Queen of Sweden and Innocent XI at St. Peter's."

The leading artist during the pontificate of Innocent XII was Andrea Pozzo, who had entered the Society of Jesus in 1665 as a simple "brother coadjuter" (that is, a lay brother) and was called to Rome in 1680, when he was thirty-eight years old, by the Jesuit General, Giovanni Paolo Oliva. It was due to Pozzo that of all the works created for the Jubilee of Pope Pignatelli, the decoration in the Jesuit church of Sant'Ignazio was the greatest attraction. Brother Pozzo's oeuvre in Sant'Ignazio made it possible for the church to be deemed "one of the most beautiful in Rome" in the new edition of *Il Mercurio errante*.[1]

In the early 1680s, the chief problem concerning the church of Sant'Ignazio was the dome; although it was included in the project of the Jesuit architect of the church, Orazio Grassi,

Andrea Pozzo
Church of Sant'Ignazio
interior of the dome

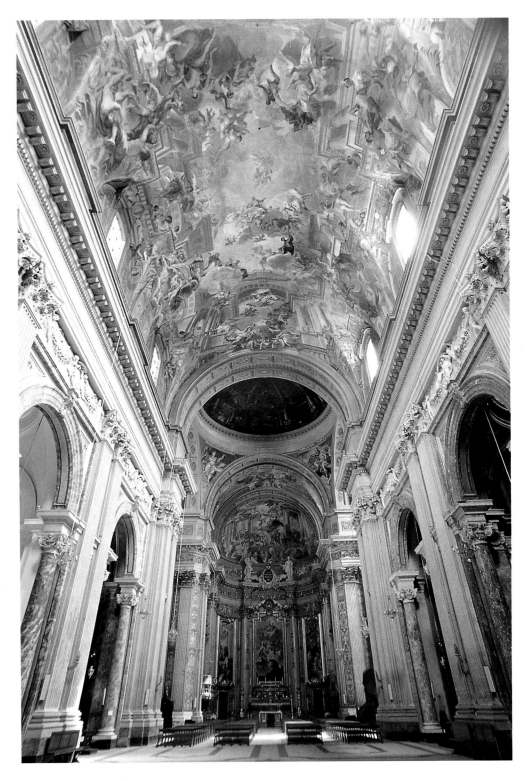

it had never been built, principally for economic reasons but also because it would have obscured the nearby convent of the Dominicans. After Grassi's death in 1654, the matter was discussed for many years until Pozzo came up with a solution in 1684: he painted a false dome in trompe-l'oeil on an enormous eighteen-meter (fifty-four-foot) circular canvas that closed the shaft of the drum. Onlookers were perplexed to see Pozzo using a housepainter's spatula to apply the watercolor paints. But when the work was completed on June 20, 1685, and on its inauguration day of July 31, the feast day of St. Ignatius, his false dome received enthusiastic approval. As is well known, there is a fixed point for viewing the dome, corresponding to an *antico giallo* disk set in the floor in the center of the nave; the visitor is urged to view from this spot so as not to lose the illusionist effect of the trompe l'oeil and see a distorted perspective.

Andrea Pozzo
Church of Sant'Ignazio
nave and ceiling

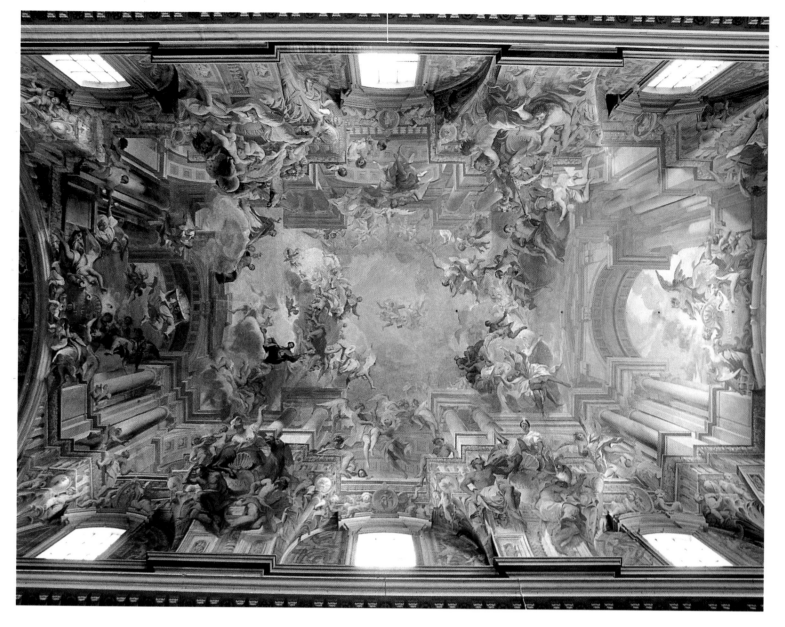

As Pozzo's biographer, Lione Pascoli, wrote, "The perspective [...] by deceiving the view for its own satisfaction, forces us to see what it is not, and gives our senses what later is not seen either from close up or from a different point [of view]." In concluding the parabola of the Baroque, Brother Pozzo caused amazement by combining virtuosity with reason.

Immediately afterward, Pozzo frescoed the four pendentives below in vivid colors on a blue ground. These are not the usual subjects, the evangelists or doctors of the church, but four bloody biblical scenes. All relate to the elected people's victories over the enemies of the faith, an allusion to St. Ignatius's battle against heresy: *David and Goliath, Jael and Sisera, Samson and the Philistines,* and *Judith and Holofernes.* Following the enormous success of his painted dome, Pozzo was commissioned to fresco the ceiling of the nave, forty meters long with a surface of more than a thousand square meters. The project started in 1691, but actual work did not commence until the autumn of 1693. It was finished within a year and unveiled to an enormous throng, including Pope Innocent XII Pignatelli and the pontifical court, on the feast day of St. Ignatius, July 31, 1694.

By using the barrel vault of the church as a visual support, Pozzo conceived of a grandiose and undivided illusionist architecture, classical in style and clearly defined in its parts so as to harmonize with the real architecture of the building. An optical continuation of the walls that Orazio

Grassi had designed yet unrelated to the structural logic of the nave, the painting transformed the nave into a boundless abyss, extending toward the infinite. This idea was not new, but it had never before been applied with such mathematical rigor and on such a vast scale. Its success made Pozzo the prince of the *quadratura* painters of the Seicento. Here, the styles developed in the preceding century in Emilia and in the Veneto and the *summa* of Roman Seicento perspective painting were merged into what must be considered the quintessence of Roman late Baroque illusionism.

Pozzo's scheme represents a colossal loggia with columns surmounted by gilded Corinthian columns, which support a cornice with projections and indentations. The loggia is pierced on its long sides by three coupled arches, while on each short side a triumphal coupled arch of Vignola imprint rises above the huge cornice. Below, the colonnade rests on a high base, which is, in turn, set on a system of painted corbels that flank the real windows of the nave. This painted architecture plays an active part in the human drama around it. And, fortunately, an exact iconographic description of the program survives in a letter written by the painter and published a year after the conclusion of the work. Pozzo stated that he had started from the words of Jesus in the Gospel of Luke (12:49): "*Ignem veni mittere in terram, et quid volo nisi ut accendatur?*" This phrase, in fact, appears on the two plaques below the triumphal arches on the short sides. As adapted by the Church for St. Ignatius, the phrase meant "zealous in propagating the Catholic religion, the light of evangelism throughout the world."

In the center of the sky, just below the figures of God the Father and the Dove of the Holy Ghost, is Jesus with the cross "Father of lights." He transmits a ray of light to St. Ignatius below on the clouds surrounded by angels. St. Ignatius sends it off toward the allegories depicting the four parts of the world, which are painted on coupled brackets between the windows on the long sides. Each region is denoted by name. On the left are *Africa*, in the guise of a Moorish queen with curly hair seated on a crocodile, an elephant's tusk in her hand, and *Asia*, who sits on a camel and holds her attribute, a censer, as St. Francis Xavier, the apostle of the Indies, looks down on her from the sky. On the right are *America*, who sits half-nude on a puma wearing a headdress of multicolored feathers and holding a spear in her hand, and *Europe*, queen of the world, seated on a horse, with a scepter and a crown, and surrounded by putti and a cornucopia. Above, in the sky, St. Luigi Gonzaga sits on a cloud, while, in the opposite corner, St. Francis Borgia stands looking at Jesus. Below the four parts of the world are groups of chained giants, the symbols of idolatry and heresy defeated by the Jesuits; above them, the sanctified souls of the Jesuits' missionary work rise heavenward following the Jesuit saints.

But Jesus emanates another ray of light, this one is directed toward the great concave shield imprinted with his monogram and held by an angel in flight inside the triumphal arch on the side of the altar. This symbolizes that "the Redeemer, having as his objective the glory of his name, wishes to adorn Ignatius," whose existence had no other scope but *ad maiorem Dei gloriam*. At the base of the two triumphal arches, two groups of angels represent the means that the Society of Jesus used to convert the world: on the altar side, the guardian angels of the nations plunge hearts into the fire of Divine Love; on the opposite side, the angels of death forge thunderbolts in the flame of Fear of Divine Retribution. The allusion to the Latin *ignis*, the etymon of Ignatius, and a word that means the fire that warms but also burns, constitutes the central motif for the whole painting; it reappears as an emblem in

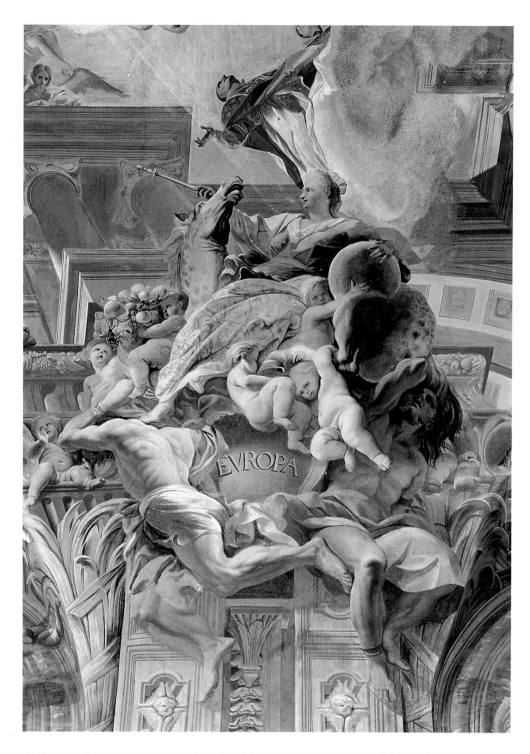

different forms on the twelve shields distributed on the pendentives supporting the base of the false loggia.

According to Jesuit thought, the program of the ceiling was a logical consequence of an ideology based on universal evangelization pursued through missionary activity, which, in turn, was a mirror reflection of the convergence of pilgrims in Rome for the jubilees. As with the fresco in the calotte, the subject of the ceiling fresco adhered to one of the constants that the Society promoted for its decorations: the impact that transcendental forces exert on this world. At the same time, the scene offers the most evolved example of the double vision of Baroque art in that the saints' revelation is also conceded to the viewer, who, in addition to perceiving its effects, can actually participate in and become emotionally involved in the same transcendental experience. In contrast to the unity and solid stability of the architecture is the throng of people who fill the vault, fly, sit on the clouds, or perch on the structures. They create the illusion of penetrating into the real space of the vault, involving the viewer in a spectacle that

is clamorous and silent at the same time, dragging him into the agitated exultation. What typifies the figures, summarily defined with simple robes, is the great visual sound produced by their movement, their vivacious colors, and the intense chiaroscuro. Echoes of Veronese and the Lombard Morazzone can be detected in these figures, not to mention Baciccio's contrasting use of the light in his work at the Gesù. However, unlike Baciccio, and the paradises of Correggio and Lanfranco from which Pozzo also drew inspiration, this vast crowd of figures appears perfectly countable and, therefore, rationally measurable.

The absolute rationality of Pozzo's perspective illusionism, which invites the viewer to assess its perfect architectural verisimilitude, is the feature that most distinguishes it from Baciccio's decoration. The viewer almost believes that the painted perspective is truer than the real space surrounding it, and, hence, believes the vision, as well. Pozzo was not about to have his painting compete with the architecture; the structure of his painted architecture is unrelated to the real architecture of the church, and the relationship between the two different spaces is not one of penetration but rather of continuity. The celestial court of the triumphal church in paradise is quite distinct from the living church on earth, but both obey the same rational laws of perspective. The continuity between nature and transcendence, between finite and infinite, therefore becomes a physical experience, perceived by the senses and thus seemingly "true." Sensations are not annulled but rather exalted, to overcome any spiritual doubt or anxiety.

As with the dome fresco, the perspective of the ceiling fresco only "works" from two points of view.

Andrea Pozzo
Church of Sant'Ignazio
detail of the ceiling

These are marked by yellow marble disks on the floor of the nave, one of which coincides with that for the dome. They underline the rigid conceptual unity of Pozzo's decoration: step outside the circles and the illusion becomes aberrant, the perspective collapses. Different interpretations, all based on the Aristotelian norm of *delectare et docere*, have been formulated about the metaphoric significance of this relativity of viewpoint. Undoubtedly, it is also invested with an ethical value as an alternative between the place of virtue—which, according to Aristotle, corresponds to the golden mean that one must seek by exercising reason—and the two extremes of defect and excess. From a theological point of view, any awareness of the relativity and instability of reality creates an anxiety for transcendental truth revealed by faith. Implicit in the adoption of a necessary (but not "obligatory") viewpoint, is the admonition that only by searching for God, who is the only absolute center, can human reason avoid losing its way.

Alternatively, one might argue that Pozzo's insistence on a single viewpoint reveals the basic contradiction of Jesuit propaganda. The "point of view" is a direct reflection of the concept of "opinion," the dialectical opposite of the concept of "judgment," which the Jesuits meant to surmount. By this logic, the exercise of research is preferred to the passive acceptance of the singular viewpoint imposed by the Society. Indeed, this view became one of the cornerstones of the new critical and lay thought in the world of art, and Pozzo became a key figure in shaping the art of the century that was about to begin.

Furthermore, the fundamental role that Pozzo gave to the rays of light and their refractions was related to the scientific research conducted years before by the Jesuit Athanasius Kircher and divulged in his *Ars magna lucis et umbrae,* which was not only a treatise on optics but also a philosophical dissertation about the essence and significance of light. The artist certainly had this text in mind when he conceived the large, mirrorlike "pan" held by the angel on the altar side of the painting. The way that Pozzo subdivided, articulated, and enumerated the figures in the vault also corresponds to the criterion of classification in the *Spiritual Exercises.* The entire scene appeared not as a vision but as a view that conformed to the *compositio loci* of Ignatius's method: the painted perspective contained history with personages to contemplate, listen to and follow in the action. On the other hand, some see the same centrifugal expansion of personages as a reflection of the diffusion of the Society of Jesus in the world, in consonance more with the orientation of the Collegio Romano and the preachings of Paolo Segneri than with the Order as a whole.

In 1697, Pozzo designed the monumental, Borromini-inspired altar dedicated to St. Luigi Gonzaga in the right transept of the church. This altar was made possible by a legacy left by the deceased Marchese Scipione Lancellotti, who had twice been healed through the intercession of that saint. The project was started in May, right after the completion of the altar to St. Ignatius in the church of the Gesù, even using the same workers (who were directed "like a clock" by his fellow brother Carlo Mauro Bonacina). The two pairs of twisted columns in *verde antico* marble and decorated with gilded bronze vines were inspired by Bernini's baldacchino in St. Peter's—an absolute innovation for Rome. They are set on a concave base that supports a curvilinear tympanum surmounted by a rich fastigium, both in pink marble, and frame the great double-arched marble altarpiece with the *Glory of St. Luigi Gonzaga.* This relief was sculpted by Pierre Legros to the great satisfaction of Pozzo, who had supplied the design. Legros is also the author of the statues of *Penitence* (or *Mortification*) and *Purity* in white marble seated on the tympanum.

Below is the magnificent sepulcher of the saint with an urn of lapis lazuli, precious stones, and silver and gilded bronze ornamentation. The altar is flanked by two large marble *Angels* bearing the future saint's attributes, the work of Bernardino Ludovisi, and enclosed by an alternating convex and concave polychrome marble balustrade on which are placed four smaller bronze angels as candleholders. The overall effect is one of delicate chromaticism, which matches the light and elegant design.

The altar was opened to the public "with universal satisfaction" on December 21, 1699; on June 21 of the Holy Year 1700, when it was supposed to have been finished, Pope Innocent XII visited it. In 1697, Pozzo frescoed the ceiling of the transept above the altar of St. Luigi Gonzaga, proposing the Baroque scheme of double vision for the last time: the *Vision of St. Maria Maddalena de' Pazzi with the Ascent of St. Luigi Gonzaga into Heaven,* the miraculous event that had been instrumental in the beatification of Luigi in 1605, flanked by two episodes from the saint's life, the *Apparition of the Virgin* on the left, and the *First Communion*, given him by St. Charles Borromeo, on the right. *Angel Musicians* are painted on the ground of the two false windows above the lateral tribunes.

Pozzo had also started his last work, the decoration of the presbytery in Sant'Ignazio in 1697. By 1701, assisted by his bottega, the artist (who, in 1685, had painted a great provisory altar on canvas), painted three frescoes in the drum of the apse.

They are rather like large altarpieces with gilded stucco frames. On the left is *The Departure of St. Francis Xavier for the Indies,* in which the future missionary kisses the crucifix brought him by St. Ignatius under the protection of an accompanying angel in the sky, while a group of the future beneficiaries of the Jesuit's redeeming action occupies the foreground. On the right is *The Entry of St. Francis Borgia into the Society of Jesus*, in which he is welcomed by St. Ignatius with the allegory of Faith above.

The two lateral scenes are placed so as to mirror one another and exalt the profundity of the central episode, *The Vision of St. Ignatius at La Storta*, with which they share a limpid, polished tone of enlightenment. Christ, under the benedictory gesture of the Father, who appears on high, descends from heaven on a cloud accompanied by nine angels (who signify the nine categories of angels). Emanating a light that is diaphanous "like the sun," he appears before the saint, who is entering a small abandoned church on the road to Rome, to show him his promise written on the oval held by two angels above the cornice: *Ego vobis Romae propitius ero* (*I shall be benevolent to you, Romans*). The top of the Pyramid of Cestius can be seen in the background and, on the right, seen from the back and wearing a broad brimmed pilgrim's hat, is Ignatius's companion. In these later works, the ceremonial tone and the perspective which no longer requires a fixed point of view differentiates them from the vault frescoes in much the same way that the certainty of judgment is differentiated from the mutability of opinion.

[1] The present text has been written on the basis of the following bibliography: E. K. Waterhouse, *Baroque Painting in Rome* (London 1937), pp. 86-88; G. C. Argan, "La 'rettorica' e l'arte barocca," in *Retorica e Barocco* (Rome 1955), pp. 257-64 (republished in G. C. Argan, *Studi e note dal Bramante al Canova* (Rome 1970), pp. 167-76; R. Marini, *Andrea Pozzo pittore (1642-1709)* (Trento 1959); N. Fabrini, *La chiesa di S. Ignazio in Roma* (Rome 1962); L. Montalto, *La storia della finta cupola di Sant'Ignazio* (Capitolium 1962), pp. 393-403; G. C. Argan, *L'Europa della capitali 1600-1700* (Geneva 1965), pp. 59 and 106; M. C. Gloton, *Trompe-l'oeil et décor plafonnant dans les églises romaines de l'age baroque* (Rome 1965), pp. 155-60; A. Griseri, *Le metamorfosi del Barocco* (Turin 1967), pp. 237-44; G. Martinetti, *S. Ignazio* (Rome 1967); P. Wilberg-Vignau, *Andrea Pozzos Deckenfresccko in S. Ignazio* (Munich 1970); B. Kerber, *Andrea*

Pozzo (New York 1971), pp. 54-74, 181-86; F. Haskell, "The Role of Patrons: Baroque Style Changes," in *Baroque Art: The Jesuit Contribution* (New York 1972), pp. 51-62; F. S. Baldinucci, *Vite di artisti dei secoli XVII-XVIII*, ed. A. Matteoli (Rome 1975), pp. 314-37; M. Fagiolo, "Strutture del trionfo gesuitico: Baciccio e Pozzo," *Storia dell'Arte* no. 38/40 (1980): 353-60; F. Haskell, *Patrons and Painters. Art and Society in Baroque Italy* (New Haven 1980), pp. 88-91; N. Spinosa, "Spazio infinito e decorazione barocca," in *Storia dell'arte italiana*, no. 6.1 (1981): 322-24 and passim; C. Strinati, "L'arte a Roma nel Seicento e gli anni santi," in *Roma 1300-1875: L'arte degli Anni Santi*, ed. M. Fagiolo and M.L. Madonna (Milan 1984), pp. 398-406; R. Bösel, *Jesuitenarchitektur in Italien 1540-1773* (Vienna 1985), pp. 199-200; C. Capitani, "Il giubileo di Innocenzo XII e di Clemente XI (1700)," in *Roma 1300-1875: La città degli Anni Santi*. ed. M. Fagiolo and M. L. Madonna (Milan 1985), pp. 284-89 passim; E. Mâle, *L'arte religiosa nel '600* (Milan 1984), pp.145-46, 177, 344, 372, 374-75; V. DeFeo, *Andrea Pozzo: Architettura e illusione* (Rome 1988); O. Ferrari, *Bozzetti italiani dal Manierismo al Barocco* (Naples 1990), pp. 44, 208; E. Levy, *Saint, Site, and Sacred Strategy. Ignatius, Rome, and Jesuit Urbanism* (Vatican City 1990), pp. 54-58, 214-21, nos. 135-39; B. Contardi, "Il modello di Andrea Pozzo per l'altare del Beato Luigi Gonzaga in Sant'Ignazio," in *In Urbe Architectus* (Rome 1991), pp. 23-27; L. Pascoli, *Vite de' pittori, scultori, ed architetti moderni* (Perugia 1992), pp. 691-715: *Vita di Andrea Pozzo*, ed. G. Marini; R. Bösel, "Andrea Pozzo," in *Dictionary of Art* (London 1996), vol. 25, pp. 413-17; M. Carta, "Le finte cupole," in *Andrea Pozzo*, ed. V. De Feo and V. Martinelli (Milan 1996), pp. 54-65; V. De Feo, "Le cappelle e gli altari," in ibid., pp. 114-43; C. Strinati, "Gli affreschi della chiesa di Sant'Ignazio a Roma," in ibid., pp. 66-93; R. Barbiellini, "I restauri sugli affreschi dell'altar maggiore a Sant'Ignazio, in Andrea Pozzo," Proceedings of the International Conference, "Andrea Pozzo e il suo tempo," Trento, November 25-27, 1992 (Milan 1996), pp. 321-28; B. Contardi, "L'altare di San Luigi Gonzaga in Sant'Ignazio," in ibid., pp. 97-112; R. Enggass, "Pozzo a Sant'Ignazio e Baciccio al Gesù: tracce della fortuna critica," in ibid., pp. 253-57; M. Fagiolo dell'Arco, "Pensare effimero: il metodo e la pratica di Fratel Pozzo," in ibid., pp. 75-95; B. Kerber, "Pozzo e l'aristotelismo," in ibid., pp. 13-16; M. Fagiolo dell'Arco, "Le finte cupole di fratel Pozzo. Artificio, meraviglia, propaganda," in *Annali Aretini, IV* (Arezzo 1996), pp. 263-75; R. Diez, "Le Quarantore: una predica figurata," in *La Festa a Roma dal Rinascimento al 1870* (Turin 1997), pp. 84-97, and M. Fagiolo dell'Arco, *La festa barocca* (Rome 1997), pp. 510, 516, 565-68.

THE JUBILEE OF BENEDICT XIII

THE LATERAN COUNCIL OF PIER LEONE GHEZZI

Anna Lo Bianco

Pier Leone Ghezzi
Lateran Council of 1725
Raleigh, North Carolina Museum of Art
detail

A reconstruction of the events surrounding the Jubilee of 1725 is facilitated by numerous firsthand sources, including the *Diario di Roma* by Valesio; the *Diario Ordinario,* a daily newspaper of the times; as well as other documents preserved in religious and patrician archives. The second Jubilee of the century was celebrated by Pope Benedict XIII Orsini, a deeply religious man whose reign lasted from 1724 to 1730. His pontificate was characterized by the holy nature of a pope primarily interested in the way the religious communities carried out their devotional exercises and pastoral rituals. Orsini became pope late in life, at the age of seventy-five, and that is how his portraits depict him. The polychrome terracotta bust by Pietro Bracci in the Museo Nazionale of Palazzo Venezia gives a realistic, though perhaps not very official, rendering of the aged pontiff.

While Clement XI combined a strong spirituality with a profound love of culture, Benedict XIII showed little interest in the world of art. Clement XI had sponsored such prestigious undertakings as the restorations of the ancient basilicas of San Clemente and San Giovanni in Laterano, and had summoned the most important artists of the time to the city, including Giuseppe Chiari, Marco Benefial, Giovanni Odazzi, Francesco Trevisani, Pier Leone Ghezzi, and many others. His spirit of holy grandeur seemed a fitting close to the monumental Baroque era, in which sculpture and painting enhanced one another in the worldly glorification of the Church.

Although the aims of Benedict XIII were different from those of Clement XI, he devoted himself to the Jubilee preparations with great fervor. He concentrated all his attention on the renewal of religious life in the city, making frequent visits to its churches, basilicas, and hospitals. He attributed particular importance to the reestablishment of ecclesiastic

discipline, the religious instruction of the clergy, and, naturally, catechismal activity. In connection with the latter, he intervened in favor of the propagation and coordination of missions, which witnessed a remarkable development during his pontificate.

The Jubilee preparations started immediately after his election, already very close to the deadline of 1725. Among the first places the Holy Father visited was the Dominican Convent of San Sisto Vecchio, where he had once been the titular cardinal. According to Valesio's *Diary*, that church was one of the first to be amplified and restored by the Pope, who gave the commission to Filippo Raguzzini, an architect from Benevento whom he himself had introduced into the artistic circle of Rome.

The pictorial decoration was entrusted to Andrea Casali, a student of Trevisani, the author of the lunette frescoes in the cloister depicting episodes from the life of St. Dominic, and to Emanuele Alfani, a second-rank painter in Rome, who executed the altar paintings of the church. The cost came to almost 5,000 scudos, as reported in Valesio's *Diary*. Behind the effort lay a precise motivation. The cycle of lunette frescoes in the cloister constituted one of the most complete programs of Dominican iconography of the eighteenth century. Since it served as an instrument for divulging the cult of the saints, it fulfilled Pope Orsini's wish, particularly in regard to the founding saint of his own religious order.

When compared to the restorations that Clement XI commissioned for the Early Christian basilicas, that of San Sisto Vecchio was modest in scale and artistic talent. However, the choice of artists and the quantity of work involved was similar in many other cases of restoration, which almost always privileged churches of the Dominican Order, such as the Carafa Chapel in Santa Maria sopra Minerva. Alfani and Casali were second-rank painters, but there were other, more famous artists working in Rome at that time, ones who could better express the variegated figurative culture of the period.

Beyond the works of art commissioned, by the Pope, there were many sponsored by the enlightened aristocracy and by a clergy with more sophisticated and knowledgeable artistic tastes. They tended to favor the leading painters of the day. Cardinal Troiano Acquaviva, for example, gave Sebastiano Conca the commission for the ceiling fresco of Santa Cecilia in Trastevere, painted between 1721 and 1724, which marks the passage from the grandiose late Baroque to the dazzling decorativeness of the Settecento. In that case, as so often happened, the monumentality of the decoration and the prestige of the artist allowed the patron to display his own power, which was unrelated to religion. The main theme of the paintings at Santa Cecilia was the Christian martyrs, a subject for celebration during the jubilee, and one that had already been popular for more than a century following the revival of Early Christian culture.

Close in manner to Conca was the Venetian Francesco Trevisani, who was able to communicate that precious international language of painting and evoke admiration and approval. Examples are to be found in his beautiful paintings depicting the four continents, now in the Galleria Nazionale di Arte Antica in Palazzo Barberini, and in his preparatory studies for the mosaics of the pendentives in the vestibule of the baptismal chapel in St Peter's in the Vatican, executed during the jubilee years 1724 through 1726. Another protagonist, by then at the end of his prestigious career, was Giuseppe Chiari, who had been Carlo Maratti's favorite student and who shared his solemn yet polished classicism. Chiari was employed by the Rospigliosi family for their chapel at San Francesco a Ripa, where he executed the superb altarpiece depicting the *Trinity with Saints Pietro d'Alcantara and Pascal Baylon*, and later by the

Pier Leone Ghezzi
Lateran Council of 1725
Raleigh, North Carolina Museum of Art

192

Colonna family at the Church of the Santi Apostoli. There, in 1726, he painted the *Ecstasy of St. Francis,* which fully expressed the ideals of arcadian grace that the mystic scene was assuming during those years.

The intervention at San Gallicano was totally different, both with regard to the destination of that modern complex and the personality of the artist called to carry out its decoration. The hospital structure of San Gallicano was one of the many charitable institutions that the Church maintained to exercise its pious duties. For one thing, it served the throngs of pilgrims who were flocking to Rome in ever-increasing numbers. But it also satisfied the growing city's need for modern struc-

tures. Incorporated into the hospital complex, a functional linear construction designed by Raguzzini, was the chapel, for which Cadinal Piermarcellino Corradini commissioned three large paintings from Marco Benefial, one of the most interesting and singular artists of the first half of the Settecento. He was committed to a classicism expressed in rigorously realistic terms.

Similar in style was the work of the Bolognese painter Aureliano Milani, who was employed by Cardinal Paolucci during the jubilee year to decorate his family's chapel in San Marcello al Corso. There, Milani painted the *Miracle of San Pellegrini Laziosi,* the *Miracle of the Madonna of the Fire at Forlì,* and the *Healing of the*

Pier Leone Ghezzi
Lateran Council of 1725
Raleigh, North Carolina Museum of Art
detail

Blind Man, scenes of miraculous events that were, therefore, consonant with the spirit of the jubilee. During his pontificate, the pope had promoted five canonizations, one of which was for San Pellegrino Laziosi, whose rite was celebrated in the Order's chapel in the church. The affable narrative realism of Milani's work was very different from Benefial's ethical commitment, however, and he remained a curious and largely isolated voice in the panorama of Roman painting.

Also working in the church of San Marcello in 1725 was Pier Leone Ghezzi. He had received a commission for a painting of St. Giuliana Falconieri from Cardinal Alessandro Falconieri, a descendant of the saint whose canonization had just been announced, who wished to promote her hagiography and cult. Like Benefial and Milani, Ghezzi tended toward realism, distancing himself, however, both from the naturalistic rigor of Benefial and the more popular and somewhat archaic tone of Milani. Ghezzi was truly unique in the artistic panorama of the Roman Settecento. Inspired by the reality surrounding him, he gave life to the personages and events in his pictures, painting them with the disenchanted eye of an observer. Benedict XII knew and appreciated his work and turned to him for important commissions, particularly those connected to the celebrations of his pastoral activity, his primary interest.

During the jubilee manifestations, the pontiff promoted a provincial council at the basilica of San Giovanni in Laterano from April 15 to May 29, 1725. Thirty-three cardinals and eighty bishops participated in the important assembly, which the pope opened with a speech calling for a greater commitment on the part of the clergy. The closing ceremony consisted of a procession of penitence that departed from San Giovanni and finished at Santa Croce in Gerusalemme. To document that prestigious event, Cardinal Niccolò

Maria Lercari, Benedict XIII's chamberlain, commissioned Pier Leone Ghezzi to make a large painting. Lercari later ordered from other artists four more paintings, all of them centering on episodes from the life of the pope and his pastoral mission. Only one of these works is known today, *Benedict XIII Consecrating St. John in Lateran* by Giovanni Odazzi, which is preserved together with the Ghezzi painting in the North Carolina Museum of Art in Raleigh. Odazzi painted two other pictures in the series: *Benedict XIII Consecrating Eight Saints* and the *Restitution of Comacchio*, both now lost. The fifth painting of the cycle, the *Restitution of Benevento* by Sebastiano Conca, is also lost.

Ghezzi's huge canvas was one of his most significant works given the importance of the commission, the subject matter, and the innovation of its artistic content. Leone Pascoli appropriately referred to it as a "masterpiece." The scene unfolds in both a grandiose and narrative manner, meticulously described in the details of the setting and the characterization of the figures. The interior of the basilica is painted with extreme faithfulness, emphasizing in particular the recent eighteenth-century decorations, which had been concluded under Clement IX and completed Borromini's project for the nave. These included the imposing sculptures of the aedicules and the ovals above, depicting the prophets; Ghezzi himself painted the one dedicated to Micah.

The scene recedes toward the background and widens in the foreground, which is accentuated by the wooden pews. The artist intended to limit this space so that the spectators could be easily identified, but it is difficult to single out individuals with certainty. In profile, on the right, richly bedecked and bewigged, is Ghezzi, in his role as a famous artist. The fifth person on the right, who turns toward the viewer in the last row of seats, his hands on the edge of the chair, is the lawyer Bagnara, whom Ghezzi often

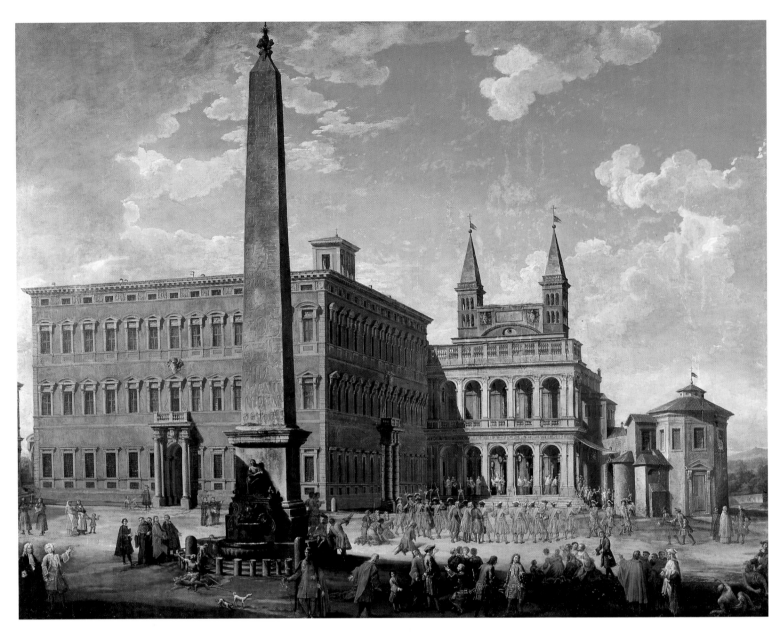

caricatured. Typical of the artist and in line with his curious vacillation between the grandiose and the anecdotal is the detail of the two dogs that the guard is trying to chase out of the basilica. The group on the left vividly portrays the representatives of that curial and affable Roman society; they are distinguished not only by their physiognomies but also by the fervor of their gestures and attitudes, which confer an unusual vivacity to the representation.

Ghezzi was obviously strongly influenced here by Giovan Paolo Pannini from Piacenza, a thoroughly acclaimed painter who had been in Rome since 1711, and whom the Roman artist considered a point of reference. There are similarities between Ghezzi's large painting and Pannini's famous *Castle of Rivoli* (now in the Castle of Racconigi in Turin) painted between 1723 and 1725, and most probably known to Ghezzi. In its lucid presentation of the historical event, the composition seems to return to the monumentality of the Seicento, but with the objectivity of a documentary. The grandiose regularity of the structure is enhanced by the minutely described details, creating a singular compromise between the grand manner and the anecdotal.

Ghezzi fully understood the scenic possibilities rooted in Pannini's language, which, together with his caricaturelike portraiture, conferred the veracity of a chronicle to the scene. It was apparently his intention to make his painting a document, as in the contemporary *veduta* paintings, which he

Giovanni Odazzi
Benedict XIII Consecrating
St. John in Lateran
Raleigh, North Carolina Museum of Art

undoubtedly knew and appreciated. Ghezzi knew Van Wittel, who had been in Rome since 1680, and made a caricature of him in 1719, describing him in the caption below the drawing as an "excellent painter." The words indicate the esteem and high consideration he had for his fellow painter, and presumably for the type of painting he did. And it was to Van Wittel, as well as to Pannini, that he turned in his research for a new dimension for historical scenes that was both objective and actual. Both artists developed a lucidly rational form of reportage in which the culture of Rome was seen in a continual and felicitous state of change.

This approach also links Ghezzi to another great artist of the eighteenth century, the Englishman William Hogarth, with whom he shared an ironic and slightly grotesque vision of society. Both drew their inspiration from everyday life around them, producing curiously anecdotal paintings even when these had to do with official or historical themes. Thus, Ghezzi's painting of the *Lateran Council* has a direct parallel in Hogarth's famous *Reception at Wanstead House* (1731), now at the Philadelphia Museum of Art, which offers a solemn yet detailed description of an interior.

During the jubilee year, Ghezzi also executed a curious portrait of Benedict XIII in a lunette in the great hall of the Castle of Torrimpietra. He was commissioned to make the fresco by Alessandro Falconieri, who wished to celebrate his own nomination as a cardinal in 1725, as well as the Pope's visit to his country residence at Torrimpi-

etra. For that occasion, the Cardinal arranged for the decoration of the huge hall and the adjoining rooms with motifs alluding to official circumstances and the pleasurable aspect of his country residence. For this reason, the representations overlap onto landscaped backgrounds, painted by a specialist of that genre, François Simonot, called Monsù Francesco, whom Ghezzi portrayed in the *Arrival of the Pope at Torrimpietra* just below the portrait of Benedict XIII. In that same scene, there is a self-portrait of the artist, kneeling with his back to the viewer, and, like his French colleague, rendering homage to the pope. The illusionistic landscapes covering the walls refer to the luxurious vegetation of the surrounding area and symbolize the harmony between man and nature that seems to prefigure the ideals of the Enlightenment.

The central lunette, the fulcrum of the entire decoration, depicts the Pope's benediction during his visit to the castle. He is accompanied by prelates and cardinals, all portrayed in a perfectly recognizable manner and immortalized in the scene as they stand behind and beside the pontiff, in an image that looks very much like a group photograph. Once again, the painter referred to Pannini's scenography and the absolute objectivity of the *veduta,* which he used here in a historical context. Ghezzi arranged the portraits of those personalities into a rational scheme, and painted them with the freely realistic style he had been using since the beginning of the century, one that was popular in artistic and religious circles.

Pietro Bracci
Portrait of Benedict XIII
Rome, Museo del Palazzo
di Venezia

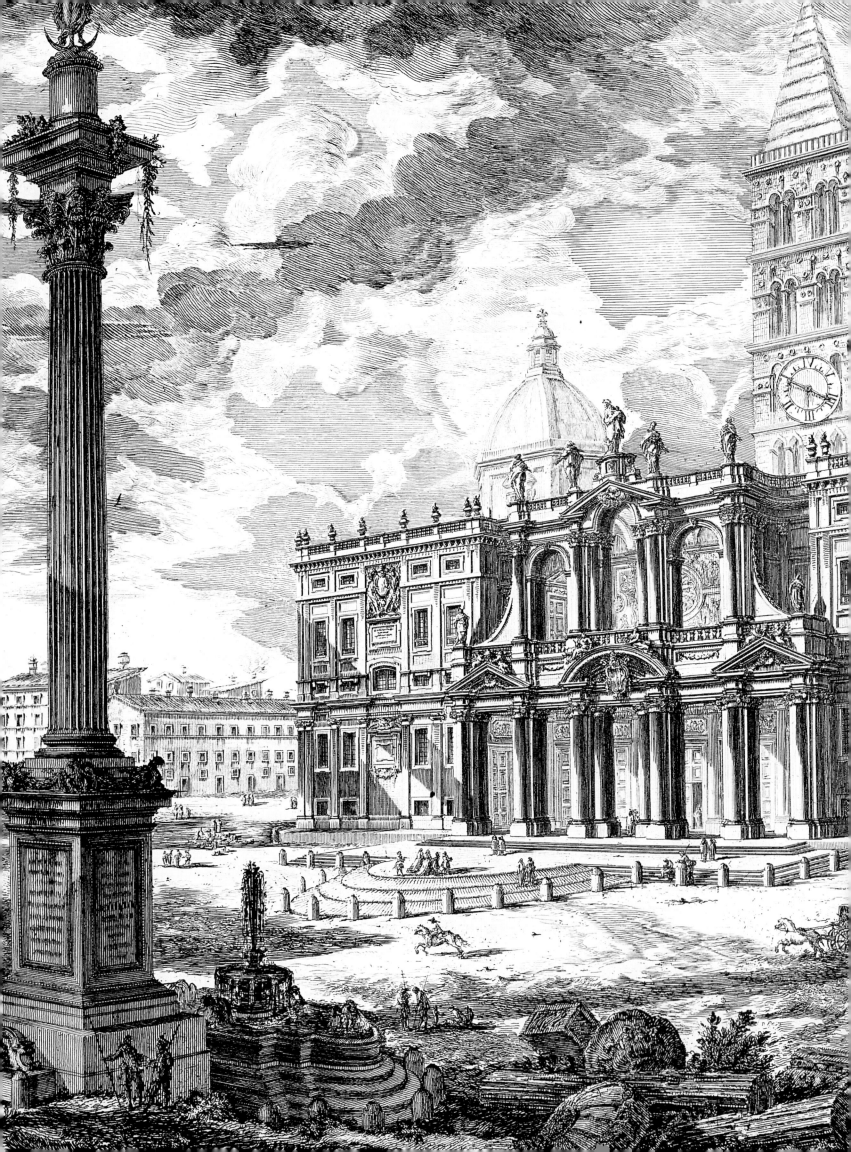

THE JUBILEES OF BENEDICT XIV

GIOVAN BATTISTA PIRANESI AND THE ROME OF ANTIQUITY
Augusta Monferini

G.B. Piranesi
View of the basilica
of Santa Maria Maggiore
detail

The election of the sixty-five-year-old Bolognese Prospero Lambertini (Benedict XIV) as pope in August 1740 coincided with the outbreak of the War of the Austrian Succession. That conflict considerably disturbed the serene development of his pontificate, and only after the treaty of Aix-la-Chapelle (October 18, 1748) could Bendict XIV direct his attention to the preparation of the imminent Jubilee. He was most concerned with improving the pilgrims' access to the city, repairing the damage that the passing armies had caused to the consular roads, and ameliorating transit within the city. Already, between 1741 and 1743, he had given one of the principal basilicas, Santa Maria Maggiore, a new façade with a portico and loggia of three arches (a façade, by the way, that Fuga built in front of the original one, thus preserving the historic mosaics). This was emblematic of the new conservative sensibility that—although at times was contradicted by excessively "modernizing"

initiatives—marked the reign of an erudite pontiff whose love for pagan antiquity made him want to give it a Christian stamp.

Symptomatic of this tendency was Benedict XIV's promotion of the Via Crucis procession at the Colosseum. At the conclusion of the Holy Year, on December 27, 1750, he had a cross erected at the center of the Colosseum, having already provided for the safeguard of the monument. An Academy of Pagan and Christian Archeology was established at the Capitol in accordance with his wishes. His edict, *Sopra la Conservazione dell'Antichità e pulizia delle pubbliche Fontane di Roma* (About the Conservation of Antiquity and the Cleaning of the Public Fountains in Rome) is dated December 6, 1749. The pontiff attached particular importance to the restoration of the fountains, considering them a fundamental element of the urban decoration. The Fountain of Trevi, started in 1732 by Nicola Salvi, and continued after 1751 by Giuseppe Pannini, was

199

Veduta dell'Atrio del Portico di Ottavia.

finally inaugurated in 1762 under Clement XIII.

As for religious buildings, numerous interventions were carried out on the churches of the city, from the consolidation of the dome of St. Peter's to the reconstruction of San Marcellino and the Sant'Apollinare complex, the enlargement of the Ospedale di Santo Spirito, as well as restorations at San Marco and Santi Quirici e Giulitta, Santa Maria dell'Anima, Santa Maria degli Angeli, Sant'Alessio, and San Martino ai Monti. The restoration at Santa Croce in Gerusalemme was entrusted to Domenico Gregorini and Pietro Passalacqua, who, in 1743, transformed the central nave and replaced the original narthex with an oval-shaped atrium on which the new façade was modeled in travertine. Between 1749 and 1751, the city walls between Porta del Popolo and Porta San Paolo were repaired. In 1747, the architect Paolo Posi redid the decoration of the inside attic of the Pantheon (Santa Maria ad Martyres).

Benedict XIV was well aware that the image of Rome was not only a matter of its physical appearance but also one that had to be illustrated by means of writings and prints. The historical culture and erudition of the Pope and the Curia regarding the city of Rome were demonstrated by a series of publications starting with the *Istoria degli Anni Santi* (History of the Holy Years) by Domenico Maria Errante (1750) and *Roma antica e moderna* (Ancient and Modern Rome) and *Roma ampliata e rinnovata* (Amplified and Renewed Rome) by Gregorio Roisecco. The jubilee year also saw the publication of a *Descrizione delle statue, busti, bassorilievi, urne sepolcrali, iscrizioni e altre ammirabili ed erudite antichità* (Description of the statues, busts, bas-reliefs, sepulchral urns,

G.B. Piranesi
View of the hall of the Portico dell'Ottavia

G.B. Piranesi
View of the basilica and of the piazza
of St. Peter's in Vatican

inscriptions and other admirable and erudite antiquities), cataloging ancient works preserved in the Capitoline Museum. In 1748, the great new map of the city by Giovan Battista Nolli was published in twelve folios; it presented a rigorous relief of the city and all its monuments, ancient and modern. A reduced one-folio version of the same plan was later published, with engravings of the basilicas of St. Peter's, Santa Croce in Gerusalemme, and Santa Maria Maggiore by Giovan Battista Piranesi, who designed the decorative and monumental border that surrounded the topographical relief.

In fact, the greatest artistic achievement of the Jubilee years of Benedict XIV, and quite in spirit with the archeological and architectural interests of the pontiff and the erudite group around him, was the engraving work of the great Piranesi. He had recently published *Invenzioni capricciose di carceri* (1745); *Antichità Romane de' Tempi della Repubblica e de' primi Imperatori* (1748); *Opere varie di architettura prospettive grotteschi. Antichità sul gusto degli antichi Romani* (1750); and the *Magnificenze di Roma* (1752). Between 1748 and 1752, he had also inserted forty-seven tables of his work in the *Raccolta di varie vedute di Roma sia antica che moderna*, while in 1756 he published the four volumes of *Antichità Romane*, which included previously executed engravings. The expectation and recurrence of the Jubilee undoubtedly influenced Piranesi in his choice of themes, since he needed to find a public for his prints among the cultivated visitors who came to the city. His greatest stimulus, however, came from an impassioned love for the eternal city and the ancient image that was perpetuated in the splendor of the modern one.

Piranesi's first and principal patron

was Monsignor G. B. Bottari, an antiquarian of note, and who, as counselor and private chaplain to the Pope, was instrumental in shaping his cultural policy. Bottari's ideology, shared by Benedict XIV, can be summarized by the words with which Piranesi prefaced his *Antichità Romane,* "On my seeing that the ruins of the ancient buildings of Rome [...] are diminishing from day to day because of the ravages of time, or because of the avarice of those who own them, who with barbarian license are clandestinely demolishing them in order to sell the fragments for use in modern edifices, I have been advised to preserve them by means of prints, urged by the sovereign beneficence of the reigning pope, Benedict XIV, who among the weighty duties of his pontificate, has always regarded with special interest and promoted the culture of the liberal arts and Roman antiqui-

ties, having instituted in their regard a special Academy, and enriched the Capitoline Museum with ancient statues, and many other illustrious monuments for the enlightenment of sacred and profane history."

Bottari identified the heritage of ancient art and ancient civilization and the art and civilization of modern Italy with Rome: he envisioned the Church as the institution that would guarantee such an ideal continuity. But because of this, the Church had to be liberated from the ignorance, prejudice, and hypocrisy that the Jesuits perpetuated. There was a direct introduction of Jansenist thought here, with Enlightenment reflections, which both Bottari and Piranesi shared. Ancient Rome also became the model for a cultural dignity that was to be sustained in Catholic Rome.

The *Vedute di Roma* that Piranesi executed in 1740-41 were small-sized

G.B. Piranesi
View of the basilica of Santa Croce in Gerusalemme

G.B. Piranesi
View of the basilica of Santa Maria Maggiore

engravings illustrating a guidebook to *Roma Moderna*. This series continued with large-format folios (up to seventy-one centimeters in width), and went on growing with new subjects until the death of the artist. In Piranesi's fertile and varied production, these *Vedute* were always in the forefront. Of all his works they were the most famous and the most in demand, as they spread throughout Europe the grandiloquent image of the Rome of antiquity and of the popes, nourishing on the one hand the romantic taste for ruins, and proposing on the other a model of monumental city planning that would influence the design of many European capitals. The architecture invented by the artist was no less important in this respect. Based on "the taste of the ancient Romans," it made up the collection called *Prima parte di Architetture e Prospettive.*

Furthermore, the great *Vedute* constitute the backbone, the foundation of the entire oeuvre of Piranesi. All his other works attest from time to time to the stages of development and the partial points of contact of his archeological research, while the *Vedute di Roma* always represent in their interior evolution a summary, a distillation of acquired knowledge. In Piranesi's other works, there is an articulation of research, a systematic analysis of sites and monuments, and the research itself is explained and documented. The *Vedute* condense the results of the preliminary cognitive operations (inspections, reliefs, measurements, sections, etc.) into the meaningfulness of the image, without didactic mediation and justification.

Especially in the beginning of this series of tables, Piranesi seems to have had in mind not only the engravings of Canaletto but also his *veduta* painting (or topographical views), memories of

his journeys to Venice. Canaletto's influence is also recognizable in the spacious, open, luminous vision, in the way the buildings are framed in perspective from a distance into a vibrant and serene scenario, with the breadth of the opening and the sky occupying most of the background. Later, instead, the single monuments, exalted as such, would advance toward the foreground, blocking most of the background and the sky by their imposing and disquieting presence.

Unlike the *Vedute*, Piranesi's *Antichità Romane* followed a historical development, attempting to furnish an organic picture of the city from the time of the first kings to the last emperors by singling out the monuments, the different zones and spaces, city walls, system of aqueducts, and city gates. The sewers, aqueducts, bridges, and streets were "prosaic" and daily aspects of the city that likened it to a living, pulsating body. The subdivision of the tables into typological schemes and topographical sequences followed a demonstrative criterion. The written material acts as a running commentary, in the economy of the work, a rational and motivated guide to the great reconstruction. It is intrinsic to the work itself. The style, essential and not at all redundant, was

congenial to the technical and scientific aims proposed by the artist as well as to the coordination and explanation of the tables that often, on the contrary, seem designed only to illustrate and demonstrate the theories expressed in the text.

Henri Focillon thought that Piranesi had engraved and prepared the tables of the *Antichità Romane* starting in 1750. However, as previously discussed, the interior of the Pantheon reproduced in a table in the first tome does not show tympanums above the niches of the superior order, these being added in 1747. Therefore, the beginning of the collection must date back to at least 1746-47, if not before. The occasion of the Jubilee may have been one of the incentives that stimulated Piranesi to produce his great work. Focillon also established (but did not investigate in depth) Piranesi's relationship with the antiquarian culture of the times. But while this connection is right and enlightening, it still does not pay full justice to the novelty of Piranesi's vision, which, in reality, seems to indicate a departure from the archeological doctrine of his contemporaries. This would also explain the vehement polemics of which he was the target, and only subsequently the impassioned actor, and all

Above, left:
G.B. Piranesi
Ustrino Arcades

Above, right:
G.B. Piranesi
Hadrian's Mausoleum

the malevolent anecdotal literature that developed around his figure. The purpose of these diatribes may even have been to reestablish the threatened hegemony of the academic culture against which he reacted.

The archeological methodologies of Piranesi's time may be grouped schematically into four currents. The first was that of the scholars, based only on literary sources, without the verification, contribution, and support of excavations or explorations of the monuments. The second current was that of the architects, headed by Desgodetz, who limited themselves to operations of relief, measurements, and graphic restorations, in the tradition of Palladium and Serlio. The third current was the engineering type of Zabaglia and others, who investigated the structural elements with a spirit of curiosity for the more complicated and statically audacious "machines." An entirely different culture was that of the amateurs, those dandies, merchants, painters, and tourists of the Grand Tour, a culture of predatory collecting against which, as we have seen, Piranesi reacted with indignation.

However, he also clashed with the other three currents, unless they combined—and here was the novelty of his method—in one single moment the operation of excavations the structural investigations, and the measurements with an attentive and scrupulous study of the sources. Such a unification was made possible by a topographical study, an almost meticulously constructed grill (of 314 entries), that included all the relevant data. Piranesi tended to overthrow the traditional procedure, which started from the literary texts and went on to examine the ruins. He replaced a somewhat "deductive" method, which proceeded from the general to the particular, with one that may be defined as "inductive," in the sense of Baconian empiricism. This view held that truths do not exist that cannot be put to the test, evidence that cannot be verified, and, if need be, corrected and modified. From this point of view, the influence of Piranesi's Scottish friends Robert Adam and Allan Ramsay, to whom he dedicated the second cluded. Yet, that felicitously empirical attitude, which gave rise to the modern methodology of archeological studies during the Jubilee years of Benedict XIV, is first and foremost to be included in Piranesi's "Enlightenment," which, as Maurizio Calvesi so acutely recognized, was opposed to the traditional, romantic interpretation of the artist.

1775

THE JUBILEE OF CLEMENT XIV AND PIUS VI

THE MUSEO PIO CLEMENTINO AND THE SACRISTY OF ST. PETER'S IN THE VATICAN
Elisa Debenedetti

The last jubilee of the eighteenth century, solemnly proclaimed by Clement XIV Ganganelli in April 1774, was not inaugurated by the same pope, who died in September of that year. The conclave did not end until February 1775, with the election of Cardinal Giovanni Angelo Braschi of Cesena, who took the name Pius VI. A few days after his election, the new pope opened the Holy Door and immediately adopted the dispositions issued by his predecessor in order to reaffirm those Christian principles which had dominated the century: the need for evangelization and a spirit of charity. Similarly, the norms which regulated the cleansing and embellishing of churches, city décor, and hospitals were ratified. But there was no room for significant interventions, other than those made in the Vatican itself. An exception was the rebuilding of Clemente Orlandi's small church San Paolo Primo Eremita, enriched in its interior with stucco work by Penna and del Righi (of which nothing re-

mains) and adorned with a statue of the titular saint, currently missing.

The names of the two popes connected with the 1775 Jubilee—the shortest, by the way, in history as it only lasted ten months—are linked particularly to the erection of a museum of antiques in papal Rome, a great enterprise and almost a response to the revolutionary ideas from beyond the Alps. Although the two popes were very different by nature, they were united by a "lay" religiosity, manifested by Clement XIV with the dissolution of the Jesuit Order, although admittedly strongly pressured by European countries, and by Pius VI through his iron will to do things "in a big way," very evident in the importance he ascribed to the fine arts as a means for political assertion.

This was a difficult period for the history of the Church, which centered all its energies on the Jubilee in order to re-establish the connection between the faithful and God. Cultural and political instability undermined the

Basilica of St. Peter's
Sagrestia Comune (Common Sacristy)

207

Church's role; the Holy Years 1700 and 1775 (there was no Holy Year in 1800) were at the two opposite poles of a historical reality which saw a change in the attitude of the papacy and in the behavior of believers. The spreading of Enlightenment thought jeopardized credibility in the tenets of faith and compromised traditional artistic perspectives. Art no longer generated forms corresponding to a univocal power strategy, but conveyed the image of a reality in which a new mentality was being molded, poised between the religious and the secular. The location and the subjects of works of art acted as a touchstone between two opposing cultural mentalities: on the threshold of the year 1775, in the Papyrus Rooms in the Vatican, Mengs celebrated not a religious theme, but the *Allegory of History*, while in that same cultural context, Corvi gave a moral example in *The Sacrifice of Iphygenia*, painted for the private palace of the Prince Borghese.

The pain at the changing times was expressed by Pius VI in the *Enciclica Inscrutabile divinae*, released when the Holy Year was drawing to a close, and although the pope endeavored to organize a solemn Jubilee open to all, following the model organized by Benedict XIV in 1750, the presence of crowned heads turned the celebration into a glamorous event, the penitential value of which was understood by ordinary pilgrims only. The sacred and the profane, like the new and old, interwove indissolubly: thus Rome offered an urban network of spiritual and artistic itineraries revealing the dialectics between tradition and change.

Initiatives for the collection and preservation of works of art were intensified under Clement XIV and Pius VI. The last pontiffs of the eighteenth century were not particularly concerned about the urban organization of the city, choosing to concentrate their attention on a new and rigorous rereading of the classical heritage. The construction of the museum of antique was fraught with complications, however. There were considerable differences between the plans of Pius VI and Clement XIV inasmuch as the enlargement desired by Braschi clashed with the simple renovation of the pre-existing building promoted by Ganganelli. The original idea, dated 1770, was designed by Alessandro Dori, the architect of the Apostolic Palace, who died in January 1772. This plan involved placing the gallery inside Innocent's Belvedere and totally reorganizing the porticoed courtyard and annexed buildings, based on a project of 1774 by Michelangelo Simonetti, who continued as official architect until 1787.

It was probably Braschi, then the Papal Treasurer, who suggested the

General plan of the Museo Pio Clementino 1782

G. Piale
Pius VI visiting the Museo Pio Clementino
(Sala delle Muse), with G.B. Viscont
and M. Simonetti kneeling at his feet

Pages 210-211:
Museo Pio Clementino
Gallery of the Statues

Palazzetto del Belvedere as the seat of the new museum. The new addition, which dates back to Pius VI, was built in 1776, and is a completely autonomous work, separate from the rest of the museum. Designed by Pietro Camporese, the addition connects the Courtyard to the Library Corridor and crosses through the Sala della Muse (Muses), the Rotonda, the Sala a Croce Greca (Greek Cross), the Grand Staircase, and lastly the Atrium of the Quattro Cancelli (Four Gates) with the Sala della Biga (Chariot) above. Except for the finishing touches, which lasted for a few years, the works were concluded between 1792 and 1793. E. Giovan Battista Visconti, who had been the director of the museum since 1781, was probably assisted by his son Ennio Quirino, whose knowledge of antiquity was unrivalled, and who became keeper of the Vatican Library in June 1783.

During Clement XIV's pontificate the Gallery of the Statues was built. To facilitate the new Baroque structure, the old dividing walls were replaced by *serliana* archways, a Palladian motif, present also in the Villa Albani, that terminated at the back wall with a niche containing the statue of *Jove Verospi,* which faced the *Barberini Juno* on the opposite wall. Some of the service rooms on the three sides of the gallery were converted to museum use, as was a portico in the octagonal courtyard. The preexisting structures were provided with supports, the old windows were closed, and new walls and windows constructed. Each side of the portico, which was supported by sixteen red-and-black granite columns that had been taken from the library garden, had a round arch flanked by architraved coupled columns—the so-called *serliana* archway—while other arches opened at the rounded corners. Triangular and semicircular tympana surmounted the arches, while bas-reliefs were inserted above the coupled columns and masks placed inside the tympana. The Ionic portico was covered with a coffered barrel vault decorated with stuccoes reproducing the heraldic devices of the pope, and above

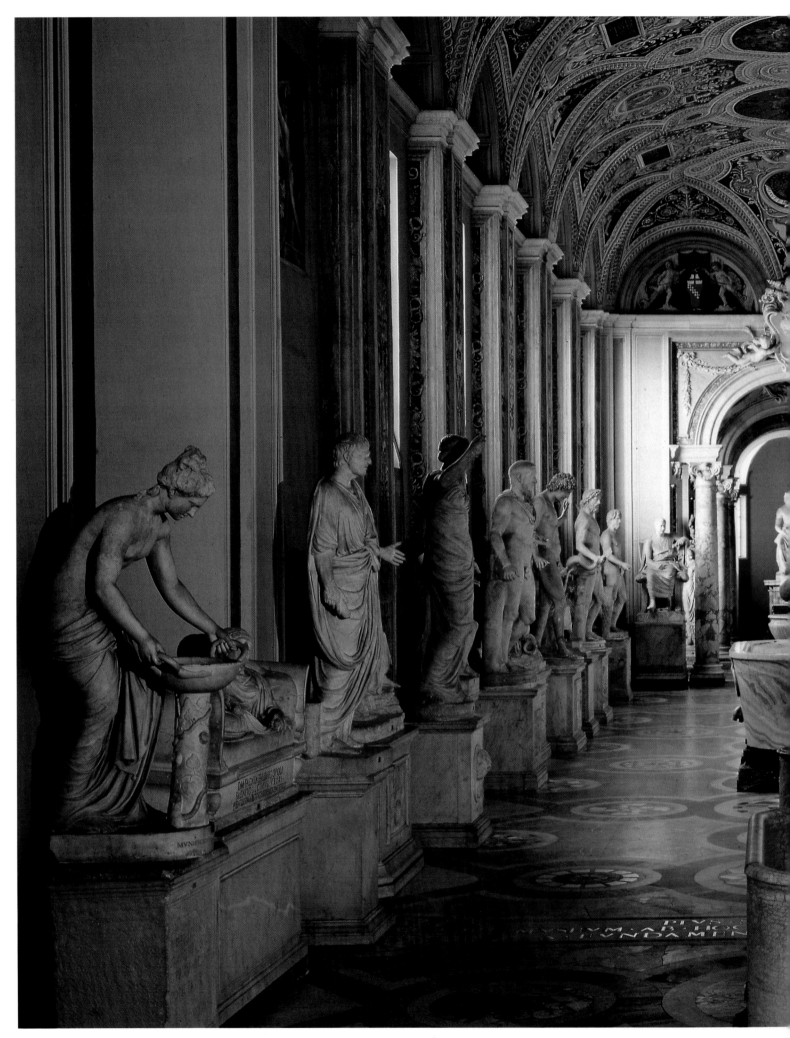

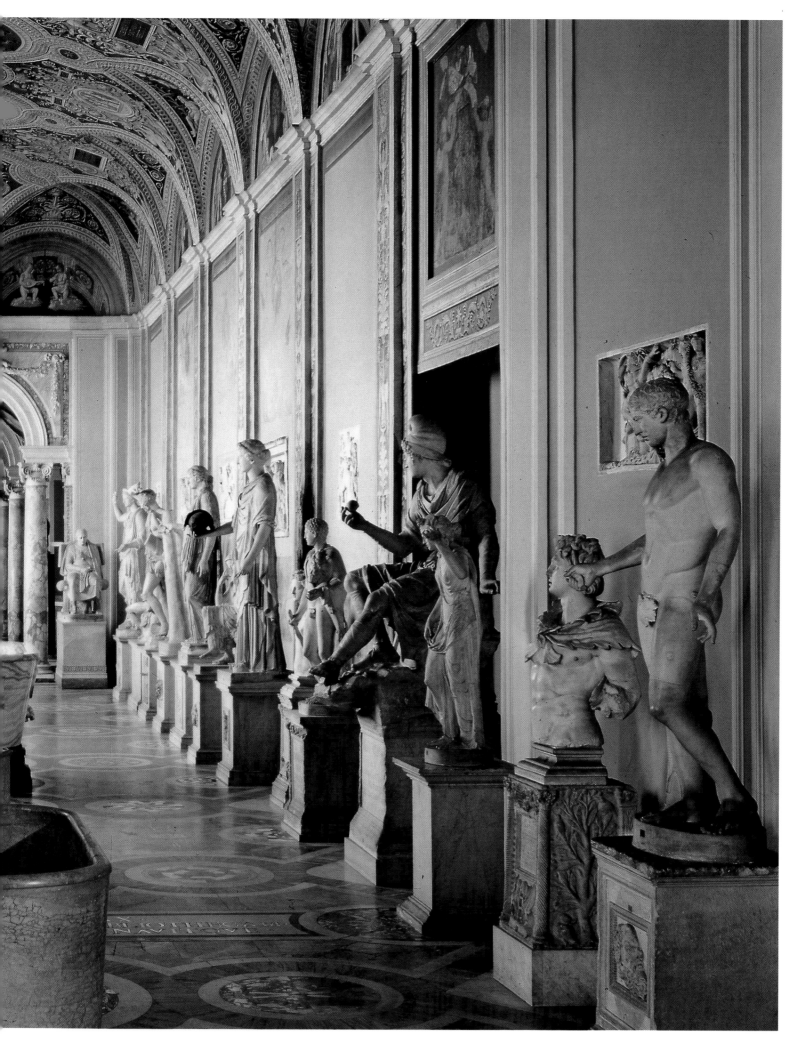

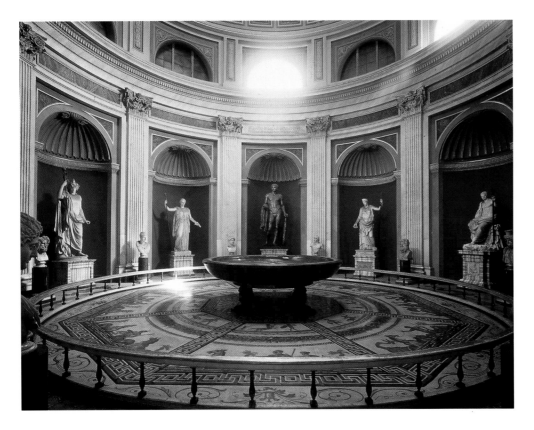

the door the coat of arms of Julius III gave way to that of Clement XIV. A porphyry fountain was placed in the center of the courtyard but was later transferred to the Sala Rotonda. During this period, the Stanza of the Torso became the Stanza degli Animali, when the statues occupying the center were moved.

A second Clementine project was Simonetti's reorganization of the east side of the courtyard. This involved the Library Corridor (the former corridor of the Lapidi); the Stanza della Cleopatra; the Vestibolo Rotondo, which was given a new entrance to the museum; the two adjoining rooms, that of Meleager and the one next to Bramante's staircase; and other rooms on the south side. The restoration and repainting of the fifteenth- and sixteenth-century frescoes, entrusted in 1772 to Cristoforo and Ignazio Unterperger, with the assistance of the stucco decorator Giacinto Ferrari and the ornamental painters Angeloni and Mezzetti, altered the original decoration very little, if at all. Later, the two Viscontis chose the subjects for the single rooms that would celebrate Clement XIV's and Pius VI's fervent activity in defending and preserving classical antiquities.

That program, archeologically inspired both in form and content, was developed more fully in the ceilings of the Gallery of the Statues, the Vestibolo Rotondo, and the Belvedere Courtyard, and suggested an ideal continuity between the power of the popes and that of the Roman emperors.

The so-called Room of the Animals, on the west side of the courtyard, had been radically transformed into a "four-sided portico." This space, which became the atrium for the central entrance and the two symmetrical large rooms, was completed in 1776 under Pius VI, who altered it only by opening an entrance on the short side by the Gallery of the Statues. Unfortunately, that opening sacrificed the Chapel of San Giovanni, where Mantegna had frescoed the walls and ceiling between 1488 and 1490, and its Sacristy, a small, square room illuminated by a single window in front of the door. Once the Gallery of the Statues had been lengthened, the decoration was again entrusted to Cristoforo Unterperger, who, between 1776 and 1779, was assisted by a team of specialists, architects, archeologists, sculptors, and painters.

Pius VI's intervention made possi-

Museo Pio Clementino
Sala Rotonda

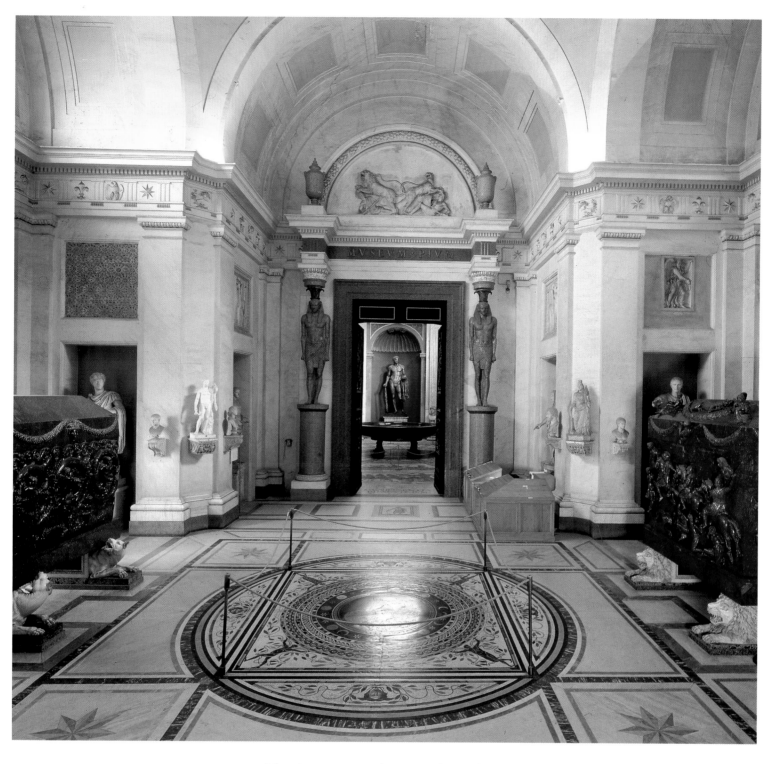

View of the Sala a Croce Greca
in the Museo Pio Clementino

ble a long passage between the Gallery and the Library. The construction of the new spaces was chronological: in 1789 the Sala delle Muse, in 1782 the Sala Rotonda, in 1784 the Sala a Croce Greca and the Staircase. For this series of rooms, Simonetti used ancient Roman art as his model—the tombs on the Appian Way and the Via Latina, Hadrian's Villa, the Domus Aurea, but first and foremost, the Pantheon and the public baths. He created grandiose spaces on an imperial scale, using the Doric order for the Staircase and the Atrium of the Muses, and Corinthian for the other rooms, whereas Clement had used the Ionic order everywhere in order to conform to the sixteenth-century capitals in the courtyard.

The Sala dedicated to the Muses, an octagon with two square vestibules on either side, covered by a barrel vault, was decorated between 1782 and 1787 by Tommaso Conca with allegorical scenes relative to Apollo, the Muses, and the sages of antiquity. These paintings tended to imitate the Baroque pictorial cycles with the creation of a false

architecture of pilasters, columns, and other decorative elements inserted in the segments of the vault. The central dome was placed on four arches, two of which were connected to the vestibules, and two were supported by four columns set into the walls. These, in turn, rested on a continuous architrave sustained by sixteen columns of Carrara marble with Corinthian capitals. Twelve of these columns were from Hadrian's Villa and had been restored by the marble carver Francesco Franzoni, who also made the other four, which are almost identical to the ancient ones. The floor design and the restoration and integration work was finished between 1780 and 1782, while the definitive conclusion of the work, including the frescoes, occurred in 1787.

Next to the Sala delle Muse is the Sala Rotonda, which is articulated in two orders. The first consists of fluted pilasters and Corinthian capitals carved by Franzoni, intercalated by eight niches with statues and two doors. Stuccoed shells by Giacinto Ferrari are placed in the calottes of the niches, while standing between them on porphyry drums are colossal busts, three of which are ancient. On an architrave cornice also carved by Ferrari, the main order supports the attic, which has ten pilaster strips that alternate with ten semi-circular windows, and concludes in an ornate cyma. Above, the hemisphere of the coffered vault is open on top thanks to a crystal cupola, inspired both by the dome of the Pantheon and that of Minerva Medica.

V. Feoli
View of the Sala delle Muse
in the Museo Pio Clementino

Most of the floor is covered by the mosaic from Otricoli, brought to Rome by Giuseppe Panini, its border of black-and-white mosaics with marine motifs comes from Hadrian's Villa; in the middle of the floor is a modern mosaic by Andrea Volpini. This room houses the most important and prestigious works of the collection. Its basic model is the Pantheon, which was frequently imitated and reproduced in the eighteenth century and even transformed into an exhibition space. But there are also many references to Renaissance and Baroque art. The very rich decoration is a departure from Roman prototypes, and the overall effect of the room is that of a hybrid art, midway between the old and the new.

Next to it is the Sala a Croce Greca, which leads to the Staircase and the Corridor of the New Library. Its most outstanding feature is the red granite doorway, the work of Giuseppe Camporese, surmounted by an ancient bas-relief and framed by two colossal Egyptian statues, which were brought to Rome from Tivoli by Visconti and restored by Gaspare Sibilla. They support Doric columns above which is a cornice with the words *Museum Pium*, decorated by two red granite vases. The installation of the mosaic floor from the Villa Rufinella at Frascati was finished in 1786, after the two enormous sarcophagi of St. Constantia and St. Helena (not in the original project) had been brought there. The room, composed of four arms of equal length with four archways with coffered intrados, derives from the ancient thermal baths, its sail vault from the Roman baths. A heavy Doric frieze decorated with the heraldic devices of Braschi extends across the walls, supported by sixteen pilasters with stucco capitals and marble bases. The walls were painted a light color, probably to give greater emphasis to the sarcophagi.

The Staircase, which completes the cycle of principal works of the Museo Pio, connects the west side of the Belvedere Courtyard to the Library Corridor. At the bottom of the Staircase is the entrance to the Apostolic Library, at the top the Sala della Biga and the Atrio dei Quattro Cancelli. The first ramp, covered by a barrel vault with stucco decorations resting on granite columns, leads to the Sala a Croce Greca. On the side of the ramp, two narrower ones lead in the opposite direction to the landing that communicates with the Galleria dei Candelabri, completed between 1787 and 1788 by Giuseppe Camporese, who had recently been named pontifical architect and assistant to Simonetti.

From here, another ramp provides access to the Museo Gregoriano Etrusco, once the apartment of Cardinal Zelada. The Doric columns in oriental granite come from the Cathedral of Palestrina, those in coral breccia from the Tivoli quarries. The pilaster and column capitals were carved by Franzoni, together with the cornice and soffits, while Ferrari was responsible for the decoration. This is extremely ornate, the dominating motif being the heraldic devices of the Braschi coat of arms: they appear in the bronze decorations of the balustrade, in the capitals of the columns, in the stuccoes of the vault and even on the steps, the surface of which was once decorated with stars. The part of the staircase that leads to the Sala a Croce Greca is formed from the lunette of the coffered arch which rests on black porphyry columns which form an aedicule, in the center of which is an urn. This last ramp has columns at the ends and marble-faced pilasters in the middle. This particular detail of Simonetti's staircase echoes that of the Palazzo Braschi designed by Cosimo Morelli.

After having completed these rooms and further enlargements in the direction of the Library, Pius VI then thought about transforming the open Clementine loggia of the Galleria dei Candelabri, six bays that formed a kind of serliana archway, using the model of the Galleria delle Statue. Another enlargement carried out by Pius VI was the Gabinetto delle Maschere, a square room next to the Gallery characterized

by eight alabaster columns from Civitavecchia that was completed in 1792-93. Domenico De Angelis decorated it with *quadri riportati* in oil (framed easel pictures), creating partitions and highly ornamental decorative effects. The mythological subjects of the paintings (*Bacchus and Ariadne, Paris, Venus and Adonis*) relate, as in the Sala delle Muse, to the sculptures exhibited there.

In conclusion, the itinerary departed from Clement XIV's staircase, and thence to the Atrio Quadrato bearing the words *Museum Clementinum,* the Vestibolo Rotondo, the Courtyard of the Statues, the Sala of the Animals, the Gallery of the Animals, the Gallery of the Statues, the Cabinet of the Masks, the Loggia, the Sala of the Muses and the Sala Rotonda. One exited from the Sala a Croce Greca, which had written on its architrave *Museum Pium.* Descending Simonetti's staircase, one reaches the Apostolic Library; ascending it, one arrives at the Sala della Biga and the Galleria dei Candelabri. Naturally, it is necessary to keep in mind the important role that the archeologist Winckelmann played in this entire context. Some years earlier, he had assembled and systematically organized the ancient statues, objects, urns, tombstones, column drums, and granite basins in the garden and pavilions of the Villa Albani. Visconti systematically organized the collections at the Museo Pio Clementino and, later, those at the Villa Borghese, according to the principle of considering them as a united whole. An ancient setting was therefore created to assemble ancient pieces in a series of modern museums decorated in the eighteenth century!

If the project for the museum turned out to be one of the biggest that had ever existed and, from a financial point of view, the most onerous for the eighteenth-century papacy, then Braschi's for the Vatican Sacristy turned out to be even bigger. Indeed, although competitions had been announced from the turn of the century, the project was constantly postponed. Under Pius VI, Carlo Marchionni

was given the commission to design a new sacristy, using Juvarra's model from 1715 and making the necessary changes. The architects who followed Marchionni in the project were Michelangelo Simonetti and Giacomo Sangermano. The building works started in 1776 with the purchase of the church of Santo Stefano degli Ungari, owned by the Collegio Germanico, and the surrounding houses. In 1777, the Old Sacristy was torn down together with other houses, as well as the Porta Fabbrica, later rebuilt with the name of Porta San Pietro, and Santa Maria della Febbre, the last of the two ancient rotondas.

The New Sacristy rises a short distance from the Basilica so as not to obstruct its view, next to the tribune of Saints Simeon and Judah. It is connected to the church by two corridors, once the ancient entrances to the rotonda of Santa Maria della Febbre. The two corridors enclose Piazza Braschi, where the principal entrance to the Sacristy is located. The noble, rectangular stairway of two flight, was decorated by Francesco Franzoni and embellished with Agostino Penna's statue of Pius VI, and by African green marble pilasters, surmounted by white marble composite capitals sculpted by Cartoni with different motifs based on the papal coat of arms. The stairway and corridors are covered by a low barrel vault painted with false monochrome stuccoes by Giovanni and Vincenzo Angeloni.

In front of the Pope's statue, a door leads into the Sagrestia Comune (Common Sacristy), built on an octagonal plan, and decorated by the Angeloni brothers with lacunaria and foliage, with eight decorated pilasters standing on high white bases with *verde antico* panels. Each segment corresponds to a stucco-decorated window by Giovanni Maria Rusca. Festoons formed of garlands and ribbons supported by cherubim emphasize the subdivision of the segments of the dome and the impost ring of the wide lantern. A broad projecting cornice,

Vatican Sacristy
Noble Stairway with the statue of Pius VI

embellished with dentils and ovolos on the lower band, divides the space in half. Below, the walls are composed of two orders separated by a string-course molding; windows with alternating linear and triangular tympanums open on the upper level. The four open sides are flanked by fluted gray marble columns with an architrave from Hadrian's Villa at Tivoli; these are surmounted by Ionic capitals of stuccoed travertine that once belonged to Bernini's demolished belltower. The doors in the two open walls lead to the minor sacristies, while a space destined for a chapel with an altar is on the wall opposite the main entrance. The left-hand door leads into the Sagrestia Canonicale, a square room with a chiaroscuro painted ceiling; the right-hand door leads into the Sagrestia dei Beneficiati, which is similar in structure. This entire side today houses the Museum of the Treasury of St. Peter's.

In addition to the Sagrestia Comune, the three sacristies are also connected to one another by a walkway that runs parallel to the Basilica, toward the entrance to the noble Stairway. This walkway also connects to the two corridors leading to the Basilica: the three galleries are similar in the subdivision of space, ceilings, and decorations. Twelve ancient columns of gray marble have been inserted between the pilasters at the entrance to the Sagrestia Comune and those leading into the Basilica; seven of these come from the demolished church of Santo Stefano degli Ungari, one is from Ostia, and the other four are from the *Porcareccia* estate. The plinths and bases of the columns and pilasters, identical to those at the entrances to the minor sacristies, are of two different colored marbles. The one that rests on the floor runs continuously along the entire perimeter of the wall. The base is of white marble, as are the composite capitals, repeating the theme of those on the inside of the noble staircase.

In addition to the Piazza Braschi entrance, there is another on the southern side of the building, surmounted by a

window with a triangular tympanum, with a mask inserted in the intrados, which leads directly into the courtyard of the Canonica. Above the tympanum, supported by engaged columns with Ionic capitals, is an arched molding; on the opposite side is a similar open one, in correspondence with the upper gallery. The lower arcades on the long sides connect the ground floor walkways; the arcades on the upper level are glassed in. The entablature below the roof, at an angle with the façade, is decorated with a frieze of triglyphs and carved metopes that continues around the outside of the Canonica.

The general view of the façade is blocked by the small Piazza Braschi.

C. Marchionni
Vatican Sacristy
Entrance in front of Piazza Braschi

The principal entrance here is divided into three sloping horizontal zones, characterized by the two orders, Doric and Ionic, which terminate in a balustrade that continues around to the Canonica; the third polygonal zone terminates with the dome. A block characterized by hollow chamfers emerges from the first order, of equal height for the entire building, in correspondence to the Sagrestia dei Canonici. The central body recedes, blocked and held in turn by the structure of the Canonica, which emerges in three orders on this same plane.

The fundamental requirement of the entire construction was uniting two buildings with different functions, the Canonica and the Sagrestia, with the renunciation of one principal point of view. Pope Braschi's architect had obtained a similar effect during the 1740s at the Villa Albani by placing the Casino inside the network of paths in the park. The terraced terrain with statues and other decorations drew attention to the principal pavilion, the central part of which was, however, hidden. Marchionni realized a spatial subdivision here as well, by keeping it proportioned and autonomous yet connected to the Basilica, forcing the viewer to look at his building.

Marchionni's work was criticized primarily from an aesthetic point of view: it was judged to be more ornate than beautiful. His contemporaries considered it a latecomer to the neoclassic trends, both because of its distribution of space, which was totally symmetrical and accommodating, and its decoration, which made use of overly complicated solutions. Marchionni was still influenced by the past, even though he exhibited a new rationality of the internal structure and a new facility of communication between one space and another. Externally, the multiplicity of the points of view of the edifice and the diagonal chamfer that uninterruptedly connects all the parts are reminiscent of Mannerist solutions. Internally, the polychrome of the marbles and reliefs are closer in style to the early eighteenth century, and there are Baroque references in the interruptions, tympana, capitals, and diagonal effects. Perhaps the architect was struck by a neoclassic conception of the ancient, conceived not as an archaic era separate from reality but as a lesson to be revived and made concrete in the present. Once again, the experience of the Villa Albani was continued in the realization of the Sagrestia, where marbles and ancient reliefs were integrated into an architectural structure which, this time, served a sacred function. In this case, therefore, Marchionni assimilated Winckelmann's theories, translating them into a rich and sumptuous language, suitable for the celebratory needs of the pontificate.[1]

[1] In the vast literature regarding the Holy Years and phenomena relating to them, it is our duty to quote P. Perali, *Cronistoria dell'anno santo 1925* (Rome, 1928), as an indispensable text for the bibliography, to which must be added, besides the very well-known recent studies: A. Monticone, ed., *Poveri in cammino. Mobilità e assistenza tra Umbria e Roma in età moderna* (Milan, 1993); C. Strinati, "I Giubilei nelle arti figurative", in *Roma e il Giubileo del Secondo Millenio. La Fede, la Storia, l'Arte*, edited by S. Polci, (Rome, 1995), 67- 85; S. Nanni, M. A. Visceglia, ed., "La città del perdono. Pellegrinaggi e anni santi a Roma in età moderna, 1550- 1750," in *Roma moderna e contemporanea*, V (1997), 2/3, 287- 617; M. Boiteux, "Parcours rituels romains à l'époque moderne," in *Cérimonial et rituel à Rome (XVIe- XIXe siècle)*, edited by M.A. Visceglia and C. Brice, (Rome, 1997), 27-87; and, lastly, the recent works of G. Palumbo, *Giubileo Giubilei: Pellegrini e pellegrine, riti, santi, immagini per una storia dei sacri itinerari*, preface by S. Boesch Gajano, (Rome, 1999) and E. Debenedetti, ed., "L'arte per i giubilei e tra i giubilei del Settecento. Arciconfraternite e chiese, personaggi, artisti, devozioni, guide," in *Studi sul Settecento Romano*, 15 and 16, (Rome 1999), currently in print.

In particular, for the Pio Clementino Museum, the following were consulted: P. Massi, *Indicazione antiquaria del Pontificio Museo Pio-Clementino in Vaticano* (Rome, 1792); C. Pietrangeli, "Il Taccuino di Gianbattista Visconti", in *Bollettino dei Monumenti, Musei e Gallerie Pontificie*, XV (1995), 317-34; G. P. Consoli, *Il Museo Pio Clementino. La scena dell'Antico in Vaticano* (Rome, 1996); for the Vatican Sacristy: S. Ceccarelli, "Carlo Marchionni e la Sagrestia Vaticana", in "Carlo Marchionni. Architettura, decorazione e scenografia contemporanea" (*Studi sul Settecento Romano*, 4), edited by E. Debenedetti, (Rome, 1988), 57-133; for the decoration of the Museo Pio Clementino: M. A. De Angelis, "Per una lettura iconografica della decorazione pittorica nel Museo Pio Clementino", in *Cristoforo Unterperger. Un pittore fiemmese nell'Europa del Settecento*, cat., edited by C. Felicetti, (Rome, 1999), 37-47.

GIUSEPPE VALADIER AND HIS PROJECTS FOR PIAZZA DEL POPOLO AND THE RECONSTRUCTION OF SAN PAOLO FUORI LE MURA

David Frapiccini

Piazza del Popolo
Rome between the Tiber and Aniene
(sculpture group by Giovanni Ceccarini)

The election to the pontificate of Annibale Sermattei of the Counts of Genga, who took the name Leo XII, occurred during a rather peculiar historical period. Supporters of the restoration were resisting the efforts of the many people who, influenced by the events that had taken place in revolutionary and Napoleonic France, were demanding more dynamic political, social, and economic policies. On the other hand, from the time of the Roman Republic of 1798-99 to the French occupation and the exile of Pope Pius VII Chiaramonti between 1809 and 1814, the Papal State had continually lost importance on the international scene. By the time of the restoration, it was at the mercy of the European powers. Their acknowledgment of the pope's sovereignty over Rome and the territories of the Papal State was a great diplomatic success for the Secretary of State, Cardinal Ercole Consalvi. A prelate of moderate standing, he had no intention of ignoring the Napo-

leonic experience, and chose to exploit what was positive in it to create a more efficient administration.

With the death of Pius VII, the more intransigent and conservative ecclesiastic party gained the upper hand and, supported by the influential Austro-Hungarian empire, elected Leo XII from the Marches. One of the first acts of the new pontiff was to dismiss Consalvi, with whom he had never been on good terms, and put Cardinal Giulio Della Somaglia in his place as Secretary of State. By then, the papacy was primarily concerned about controlling its own territory, for it feared, above all, the destabilizing effect and the diffusion of the secret sect of the *carboneria*, an underground political organization that was gaining power at this time, particularly in the Romagna region.

In such a delicate situation, Leo XII decided to announce the Jubilee Year of 1825; it was a declaration of his autonomy from the European powers. The event was particularly significant

given the dramatic circumstances at the end of the eighteenth century, which terminated with the election of Pius VII in a conclave held in Venice. No Jubilee had been celebrated in the year 1800, the previous one being that of 1775. The pope's resolution was not greeted with unanimous favor in the Catholic world. The Kingdom of Naples and the Austro-Hungarian Empire were worried about the maintenance of public order in the presence of so many pilgrims. The Kingdom of Naples feared it would not be able to properly handle the transit of people through the territories bordering the Papal States. Only the kingdoms of France and Sardinia showed any enthusiasm about the jubilee initiative, realizing perhaps that the way to restoration also involved a recovery of

those devotional forms that had continued until just before the French Revolution.[1] Leo XII announced the Jubilee on May 27, 1824, with the the Bull *Quod ineunte saeculo*, which was publicly read and affixed at the jubilee basilicas, Palazzo di Monecitorio and Campo dei Fiori. The pope indicated he would restore ancient monuments and places of cult for the occasion, but the actual results proved to be quantitatively modest, probably because of the serious economic straits of the Papal State.

On June 22, an ordinance from the Cardinal Vicar required that an apostolic inspection be made of all the churches of Rome. The idea was to "clean them again" inside and outside, so that they would be in a condition deemed proper for the city that was

Piazza del Popolo
View near the Pincian Hill
(from *Nuovi punti delle più interessanti vedute di Roma*, Rome 1828)

Piazza del Popolo
Marble lion at the base of the obelisk
and exedra near the Pincian Hill

the center of Catholicism. However, no real restoration could be carried out without the preliminary approval of the Fine Arts Commission. This commission, through the activity of the experts, scholars, and architects associated with it, played a significant role in the major architectural interventions connected to the Jubilee of 1825. In any case, no project was actually planned expressly for the jubilee. The completion of the decoration of Piazza del Popolo was the result of a project that had actually started several years earlier, and was strongly conditioned by solutions imparted during the Napoleonic period. The reconstruction of San Paolo fuori le Mura, on the other hand, was based on the urgent need to recover an important center of Christian devotion, and it extended well beyond the 1825 appointment (it was not concluded until the pontificates of Gregory XVI and Pius IX). The baptistery of Santa Maria Maggiore, another project undertaken during Leo XII's reign, was finished two years after the Jubilee, although some decorations of minor importance had been carried out inside that basilica.[2] The architect Giuseppe Valadier (1762-

1839) was involved with the three above-mentioned building projects prior to the Jubilee. Piazza del Popolo certainly represents Valadier's greatest achievement in town planning, but it was also the result of a long period of planning that included the contributions of many craftsmen who were pressured by that historical event.

The problem of reorganizing the area between the churches of Santa Maria di Monesanto, Santa Maria dei Miracoli, and the Porta del Popolo had been under consideration since the end of the eighteenth century. There was an urgent need to create a proper northern access to Rome in the direction of Via Flaminia and Via del Corso given the massive numbers of visitors and pilgrims traveling to the city, especially during the jubilee period. Just as it had been when Queen Cristina of Sweden came to Rome during the pontificate of Alexander VII Chigi, the Porta Flaminia (or del Popolo) remained the obligatory passage for whoever was arriving from continental Europe during the reigns of Pius VI and Pius VII and throughout the Napoleonic period. Starting with Alexander VII, the area was endowed with a scenographic look which was

centered on the "funnel," which opened into the city from the Porta Flaminia, and exited at the "trident," represented by the three streets of the Corso, Babuino, and Ripetta. Valadier's first projects kept that layout by creating a trapezoidal space, wider in the direction of the trident, narrower near the city gate. The direction of the Flaminia-Corso axis was accentuated by means of a similar solution in a later project of Valadier's which was, however, never executed. That plan included the elevation of the obelisk that had been placed there during Sixtus V's reign above an arch. In that way, the street axis would not be interrupted and anyone who came through the city gate would have a view of the Corso through the arch. It was not until the Napoleonic occupation (1809-14), however, that the idea was broached of making the piazza a junction, in which the Flaminia-Corso axis would cross that of the Pincio-Tiber. This was suggested by the creation of the two hemicycles, one in the direction of the Pincian Hill, the other toward the Tiber River, which originally were to be separated from the perimeter of the piazza by means of

railings but later became the essential elements in the vast elliptical area.

Under the French administration, town planning was supervised by the architects Guy de Gisors and Louis Martin Berthault. The latter, the author of the Malmaison and Compiègne gardens in France, was particularly instrumental in coming up with a way to connect the piazza with the Pincian Hill by means of a series of ramps. However, it was Valadier, in the years 1816-24, who was responsible for the harmonious layout of roads and trees. He established a successful relationship between the preexisting monuments and the new structures by planting a row of cypress trees around the edge of the western hemicycle and decorating the piazza with fountains and sculptures. A fountain with the personification of *Roma between the Tiber and Aniene* was placed in the center of the exedra near the Pincian Hill, while the group of *Neptune between two Tritons with Dolphins* was placed on the opposite side, both works by the sculptor Giovanni Ceccarini. Statues of the *Four Seasons* were raised on the terminal pilasters of

Piazza del Popolo
Marble lion

Above:
Interior view of San Paolo fuori le Mura
after the fire of 1823
(from L. Rossini, *Le antichità romane*,
Rome 1823)

Pages 226-227:
Santa Maria Maggiore
Baptistery with the baptismal font by
Giuseppe Valadier

the hemicycles: on the east, *Spring* by Filippo Gnaccarini, and *Summer* by Francesco Massimiliano Laboureur; on the west, *Autumn* by Achille Stocchi, and *Winter* by Felice Baini. Valadier also added four groups of buildings at the external corners of the piazza to make it symmetrical: a barracks building across from the church of Santa Maria del Popolo; a new sacristy and other rooms where the demolished Agustinian convent once had been, thus unifying the different architectures; and the two buildings on the corners of Via del Babuino and Via di Ripetta, which were the property of Giovanni Torlonia and Giuseppe Valenti and destined for commercial use.

The last part of the project of the Piazza del Popolo, completed practically at the end of the jubilee year, was the installation of the obelisk in the center of the four circular basins. This was an idea that dated back to the projects made under Sixtus V. The obelisk of Ramses II thus became the focal point of the entire area, which was somewhat promiscuous in its appearance given the Christian images of the three churches, and the secular ones of the sculptural groups.[3]

There is still no convincing iconological interpretation of the Piazza del Popolo complex. Any such analysis would have to take into consideration the subsequent phases of development

of the project and the variations made during the years following the Pope's return to Rome. Valadier's project was unquestionably indicative of the cultural situation existing during Consalvi's restoration and the pontificate of Pius VII, characterized by moderation in its politics and openness in its relations with the European powers. An interest in archeology and the models of antiquity was also evident in the other works in progress, one of which was Raffaele Stern's *Braccio Nuovo* for the Museo Chiaramonti in the Vatican. It was clear from the latter example that the spirit behind the conception of the truly urban layout of Piazza del Popolo had remained immutable.

But things did change radically when Leo XII was elected. Consalvi was ousted, as was the Cardinal Chamberlain, Bartolomeo Pacca, whose name was tied to the famous protection edict of 1820, and who was replaced by Cardinal Francesco Galeffi (or Galleffi), a member of the conservative faction.[4] It was significant in that context that the most important event to take place in the Piazza del Popolo during the Jubilee was the execution of the two *carbonari*, Leonida Montanari and Angelo Targhini, on November 23, 1825.[5] But the dimension of the cultural change, a consequence of the much more intransigent line of restoration, can be seen from the conflicts that arose regarding the reconstruction of San Paolo fuori le Mura. The ancient basilica had been destroyed by a terrible fire on the night of July 15, 1823. The event made an enormous impression on the Catholic world, and projects for its reconstruction were immediately elaborated by architects and experts. On January 25, 1825, Leo XII himself published the encyclical *Ad plurimas easque gravissimas* in which he invited the bishops, archbishops, primates, and patriarchs of Christianity to collect alms for the rebuilding of the church.[6] Furthermore, on March 26, 1825, a special reconstruction commission was established to oversee the work, presided

over by the Cardinal Secretary of State Della Somaglia.

Initially, Valadier was given the option of designing a radically new project, and, after some precautionary measures had been carried out by the architects Pasquale Belli and Andrea Alippi, he was named director of the building works on September 24, 1824, with Gaspare Salvi as his assistant. His design was based on a Greek-cross plan, and involved the transformation of the transept of the old basilica into the major nave, the orientation of the new entrance toward the city, and a barrel vault covering the nave and a sail vault over the cross vault. In this way, the basilica plan, typical of the Roman-Christian tradition, was set aside in favor of a more secular model, yet one rich in references to ancient architecture. The main nave of the preceding basilica of San Paolo was to have been eliminated. But this would have damaged a historical memory, something the Church could not risk doing in such uncertain times if for no other reason than that of the major basilicas' close connection with the original Christian Church. Furthermore, exponents of the most reactionary wing, who were also fierce adversaries of Valadier, were members of the commission that had been created in March 1825. One of these was the Abbot Angelo Uggeri, who, through a publication dated July 30, 1823, and then, through a project elaborated with the help of Pasquale Belli and Andrea Alippi (December 1, 1823), declared that it was imperative to respect the ancient plan of San Paolo. He proposed a reconstruction based on its primitive state, with only minor variations. Uggeri, moreover, criticized Valadier's idea to reduce the size of the basilica, saying that it was detrimental to religion and to the devotion of the patron saint of Rome. Uggeri's party rapidly consolidated and produced other plans, like that of Carlo Donati which was similar in substance to that of Uggeri, except for a vault covering which would limit the risk of future fires.

However, what really marked the destiny of Valadier's project and his position as director of the works was the strong opposition of the archeologists and scholars of antiquity. The Abbot Carlo Fea, an extremely influential figure in the world of Roman culture, railed violently against the architect's ambitious proposals, since, in his opinion, the arts were to serve and help religion, not dominate or condition it. Valadier's situation precipitated rapidly, and a pontifical chirograph dated September 25, 1825, approved a deliberation of the experts in which the original state of the basilica was to be maintained without any modification in its shape, proportions, or decorations.

Leo XII soon became dissatisfied with the slow progress of the work realizing that the basilica would not be ready in time for the jubilee year. The church of Santa Maria in Trastevere was chosen to replace San Paolo for the occasion. Here (as a specially coined medal recalls) the Holy Door was opened by Cardinal Bartolomeo Pacca. It comes as no surprise that on November 23, 1825, the reconstruction commission dismissed Valadier from his position and put Pasquale Belli in his place, assisted by Pietro Bosio, Andrea Alippi, and Pietro Camporese the Younger.

The reconstruction of San Paolo proceeded slowly, and Pasquale Belli was soon replaced by Luigi Poletti as director of the building works. Finally, on October 5, 1840, Gregory XVI consecrated the confession altar, but it was not until December 10, 1845, that the entire basilica was consecrated by Pius IX.[7] This is not the place to analyze the successive stages of the complicated reconstruction as much as to describe Valadier's personal experience. The attacks by the experts were not directed at him personally but at the cultural world he represented, which had been compromised by the experience of the Roman Republic

and the Napoleonic occupation. The era of ambitious town-planning projects, like that of Piazza del Popolo, which Consalvi's administration had supported, no longer existed. Under Leo XII, it became more important to restore and keep intact the values that had legitimized the spiritual and temporal power of the Church since its earliest days.[8] The case of the basilica of San Paolo was exemplary because it was dedicated to St. Paul, one of the pilasters of Roman primacy.

Valadier was therefore downgraded but not deprived of everything since he was commissioned to carry out a fairly important work at Santa Maria Maggiore between 1825 and 1827. In preparation for the Jubilee, restoration work had already started in 1823 on the mosaics of the triumphal arch, and, at the same time, the porphyry columns of the main altar were decorated with bronze palm leaves.[9] Pope Liberio's basilica, following an encyclical issued on November 1, 1824, by Leo XII, took on the title of parish church, and, for the occasion, it was decided to transform the Chapel of the Assumption into a baptistery, and Valadier was given the commission.

The chapel space was divided in two by the installation of red granite Ionic columns and pilasters, and a porphyry basin that came from the Borgia Apartment in the Vatican and had been donated by the pope was placed in the middle of a circular enclosure. The basin, which was to serve as the baptismal font, was decorated with sprays of leaves and the heads of cherubim in bronze and surmounted by a bronze cover decorated with reliefs and the figure of St. John the Baptist.[10] This project, directed by Valadier, with the executive contribution of the goldsmith Giuseppe Spagna, makes it clear that the Roman architect was still held in esteem, even after the events of the San Paolo project. Here, however, his talents were limited to giving a certain space a different function, and providing for its decoration, all of which was once again a matter of layout and decoration rather than one of real architecture. In substance, Valadier's cultural vision was marginalized more than rejected. It would no longer find expression in important town-planning and building projects for it no longer responded to a particular historical context.

[1] For a complete historical picture, see M. Caravale and A. Caracciolo, *Lo Stato Pontificio da Martino V a Pio IX* (Turin 1978), esp. pp. 609-11. For the pontificate of Leo XII, see A. di Montro, *Storia del Pontefice Leone XII* (Milan 1843), in particular, for the Jubilee of 1825, pp. 125-31, 245-48.

[2] For the Jubilee of 1825 and the interventions connected to it, see the text by E. Mugavero in *Roma 1300-187: La città degli Anni Santi*, ed. M. Fagiolo and M. L. Madonna (Milan 1985), pp. 352-55.

[3] For Piazza del Popolo and Valadier's achievements, see P. Marconi, *Giuseppe Valadier* (Rome 1964), pp. 80-89, 177-81, 200-6; G. Ciucci, *La piazza del Popolo: Storia architettura urbanistica* (Rome 1974), pp. 91-117; G. Spagnesi, *Il centro storico di Roma: Il rione Campo Marzio* (Rome 1979), pp. 23, 65, 73; R. Di Fusco, *L'architettura* dell'Ottocento (Turin 1980), pp. 41-47; P. Hoffman, "Rione IV. Campo Marzio," in *Guide rionali di Roma* (Rome 1981), vol. 1, pp. 128-36. For Valadier's projects for the reorganization of the piazza and the Pincian Hill, see E. Debenedetti ed. *Valadier segno e architettura* (Rome 1985), pp. 68-92, entries 110-96.

[4] Cardinal Pier Francesco Galeffi (or Galleffi) was born in Cesena on October 20, 1770. He was created cardinal in 1803 by Pius VII, and became Prefect of the Congregation of the Holy Building Works of St. Peter's in 1820. See G. Moroni, *Dizionario di erudizione storico-ecclesiastica da S. Pietro sino ai nostri giorni* (Venice 1844), vol. 28, pp. 114-16.

[5] Regarding Targhini and Montanari, see F. Bartoccini, *Roma nell'Ottocento: Il tramonto della "Città Santa": Nascita di una capitale* (Bologna 1985), pp. 25, 344.

[6] Excerpts from the encyclical are printed in A. di Montor, *Storia*, pp. 137-41.

[7] Regarding the reconstruction of the basilica of San Paolo, see C. Ceschi, *Le chiese di Roma dagli inizi del Neoclassico al 1961* (Rome 1963), pp. 57-65; Marconi, *Giuseppe Valadier*, pp. 215-38; A. M. Cerioni, "L'incendio del 1823. Problemi e polemiche per la ricostruzione e sua realizzazione," *in San Paolo fuori le Mura a Roma*, ed. C. Pietrangeli (Florence 1988), pp. 67-72.

[8] For an interesting analysis of the cultural climate that characterized Leo XII's Restoration at the time the restoration work began at San Paolo, see Marconi, *Giuseppe Valadier*, pp. 114-15.

[9] For the minor interventions at Santa Maria Maggiore in view of the Jubilee, see the text by E. Mugavero in Fagiolo and Madonna, *Roma 1300-1875*, p. 358, entry 4.

[10] For the Baptistery at Santa Maria Maggiore, see L. Barroero, "La basilica dal '500 all'800," in *La basilica romana di Santa Maria Maggiore*, ed. C. Pietrangeli (Florence 1987), p. 254.

THE JUBILEES OF THE TWENTIETH CENTURY

FROM THE JUBILEES OF POST-UNITARIAN ITALY TO THE WORKS FOR THE JUBILEE OF 2000
Marco Di Capua

One demonstration of the conflicts between Italy and the Vatican is the fact that some people actually believed it highly meaningful that an anticlerical congress be organized in Rome during the Holy Year of 1900 to commemorate Giordano Bruno, who had been burned at the stake three centuries before. And yet, Pope Leo XIII, around whom the Jubilee revolved, wanted that event to have a solemnly mystical atmosphere when he promoted devotion to Christ the Redeemer at the beginning of the new century.

Vincenzo Gioacchino Pecci was ninety years old when he opened the Holy Door in 1900, and fifteen at the time of the last Jubilee in 1825. Then, as a model student, he had paid homage in Latin to Pope Leo XII. He remembered that fact when he became Pope in 1878 and had to choose his own new name. A cultured and sophisticated pope, the author of *Rerum Novarum,* the most politically discussed encyclical of the nineteenth century, Pecci never lost his passion for literature and Latin poetry. He was also the composer of some *Carmina* which had been appreciated by poets, like Giovanni Pascoli, who dedicated his own poem *La Porta Santa*, included in *Odi e Inni,*[1] to the Jubilee of 1900.

The Lombard Achille Ratti, Pope Pius XI, was the perfect embodiment of the sedentary scholar. He had directed the Vatican Library since 1911, and was an expert in the restoration of codices and the organization of archives and bibliographies. Yet, he was the one who dedicated the Holy Year of 1925 to the missionary spirit of the church throughout the world. The postwar climate that was still in the air suggested the inspiring motto: *Pax Christi in regno Christi.* The enormous Missionary Exposition organized for the occasion occupied the Courtyard of the Corazze, part of the Gardens, the long arm of the Museo Chiaromonti, and the Museo Lapidari in the Vatican. Midway between a history of evangeliza-

Ferruccio Ferrazzi
The Words of Christ
Vatican City, Vatican Museums
Coll. Arte Religiosa Moderna
detail

tion and ethnographic recognition, it exhibited thousands of objects sent from missions all over the world and paintings belonging to the protagonists of the apostolate. Ultimately, the exhibition was transformed into the Ethnographic Museum, the largest in Italy after the Museo Pigorini, and for a long time housed in the Lateran Palace, which had been renamed the Museo Lateranense.

«After the Breach of Porta Pia, the outside loggia of St. Peter's, from which the popes blessed the populace, remained closed. Pope Ratti had it reopened and delivered his benediction *Urbi et Orbi* in front of Rome, the capital of Italy. It was interpreted as a gesture of peace between the Vatican and the Italian state.»[2] St. Peter's was lit up by a spectacular illumination of lights. Ugo Ojetti described it at length in his book of memoirs *Cose viste,* which was published that same year. As has been correctly written, «Rome in 1925 is suspended in expectation of the modern. The new demolitions ideated by the art historians Antonio Muñoz and Corrado Ricci have already started to follow the pattern of the modern transformations of the Italian cities. Paying tribute to these was Corso Vittorio Emanuele, a street that had been opened in the heart of the Renaissance city with the objective of connecting Piazza Venezia directly to the bridge over the Tiber that led to St. Peter's. Based on time-consecrated models, those of the city remodeled by Sixtus V, the practicality of the streets was accompanied by their visual impact, that is by the choice of visual props of great historical note that would enhance them with solemnity.»[3]

In any case, this practical and monumental use of the city was much more important in serving the representational needs of the new secular capital, composed of ministries, Parliament, the Senate, military barracks, and industries than those of the groups of pilgrims who were coming to the Rome of the Pope and the Seven Churches.[4] From the point of view of the relationship between art and the church during the Holy Year, we know that «[…]His Eminence, Cardinal Pietro Gasparri, Secretary of State of His Holiness, gave notice of a publication, published by the "Pontificia Commissione Centrale per l'Arte Sacra" [Central Pontifical Committee for Sacred Art],[5] containing precise pontifical indications for sacred art with norms and suggestions for the committees of the diocese and the regions, and with the reprinting of the canons of Canon Law relative to that subject. It was the desire of the Holy Father that said publication be especially recommended, "in order that incentives and examples be drawn from it everywhere so as to properly protect the works of ancient sacred art and to cooperate as much as possible so that modern sacred art returns to the path of that magnificent tradition that has enriched the Church and Religion with so many treasures."»[6]

The Holy Year of 1950, proclaimed by Pius XII, was called the year of the great return and the great pardon. The memory of World War II was still very vivid, as were the echoes of the bombing of the quarter of San Lorenzo in Rome, and the image of the Pope with his arms outspread amidst the ruins. The city, meanwhile, had been subject to a new and decisive form of violence in the form of building speculation; the very profile of the city became hideous, the body of a civilization that had managed to resist the blows of history.

This time, a proper exhibition of missionary work was organized, with the goal of demonstrating the great ability of the Catholic apostolate in spreading the faith. The exhibition had been conceived in 1937 by Pius XI. In a letter to Cardinal P. Fumasoni-Biondi, he stated that he wished to show how «fertile the Christian idea is even in the field of art […] Therefore the new exhibition of Christian art will be like a wonderful

mirror in which the tastes of diverse people are reflected, and all that documentation will make it possible to study how indigenous art adapts to missionary needs.»[7]

As a matter of fact, what emerged from the exhibition was a new attention to the expressive differences of populations, respecting all separate cultural identities and opposing homogenization. Indeed, it was up to the mission to protect and assess a multiplicity of artistic experiences that were otherwise imperceptible. In this way, viewers were invited to grasp the spontaneous communicative force of "primitive" art, in its immutable perseverance of a Christian iconography grafted onto native stylistic traditions. The great exhibition, articulated according to geographical and national sections (India, China, Japan, Indonesia, Latin America, the Philippines, Africa, etc.), sought to restore a faithful interpretation to the sacred image, albeit one influenced by local typification.

There was also an exhibition at San Luigi de' Francesi dedicated to paintings, illustrated books, engravings, pottery, miniatures, enamels, stained glass windows, gold work, vestments, and bookbinding executed by French artists. Pié Régamey of the Order of the Frères Precheurs presented the works of Matisse (who was then finishing the decoration of the Chapel of the Rosary in Vence), Chagall, Denis, Manessier, Rouault, Braque, Bazaine—to name just a few—with acute and intelligent comments. «There is something rigorous, pondered and weighty, a certain detachment even, the sense of a delicate harmony in the lines, these are the qualities that result in the best craftsmen of today,» he wrote. «They are indicative of a very opportune reaction against the excesses of symbolism which under the pretext of modernity have deteriorated the current production. Is such a need for purity necessary for the service of the cult?»[8] And, for example, considering

the situation of international art at the moment, in a note to *Arte non figurative,* there was an insistence on the unpredictability of the future development of art and the liberating quality of abstraction, which could communicate new and more authentic spiritual energies.

Since 1948, the Pontifical Academy of the Pantheon (instituted in 1543, next to Raphael's tomb to foster the arts that *"florent in domo Domini"*) had been considering promoting an international exhibition of sacred art for the Holy Year. This mid-century balance would be installed in the new buildings constructed at the entrance to Piazza San Pietro. Extremely explicit regulations stipulated that the works had to be executed between 1900 and 1950, and correspond to the directives issued by Pius XI and Pius XII. At the

opening of the exhibition, some phrases taken from the Encyclical *Mediator Dei* of November 20, 1947, were quoted: «[…]Recent forms and images, more suitable to the new materials with which they are created, are not to be generically and deliberately disdained and repudiated; by wisely avoiding excessive realism on the one hand and exaggerated symbolism on the other, and by taking into account the needs of the Christian community rather than the artists' personal tastes and judgments, the way can be made free for modern art, if it is used with due reverence and due honor for sound buildings and sacred rites […] However, in all conscience, we cannot help but deplore and disapprove those images and forms that have recently been presented by some artists which seem to be a depravation and deformation of

Above, left:
Carlo Carrà
Deposition
Vatican City, Vatican Museums
Coll. Arte Religiosa Moderna

Above, right:
Ottone Rosai
Crucifixion
Florence, Tabernacle in Arcetri

real art and which at times are revolting to decorum, modesty, and Christian piety, and miserably offend real religious feeling. These must absolutely be distanced and eliminated from our churches just like all that in general which does not harmonize with the holiness of the place.»[9] Such explicit directions were also given regarding the restoration and reconstruction of the churches destroyed during the war.

The exhibition presented a vast and impressive production, and one that was convincing in subject matter despite the fact that so many contemporary artists were included. All the nations were represented. Among the Italians were painters with recently executed works, often especially created for the exhibition: Ferrazzi, Previati, Casorati, Oppi, Sartorio, Rosai, Tozzi, Carrà, Carena, Funi, and Ceracchini. The Italian sculptors included Andreotti, Bistolfi, Biagini, Selva, Rosso, Manzù,[10] Tadolini, Wildt, Gemito, Cambellotti, Messina, and Drei. Among the Italian architects were Clemente Busieri Vici (Church of S. Benedetto, 1948-49), Adriano Marabini (Church of S. Maria Assunta in Solarolo, 1950), and Ludovico Quaroni (Chiesa di S. Maria Maggiore in Francavilla a Mare, 1948), together with Marcello Piacentini and Giovanni Muzio, who, respectively, with Cristo

Re in Rome and the Church of S. Antonio in Cremona, had introduced modern tension into Italian religious architecture. Information is now being gathered relative to the Church of Divina Sapienza at the Città Università of Rome (1949-50), offered by Pius XII, where Piacentini availed himself of the collaboration of artists like Dazzi, Romanelli, and Prini, and the Church of S. Maria Mediatrice in Rome (1947-50), where a cartoon by Quaroni for a mosaic was used in Muzio's project, together with a fresco by Ceracchini dedicated to the Franciscan Order and paintings by Avenali.

For the Jubilee of 2000, proclaimed by Pope John Paul II, Rome will have a new church designed by Richard Meier, who won a competition in which Tadao Ando, Calatrava, Behnisch, Eisenman, and Gehry also participated. Built in the Tor Tre Teste quarter, it has the lightness of a building that is literally being "skimmed" like the pages of an enormous book, with its three sails unfurled to the light, and the brightness of the shell that opens. «I always think of architecture,» Meier has written, «as a place without time, as a space, that is, that is organized in such a way as to be completely detached from the problems of fashion and taste. In fact, the actuality of architecture, and its being in harmony with its own historical period as it is observed, depends on

Above, left:
Marcello Piacentini
Church of Divina Sapienza
Rome, Città Universitaria

Above, right:
Giovanni Muzio
Church of S. Maria Mediatrice in Rome

its basic indifference to time and its ability to be shaped by the ideas and aspirations that pass through history and look beyond it.»[11]

In preparation for the extraordinary number of pilgrims coming to Italy for the Jubilee of 2000, the architect Renzo Piano was asked to design the new Aula Liturgica (Liturgical Hall) dedicated to Padre Pio in the Sanctuary of San Giovanni Rotundo [in Apulia]. The complex iconographic and theological program has been coordinated by Monsignor Crispino Valenziano. Still in the building phase, the church looks like a modern version of the great Christian basilicas and, at the same time, like an extremely innovative building. «The same concept of an inside and outside that has almost been eliminated, reduced to the subtle trans-

parent membrane of the façade, has led him [Piano] to conceive of the entire construction as a kind of fossilized shell, a delicate spiral structure that emerges miraculously intact from the viscera of the earth, and almost blends with it.»[12] Perceiving that the communicative vocation of Pop Art is still intact, Piano involved the American artists Roy Lichtenstein and Robert Rauschenberg in his project. Before his death, Lichtenstein managed to finish the preliminary design of a *Last Supper* that will decorate the central chapel of the Eucharist, while Rauschenberg will execute a design for the enormous stained glass door of the entrance based on the theme of Celestial Jerusalem. The tabernacle and pulpit will be realized by two great Italian sculptors, Floriano Bodini and Giuliano Vangi.

Many thanks to Metella Ninetta Ferrazzi for her help.

[1] P. Bargellini, *L'Anno Santo nella storia, nella letteratura, nell'arte* (Florence 1974).

[2] Ibid., p. 241.

[3] P. Becchetti, M. Falzone del Barbarò and S. Weber, *Dagli Anni Santi al Giubileo del 2000* (Florence 1996), pp. 26-27.

[4] Symbolically significant of the opposition between the secular state and the Vatican was the installation in 1925 of the sculptor Ettore Ximenes's bronze quadriga on the façade of the Palace of Justice next to St. Peter's.

[5] Established in 1924.

[6] *Cronistoria dell'Anno Santo MCMXXV*, ed. Secretary General of the Central Committee (Rome, 1928), p. 436. It is useful to remember how these words correspond perfectly with what the Italian painter Gino Severini was doing and thinking. In 1924, his friend Jacques Maritain procured for him the commission to paint the church of Semsales in the Swiss canton of Fribourg. In 1926, he published "D'un Art pour l'Eglise" in the Catholic magazine *Nova et Vetera* in an effort to concili-

ate religious aspirations and modern figurative culture.

[7] *Mostra d'Arte Missionaria* (Vatican City 1950), p. 7.

[8] P. Régamey, *Libri e oggetti d'Arte religiosi in Francia* (Paris 1950), p. 8.

[9] *Esposizione Internazionale d'Arte Sacra* (Verona 1950), pp. 21-22.

[10] In April 1950, Giacomo Manzù, after the first two stages of a competition, was chosen to execute one of the three bronze doors that was to replace the existing wooden ones at St. Peter's. The sculptor had also accepted a commission that same year to execute the last four stations of the Via Crucis for the new church of Sant'Eugenio in Rome. This was offered by the Catholic world on the twenty-fifth anniversary of the episcopal consecration of Pius XII, designed by the architects Enrico Galeazzi and Mario Redini, and completed in 1951. There are important works in that same church by Alfredo Biagini, Pericle Fazzini, Domenico Rambelli, Attilio Selva, Ferruccio Ferrazzi, Gisberto Ceracchini, and Giovanni Prini.

[11] R. Meier, "L'architettura e Il Sacro," in *Quadri & Sculture* no. 31 (June-July 1998): 60.

[12] M. D'Argenzio, "Renzo Piano: un santuario per Padre Pio," in *ARS* no. 11 (November 1998): 111.

Above, and opposite page:
Richard Meier
Church for the Jubilee of 2000
Rome, Tor Tre Teste quarter

INDEX